BODY ART/
PERFORMING THE SUBJECT

BODY ART/
PERFORMING THE SUBJECT

AMELIA JONES

University of Minnesota Press
Minneapolis
London

Published by the University of Minnesota Press
111 Third Avenue South, Suite 290
Minneapolis, MN 55401-2520
http://www.upress.umn.edu

Library of Congress Cataloging-in-Publication Data

Jones, Amelia.
 Body art/performing the subject / Amelia Jones.
 p. cm.
 Includes bibliographical references and index.
 ISBN 0-8166-2772-X (hc : acid-free paper). — ISBN 0-8166-2773-8
(pbk. : acid-free paper)
 1. Body art. 2. Performance art. I. Title.
N6494.B63J66 1998
700'.9'045—dc21 97-34688

Printed in the United States of America on acid-free paper

The University of Minnesota is an equal-opportunity educator and employer.

10 09 08 07 06 05 04 03 02 01 00 99 10 9 8 7 6 5 4 3 2

[G]o back to the body, which is where all the splits in
Western Culture occur.
—CAROLEE SCHNEEMANN,
 CAROLEE SCHNEEMANN: UP TO AND INCLUDING HER LIMITS

Only the Slave can transform the World.
—ALEXANDRE KOJÈVE,
 "INTRODUCTION TO THE READING OF HEGEL"

CONTENTS

ILLUSTRATIONS

Unfortunately, the author was not able to reproduce any works by Laurie Anderson in this book.

ACKNOWLEDGMENTS

I am deeply indebted to many people who have all conspired to make this book possible. Breaking tradition, I want to begin by engaging my emotional others: those who have, through healthy resistance as well as tenacious support, continually brought the author of this book back to "herself." To Tony Sherin and Evan Sherin-Jones, especially, thanks for always making me smarter and more compassionate than I would otherwise be; your collective strength, humor, and resilience and your gift of family have given me the necessary fortitude to finish this task. As always, I am inspired by the various members of my extended family. I owe a special debt to Caroline Jones, whose sisterly support has been invaluable and whose scholarship on postwar art has informed many aspects of this study; her astute critical comments on various stages of the book improved it immeasurably.

Thanks to those artists I dealt with directly who shared with me their work and documentation of it: Marina Abramović, Vito Acconci, Laura Aguilar, Chris Burden, Maureen Connor, Karen Finley, Bob Flanagan, Coco Fusco, Lyle Ashton Harris, Mary Kelly, Uwe Laysiepen (Ulay), James Luna, Robert Morris, Yoko Ono, Sheree Rose, Joe Santarromana, Carolee Schneemann, Shozo Shimamoto, Annie Sprinkle, and Hannah Wilke. Great thinkers and supportive colleagues whose ideas directly inform this study include Toni De Vito, Didi Dunphy, Karen Lang, Kathy O'Dell, Donald Preziosi, Joanna Roche, Moira Roth, Vivian Sobchack, Erika Suderburg, and Faith Wilding. I thank also Annie Chu, Christine Magar, Pat Morton, and the other contributors for the inspiration of *WomEnhouse* and Nancy Barton, Roberto Bedoya,

Nancy Buchanan, Thatcher Carter, Meiling Cheng, Judy Chicago, Michael Cohen, Allan deSouza, Saundra Goldman, Lou-Anne Greenwald, Kathrin Hoffmann-Curtius, Bea Karthaus-Hunt, Kris Kuramitsu, Sam McBride, Yong Soon Min, Mira Schor, Barbara Smith, and Lisa Tickner for their good thoughts on bodies/selves in culture. I am deeply grateful to Mario Ontiveros for his ongoing intellectual insights as well as his assistance with the picture research on this book, to Rebecca Weller for research assistance, and to the other deeply intelligent students from the seminars I have taught on body art in the last four years at University of California, Riverside, and UCLA.

I am grateful, too, to the various archives, galleries, and libraries that supported this research, including the J. Paul Getty Institute, the Museum of Modern Art library and video and film study centers, the Archives of American Art, the UCLA and University of California, Riverside, libraries, and the staffs at the Ronald Feldman Gallery (especially Marc Nochella), Galerie Lelong, Ace Contemporary Exhibitions, Sandra Gering Gallery, Craig Krull Gallery, Barbara Gladstone Gallery, Jack Tilton Gallery, and John Weber Gallery. This book was completed with the generous assistance of grants from the American Council of Learned Societies and from the University of California, Riverside, for which I am deeply appreciative.

Body Art/Performing the Subject would not have materialized without the support and vision of Biodun Iginla, former University of Minnesota Press editor, and the energetic good faith of the present staff at the Press—especially editor William Murphy.

Finally, this book is dedicated to Virginia S. and Edward E. Jones, my mother and father, whose intersubjective postwar identities conditioned my approach to the set of questions raised in this study in deep ways I have not yet fully grasped. A special note of admiration is due to Mom, who has continued bravely to develop her selfhood beyond the sudden death of my father in 1993: she has enacted for me how subjects chiasmically intertwine but remain stubbornly particular.

INTRODUCTION

We abolish the stage and the auditorium and replace them by a single site, without partition or barrier of any kind, which will become the theater of the action. *A direct communication will be re-established between the spectator and the spectacle, between the actor and the spectator,* from the fact that the spectator, placed in the middle of the action, is engulfed and physically affected by it.
—ANTONIN ARTAUD[1]

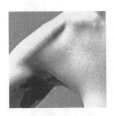

As Artaud realized in 1938, the radicalization of cultural expression would most dramatically take place in this century through a direct theatrical enactment of subjects in relation to one another, such that the hierarchy between actor and spectator would be dissolved and social relations would be profoundly politicized. In Artaud's "Theater of Cruelty," the performance of subjects in a "passionate and convulsive conception of life" would correspond "to the agitation and unrest characteristic of our epoch."[2] This book argues a similar relationship for body art practices, which enact subjects in "passionate and convulsive" relationships (often explicitly sexual) and thus exacerbate, perform, and/or negotiate the dislocating effects of social and private experience in the late capitalist, postcolonial Western world. Body art is viewed here as a set of performative practices that, through such intersubjective engagement, instantiate the dislocation or decentering of the Cartesian subject of modernism. This dislocation is, I believe, the most profound transformation constitutive of what we have come to call postmodernism.[3]

CASE ONE: CAROLEE SCHNEEMANN

In 1963 Carolee Schneemann stated the following in her personal notes:

> That the body is in the eye; sensations received visually take hold on the total organism. That perception moves the total personality in excitation. . . . My visual dramas provide for an intensification

CAROLEE SCHNEEMANN, *EYE BODY*, 1963. PHOTOGRAPH BY ERRÓ, COURTESY OF THE ARTIST.

of all faculties simultaneously—apprehensions are called forth in wild juxtaposition. My eye creates, searches out expressive form in the materials I choose; such forms corresponding to a visual-kinaesthetic dimensionality; a visceral necessity drawn by the senses to the fingers of the eye . . . a mobile, tactile event into which the eye leads the body.[4]

In the same year Schneemann performed her eroticized body in a performance called *Eye Body*. "Covered in paint, grease, chalk, ropes, plastic," she has written, "I establish[ed] my body as visual territory," marking it as "an integral material" within a dramatic environmental construction of mirrors, painted panels, moving umbrellas, and motorized parts.[5] As early as 1963, then, several years before the development of a cohesive feminist movement in the visual arts, Schneemann deployed her sexualized body in and as her work within

the language of abstract expressionism but against the grain of its masculinist assumptions. Describing this piece in her book *More Than Meat Joy*, Schneemann is clear about her motivations: "In 1963 to use my body as an extension of my painting-constructions was to challenge and threaten the psychic territorial power lines by which women were admitted to the Art Stud Club."[6]

In *Interior Scroll*, originally performed in 1975, Schneemann extended her sexualized negotiation of the normative (masculine) subjectivity authorizing the modernist artist, performing herself in an erotically charged narrative of pleasure that challenges the fetishistic and scopophilic "male gaze." [7] Her face and body covered in strokes of paint, Schneemann pulled a long, thin coil of paper from her vagina ("like a ticker tape . . . plumb line . . . the umbilicus and tongue"), unrolling it to read a narrative text to the audience. Part of this text read as follows: "I met a happy man, / a structuralist filmmaker . . . he said we are fond of you / you are charming / but don't ask us / to look at your films / . . . we cannot look at / *the personal clutter / the persistence of feelings / the hand-touch sensibility*."[8] Through the action, which extends "exquisite sensation in motion" and "originates with . . . the fragile persistence of line moving into space," Schneemann integrated the occluded *interior* of the female body (with the vagina as "a translucent chamber") with its *mobile*, and apparently eminently readable (obviously "female") exterior.[9] Schneemann projects herself as fully embodied subject, who is also (but not only) object in relation to the audience (her "others"). The female subject is not simply a "picture" in Schneemann's scenario, but a deeply constituted (and never fully coherent) subjectivity in the phenomenological sense, dialectically articulated in relation to others in a continually negotiated exchange of desires and identifications.[10]

Through works such as *Interior Scroll* Schneemann has established a "passionate and convulsive" relationship to her audience that dynamically enacts the dislocation of the conventional structures of gendered subjectivity characteristic of this explosive period. Not only does Schneemann clearly refuse the fetishizing process, which requires that the woman not expose the fact that she is *not* lacking but possesses genitals (and they are nonmale), she also thus activates a mode of artistic production and reception that is dramatically *intersubjective* and opens up the masculinist and racist ideology of individualism shoring up modernist formalism. This reigning model of artistic analysis (dominated by Clement Greenberg's then hegemonic formalist ideas) protected the authority of the (usually male, almost always white) critic or historian by veiling his investments, proposing a Kantian mode of "disinterested" analysis whereby the interpreter presumably determined the inherent meaning and value of the work through objective criteria.[11]

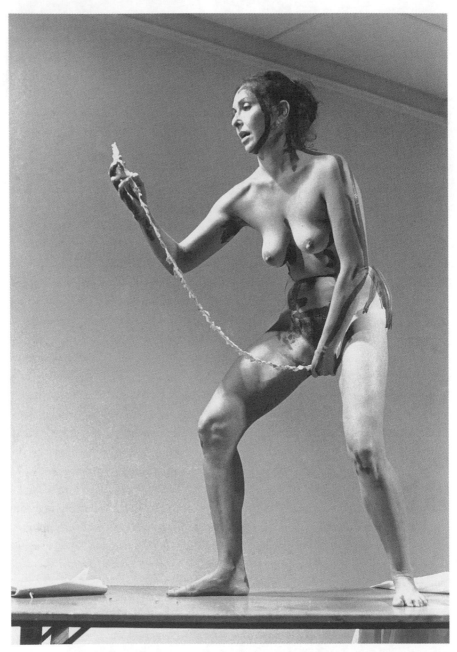

CAROLEE SCHNEEMANN, *INTERIOR SCROLL*, 1975. PHOTOGRAPH BY ANTHONY MCCALL, COURTESY OF THE ARTIST.

Body art is specifically antiformalist in impulse, opening up the circuits of desire informing artistic production and reception. Works that involve the artist's enactment of her or his body in all of its sexual, racial, and other particularities and overtly solicit spectatorial desires unhinge the very deep structures and assumptions embedded in the formalist model of art evaluation. Schneemann's self-enactment and engagement with the audience seriously compromise the myth of a "disinterested" art history or art criticism. The performative body, as Schneemann argues, "has a value that static depiction . . . representation won't carry"; she is concerned with breaking down the distancing effect of modernist practice: "my work has to do with cutting through the idealized (mostly male) mythology of the 'abstracted self' or the 'invented self'— i.e., work . . . [where the male artist] retain[s] power and distancing over the situation."[12]

Schneemann's work thus points to what I will argue in this book to be the particular potential of body art to destabilize the structures of conventional art history and criticism. In addition, *Interior Scroll* opens up the issue of the potentially heightened effects of *feminist* body art, as well as body-oriented projects by otherwise nonnormative artists who *particularize* their bodies/selves in order to expose and challenge the masculinism embedded in the assumption of "disinterestedness" behind conventional art history and criticism. As I will argue at length, it is such work that has the potential to eroticize the interpretive relation to radical ends by insisting on the *intersubjectivity* of all artistic production and reception. By surfacing the effects of the body as an integral component (a material enactment) of the self, the body artist strategically unveils the dynamic through which the artistic body is occluded (to ensure its phallic privilege) in conventional art history and criticism. By exaggeratedly performing the sexual, gender, ethnic, or other particularities of this body/self, the feminist or otherwise nonnormative body artist even more aggressively explodes the myths of disinterestedness and universality that authorize these conventional modes of evaluation.

CASE TWO: YAYOI KUSAMA

The particularization of the subject took an especially charged turn in the performative self-imaging of Japanese artist Yayoi Kusama. In a collage from the mid-1960s Kusama enacted herself as pinup on one of her vertiginous landscapes of phallic knobs, here a couch cradling Kusama as odalisque; this phallic/feminine image of Kusama embedded in her own work is glued above a strip of decidedly unerotic macaroni with a labyrinthine maze of one of her *Infinity Net* paintings covering the surface behind her. Here, naked and heavily made up in

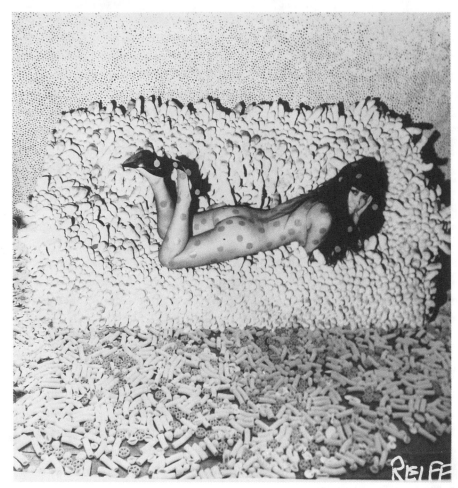

YAYOI KUSAMA, *SEX OBSESSION FOOD OBSESSION MACARONI INFINITY NETS & KUSAMA,* 1962. PHOTOGRAPH BY HAL REIFF, COURTESY OF THE ARTIST.

the style of the 1960s, Kusama sports high heels, long black hair, and polka dots covering her bare flesh: all surfaces are activated in a screen of decoration, merging the body of the artist with her created universe of phallic, patterned hyperbole. I am especially interested in the role such images, as performative documents, play in *enacting* the artist as a public figure.[13] As Kris Kuramitsu has argued, this photograph "is only one of many that highlight [Kusama's] naked, Asian female body. These photographs, and the persona that cultivated/was cultivated by them is what engenders the usual terse assessment [in art discourse] of Kusama as 'problematic.'"[14] Or, in the words of J. F. Rodenbeck, "Priestess of Nudity, Psychotic Artist, the Polka-Dot Girl, Obsessional Artist, publicity hound: in the 1960s Yayoi Kusama was the target of a number of

epithets, some of them self-inflicted, all of them a part of an exhibitionist's notoriety."[15]

Working in New York at the time she was producing these performative images, Kusama played on what Kuramitsu calls her "doubled otherness"[16] vis-à-vis American culture: she is racially *and* sexually at odds with the normative conception of the artist as Euro-American male. Rather than veil her differences (which are seemingly irrefutably confirmed by the visible evidence of her "exotic" body), Kusama exacerbates them through self-display in a series of such flamboyant images. In this posed collage, she performs herself in a private setting for the public-making eye of the camera. But Kusama enacts her "exoticism" on a public register as well, executing other performances (including at least seventy-five performative events between 1967 and 1970)[17] and posing in more public situations. In a portrait of artists participating in the 1965 exhibition of the Nul group at the Stedelijk Museum in Amsterdam,[18] Kusama sticks out like a sore thumb: there she stands, front and center—among a predictably bourgeois group of white, almost all male Euro-Americans (dressed in suits)—her tiny body swathed in a glowing white silk kimono.[19]

The pictures of Kusama are inextricably embedded in the discursive structure of ideas informing her work; viewers are forced to engage deeply with this particularized subject who so dramatically stages her work and/as her self. Too, in the collage images of Kusama such as the one discussed here, her body/self is literally absorbed into her work and indeed *becomes* it: "I was always standing at the center of the obsession over the passionate accretion and repetition inside me."[20] As Schneemann did in *Interior Scroll*, Kusama enacts her body in a reversibility of inside and out, the work of art/the environment is an enactment of Kusama and vice versa.

In her large-scale mirrored installations, such as *Kusama's Peep Show— Endless Love Show* (at Castellane Gallery in 1966), she forced the viewer into a similarly reversible relation.[21] Here, while listening to a loop of Beatles music, visitors poked their heads through openings in the wall of a closed, mirrored hexagonal room to see infinitely regressing reflections of themselves, illuminated by flashes of colored lights. A vertiginous sense of dislocation rocketed the visitor out of the complacent position of voyeurism conventionally staged and assumed vis-à-vis works of art. With such works, the spectator is locked into an exaggerated self-reflexivity that implies an erotic bond (an "endless love show")—one that is both completely narcissistic and necessarily complicitous with Kusama's (here absent) body/self.

In all of these works, Kusama refuses the artificial division—that which enables a "disinterested" criticism to take place—conventionally staged between

viewer and work of art. Folding the work of art into the artist (and vice versa), Kusama also sucks the viewer into a vortex of erotically charged repulsions and attractions (identifications) that ultimately intertwine viewer, artwork, and artist (as artwork). Kusama constructs obsessional scenes both to stage her particularized body/self and to express it externally—to spread it over the surrounding environment while simultaneously incorporating the environment into her own psychically enacted body/self: everything becomes a kind of extended flesh. But these scenes never fully contain Kusama, who performs herself well beyond the controlling mechanisms of art historical and critical analysis (hence her disturbance to the critical discourse, noted by Kuramitsu).

Am I an object? Am I a subject? Kusama performed these questions from the 1960s on, enacting herself ambivalently as celebrity (object of our desires) or artist (master of intentionality). Either way, Kusama opens herself (performatively) to the projections and desires of her audience (American, Japanese, European), enacting herself *as representation* (pace Warhol, she's on to the role of documentation in securing the position of the artist as beloved object of the art world's desires).[22] Kusama's gesture, which plays specifically with the intertwined tropes of gender, sexuality, and ethnicity (as well as those of artistic subjectivity in general), comprehends the particular resonance of such performative posing for women and those outside the Western tradition, subjects whose nonnormative bodies/selves would necessarily rupture embedded conceptions of artistic genius. It is Kusama's exaggeration of her otherness that seals this disturbance, building it into the effect of the work rather than veiling it to promote a formalist reading.[23]

Kusama's artistic strategies were inextricable from her identity politics and social politics; her work makes explicit the connections I trace throughout this book among social and identity politics and the deep interrogation of subjectivity characterizing this period. Kusama activated her always already marginalized body/self in a classically 1960s protest against bourgeois prudery, imperialism, racism, and sexism. Many of her public events were posed as demonstrations against the Vietnam War, and her strategic use of self-exposure was intimately linked to the openness urged by the sexual revolution: like Schneemann's body art works, Kusama's are both enactments and effects of the sexual revolution and antiwar movements as well as the women's movement. [24]

In its radical narcissism, where the distances between artist and artwork, artist and spectator are definitively collapsed, such body art practices profoundly challenge the reigning ideology of disinterested criticism. As I have already suggested, when the body in performance is female, obviously queer, nonwhite, exaggeratedly (hyper)masculine, or otherwise enacted against the grain

of the normative subject (the straight, white, upper-middle-class, male subject coincident with the category "artist" in Western culture), the hidden logic of exclusionism underlying modernist art history and criticism is exposed. The more exaggeratedly narcissistic and particularized this body is—that is, the more it surfaces and even exaggerates its nonuniversality in relation to its audience— the more strongly it has the potential to challenge the assumption of normativity built into modernist models of artistic evaluation, which rely on the body of the artist (embodied as male) yet veil this body to ensure the claim that the artist/genius "transcends" his body through creative production. As I will explore at greater length in chapter four, the narcissistic, particularized body both unveils the artist (as body/self necessarily implicated in the work of art as a situated, social act), turning her inside out, and strategically insists upon the contingency of this body/self on that of the viewer or interpreter of the work. As the artist is marked as contingent, so is the interpreter, who can no longer (without certain contradictions being put into play) claim disinterestedness in relation to this work of art (in this case, the body/self of the artist).

BODILY ENGAGEMENTS: A THEORETICAL PROJECT THAT IS DEEPLY HISTORICAL

It is important to emphasize that I argue that such body art works have the *potential* to achieve certain radically dislocating effects: it is one of the goals of this book to enact just the kind of engagement that I argue these works open up. That is, if I were to insist that Schneemann's and Kusama's practices *necessarily* destroy the structures of interpretation in art history and criticism, I would be denying the very notion of interpretation-as-exchange that this book attempts to argue through body art. I would also be hard put to explain why these structures are still so firmly in place so much of the time if this work I discuss has really been so destructive of them; and, finally, I would be catching myself in a fundamental hermeneutic dilemma, since I would be defining works that supposedly will not allow definitive interpretation (and suggesting that I am somehow "outside of" the structures and assumptions of conventional interpretive models). To this end, all of the projects highlighted in this book are described and interpreted through a model of *engagement* that allows for and indeed frequently foregrounds my own investment in reading them in particular ways. These are strategic readings meant to highlight specific aspects of postmodern subjectivity and specific art historical questions. At the same time, I have tried throughout to stay close enough to the documentation and other critical discourses that have framed the works historically so as not to provide readings that are pure fantasy.[25] I am fully responsible for these readings, which are highly invested and meant to be provocative.

Again, I stress the notion of *engagement* and *exchange:* I engage with what I experience as these works in relation to contemporaneous theories of subjectivity and aesthetics; I consider my readings to be a dialogue with the bodies/selves articulated in these important practices. This project thus attempts to enact the "paradoxical performative" that art historian Thierry de Duve has located as constitutive of postmodernism: it proclaims body art projects as radically postmodern even as it makes them so—it *performs* their postmodernism.[26] My readings themselves are offered as "performances," as suggestive, open-ended engagements rather than definitive answers to the question of what and how body art means in contemporary culture.[27] But a fundamental dilemma is built into this project: while I argue that these works in various ways challenge the framing apparatuses of modernist criticism and art history and reconceive the subject, in so doing I inevitably reframe them through my own invested point of view and refix the works as having particular meanings. I have generally tried to avoid sinking too deeply into the mire of this contradiction by reading the works as enactments of subjects (bodies/selves) whose meanings are contingent on the *process* of enactment rather than attributing motives to the authors as individuals or origins of consciousness and intentionality; in the cases where I know the artists personally, this is inevitably a fraught enterprise and I simply try to surface the particularities of these relationships.[28]

It should be clear by now that this book is not a history of performance or body art but a study, through the intensive exploration of particular practices, of the ways in which body art radically negotiates the structures of interpretation that inform our understanding of visual culture. It is also an exploration of body art as an instantiation of the profound shift in the conception and experience of subjectivity that has occurred over the past three decades. Schneemann's and Kusama's performative self-exposures, their enactments of themselves as both author and object, dramatize this shift: these projects insistently pose the subject as *intersubjective* (contingent on the other) rather than complete within itself (the Cartesian subject who is centered and fully self-knowing in his cognition). These projects make clear that the Cartesian "I think therefore I am," the logic powering modernist art theory and practice wherein the body (privileged as male) is transcended through pure thought or creation, is no longer viable in the decentering regime of postmodernism (if it ever was).

The issues addressed in this book, then, are deeply theorized in terms of models of subjectivity, artistic meaning, and identity formation, but they are also implicitly and explicitly historical. I suggest—reading through body art—that the very poststructuralist model of the subject as decentered is itself a

broadly historical idea, corresponding to the complex interrelationships and transformations in recent intellectual history as well as shifts within the political, social, and cultural arenas. Frustrated with what I view as an increasingly narrow, instrumental conception of postmodernism in the visual arts (as characterized by formal techniques such as montage and allegory or avant-gardist strategies such as Brechtian distanciation), as well as by the frequent use of reductive Lacanian models that reduce art reception to purely visual models, I turn strategically to body art and to a phenomenologically inflected feminist poststructuralism (particularly the works of Maurice Merleau-Ponty as read through Simone de Beauvoir, Judith Butler, and others) *to re-embody* the subjects of making and viewing art.[29] Informed and driven by the vicissitudes of body art itself, I attempt to provide a more complex model for understanding postmodernism.

In this book, theory and practice are viewed as mutually constitutive. Thus, I do not view poststructuralism (or even economic or social shifts or body art itself) as having "caused" the death of the centered subject; nor do I view any of these as, strictly speaking, effects of the decentering of the Cartesian subject. I view poststructuralism (in its feminist and phenomenological dimensions) as one of the most dynamic modes of the speaking of a new experience of subjectivity, as the philosophical version of what body art enacts in the realm of culture. While body art is surely not the *only* type of cultural production to instantiate the dispersal of the modernist subject (a fair amount of the discourse surrounding feminist art has pivoted around claims that various practices exemplify this dispersal), I argue here that it is one of the most dramatic and thorough to do so *if it is engaged with on the deepest levels of its production*, precisely because of its entailment of the subject as embodied in all of its particularities of race, class, gender, sexuality, and so on.

At the same time, social, political, and cultural context is crucial to this analysis of what body art (and, for that matter, poststructuralism, feminism, and theories of postmodernism) can tell us about our current experience of subjectivity. I address throughout the book issues such as the suppressed crisis of masculinity in the 1950s and the rise of activism in the 1950s and into the 1960s and 1970s (including the rights movements, which began insistently to foreground the particularization of subjectivity that the most powerful body art projects address); the obvious impact of the Vietnam War and its attendant protests on, especially, Americans' conception of their relationship to the state is a subtextual but also crucial context in the shift to an unveiled, activist artistic body, as are the free love and drug cultures so active during this period (they promoted an atmosphere of experimentation to which body art is intimately

connected).[30] The multinationalization of economies and the proliferation of increasingly advanced technologies of representation and communication are discussed as deeply implicated in articulations of the body in more recent work.

It is important to stress again that neither poststructuralism nor these other social events and processes are to be viewed as "causes" of body art, nor is body art seen to be their motivating "origin." Rather, body art—like these other elements—is examined as an *instantiation* (both an articulation and a reflection) of profound shifts in the notion and experience of subjectivity over the past thirty to forty years. The key question I address through my engagement with body art is the question that initially motivated my interest in this topic: why, climaxing in the late 1960s and early 1970s, did the implicitly masculine, modernist artistic subject (who had been largely veiled under the rhetoric of "disinterestedness" in art criticism and art history) come increasingly into question through a performative conception of the artist/self as in process, commodifiable *as* art object (*viz.* Kusama), and intersubjectively related to the audience/interpreter?[31]

BODY ART VERSUS PERFORMANCE

The body is the inscribed surface of events (traced by language and dissolved by ideas), the locus of a disassociated Self (adopting the illusion of a substantial unity), and a volume in perpetual disintegration.
—MICHEL FOUCAULT[32]

The body is at once the most solid, the most elusive, illusory, concrete, metaphorical, ever present and ever distant thing—a site, an instrument, an environment, a singularity and a multiplicity. The body is the most proximate and immediate feature of my social self, a necessary feature of my social location and of my personal enselfment and at the same time an aspect of my personal alienation in the natural environment.
—BRYAN TURNER[33]

[T]he body itself . . . is both biological and psychical. This understanding of the body as a hinge or threshold between nature and culture makes the limitations of a genetic, or purely anatomical or physiological, account of bodies explicit.
—ELIZABETH GROSZ[34]

These evocative descriptions of the body open up the problematic of body art and lead me to clarify why I use the term "body art" rather than the perhaps more obvious "performance art" rubric. I use "body art" rather than "perfor-

mance art" for a number of interrelated reasons. First, linking back to the descriptions of the body I have mentioned (all exemplary of a poststructuralist theory of embodied subjectivity), I want to highlight the position of the *body*—as locus of a "disintegrated" or dispersed "self," as elusive marker of the subject's place in the social, as "hinge" between nature and culture—in the practices I address here. The term "body art" thus emphasizes the implication of the body (or what I call the "body/self," with all of its apparent racial, sexual, gender, class, and other apparent or unconscious identifications) in the work. It also highlights both the artistic and the philosophical aspects of this project—aspects that, I am arguing, are deeply intertwined and mutually implicated in the profound shift in the conception of subjectivity that I am "performing" here (through body art) as constitutive of the condition of postmodernism.

Second, while I tangentially make note of the broader history of "performance" in the visual arts, I focus in this book on a particular moment in which the body emerged into the visual artwork in a particularly charged and dramatically sexualized and gendered way. The work that emerged during this period—from the 1960s to the mid 1970s—was labeled "body art" or "body-works" by several contemporaneous writers who wished to differentiate it from a conception of "performance art" that was at once broader (in that it reached back to dada and encompassed any kind of theatricalized production on the part of a visual artist) and narrower (in that it implied that a performance must actually take place in front of an audience, most often in an explicitly theatrical, proscenium-based setting).[35] I am interested in work that may or may not initially have taken place in front of an audience: in works—such as those by Kusama, Schneemann, Vito Acconci, Yves Klein, and Hannah Wilke—that *take place through an enactment of the artist's body,* whether it be in a "performance" setting or in the relative privacy of the studio, *that is then documented such that it can be experienced subsequently through photography, film, video, and/or text.* In this way, I see body art as a complex extension of portraiture in general (as will emerge in chapter 2) as well as an obvious negotiation of the trajectory of performance art that emerged from the early-twentieth-century European avant-gardes.[36]

Performance art has typically been defined as motivated by a "redemptive belief in the capacity of art to transform human life," as a vehicle for social change, and as a radical merging of life and art.[37] As I explore it here, body art is both far more and far less than this. Articulated by artists such as Schneemann, Kusama, Vito Acconci, and Hannah Wilke, body art does not strive toward a utopian redemption but, rather, places the body/self within the realm of the aesthetic *as a political domain* (articulated through the aestheticization of the particularized body/self, itself embedded in the social) and so unveils the

hidden body that secured the authority of modernism.[38] Again, in this regard body art is *not* "inherently" critical, as many have claimed, [39] nor (as we will see others have argued) inherently reactionary, but rather—in its opening up of the interpretive relation and its active solicitation of spectatorial desire—provides the *possibility* for radical engagements that can transform the way we think about meaning and subjectivity (both the artist's and our own). In its activation of intersubjectivity, body art, in fact, demonstrates that meaning is an exchange and points to the impossibility of any practice being "inherently" positive or negative in cultural value.

As François Pluchart melodramatically warned in 1974, body art "is not a new artistic recipe meant to be recorded tranquilly in an history of art which is bankrupt,"[40] particularly in its shifting of the very parameters by which this history is constructed. Body art—which projects the body of the artist into the work as a particularized subject, revising, as Ira Licht argued in 1975, "the relationship among artist, subject and public"—encourages us to rethink the very methods by which we fabricate histories of art and to rethink the ways in which we understand meaning to take place.[41] Thus, we will see that it is *body art* rather than performance art that specifically opens out the closed circuits by which the art object was determined to have significance within modernist criticism. Body art proposes the art "object" as a site where reception and production come together: a site of intersubjectivity.[42] Body art confirms what phenomenology and psychoanalysis have taught us: that the subject "means" always in relationship to others and the locus of identity is always elsewhere.

As I view body art here, it does two potentially radical things. By surfacing the desires informing interpretation, it encourages a "performance of theory" that aims "to replot the relation between perceiver and object, between self and other,"[43] illustrating what is at stake in such claims by encouraging acts of interpretation that themselves are performative. And it opens out subjectivity *as* performative, contingent, and always particularized rather than universal, implicating the interpreter (with all of her investedness, biases, and desires) within the meanings and cultural values ascribed to the work of art.

THE BODY OF THE TEXT

The chapter following this introduction seeks to provide a firm historical and theoretical basis for the book by aligning body art with the philosophical (phenomenological, feminist, poststructuralist) theories of subjectivity that it both amplifies and takes radical value from. Following an examination of the tendency to downplay or ignore body art in art discourse from the mid 1970s onward, which locates the politics of this omission in relation to the fixation on

avant-gardist theories of cultural production and narrowly visual models of the "gaze," I trace a particular intellectual history in the United States and France from the 1950s onward. I foreground Ana Mendieta's performative artistic project as exemplary of the problematics of presence and absence brought to the surface by body art, exploring the ontology of body art projects and addressing the specificity of their multiplicitous existence as "live" performances, photographic, textual, film, and/or video documentations.

This history highlights the repressed phenomenological dimension of the French poststructuralist theories that have so deeply informed dominant discourses about postmodern art, stressing the *embodiment* of subjectivity over what has come to be a reigning model of pure visuality. In order to understand the way in which body art (which I discuss largely as a U.S. and European phenomenon, foregrounding U.S. practices) inflects and is inflected by the poststructuralist conception of the dispersed or decentered subject, I thus trace an intellectual history through the phenomenological arguments of Maurice Merleau-Ponty, linking his radical critique of the Cartesian subject to Simone de Beauvoir's specifically *feminist* rethinking of the existentialist and phenomenological theory of the social subject in *The Second Sex* and then to phenomenologically inflected, feminist poststructuralist models of performative subjectivity.

Through this renewed attention to a phenomenology updated through poststructuralist and feminist thought, I set the stage for a new understanding of the ways in which body art, in particular, can radicalize our understanding of postmodernism as not only a new mode of visual production but also a dramatically revised paradigm of the subject and of how meaning and value are determined in relation to works of art. The chapter thus suggests that engaging deeply with the contradictions and insights regarding the subjects of making and viewing put into play in body art projects can develop a new (implicitly feminist) reading praxis that is suspicious of the assumptions and privileges embedded in and veiled by conventional, masculinist models of artistic interpretation.[11]

Chapter 2 is an extended exploration of Jackson Pollock, who has functioned in art discourse as a kind of hinge or pivot between the modernist genius and the performative subject of postmodernism. Pollock (as perceived and interpreted through the well-known series of photographs of him painting by Hans Namuth and others taken around 1950) is a figure who was first, in de Duve's paradoxical performative, *spoken* as the quintessential modernist genius: Pollock's body is veiled and his transcendence averred by enthusiastic supporters such as Clement Greenberg and Harold Rosenberg, whose image of Pollock as "action painter" celebrates his existentialist triumph over the mute

canvas.[45] Pollock is then *rearticulated* as a crucial origin for the performative artistic subject of postmodernism by younger artists such as Allan Kaprow (who, in his formative 1958 essay "The Legacy of Jackson Pollock," reworks Rosenberg's action painting existentialist Pollock into an aggressively performative one).[46] Pollock is thus engaged with and opened out as a *performative author function* (Michel Foucault's useful term for the "plurality of egos" put into play by the cultural text.)[47] This focus on Pollock clarifies my approach to the "author" (the body/self) of the body art project as a "function" of my engagement with its multivalent "texts" (photographs, "live" performance, etc.). Stressing its performative dimension, I call this particular author function the "Pollockian performative."

Examining at some length the historical contexts for what I term Pollock's "equivocal masculinity" (with Pollock enacted both as a quintessential centered subject of *modernism* and then as feminized/homosexualized and proto-*postmodern* subject/object of spectatorial engagement in his theatrical photographic display), I address 1950s U.S. culture and its celebration of the "individual" (which itself relates to the Cartesian subject addressed by French theory). The chapter thus reviews the critical reception of Pollock through a feminist and phenomenological grid that emphasizes the transferential, intersubjective dimension of how, on the one hand, an artist and her or his works come to mean in relation to her or his publicly articulated body/self; and, on the other, of how performativity is not simply "adopted" by a younger generation of artists spontaneously in the 1960s but, rather, was always already a part of modernism (again, this relates to the paradoxical performative that appropriates and exaggeratedly rearticulates particular modernist practices as postmodern).

Chapters 3 and 4 take on specific case studies in order to delve more deeply into the dramatic shifts I identify in relation to body art. Chapter 3 deals with Vito Acconci's body art practices from the late 1960s and early 1970s, which I read in relation to the then still powerful Pollock myth. I view Acconci's performance and video-oriented works through poststructuralist, feminist, and phenomenologically oriented theories of subjectivity to argue that he both stages the heterosexual masculine norm of subjectivity and, by overtly theatricalizing himself in relation to his own eroticism and the desires of female subjects (often within the pieces themselves), potentially destabilizes its link to cultural privilege. As I engage with his work, Acconci opens himself to the other and makes his heterosexual, white masculinity extremely vulnerable to the penetratory gazes of spectatorial desire (both female and male).

In relation to Hannah Wilke's work I explore at length the way in which the female subject who displays her body/self is always forced to negotiate what

Craig Owens astutely termed the "rhetoric of the pose."[48] Wilke's work, which insistently articulates what I call the radical narcissism typical of much feminist body art from this period (already noted in relation to Kusama), flamboyantly objectifies the (her) female body but also simultaneously performs her body/self as subject. At the same time, a usually ignored dimension of Wilke's work traces the intersection between her woundedness as an objectified female in Western culture and her "scars" from the anti-Semitic prejudices that externally condition her relationship, as a Jewish female, to dominant Western culture. In this way, I argue that Wilke's radical narcissism (which perverts the simplistic conception of self-other relations by pulling the viewer/other inexorably into Wilke's interpersonal structures of viewing and self-display) also politicizes white feminism by particularizing her feminity in terms of her ethnicity.

The final chapter explores the return to the body in recent work after a decade or so of antipathy in art discourse toward any artwork negotiating, representing, or otherwise addressing subjectivity in terms of the body. Again, I use several practices as case studies to explore in some depth the ways in which recent body-oriented practices articulate even more aggressively the dispersal of the subject traced in poststructuralism and earlier body art. The performative installation work of Maureen Connor and the large-scale techno-performances and CD-ROM project of Laurie Anderson facilitate a discussion of what I call the "technophenomenological body," allowing a preliminary reworking of phenomenology through these technologically based rearticulations of the gender-particularized subject. Lyle Ashton Harris's dramatic extension of a feminizing narcissism and Laura Aguilar's highly charged articulation of a personalized and particularized subjectivity—both enacted through the technological gaze of the photographic image—exemplify the ways in which the effects of new technologies and the transformations wrought by 1970s identity politics have informed a powerful new approach to identities and explorations of subjectivity. Thus Aguilar uses her body in her work, mediated through technologies of representation, to enact a subject that is simultaneously particularized (Latina, lesbian, artist, dyslexic) and dispersed (engaging with the audience, she defines the viewer as the "self" that has designated her elusive "otherness"). Aguilar enacts just the dynamic of intersubjectivity that I argue is constitutive of the most powerful effects of recent body-oriented practices: she solicits her viewers to *make us responsible* for the effects of our own perceptions and interpretive judgments.

Finally, I examine the work of artists Orlan and Bob Flanagan, both of whom (for very different reasons) have had their bodies mutilated, turning them *inside out* and thus deeply interrogating what it means to be a body/self in

this hypercommodified end of the millennium. Orlan's now notorious facial surgeries, choreographed and publicly documented in performances that aim to transform her either into an amalgam of ideal feminine features from art historical images or into a grotesque parody of "perfect" femininity, and Flanagan's humorous approach to having his body parts lacerated in sadomasochistic performances bring to the surface basic taboos informing our ongoing desire to *transcend* our bodies through fantasy, technology, or (in Cartesian terms) "pure" thought. Their projects, I argue, also end up reinforcing the inexorability of our embodiment, of the body as "meat," and thus reconfirm the importance of maintaining an embodied theory of postmodern art and subjectivity that accounts for rather than suppresses the contradictions, difficulties, and traumatic engagements involved in our relationship to the world.

Often using high tech modes of presentation—such as digitized imagery projected in installation formats—artists in the 1990s construct fragmented, dispersed, and explicitly particularized subjects that encourage the spectator's committed engagement. These works are not only insistently inter-subjective, they are also what Vivian Sobchack terms inter*objective:* they clarify the subject's interrelatedness with the world (of others as well as things).[49] Such an insistence on the interrelatedness of subjects and objects, our inevitable simultaneous existence as subject and object, and our interdependence with our environments asserts the necessary responsibility of the multiplicitous and dispersed, but fully embodied, social and political subject.

Thus, while I am arguing that postmodernism is, indeed, characterized by the splitting, decentering, dislocation, or fragmentation of the self that is either celebrated or lamented in so much contemporary cultural theory, this dispersal is played out here, through recent body-oriented practices, as having potentially radically progressive and inevitably political effects. It is in these recent projects, which extend the intersubjective dimension of 1960s and 1970s body art as well as exaggerating the dispersal and particularization of the subject enacted in poststructuralist theory, that the postmodern "cyborg" subject so popular in much recent technotheory is most dramatically enacted in all of its complexities. The profound shifts in our experience of ourselves and the world occasioned by new bio-, communications, and travel technologies are both performed by and reflected in recent body-oriented practices, which can thus tell us a great deal about the philosophical and political implications of this rethought paradigm of the condition of postmodernism.

Finally, then, this book *uses* body art (including here the body-oriented practices of recent years) to move beyond the rather reified conceptions of postmodernism dominating contemporary art discourse. When it is engaged

with through a phenomenologically informed feminism, body art can open up the entire domain of art interpretation, encouraging the development of a new reading praxis that acknowledges the masculinist, racist, homophobic, and classist assumptions underlying the disciplines of art history and criticism and their rhetoric of "disinterested" aesthetic judgment and historical narration. Body art practices surface our embeddedness in the determinations of meaning and value. Body art practices *perform* the gradual but dramatic shift that has occurred over this past half century in the very articulation of the subject within the social domain.

1

POSTMODERNISM, SUBJECTIVITY, AND BODY ART: A TRAJECTORY

 Body art and performance art have been defined as consti-
tutive of postmodernism because of their fundamental
subversion of modernism's assumption that fixed meanings
are determinable through the formal structure of the work
alone.[1] Thus, M. Bénamou states unequivocally that "per-
formance [is] the unifying mode of the postmodern," a
claim seconded by Johannes Birringer and numerous others.[2] And yet in 1980s
art discourse, while performance art in its more theatrical manifestations con-
tinued to generate intellectual support and broad audiences (often outside the
parameters of the art world), body art was increasingly frequently dismissed by
those interested in debunking or overthrowing modernism because of its sup-
posedly reactionary desire to ensure artistic presence. By the late 1970s, artists
had generally moved away from the relatively modest, raw staging of themselves
in body art projects.[3] Body art mutated into either performative photographic
work, such as the "film stills" of Cindy Sherman, or large-scale, ambitious, and
at least seminarrative performance art practices such as Laurie Anderson's the-
atrical, proscenium-bound *United States*.

Understanding this shift away from the body enables a deeper con-
textualization of body art projects from the earlier period, projects that were
largely dismissed, ignored, or downplayed in subsequent art critical discourses.
In the 1980s, body art as conceived in the late 1960s and early 1970s was in-
creasingly perceived and spoken of as modernist in the conservative, Green-
bergian sense—especially by art historians and critics from England and the

United States oriented toward a Marxian, feminist, and/or poststructuralist critical theory.[4] A look at one particular example of the negative evaluation of body art during this period will highlight my strategic motivation in pulling body art out of this state of critical oblivion and will set the stage for a deeper examination of the philosophical issues I believe to be at stake in such negative determinations.

FEMINIST CONDEMNATIONS OF BODY ART AS NAIVE ESSENTIALISM

In her important 1981 essay "Re-Viewing Modernist Criticism," the feminist artist and theorist Mary Kelly articulated a harsh critique of 1970s "performance work" as theoretically unsophisticated and idealist:

> In performance work it is no longer a question of investing the object with an artistic presence: the artist is present and creative subjectivity is given as the effect of an essential self-possession. . . . [According to supportive critics] . . . the authenticity of body art cannot be inscribed at the level of a particular morphology, it must be chiselled into the world in accordance with direct experience. The discourse of the body in art is more than a repetition of the eschatological voices of abstract expressionism; the actual experience of the body fulfills the prophecy of the painted mark.[5]

Kelly's argument, part of her extended and compelling critique of Greenbergian, formalist modernism, marks the decisive shift in 1980s U.S. and British art critical discourse away from an appreciation of the overt enactment of the artist's body. Here and elsewhere, Kelly has been unbending in her condemnation of artists (especially women) who deploy their own bodies in their works.[6] Working at the time in the developing context of British poststructuralist feminist discourse in the visual arts and film (including the work of well-known figures such as Laura Mulvey and Griselda Pollock), Kelly focused her critique primarily on the rather crudely metaphysical statements of 1970s supporters and practitioners of body art (such as Lea Vergine and Ulrike Rosenbach),[7] which she then criticizes for their idealism. Her criticism is convincing (especially when one understands the importance of this argument in its particular context at the time), but in dismissing wholesale the possibility of an embodied visual practice, I believe that Kelly's polemic is far too limiting in understanding the ways in which such work can radically engage the viewer toward ends not incompatible with those Kelly calls for in her own work and writing (activating the viewer, positing sexual and gender identities as fully contingent and intersectional with class, race, and other aspects of identity, etc.).

In the essay Kelly, whose writing and artwork have come to be paradigmatic of what we might call "antiessentialist" feminist postmodernism as it developed in England in the 1970s and 1980s, demotes body art to the provinces of a naive essentialism—an untheorized belief in the ontology of presence and in an anatomical basis for gender. Again, Kelly's criticism of body art, which she aligns with her critique of Greenbergian modernism, was highly strategic at the time in that it served well the purpose of legitimating a rigorous antiessentialist feminist art discourse and practice. While acknowledging the importance of Kelly's writings and art practice to the development of a critical feminist practice in the 1970s and 1980s, it is useful at this point to open up the prescriptive dimension of Kelly's critique, which implies that *any* artwork including the artist's body is *necessarily* reactionary.

As I have suggested, Kelly's antipathy to body art is typical of 1980s art discourse in the United States and England, both feminist and otherwise, which tended to be motivated in its judgments by suspicion of the embodied and desiring subject—in Marxian terms, especially the spectatorial subject who could easily be manipulated by the seductive effects of commodity culture. Informed by an avant-gardist and Marxian conception of the political importance of building cultural resistance to capitalist structures and drawing on a particular interpretation of Jacques Lacan's model of subjectivity evacuated of its phenomenological dimension, this discourse turned definitively away from the body.[8] Employing a psychoanalytic, castration-oriented model of subjectivity pivoting around the registering of sexual difference in terms of the (visual) presence or absence of the penis/phallus as determined through the (male) "gaze," proponents of this art critical approach evaluated art practices in terms of their putative ideological effects on the spectatorial subject, in turn conceived virtually entirely as a function of vision. The phenomenologically experienced dimension of the corporeal (the subject as desiring and intersubjectively articulated body/self) slipped away in this emphasis on the body as image, whose visual effects are experienced on a psychic register.

While it is obviously tempting to focus exclusively on the visual in addressing a mode of expression (the "visual" arts) that works to produce images and objects that can be seen, I would like to suggest, precisely as I believe body art is teaching us, that such a focus is not enough. Such a focus can miss the point of practices that, as I read them, beg us to reconsider the artistic and broader cultural dimensions in relation to open-ended but also definitively *embodied* intersubjective relations. Body art asks us to interrogate not only the politics of visuality but also the very structures through which the subject takes place through the inevitably eroticized exchange of interpretation.[9] While 1980s

23

art critical discourse (including Kelly's article) viewed body art as reactionary and metaphysical, as reinforcing rather than challenging problematically exclusionary aspects of modernism, I insist here that this interrogation on the part of body art is deeply political when it is engaged with through a phenomenological and feminist model. Body art, unlike the static, almost inevitably commodified works produced in response to Lacanian-oriented theories of the oedipal subject, more effectively gets at the *structures* of interpretation, encouraging us to see that all political and aesthetic judgments are invested and particular rather than definitive or objective.

The feminist articulation of this turn away from the corporeal was particularly vehement about the absolute need to remove the *female* body from representation; *any* presentation or representation of the female body was seen as *necessarily* participating in the phallocentric dynamic of fetishism, whereby the female body can only be seen (and, again, the regime is visual in these arguments) as "lacking" in relation to the mythical plenitude represented by the phallus. Feminist artists, then, simply must avoid any signification of the female body (since it is always already an object). In a 1982 interview, Kelly asserted that

> when the image of the woman is used in a work of art, that is, when her body or person is given as a signifier, it becomes extremely problematic. Most women artists who have presented themselves in some way, visibly, in the work have been unable to find the kind of distancing devices which would cut across the predominant representations of woman as object of the look, or question the notion of femininity as a pre-given entity.[10]

The negative attitude toward body art on the part of many feminists, then, seems to have stemmed from a well-founded concern about the ease with which women's bodies have, in both commercial and "artistic" domains, been constructed as object of the gaze.[11] It also often stemmed in part from an anxiety about the dangers of the artist (especially the female artist) exposing her own embodiment (her own supposed "lack") and thus compromising her authority.[12]

The "distancing devices" Kelly invokes here relate to the Marxian dimension of the critical model dominant in 1980s art discourse. Bertolt Brecht's theory of *distanciation*, an avant-gardist theory of radical practice, was adopted and developed by British feminists (including Kelly, a U.S. transplant at the time) as a model: the radical feminist practice must aim to displace and provoke the spectator, making her or him aware of the process of experiencing the text and precluding the spectator's identification with the illusionary and ideological functions of representation.[13] The rejection of 1970s body art in general ex-

tends in part from this Marxian distrust of art forms that elicit pleasure, that seduce rather than repel viewers, engaging them in the ideological field of the work of art as passive consumers rather than active critics.[14] As Griselda Pollock, a British feminist art historian who has strongly articulated this view within feminism (and who has been a longtime supporter of Kelly's visual artwork), argues, distanciation is a crucial strategy for feminist artists because of its "erosion of the dominant structures of cultural consumption which . . . are classically fetishistic. . . . Brechtian distanciation aims to make the spectator an agent in cultural production and activate him or her as an agent in the world."[15] This is a feminist strategy for Pollock because the objectifying regime of consumerist capitalism is consummately patriarchal. Work that does not distanciate, then, is not effectively (or properly?) feminist.

My discomfort with arguments such as Pollock's and Kelly's stems from what I view as their insistence on one mode of production that will supposedly have effects in the viewer that can be determined in advance through an analysis of the formal structures and historical context of the work. I believe such readings, which polemically aim to produce a critical mode of cultural engagement as constitutive of a radical postmodern (or in this case radical feminist) practice, fundamentally foreclose on the most dramatic and transformative potential of such engagement precisely by assuming that spectators will necessarily react or participate in a predictable way. In this way, body art projects and body-oriented feminist art are simply rejected as necessarily reiterating the structures of fetishism; no possibility is allowed for the myriad disruptions that, in fact, these practices *have* made in the modernist fabric that Pollock and Kelly want so to dismantle.[16] The wholesale dismissal of body art practices (or, in Pollock's case, non-"Brechtian" practices) in 1980s art discourse fails to account for the strategic force of body art projects in the late 1960s and 1970s and for the contingency of all meanings and values of cultural products on the social and political contexts of reception as well as on the particular desires of the interpreter in question (here, Pollock and Kelly themselves).

What I hope to suggest in this book as a whole is that such sweeping dismissals of a particular kind of practice (here, the performance of the artist's body in or as the work of art), while certainly strategically articulated at the time, can be seen with hindsight as reiterating one of the most damaging impulses of modernist criticism: the definitive evaluation of works of art in terms of an externally conceived, hierarchical system of value (in this case, replacing Greenberg's aesthetic categories with Brechtian ones). It is probably inevitable that we will tend to evaluate practices according to some arbitrary system of value, for art history and criticism are structured by this impulse. But, if we are

to extend the insights of poststructuralist philosophy into art discourse in a convincing way, we must at least surface our own implication in such determinations. Body art, I believe, encourages such a surfacing in its dispersal and particularization of the subject (as body/self) and opening of the art-making and -viewing processes to intersubjective desires and identifications.[17]

The issue of interpretive engagement can be brought to the fore through attention to works such as Ana Mendieta's *Silueta* series (1973–1980) or, in fact, Kelly's own *Corpus* installation (part of the *Interim* project first installed in 1990), which produces certain effects that I interpret here (certainly against the grain of Kelly's proposed reading) as consistent with body art.[18] Born and raised in Cuba and brought to the United States at the age of thirteen, Ana Mendieta involved her body in ritual acts (related to Santería rites she first came into contact with as a child and to the Taíno Indians' goddess culture) that were documented by photographs in which she increasingly absented her body altogether.[19] These luminous, eerie photographs present the impression of her body on the landscape, often in vulvar formations reminiscent of stone-age "goddess" sculptures. In the later photographs especially, with the body absent, Mendieta is marked as mere trace rather than idealist or essentialized, fully feminine self.[20] At the same time, Mendieta herself wrapped these pieces in an elegant shroud of essentializing language:

> I have been carrying on a dialogue between the landscape and the female body (based on my own silhouette). . . . I am overwhelmed by the feeling of having been cast from the womb (nature). My art is the way I re-establish the bonds that unite me to the universe. It is a return to the maternal source. Through my earth/body sculptures I become one with the earth . . . I become an extension of nature and nature becomes an extension of my body. This obsessive act of reasserting my ties with the earth is really the reactivation of primeval beliefs . . . [in] an omnipresent female force, the afterimage of being encompassed within the womb, in a manifestation of my thirst for being.[21]

While the *Silueta* project is thus framed by the artist in terms of bodily performance of rituals and spiritual ideas concerning women's relationship to "mother earth," I insist in engaging the *Silueta* pieces for their other aspects, deeply disruptive to modernism's desire for presence and transparency of meaning, which Kelly's wholesale condemnation of body art would overlook.

Kelly's model would position Mendieta's assertion of her body, and her verbal reiteration of an essential link between her female body as maternal and

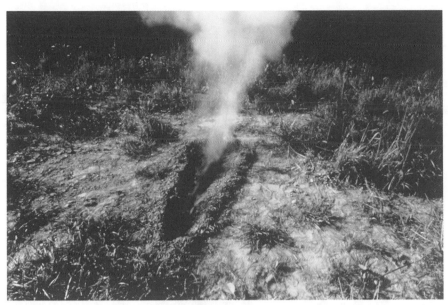

ANA MENDIETA, *UNTITLED* FROM *SILUETA* SERIES, 1978; EARTH WORK WITH
GUNPOWDER, EXECUTED IN IOWA. PHOTOGRAPH COURTESY GALERIE LELONG.

as the womb of the earth, as acceding too easily to psychoanalytic notions of
women's incapacity to be subjects; in Griselda Pollock's terms, Mendieta is of-
fering herself as fetish object for a pleasure-seeking male gaze. And yet, working
through her own body and ultimately producing photographs documenting its
absence (marking her body's having been there as a wound on the landscape),
Mendieta's project also opens itself to an intense intersubjective engagement—
one that encourages the spectator's acknowledgment of Mendieta's *particularized*
relationship to the earth through her adoption of Cuban Santería beliefs, in-
cluding the idea that the earth is a "living thing" from which one can derive per-
sonal power.[22] I experience the burning wound that links Mendieta's body to
the earth as the same wound that marks the absence and loss of her body/self
(as Cuban immigrant woman trying to be an artist in the United States in the
1970s). Mendieta's feminist desire to recuperate lost goddess cults or matriar-
chal cultures, with their putative celebration of women's power, "female" attri-
butes such as nurturing, and holistic attitudes toward life, merged with her par-
ticular experience as a privileged Cuban exiled from her country as a child. This
particular experience or identity has no "essential" meaning in relation to her
work: on the contrary, I read her particularity *through* the works (including the
discourses contextualizing them) and vice versa; I know her particularity only as
I engage with the codes I experience in the works and their descriptive contexts.

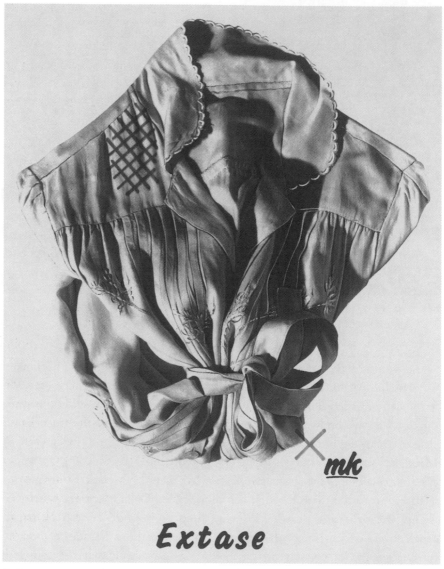

MARY KELLY, *INTERIM* PART I, *CORPUS*, DETAIL FROM "EXTASE," 1984–85; ONE OF THIRTY PANELS 48 X 36 INCHES, LAMINATED PHOTO POSITIVE ON PLEXIGLAS. PHOTOGRAPH COURTESY POSTMASTERS GALLERY AND THE ARTIST.

Mendieta's late images of her body's trace as gashes in the earth relate closely to Kelly's *Corpus*. Mendieta marks *her* (highly particular) body (as absence) on the earth; Kelly marks *the* female body or "corpus" through photographed images of twisted and knotted articles of clothing, placed alongside text panels with hand-written first-person accounts of older women experienc-

ing their bodies in the social realm. Both produce a stand-in for the body itself in order to explore the effects of subjectivity as well as the social processes that inform it. Mendieta's primary referents are Santería and goddess rituals; Kelly's referents are the photographs of female hysterics taken under the direction of Freud's mentor J. M. Charcot (the articles of clothing are arranged in "passionate attitudes" reminiscent of these female hysterics and labeled with Charcot's terminology).[23] Mendieta's absent bodies are conditioned, written into, and given meaning by culturally specific discourses assigning spiritual value to the female body/self; Kelly's absent bodies are conditioned, written into, and given meaning by a theoretical project (Freudian and Lacanian psychoanalysis) and personal narratives construing femininity as a cultural construct. Both projects negotiate the (female) body/self in its absence/presence. Both ultimately confirm that it cannot be known outside of its cultural representations (which, paradoxically, produce subjectivity as absence rather than plenitude). Both may distance as well as seduce various spectators to various effects. Both produce female bodies/selves that are particularized in various ways, as they engage specific subjects in a negotiatory and highly charged project of reading and seeing.[24]

POSTMODERNISM AS PASTICHE, ALLEGORY, OR MONTAGE: RESISTING THE BODY/SELF

As I have already noted, the prohibition against representing or including the body in the work of art and against the pleasurable effects assumed to accompany such inclusions resulted in the wholesale turn away from body art—and, not incidentally, a general devaluation and subsequent historical exclusion of 1970s body art and of most U.S. feminist practices (which did tend to reference the body)—in the 1980s.[25] In this turn away from the body, postmodernism came increasingly to be defined not in relation to subjectivity, identity, or embodiment but was generally stripped of its corporeal politics and situated in terms of strategies of production.[26] In mainstream critical writing, dominated by venues such as *October* and *Artforum*, postmodernism came to be defined again and again in relation to strategies such as appropriation, allegory, pastiche, or, more broadly, institutional critique. Thus, Benjamin Buchloh and Craig Owens, both associated with the *October* editorial board, published articles in *Artforum* and *October* in the early 1980s ("Allegorical Procedures" and "The Allegorical Impulse," respectively). These essays situate allegorical strategies of appropriation and montage as, in Owens's words, a "unified" impulse behind postmodern art.[27] Bypassing questions of subjectivity (here, especially, authorial identity) and interpretation (especially their own interpretive investments), Buchloh and any number of other historians and critics have focused on the political effects

of works (especially their capacity for institutional critique) as determined through their formal or narrative structure (read through coded symbolic systems such as allegory) and, to a lesser extent, content.[28] Not incidentally, the body/self, including the relations of desire informing particular interpretations, is generally left out of this broader picture: body art, with its solicitation of spectatorial desires and deliberate confusion of conventional artistic presentational formats, complicates the tendency to codify postmodernism purely in terms of artistic strategies of production.

The focus on production in dominant discourses of postmodernism links problematically to a metaphysics of intentionality that contradicts the poststructuralist claim to understand meaning as contingent rather than fixed. Thus, Kelly's wholesale rejection of all body art as necessarily essentialist, while it was strategic at the time, failed to account for Kelly's own investment—as an *embodied* artist and critic reacting to the messy and, in her view, ideologically problematic effects of other artists' bodies in performance—in interpreting them (*essentializing* their meanings) in this way.[29]

It is precisely the acknowledgment of such investments that Craig Owens remarked upon in a later, self-critical reflection on his allegory essay. In an essay published in 1983 as "The Discourse of Others: Feminists and Postmodernism," Owens deconstructs his own earlier reading, in "The Allegorical Impulse," of Laurie Anderson's *Americans on the Move* (not incidentally, it is a multi-media performance/body art work that has motivated his rereading). In the 1983 essay he chastises himself for having completely ignored the ways in which her work particularizes the examination of language and subject formation in terms of sexual difference. He writes, "If I return to this passage . . . it is not simply to correct my own remarkable oversight, but more importantly to indicate a blind spot in our discussions of postmodernism in general: our failure to address the issue of sexual difference—not only in the objects we discuss, but *in our own enunciation as well.*"[30] Through his deep engagement with Anderson's body art work, then, Owens recognizes, precisely, both his own investment in interpreting her work and the particularization of subjectivity that it puts into play.

Owens's self-reflections highlight the limitations of much dominant writing about postmodern art, which, in its refusal to acknowledge interpretation as an exchange and haste to proclaim particular practices as politically efficacious or not, largely operates to reinforce the modernist project of privileging certain practices and derogating others on the basis of their interpretively determined cultural value. Such a strategy (which has entailed the derogation of body art) simply replaces the modernist formalist conception of aesthetic value

with an avant-gardist notion of political value, determined according to systems of judgment that are ultimately just as authoritative as those they seek to go beyond. The judgments of self-proclaimed *post*modernist criticism (or criticism of postmodern art that aligns itself with poststructuralism) have tended to rely on value systems and methods of analysis that are still heavily informed by the rhetoric of avant-gardism so central to modernist criticism: a rhetoric that *disembodies*—that, as Owens acknowledges in his later essay, insists upon a "disinterested" relation to the work of art and that assumes that this work's cultural value lies in its formal structure or its conditions of production.

My interest in the work of Mendieta, Schneemann, Kusama, and other body artists is informed both by a desire to rethink postmodern culture (and subjectivity) in the broadest sense and by a desire to push beyond what I perceive to be the prescriptive nature of 1980s art history and criticism as well as its rather narrowly conceived focus on the formal or narrative structures of the work (including its for the most part disembodied structures of vision and power). I am intrigued by the propensity of body art to unveil the hidden assumptions still embedded in critical discussions about postmodernism, its interweaving of the corporeal, the political, and the aesthetic: thus, Mendieta's photographs of her body-as-trace both address the spectator's own interpretive body and thwart its conventionally masculinist, colonizing "gaze" by ritualizing and in many cases erasing the "actual" body from their purview. I have turned with pleasure to body art for its dramatic potential to interrupt the closed circuit of modernist and most postmodernist critical practice. I want both to *give in* to Mendieta's anti-Brechtian solicitation of a pleasurable gaze and also to extricate myself from moment to moment in order to interrogate my own desiring relationship (here, as potentially colonizing Anglo-American feminist "eye" gazing on Mendieta's "exotically" ritualized body) to the work that I study here.[31]

Body art practices solicit rather than distance the spectator, drawing her or him into the work of art as an intersubjective exchange; these practices also elicit pleasures—seen by Marxian critics to be inexorably linked to the corrupting influence of commodity culture, but interpreted here as having potentially radical effects on the subject as it comes to mean within artistic production and reception.[32] Body art, in all of its permutations (performance, photograph, film, video, text), insists upon subjectivities and identities (gendered, raced, classed, sexed, and otherwise) as absolutely central components of any cultural practice. In the following, I attempt to interweave phenomenological and poststructuralist philosophies of the subject and theories and practices of body art to highlight the issue of *subjectivity*, especially in its sexual/gendered dimension, as *the* central issue of postmodernism. I hope to suggest through an

exploration of the ontology of body art that body-oriented practices can be mapped quite differently from their codification in the 1980s as essentialist and reactionary.

THE ONTOLOGY OF BODY ART

In 1975 Laurie Anderson was invited to give a performance in conjunction with the "Bodyworks" exhibition at the Museum of Contemporary Art in Chicago. She noted at the time that she was struck by the term "body art": the show, she wrote, consisted of "pieces of paper on a wall, photographs, notes, tapes. Artists putting their bodies on the line, on the shelf, dressing in drag, assuming alter egos, putting themselves through various exercises, contortions, exorcisms. . . . But in fact, *no bodies were there.* Only paper."[33] Debunking the myth of presence circulating around body art at the time, Anderson's comments testify to the philosophical conundrums put in play by body art, which highlights the fact that the body is both insistently "there" and always absent (never knowable through vision), that, in the words of Jed Perl, "wholeness is an illusion, an ideological trap."[34]

Anderson's statements, too, are deeply performative and carefully orchestrated, constituting an integral part of her public display as performer, artist, and celebrity.[35] It is thus notable that Anderson reprinted this 1975 statement alongside her observations about documenting her work in her 1994 collection of writings and performance documentation, *Stories from the Nerve Bible.* Anderson notes here that, although she was initially strongly opposed to documenting her own work in photographs, film, or video, wanting to avoid the appropriation and commodification of her work ("I thought that since my performances were about memory, the best way to record them was in other people's memories"), she subsequently realized that "other people [don't] remember them very well."[36] The assumption that the body art or performance event is only "real" once, or that it remains itself only through the memories of people who were present during its live performance, is undermined by Anderson's own experience of having people ask her about elements of performances she never did or never remembered doing ("There was no orange dog. I never did anything with an orange dog"). Anderson thus claims that she began documenting her performances in order to be able to demonstrate to her fans when they are wrong ("I decided it was time to document a performance on film so that I could run the projector and say, 'OK! Now do you see an orange dog?'"): to make them more "real," more faithful to the event—to ensure their accurate existence in history.[37]

It is to my point that Anderson chose to publish these more recent ruminations, "A Note on Documentation: The Orange Dog," on the same page as

her 1975 discussion of body art: the juxtaposition makes clear that it is body art that most insistently raises the question of the "real" in relation to the subjects and objects of production and reception. One of the major conceptual and theoretical issues highlighted by body art as performance, as Anderson has recognized, is that of the *ontology* of the art "object" as well as the status of the subject of artistic production. Most early accounts of these practices made heroic claims for body art's status as the only art form to guarantee the *presence* of the artist. Thus, in the catalog for the 1975 Chicago *Bodyworks* exhibition, Ira Licht triumphantly proclaims that bodyworks do away with the "intermediary" mediums of painting and sculpture to "deliver . . . information directly through transformation."[38] And, also in the 1970s, Rosemary Mayer claimed body art to be a direct reflection of the artist's life experiences, while Cindy Nemser described the "primary goal of body art" as "the desire to bring the subjective and objective self together as a totally integrated entity," which is then directly projected to the audience.[39] In 1982, Chantal Pontbriand privileged performance by arguing that it "presents; it does not re-present."[40] More recently, Catherine Elwes argued that performance art "offers women a unique vehicle for making that direct unmediated access [to the audience]. Performance is about the 'real-life' presence of the artist. . . . She is both signifier and that which is signified. Nothing stands between spectator and performer."[41]

It is precisely such idealism of which Mary Kelly is, I think rightly, suspicious in her critique of the early claims about body art. But contemporaneous descriptions of the works do not fully constitute their meanings. This book specifically rejects such metaphysical conceptions of body art or performance as delivering in an unmediated fashion the body of the artist to the viewer, engaging the works on the level of a feminist phenomenology deeply informed by a poststructuralist suspicion of discourses of presence. Art historian Kathy O'Dell has trenchantly argued, to this end, that, precisely by using their bodies as primary material, body and performance artists highlight the "representational status" of such work rather than confirming its ontological priority. The representational aspects of this work—its "play within the arena of the symbolic" and, I would add, its dependence on documentation to attain symbolic status within the realm of culture—expose the impossibility of attaining knowledge of the self through bodily proximity. Body art, finally, shows that the body can never "be known 'purely' as a totalizable, fleshy whole that rests outside of the arena of the symbolic."[42] Having direct physical contact with an artist who pulls a scroll from her vaginal canal does not ensure "knowledge" of her (as individual and/or artist and/or work of art) any more than does looking at a

film or picture of this activity, or looking at a painting that was made as the result of such an action.

The self is inexorably embodied, body art tells us. And yet, as I will argue these works suggest, this does not mean that the performed body/self is ever completely legible or fixed in its effects. Body art, through its very performativity and its unveiling of the body of the artist, surfaces the insufficiency and incoherence of the body/self (or the body-as-subject) and its inability to deliver itself fully (whether to the subject-in-performance herself or himself or to the one who engages with this body). Perhaps even more to the point than O'Dell's suggestive observations is Peggy Phelan's insistence on the way in which the body in performance puts forward its own lack:

> Performance uses the performer's body to pose a question about the inability to secure the relation between subjectivity and the body *per se;* performance uses the body to frame the lack of Being promised by and through the body—that which cannot appear without a supplement. . . . Performance marks the body itself as loss. . . . For the spectator the performance spectacle is itself a projection of the scenario in which her own desire takes place.[43]

As epitomized in Mendieta's images, in which the body is enacted as *trace* or "silueta," body art can thus be said to flaunt the body itself as loss or lack: that is, as fundamentally lacking in the self-sufficiency (claimed by Elwes et al.) that would guarantee its plenitude as an unmediated repository of selfhood.[44] The "unique" body of the artist in the body art work only has meaning by virtue of its contextualization within the codes of identity that accrue to the artist's name/body. Thus, this body is not self-contained in its meaningfulness; it is a body/self, relying not only on an authorial context of "signature" but also on a receptive context in which the interpreter or viewer may interact with it. This context is precisely the point (always already in place) at which the body becomes a "subject."[45] Live performance, in fact, makes this contingency—the intersubjectivity of the interpretive exchange—even more pronounced and obvious since the body's actions can be interfered with and realigned according to other bodies/subjects; however, documents of the body-in-performance are just as easily, if not as obviously, contingent in that the meaning that accrues to the image of the body is open-ended and dependent on the ways in which the image is contextualized and interpreted.

Seemingly acting as a "supplement" to the "actual" body of the artist in performance, the photograph of the body art event or performance could, in fact, be said to expose the body itself as supplementary, as both the visible

proof of the self and its endless deferral. Mendieta's later *Silueta* pieces, which document the body only through the marks it has left on the landscape, explicitly enact this doubled lack indicated by the photograph. The photograph, like the body image itself, is a supplement to the inescapable lack that founds subjectivity (the existence of the body in the social, vis-à-vis other subjects). The supplement, argues Jacques Derrida, is a "terrifying menace" in its indication of absence and lack but also "the first and surest protection . . . against that very menace. This is why it cannot be given up."[46] The sequence of supplements initiated by the body art project—the body "itself," the spoken narrative, video, and other visuals within the piece, the video, film, photograph, and text documenting it for posterity—announces the necessity of "an infinite chain, ineluctably multiplying the supplementary mediations that produce the sense of the very thing they defer: the mirage of the thing itself, of immediate presence, or originary perception. Immediacy is derived. . . . The play of substitution fills and marks a determined lack."[47] Derrida notes that "the indefinite process of supplementarity has always already *infiltrated* presence, always already inscribed there the space of repetition and the splitting of the self."[48]

Elsewhere, Derrida explicitly examines why the body must be excluded from determinations of meaning within the idealistic regime of signification and Cartesian subjectivity posited in Western metaphysics. The impure and *supplementary* body must be opposed to the soul, where the will is lodged and meaning is generated: "Visibility and spatiality as such could only destroy the self-presence of will and spiritual animation which opens up discourse. *They are literally the death of that self-presence.*"[49] Derrida's insight explains the equivocal position of the body in modernist and postmodernist art discourse. Within the modernist logic of formalism, the body of the artist—in its impurity—must be veiled, its supplementarity hidden from view. The formalist insists upon the "disinterestedness" of his interpretations, and such disinterestedness is predicated upon a pure relation between the art object and its supposedly inherent meaning (embedded in its "form," to be excavated by the discerning interpreter). The supplementarity of the body corrupts this logic. For those who wish to privilege performance or body art for its merging of art and life, its delivery of the body/subject of the artist directly to the viewer, the body must be seen as an unmediated reflection of the self whose presence guarantees the redemptive quality of art as activism.

Rather than confirming the ontological coherence of the body-as-presence, body art confirms—or, rather, exacerbates—the supplementarity of the body itself. This is not to say that body art is necessarily radically critical of essentialism and idealism (or is radically anti- or postmodernist) in all of its

dimensions, however. As we have seen, the discursive positioning of body art in the early 1970s often placed it definitively on the side of a conservative, modernist investment in a metaphysics of presence. Body art is not definitively or inherently progressive any more than it is definitively or inherently reactionary (as Kelly had wanted to claim). Precisely not: in its insistently intersubjective dimension, it marks the contingency of such meanings and values on the interpretive relation. Body art opens up the vicissitudes of subject/object relations within art discourse; in its refusal to confirm anything other than the absence of the body/self (the subject's contingency on the other), body art refuses to "prove" presence.

While, predictably, many have relied on the photograph, in particular, as "proof" of the fact that a particular action took place, of the meaningfulness of the subject-in-performance, or as a marketable object to be raised to the formalist height of an "art" photograph, in fact such a reliance is founded on ideological belief systems similar to those underlying the investment in the "presence" of the body in performance. Kristine Stiles has brilliantly exposed the dangers of using the photograph of a performative event as "proof" in her review of Henry Sayre's book *The Object of Performance*. Sayre opens his first chapter with the now mythical tale of Rudolf Schwarzkogler's self-mutilation of his penis, a myth founded on the circulation of a number of "documents" showing a male torso with bandaged penis (a razor blade lying nearby). Stiles, who has done primary research interviewing and retracing the event, points out that the photograph, in fact, is not even Schwarzkogler but, rather, another male artist who poses for Schwarzkogler's *entirely fabricated* ritual castration.[50]

Sayre's desire for this photograph to entail some previous "real" event leads him to ignore the contingency of the document in relation not only to a former action but also to the construction of what Stiles terms a wholly fictive space.[51] This is the very contingency that his book attempts to address through his argument that the shift marked by performance and body art is that of the "site of presence" from "art's object to art's audience, from the textual or plastic to the experiential." Sayre's fixation on "presence," even while he acknowledges its new destabilized siting in reception, and his lack of self-interrogation inform his unquestioning belief in the photograph of performance as "truth" (*why*, after all, does he want the photograph to do this for him?).[52] The photograph of the performance is a supplement of a supplement: a seemingly rigorous visual, indexical marker of a body's having "been there" before the camera/audience ("in the Photograph," Roland Barthes writes, "something *has posed* in front of the tiny hole and has remained there forever. . . . In Photography, the presence of the thing (at a certain past moment) is never metaphoric").[53]

Rosalind Krauss recognized the philosophical reciprocality of photog-

raphy and performance in her 1977 essay "Notes on the Index," in which she situates the two as different kinds of indexicality. As indexes, both labor to "substitute the registration of sheer physical presence for the more highly articulated language of aesthetic conventions."[54] And yet, I would stress, in their failure to "go beyond" the contingency of aesthetic codes, both performance and photography announce the supplementarity of the index itself (there is no original gesture toward which the index simply directs us). The presentation of the self—in performance, in the photograph, film, or video—calls out the mutual supplementarity of the body and the subject (the body, as material "object" in the world, seems to confirm the "presence" of the subject; the subject gives the body its significance as "human"), as well as of performance or body art and the photographic document. The body art event *needs* the photograph to confirm its having happened; the photograph *needs* the body art event as an ontological "anchor" of its indexicality.[55]

THE ONTOLOGY OF THE SUBJECT: THROUGH THE BODY/AGAIN

I read body art as dissolving the metaphysical idealism and the Cartesian subject (the artist as heroic but disembodied genius, the transcendent "I" behind the work of art) embedded in the conception of modernism hegemonic in Europe and the United States in the postwar period. This Cartesian subject has had a long history in Western thought. René Descartes's dualistic conception of a consciousness or cogito (disembodied and transcendent) opposed to the brute object of the body dominated Enlightenment and then modernist (nineteenth- and twentieth-century) ways of conceiving the subject. Predicated on vision (the "I" of the subject was a disembodied "eye" turning all bodies into objects), Cartesianism had a special force within artistic modernism, which was first dominated by French artists and writers embedded in the Cartesian tradition, then borrowed by the United States from France after World War II. Descartes's dualism is highlighted in his famous comment, from the *Discourse on Method*, that "this *me*—that is, the soul by which I am what I am—is completely distinct from the body: and is even easier to know than is the body."[56] Art history and criticism have long taken their direction from this conception—with the eye/I of the artist closely paralleled by the eye/I of the art critic or historian, who takes her or his authority from a close identification with the transcendent "vision" of the original creator.

But, as intellectual historian Martin Jay has suggested, it was precisely this issue of the dualism of mind and body that motivated "twentieth-century phenomenological critics of Cartesian perspectivalism like Heidegger and Merleau-Ponty [to] . . . challenge his version of sight, and feminists like Irigaray

[to] . . . condemn the gender bias of his philosophy."[57] I would like to suggest, then, that it was the same assumption in artistic modernism that, at least in part, motivated body artists who, often drawing on phenomenological models of subjectivity (not to mention feminism), began to enact their embodied subjectivities in relation to audiences with this intersubjective exchange constitutive of the work of art. Working in concert with the major shifts in philosophical thought and in the social realm, where the normative subject was being profoundly challenged by the various rights movements, body art dissolves the opposition informing the Cartesian conception of the self and, in so doing, assists in dissolving the modernist subject.

In the very beginning of her 1971 article "Subject-Object Body Art," one of the major early discussions of body art, Cindy Nemser quotes Merleau-Ponty, substantiating the conceptual link between body art and phenomenology:

> Our body is not in space like things; it inhabits or haunts space. It applies itself to space like a hand to an instrument, and when we wish to move about we do not move the body as we move an object. We transport it without instruments as if by magic, since it is ours and because through it we have direct access to space. For us the body is much more than an instrument or a means; it is our expression in the world, the visible form of our intentions. Even our most secret affective movements, those most deeply tied to the humoral infrastructure, help to shape our perception of things.[58]

Body art, however, does not *illustrate* Merleau-Pontyan conceptions of the embodiment of the subject and theories of the decentered self that we are now familiar with from poststructuralist theory; rather, it *enacts* or *performs* or *instantiates* the embodiment and intertwining of self and other.[59] Body art is one of the many manifestations or articulations of this contingency or reciprocity of the subject that we now recognize as postmodern. The trajectory linking French theories of subjectivity and signification—with the phenomenological attack on Cartesianism leading into what we now call poststructuralism—to body art is complex, but worth examining here at least in part. These links confirm the usefulness of exploring body art through a phenomenological and feminist framework, as all three phenomena are interrelated in their compulsion to dissolve and/or interrogate the modernist subject.

In 1959 the U.S. sociologist Erving Goffman published a book entitled *The Presentation of Self in Everyday Life*, which discusses the self as a *performance* in relation to others, a negotiation involving complex intersubjective cues and behaviors. The self, Goffman argues,

does not derive from its possessor, but from the whole scene of his action. . . . A correctly staged and performed scene leads the audience to impute a self to a performed character, but this imputation—this self—is a *product* of a scene that comes off, and is not a *cause* of it. The self, then, as a performed character, is not an organic thing that has a specific location . . . it is a dramatic effect arising diffusely from a scene that is presented.[60]

Drawing from the work of sociologists, cultural theorists, and psychoanalysts, and from the existential phenomenological texts of Simone de Beauvoir and Jean-Paul Sartre (which Goffman "Americanizes" in the direction of a rather flat empiricism), Goffman's book links together the theoretical exploration of the self and the performative bodies of body art (especially in its U.S. manifestations). In the 1960s, a number of artists in the United States read Goffman's book, as well as some of the work of Merleau-Ponty. Goffman's instrumentalized version of French existentialist phenomenology along with Merleau-Ponty's own writings, among other texts, provided a model for younger-generation artists such as Vito Acconci who came of age after the heroic era of abstract expressionism, and within the explosive social changes in the 1960s.[61] The philosophical notion of the self as an embodied performance (a notion informed by and conditioning the experience of shifts in the social and cultural realms) was expanded and developed through body art's radical opening up of the structures of artistic production and reception. Body art enacted the activist, particularized body of the rights movements—the intersubjective, performative self of phenomenology—within the structures of art making and reception.

The performative self, whose meaning and significance is not inherent or transcendent but derived "from the whole scene of his action," dramatically overturns the Cartesian self of modernism, which construes the body not as enacting the self but as a brute object or hollow vessel given meaning only through the animating force of the consciousness that presumably can thus transcend it.[62] The lived body, Merleau-Ponty observed in his 1945 *Phenomenology of Perception*, is not discrete from the mind as vessel but is, in fact, the "expressive space" by which we experience the world. Unlike other objects in the world, the body cannot be thought as separate from the self, nor does it signify or "express the modalities of existence in the way that stripes indicate rank, or a house-number a house: the sign here does not only convey its significance, it is filled with it."[63]

Phenomenology interprets and produces the self as embodied, performative, and intersubjective—the critique of Cartesianism thus also involves a

Hegelian dimension as the French phenomenologists theorized a self that was both embodied but also articulated in relation to a self/other (master/slave) dialectic. Not incidentally, in fact, Alexandre Kojève had lectured on Hegel in a series of 1930s seminars in Paris to Jean-Paul Sartre, Maurice Merleau-Ponty, and Jacques Lacan.[64] This conception of an intersubjective, embodied subject contingent on her or his others (the master defining the slave and vice versa) has been expanded upon and radicalized by poststructuralism and feminism as well as, I am arguing, by body art. Thus, the intellectual trajectory of phenomenology (especially from France) and a feminist poststructuralism, both of which articulate an explicitly anti-Cartesian theory of the subject, underlies and informs my attempt to rethink body art and move it out of its consignment to essentialist oblivion.[65]

In the 1940s and 1950s, it was Merleau-Ponty and Lacan who most vigorously began to theorize (through philosophy and psychoanalysis) the splitting or dissolving of the Cartesian subject. Merleau-Ponty's observations about the contingency and reciprocity of the self/other, and his emphatic critique of vision-oriented theories that polarize subject/object relations, seem to relate closely to Goffman's paradigm but go far beyond its instrumental—more Sartrean and rigidly oppositional—dimensions: "The behavior of another expresses a certain manner of existing before signifying a certain manner of thinking. And when this behavior is addressed to me, as may happen in dialogue, and seizes upon my thoughts in order to respond to them . . . I am then drawn into a *coexistence* of which I am not the unique constituent and which founds the phenomenon of social nature as perceptual experience founds that of physical nature."[66]

Merleau-Ponty's antiempiricism and his insistence on the fully embodied nature of intersubjectivity enables him to conceptualize intersubjectivity as imbricated rather than oppositional (as in Sartre's existentialist model), as intersubjective and embedded rather than simplistically staged in a discrete social environment (per Goffman).[67] While Sartre sustains in his phenomenological work a more strictly Hegelian view of self/other relations as structured by conflict, Merleau-Ponty posits the self/other as reciprocal: not in the sense of oscillating positionalities but in terms of *simultaneous* subject/objectification—one is *always already both at the same time.* And Merleau-Ponty's insistence on embodiment and on going beyond vision-oriented models of self and other differentiate his work from Lacan's theories of self, at least as the latter have been popularized in contemporary cultural discourse in the United States (where, as noted, the subject is staged through a disembodied—if psychically invested—sense of vision that produces her/him as image).[68] Merleau-Ponty's writings

seem singularly interesting in relation to body art in that they articulate an understanding of intersubjectivity as dramatically *intercorporeal:* as embodied as well as contingent.

Furthermore, although he views sexuality as a universal phenomenon rather than one with asymmetrical effects, Merleau-Ponty understands the fully sexual nature of the body/subject: its saturation with an eroticism that instantiates the merging of the active, cognitive being with the sexual body. A body is perceived (and perceives itself through its relationship to others) as sexual through and through. Merleau-Ponty's theory of intersubjectivity becomes even less instrumental in his later work, moving away from the lingering idealism of *Phenomenology of Perception* (which posits an eroticism existing a priori to the subject)[69] to theorize a *chiasmic* intertwining of self and other. His "The Chiasm—The Intertwining," published posthumously in 1964, is especially rich in relation to body art. In this text, Merleau-Ponty embeds vision in touch, touch in vision, and their chiasmic crossing is the flesh of the world/the body itself: differentiating modes of vision (color and visibles) is a *tissue* that is "not a thing but a possibility, a latency, and a *flesh* of things." The chiasmus is the "doubled and crossed situating of the visible in the tangible and of the tangible in the visible," and the *flesh of the visible* indicates the carnal being—at once subjective and objectified.[70] There is a "reciprocal insertion and intertwining" of the seeing body in the visible body: we are both subject and object simultaneously, and our "flesh" merges with the flesh that is the world. There is no limit or boundary between the body and the world since the *world is flesh.*[71] (Mendieta's *Silueta* pieces, which turn the earth itself into flesh and vice versa, seem to instantiate Merleau-Ponty's observation.)

The relation to the self, the relation to the world, the relation to the other: all are constituted through a *reversibility* of seeing and being seen, perceiving and being perceived, and this entails a reciprocity and contingency for the subject(s) in the world (with Mendieta's body made reversible in two directions: back to its cultural and personal siting, through Santería and goddess rituals; and forward to our situation, through our embodied experience and conceptual incorporation of it). The body/self is simultaneously both subject and object; in the experience of dialogue (or, in our case, the production and reception of works of art), the two subjects involved (art maker, art interpreter) "are collaborators for each other in consummate reciprocity."[72]

Through the notion of flesh—a hinge or two-sided boundary (that is also part of the things it separates) marking "being's reversibility"[73]—Merleau-Ponty theorizes the interrelatedness of both mind and body (the embodiedness of the self) and the reciprocity and contingency of the body/self on the other.

This is what Lacan, in a formulation that derives its theoretical force from linguistics and Freudian psychoanalysis but also, as is often not recognized in U.S. art discourse, from phenomenology, describes as the *phenomenology of the transference* by which the self is located in the other: "What I seek in speech is the response of the other. What constitutes me as subject is my question. . . . I identify myself in language, but only by losing myself in it like an object."[74] Lacan redeploys Hegel's master/slave in terms of a metaphorics of desire, as articulated through language; in Kojève's words, "all human, anthropogenetic Desire—the Desire that generates Self-Consciousness, the human reality—is, finally, a function of the desire for 'recognition'" by an other, marking the contingency of self-consciousness, of the "master" on the "slave." In Lacan's terms, "it is in seeing a whole chain come into play at the level of the desire of the Other that the subject's desire is constituted."[75]

But, while the body/self is inexorably sexual in Merleau-Ponty's formulation, and while he acknowledges (with a distant glance toward the master/slave dialectic) the asymmetry of the reversibility of perception, like Lacan he theorizes the sexual subject/object from an implicitly masculine point of view. A number of feminist philosophers have reworked Merleau-Ponty's formulation through the lens of sexual difference, acknowledging the *gendered* configuration of the asymmetrical master/slave aspect of the subject/object relations in Western patriarchy.[76] Thus, Judith Butler pinpoints Merleau-Ponty's tendency, in the earlier work, to theorize self/other relations in terms that implicate without theorizing gender asymmetry.[77] And Luce Irigaray plays against Merleau-Ponty's blindness to gender by inserting the "maternal-feminine" into his language: the flesh is feminized as "a maternal, maternalizing flesh, reproduction . . . placental tissue."[78]

But it is Simone de Beauvoir, friend and colleague of Merleau-Ponty, lover of Sartre, who was the first to expose the gendered specificity of the self/other relation in her 1949 opus *The Second Sex.*[79] Beauvoir's book was the first to expand the general critique of the Cartesian subject of modernism and to interrogate it as having an exclusionary, masculinist dimension. Beauvoir's book begins a radical particularization of the phenomenological theory of a subject still (in the 1940s) largely assumed to be "universal." Here, the dialectic between the self and other outlined by Sartre (and more subtly transformed by Merleau-Ponty and Lacan) is reworked with an awareness of the mapping of power through gender in patriarchy. Sartre's existentialist argument, in *Being and Nothingness,* that the subject has the capacity to project himself into transcendence (the *pour-soi*) out of the fundamental immanence of the *en-soi,* is reread by Beauvoir as a privileged potentiality open only to male subjects in patriarchy.

Stating clearly her allegiance to an "existentialist ethics," Beauvoir goes on to specify its different applications for women subjects:

> Every subject plays his part as such specifically through exploits or projects that serve as a mode of transcendence; he achieves liberty only through a continual reaching out toward other liberties. There is no justification for present existence other than its expansion into an indefinitely open future. Every time transcendence falls back into immanence, there is a degradation of existence into the *en-soi*—the brutish life of subjection to given conditions—and of liberty into constraint and contingence. . . . Every individual concerned to justify his existence feels that his existence involves an undefined need to transcend himself, to engage in freely chosen projects. . . . Now, what peculiarly signalizes the situation of woman is that she—a free and autonomous being like all human creatures—nevertheless finds herself living in a world where men compel her to assume the status of the Other. They propose to stabilize her as object and to doom her to immanence since her transcendence is to be overshadowed and forever transcended by another ego . . . which is essential and sovereign.[80]

As Judith Butler has noted, Beauvoir's paradigm accounts for the masculine project of *disembodiment* by which men transcend their bodies by projecting their otherness (their immanence, their contingent corporeality) onto women.[81] Ultimately, Beauvoir's argument, especially as extended by feminist poststructuralists such as Butler, extends phenomenology's critique of Cartesianism but also interrogates its sex-blind models of self/other (as well as the male-centered paradigm of Lacan's model of sexual difference)[82] by exposing such projections as *failed* attempts to secure coherent selfhood on the part of male subjects in patriarchy. As Butler argues, the fact that the "Other" is, in fact, his alienated self "establishes the essential interdependence of the disembodied 'man' and the corporeally determined 'woman.' His disembodiment is only possible on the condition that women occupy their bodies as their essential and enslaving identities."[83]

Luce Irigaray, a one-time student and subsequent intellectual adversary of Lacan's, explores this dynamic at great length in her 1974 book *Speculum of the Other Woman*, in which she remarks that "man" exiles himself "ever further (toward) where the greatest power lies . . . [becoming] the 'sun' if it is around him that things turn. . . . Meanwhile . . . 'she' [as Mother Earth] also turns upon herself . . . [knowing] how to re-turn (upon herself) but not how to seek outside for identity within the other."[84] The immanence of women *is*, as Mendieta's

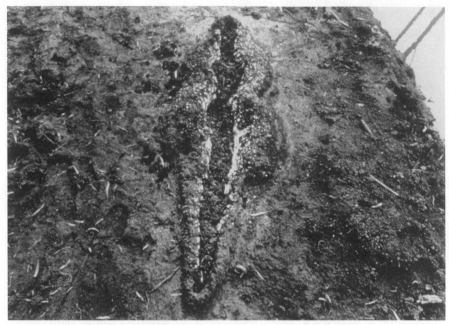

ANA MENDIETA, *UNTITLED* FROM *SILUETA* SERIES, 1979; GUNPOWDER SILHOUETTE, EXECUTED IN IOWA. PHOTOGRAPH COURTESY GALERIE LELONG.

work enacts, their conflation with the static, unchanging "earth," which can only revolve around the "transcendent" sun/man/God. This ideological structure is necessary for the maintenance of the idea that the subject as self (a masculine prerogative) is coherent and beyond "earthly" intervention or reproach. Mendieta's *Silueta* pieces, like Irigaray's subtle, poetic arguments, expose the fact that, precisely because of this *projection* of immanence upon the female, the (masculine) subject (Mendieta's interpreter?) is always/already earthbound, implicated in that which he attempts to survey through his distanced, "transcendent" gaze.

To this end, in her book on the split subject of postmodernism, Carolyn Dean argues that the model of the decentered self that U.S. scholars know primarily from Lacan is, in fact, a description of the fragmentation of the *male* subject in late capitalism. Lacan's model of the self situates it as constructed through a misrecognition, through the mirrored reflection of the self-as-coherent, of "the truth about the real fragmentation, helplessness, and lack that defines human identity."[85] Dean suggests that it was out of a specific crisis in male authority in the post—World War I period that such a model of lost coherence was constructed: it was only the male subject, after all (as Beauvoir pointed out), who had ever had access to this mythical coherence in the first place.

Dean's observation would translate interestingly to the crisis of masculinity during the post–World War II period, with the general cultural anxiety about conformity and the growing recognition that the (implicitly male) subject was not full-within-himself but, indeed, articulated in relation to others on whom he may or may not be able to depend for reinforcing his appearance of "coherent" masculinity. [86] As Barbara Ehrenreich has pointed out, David Riesman's influential sociological study, published in 1950 as *The Lonely Crowd: A Study of the Changing American Character,* describes a shift in masculine subjectivity away from the self-contained, authoritative "inner-directed" man (relatively "immune to the . . . nudgings of peers") toward an "other-directed" character, who, rather than standing tall against social pressures, finds himself adapting his tastes and behavior to those of the people around him. The "other-directed" man is the ultimate conformist, and, as Ehrenreich notes, Riesman's book "reinforced the average gray flannel rebel's gnawing perception that conformity, notwithstanding the psychologists' prescriptions, meant a kind of emasculation."[87] Ehrenreich's observations highlight the way in which philosophical explorations have a political and social dimension (the phenomenological and nascent poststructuralist critiques of the Cartesian subject dovetailing with the collapse of this [masculine] subject as identified in negative terms by intellectuals such as Riesman). As I will explore in chapter 2, this confluence of discourses certainly marks an exacerbation of the crisis in masculinity noted by Dean as having occurred after World War I and in the post–World War II period.

The (masculine) subject thus became increasingly decentered and "other-directed" from the 1950s into the 1960s, when this dislocation became far more dramatic and often even self-consciously performed (as in body art projects or Andy Warhol's flamboyant self-construction on the stage of public life). Part of this decentering, as Riesman inadvertently highlights and as Lacan and Merleau-Ponty explicitly outline without fully opening up its gendered implications, entailed a rethinking of the (masculine) self as both other-directed and also fundamentally narcissistic (feminized and/or homosexualized). Thus, for Lacan as well as Merleau-Ponty, the (implicitly male) subject attempts to cohere himself in the eyes of the other, but in this move paradoxically enacts the subject in terms of himself: in Merleau-Ponty's terms, "since the seer is caught up in what he sees, it is still himself he sees: there is a fundamental narcissism of all vision."[88] Lacan's now well known model of the mirror stage—in which the subject "coheres" in relation to a misrecognized image of his own unity as body/image/self (situating him always already as an "other" to himself)—coincides with Merleau-Ponty's observations (as well as with Beauvoir's) in its

[handwritten margin notes: "refer to Cirque De La Lube search"]

acknowledgment of the simultaneous contingency of self on other and the fundamental narcissism of this relation. It is the image (of the self-as-other) through which the subject seeks to know herself or himself but fails, succumbing to self-alienation ("the total form of the body . . . is given to him only . . . in an exteriority"), and through which the subject attempts to cohere itself but can only do so at the price of becoming *other*.[89] Subjectivity—as we understand it in the postmodern condition—is performed in relation to an other yet is paradoxically entirely narcissistic. In its "other-directedness," it opens itself dangerously to the other, but always in an attempt to rethink itself.

In this way, while Riesman's other-directed man is viewed with some trepidation because he is open to the other, he is also described and examined entirely in relation to *himself* (and is thus necessarily viewed as horrifyingly emasculated).[90] The potentially felicitous effects of his openness to the other are never explored in terms of what it might mean for women or other "others." While the other-directed subject and the narcissistic (by definition, self-oriented) one may seem opposed, in fact they are different ways of defining the same—and specifically, in the eyes of 1950s culture, emasculated—subject. Calling the subject narcissistic might thus be another way of opening out how body art works in terms of a phenomenological conception of subjectivity as "other-directed" (reciprocal and intertwined with the other).

BODY ART AND THE "CULTURE OF NARCISSISM"

Not incidentally, body art, especially in its feminist varieties, has frequently been condemned (and occasionally exalted) for its *narcissism*; I discuss the particular alignment of narcissism with feminist body art in chapter 4. Here, rather than accepting the conventional negative connotations that accrue to this term, I want to open up this narcissism as manifested in body art (through a fixation on performing the self) for its potentially radical implications. As I have suggested, narcissism—the exploration of and fixation on the self—*inexorably* leads to an exploration of and implication in the other: the self turns itself inside out, as it were, projecting its internal structures of identification and desire outward. Thus, narcissism interconnects the internal and external self as well as the self and the other.

Narcissism intersects with the politicization of personal life that was so empowering to feminists in the late 1960s and early 1970s. For the majority of feminists from this period, for whom the clarion call was "the personal is political" and for whom activism was often a central part of their agenda, it was crucial to *embody* the female subject publicly in order to politicize her personal experiences. The enacted body/self is explicitly political and social in that it

opens out onto otherness and the world in general; in phenomenological terms, this body/self performs itself through its own particular social situation. Women's particular social situation entailed narcissism. Since women are always already interpellated in patriarchal culture as embodied objects who are, paradoxically, at the same time narcissistic (i.e., self-involved or *subjectified*), the overt expression of women's fully embodied, desiring experiences and (narcissistic) self-involvement was seen as the surest way to repudiate the objectification of women and to politicize personal experience. Women began to act narcissistically (that is, began to speak their personal concerns in the public domain) in order to proclaim their needs and particularities as subjects.[91]

Lea Vergine, ecstatic supporter of body art, explores the fundamental relationship between body art and narcissism in her important 1974 catalog *Il corpo come linguaggio (La 'body-art' e storie simili)*:

> Narcissus projects himself outside of himself in order to be able to love what is inside of himself. . . . Projection expels an internal menace that has been created by the pressure of an intolerable impulse and thus it is transformed into an external menace that can be more easily handled. The artists shift their problem from the subject to the object, or from the inside to the outside. . . . The consensus of the spectator is essential if the artist is to find 'confirmation' in his work. The work is the artist and his narcissism [is] no longer invested in an art object but allowed to explode within his own body.[92]

The narcissism enacted by body artists is fundamentally intersubjective and highlights the psychic dynamic by which self/artist/artwork is constituted in relation to other/interpreter (and vice versa). Licht, in the *Bodyworks* catalog, also focused on the narcissistic dimension of body art, arguing that "bodyworks" are linked to the "tradition of the cult of the self" in art.[93]

But why would artists turn to themselves at precisely the moment when the fundamental fragmentation of these "selves" was becoming increasingly manifest (a fragmentation particularly dramatic in relation to the increasing challenges leveled at the normative male subject through the various rights movements and economic and geopolitical shifts)? Different subjects have had different relationships to this fragmentation of the subject, and body art projects can be seen variously as *enacting* and so exacerbating the fragmentation of the normative subject of modernism (the "transcendent" white male who projects his immanence onto women, people of color, the colonized, the poor) or, in some cases and contexts, as attempting to reverse the effects of this fragmen-

tation.[94] As I will explore in the chapters on Acconci and Wilke, precisely because of the asymmetry of their relationship to the coherent, Cartesian subject of modernism (the modernist artistic genius), we tend to view the men and the women body artists from the 1960s and 1970s as having approached the problematic of intersubjectivity from vastly different positions. For feminists (especially white feminists),[95] who were far more daring than were the men in exposing their narcissism (in particular through their unveiled and explicitly sexualized bodies), there was much to be gained in the exacerbation of the breakdown of the "inner-directed" (male) subject, the opening of the self to the other. Male body artists often produced works that equivocated the opening of their bodies/selves to otherness (Acconci is unusual in his narcissistic self-exposure to the other); far more commonly, they refused to acknowledge their "other-directed" narcissism, either through irony or authoritativeness reinforcing the veiling of the male artist that has conventionally ensured his alignment with the "phallus" of artistic authority.[96]

Narcissism, enacted through body art, turns the subject inexorably and paradoxically outward. For understanding the vicissitudes of narcissism in relation to body art, it is useful to explore the way in which narcissism opens out the intersubjective dynamic. Narcissism can be understood as endemic to late capitalist commodity culture, which requires the "manufacture" of desire and the simultaneous turning outward of the self toward commodities and obsessive self-absorption, in a "disturbance" of the oedipal structures by which subjects (and male subjects in particular) have long attempted to project themselves into coherent selfhood in Western patriarchy.[97] On the one hand, this disturbance has been viewed in a positive light by feminists and other theorists interested in decomposing the structure of the nuclear family, with its attendant privileging of the normative (white, male) subject as sign of transcendence (keeper of the law). Lacan mapped this "disturbance" on a theoretical register by shifting the paternal law away from the actual father, who had anchored Freud's formulation of the postoedipal subject, to the social order (to the *law of the father*); other leftist critics of modern patriarchy, such as French theorists Gilles Deleuze and Félix Guattari, have explicitly privileged the "decoding" of the oedipal structure as a potentially revolutionary freeing of desire.[98]

On the other hand, and not surprisingly, conservative critics have viewed this disturbance with alarm, as a marker of the anarchic dissolution of the nuclear family and the authority and coherence of (masculine) subjectivity in late capitalist Western culture. Consistently with Riesman's formulation, Christopher Lasch's best-selling 1979 book *The Culture of Narcissism: American Life in an Age of Diminishing Expectations* extrapolates from the individual to the social,

labeling the contemporary U.S. subject (who is implicitly male) in terms that align him negatively with immanence and emasculation. The narcissistic subject of late capitalism demands immediate gratification and, like Riesman's "other-directed" man, depends on others to validate his self-esteem (thus Lasch labels as negative a quality that I am situating as positive in its radical effects: the narcissist's overt dependence on the *other* to negotiate his subjectivity in the world). "The narcissist," Lasch writes, drawing on the work of Goffman, "cannot identify with someone else without seeing the other as an extension of himself"— without, he continues, "obliterating the other's identity." Lasch makes this argument on the basis of his assumption that the other has a stable identity that is thus being obliterated by the narcissist's specifically *performative*, but ultimately stabilizing, projections.[99] I am suggesting here, through Merleau-Ponty, that such projection of the self is, rather, a marker of the *instability* of both self and other (of their chiasmic intertwining) and that this, from the point of view of those who have every stake in dislocating the mythological, transcendent self of modernism, is a positive thing.

Affirming the social activism of the rights movements of the late 1960s and 1970s, the critique of what Audre Lorde has called the "mythical norm" of Western subjectivity ("white, thin, male, young, heterosexual, Christian, and financially secure"), body art *plays out* the narcissism that Lasch identifies negatively with the postwar, late capitalist dissolution of paternal authority and the nuclear family.[100] Body art, following Judith Butler's recent formulation, proposes a performativity of subjectivity that situates the sexual self through a "reiteration of norms or set of norms": particularly through the *reiteration of the narcissistic relation* through which the subject, in Lasch's psychoanalytic terms, projects itself into its own image as other.[101] Through this narcissistic self conception (which thus always entails the other), as Rosalind Krauss has argued, "[i]dentity . . . is primally fused with identifications (a felt connection to someone else)."[102] The fundamentally narcissistic imaginary by which the subject constitutes itself, paradoxically in relation to others through a fixation on itself, *turns the subject inside out* (via a relation of reversibility), producing the body/imago as the image of the other (hence its threat to conservative culture theorists such as Lasch).[103]

Butler further theorizes that the reiteration of norms, which compels the subject to sustain itself in relation to particular bodily standards through specific identifications, also thus opens up the possibility for *dis*identifications. Thus, while the heterosexual imperative that still works to structure self/other relations in Western late capitalism enables certain sexed identifications and disavows others, a reiterative narcissism, which exaggerates the structures by which

the self attempts (and fails) to coalesce in the oedipal regime, may access the domain of *abject* beings who otherwise form the outside to the domain of the subject.[104] It is this domain of abject beings that I believe the most interesting body art projects to be enacting: women as (provisional) subjects, men who are openly ambivalent in their relationship to the phallus and particular in spite of their privileged masculinity, subjects who are otherwise not normative.

Through the citation or reiteration of heterosexist and sexist codings of men and women subjects, the narcissistic body artist instantiates what Butler identifies as the always *derivative* aspect of performativity: marking the fact that the subject is never fully coherent in her or his intentionality. This lack of certainty in the projection of intentionality is, of course, what enables my critical interventions in these practices in terms of a 1990s dislocation of the very conception of gender that underlies such work. Through the reiteration of norms (such as Mendieta's reiteration of the link between nature and the bodies of women and "primitive," "Third World" subjects), Butler argues, "sex is both produced and destabilized."[105] The sexed, raced, classed bodies of body art performers figure into this narcissistic regime in complicated and provocative ways; especially for feminist body artists, the narcissistic reiteration of the nude or partially nude female body exacerbates to the point of absurdity the Western fixation on the female body as object of a masculine "gaze" (it is the very narcissism of such performances that take this body back from such alignments and link it to the contingent but active subjectivity of the woman artist).

Rather than Brechtian distanciation, body art proposes *proximity:* as a critique exploring rather than repudiating the seductions of late capitalism through specific bodies that force the spectator's own narcissistic self-containment to account (through its reversibility) for the "other" of the artist as the artist accounts for her or his interpreters by performing specific bodies that force the interpreter to acknowledge her or his implication in determining the meanings of the artist/work of art. This proximity, the loss of distance between self and other that feminists such as Mary Kelly and Griselda Pollock have argued has served patriarchal modernism (and modernist art history) so well, also parallels and exacerbates the collapse of the distinction between public (the male realm of exchange values) and private (the female domain of use values) that characterizes late capitalism, and the collapse of the distinction between self and other that Riesman and Lasch lament.[106] As I suggest here via Mendieta and explore in relation to Hannah Wilke's work in chapter 4, it is no accident, then, that feminist body artists and artists of color—with their explicitly sexualized and specifically encultured performances of their embodied subjectivities—are perhaps the most obviously successful in engaging narcissism to radical ends (in

the terms I have laid out here), even as they collapse the distinction between subject and object in a way that is anathema to Brechtian-oriented feminists such as Kelly and Pollock.

Feminists have had much to gain from the narcissistic collapse of the boundaries between self and other, the distinctions between the public and the private, the difference between the signifier and signified itself. Through the narcissistic constitution of the self, as Lacan maps it in "The Mirror Stage," we can see how the *alienation* that many have identified as constitutive of the postmodern condition is marked as fundamental to the human condition such that, as Krauss states in "Notes on the Index, Part 1," "identity (self-definition) is primally fused with identifications (a felt connection to someone else)." Such a recognition has the potential of overthrowing the paternal function, with its stake in maintaining the illusion of an untouchable transcendence rather than a fantasy forever bound up in the corporeal immanence of the other. In this way, Schneemann's, Kusama's, and Mendieta's narcissistic, corporeal displays can be seen as claiming the immanence and intersubjective contingency of *all* subjects (as well as the particular oppressive history of women's bodies/subjects) in white, Western patriarchy.

Because of body art's *exposure* of the contingency of the performing self, the narcissistic focus on the self by body artists—including the male artists—hardly confirms in any simple way the heroic genius (and "transcendence") of the artistic subject; nor does it align with the rather simplistic, loosely Freudian usages of the notion of narcissism as a regressive inability to go beyond self-relations to object-relations (an inability to attain "normal" adulthood, which Freud first identified with the "pathology" of homosexuality).[107] Body art splinters rather than coheres the self; far from assuring some presocial coherence of the self, body art enacts narcissism as contingency. Schneemann's, Kusama's, and Mendieta's externalization of their "lack" both exposes the masculinism and Anglocentrism of the coherent self and ironicizes the immanence projected onto women in patriarchy. While they might well be accused, per the Brechtian antiessentialism of 1980s feminist art discourse, of narcissistically projecting their body/self through an assumed, idealist conception of the female body as conveying the truth of female experience, they might just as well be seen as radically opening that experience to the multiplicity of intersubjectivity through their performance of the *flesh* of the world.

The poststructuralist and feminist discussion of the destabilization of the subject in postmodernism, the contingency of the self on the other, the interconnectedness of body/self, and the materiality of the body as subject can be seen as describing a set of conditions that both *explain* (retroactively) and

51

motivate (precede) the effects of body art. Such formulations *make evident* what modernism has labored to conceal: the fundamental narcissism of the self and the contingency of this narcissistic self on its others. Within art discourse, the goal has been to align the art historian or critic with the artist as ostensibly reflected in the work of art and to cohere the art historian's sense of authority and sense of self through identification with the creative other, whose identity must be decorporealized—made transcendental—and fixed through masculinized and heterosexualized (not to mention imperialist and Anglo) tropes of genius and mastery. The mediated nature of the narcissistic body/self recognized by poststructuralism and feminism and played out in body art projects complicates this goal, pointing not only to the dissolution of the nuclear family, state authority, and the general authority of the paternal function (or Lorde's "mythical norm" of subjectivity) in late capitalism but also to the dissolution of epistemological certainty within disciplines such as art history.

Attending to the body of the artist (the body as enactment of the self)—as the body artists encourage us to do—is a way of pointing out the ahistorical nature of the framing enterprise of conventional aesthetic interpretation, which works to eliminate that body in any but its most reduced, objectified forms.[108] Once the body in representation is returned to the body in production and linked—through interpretive desire—to the bodies of reception, history and sociality return. The enactment of the artistic body (particularly that of the usually objectified female artist) enables the circulation of desire among subjects of making and viewing. This circulation of desire is historically and socially specific: while the subject of making is situated within particular relations of production that inform her or his products in various ways, each subject of viewing interprets the body art work in a manner specific to her or his particular desires, which in turn have developed in relation to her or his psychic and social contexts. Two embodied socialities and subjectivities come into contact (in phenomenological terms, into "being") through the body art work.

As I will explore in the following chapter, the body/self Jackson Pollock provides a pivotal point of contact for both modernists and postmodernists, serving as an ambivalent figure of both regimes. While modernists such as Clement Greenberg veil Pollock's narcissism (and their own) to confirm him as a unified source of divinely inspired intentionality, incipient postmodernists such as Happenings performer and theorist Allan Kaprow claim Pollock's performativity openly, emphasizing his *body* in its public display as central to the transformation of the art project into an open-ended process rather than a set of "mute" products that can be made to speak their true meanings only by privileged specialists through authoritative structures of interpretation.

2

THE "POLLOCKIAN PERFORMATIVE" AND THE REVISION OF THE MODERNIST SUBJECT

 In a 1951 issue of *Art News*, Robert Goodnough published "Pollock Paints a Picture," one installment in a series of essays on artists "painting a picture" or "making a sculpture." This essay describes Pollock's working process in terms that stress his uniqueness and genius ("creating his unique world as a painter [and] . . . penetrating nature to the core," Pollock produces "a sense of the freedom" of the American landscape in his work) and is accompanied by photographs of Pollock working by Hans Namuth.[1] These images, as mobilized in relation to the artistic subject across the following decades, signal a shift in the conception and enactment of this subject and his relationship both to the work and to the viewer. While other essays in the series often showed the artist at work in a relatively conventional manner (artist sitting with easel and other tools of the trade), the Namuth images of Pollock show him standing above or within his huge canvases, overtly and theatrically *performing* the act of painting in photographs that overwhelm the layout of the article rather than appearing as incidental illustrations of the text.[2]

Namuth's photographs, along with photos by Rudolph Burckhardt and others, were disseminated around the world in the 1950s through *Art News* and other venues.[3] Namuth's film *Jackson Pollock* (filmed in 1950, at the end of the same year in which the photographs were taken) was screened first in 1951 at the Museum of Modern Art in New York, marking even more dramatically the performative dimension of Pollock's practice.[4] These images of Pollock in the act of painting presented art as a performance (that is, thus contingent on

HANS NAMUTH, FILM STILL FROM *JACKSON POLLOCK*, 1950/51. PHOTOGRAPH © 1990
ESTATE OF HANS NAMUTH.

the act of reception) rather than a fixed object, presumably embedded with the artist's original intentionality, its "inherent" meaning determinable by a specialized reader.

Supported by Harold Rosenberg's description of abstract expressionism in 1952 as "American Action Painting,"[5] of painting as an *act* rather than a final object, these photographs, and the ways in which they have been used and reworked within discourses about Pollock in relation to contemporary art, exemplify the speaking of a new mode of thinking not only about "art" as an expression of individual subjects, but about subjectivity itself. This performing Pollock (what I will call the "Pollockian performative," in an attempt to get away from the idea of Pollock as an intentional individual or originary subject) was, from early on, constructed largely in relation to the photographs and, to a lesser extent, the film of Hans Namuth. Even Rosenberg's construction of Pollock as laboring existentialist hero was taking off from the photographs; as Barbara Rose has written: "In retrospect, I realize Rosenberg was not talking about painting at all; he was describing Namuth's photographs of Pollock."[6]

This Pollockian performative articulated by Goodnough, Rosenberg, and others through Namuth's images produces a subject that is potentially dispersed, dislocated, and open to spectatorial engagement; in this sense, the Pollock "spoken" by Namuth and others dovetails in interesting and productive ways with the primarily French philosophical reconceptualization of subjectivity that we now call poststructuralism, which I discussed at some length in chapter 1. Only a year after Rosenberg's article appeared, for example, the French philosopher Mikel Dufrenne published a book called *The Phenomenology of Aesthetic Experience*, in which he dramatically rethinks the definition of art: "In truth, all the arts require a performance: the painter executes or 'performs' a portrait. . . . Creation is performance."[7] The philosophical articulation of art-making as act appears at the same moment as the very similar descriptions of painting as an act within art discourse; whether or not Dufrenne was directly inspired by the action painting figure of Jackson Pollock (who had, as noted, become internationally known through photographs published in art and popular magazines by the mid 1950s), this confluence of ideas suggests that the Pollockian performative can productively be viewed as signaling a profound philosophical shift in conceptions of artistic subjectivity (and subjectivity itself). This is how this book views the performative dimension of the work of Pollock and the body artists following him: not as "causing" the shift or as "following" it but, rather, as indicator of its profound effects.[8]

Within art discourse, reformulations of painting as act or performance in the 1950s and 1960s explicitly cite Pollock as the model for this new

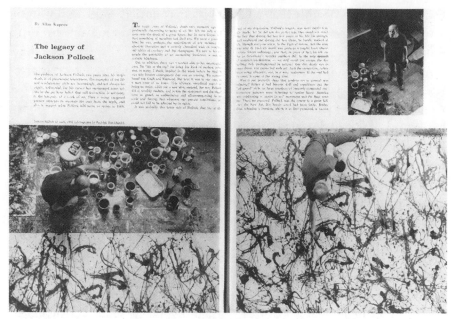

ALLAN KAPROW, "THE LEGACY OF JACKSON POLLOCK," *ART NEWS*, OCTOBER 1958.

way of conceptualizing the work of art and the artistic subject. Thus Allan Kaprow's important 1958 essay "The Legacy of Jackson Pollock" forms a sort of pivot between the static Pollock of modernism and the performative Pollock who would be spoken as one of many origins for postmodernism. In spite of its lingering romanticism in his characterization of the "grand . . . authoritative, and all-encompassing . . . scale and daring" of Pollock's "ritual" statement (which aligns Pollock implicitly with modernist conceptions of the artist as heroic and individual), Kaprow's articulation of Pollock clearly also aligns him with the kind of performative, open-ended, and processual conception of art-making that we now associate with practices critical of modernist formalism.[9] Most importantly for Kaprow, Pollock's apotheosis as tragic genius of modernist painting opens out into his destruction of the modernist conception of painting through performance: "With Pollock . . . the so-called 'dance' of dripping, slashing, squeezing, daubing and whatever else went into a work, placed an almost absolute value upon a kind of diaristic gesture."[10]

Finally, and most radically, for Kaprow, Pollock's painting must be understood in terms of its dramatic activation of spectatorial participation. The scale of Pollock's paintings results in "our being confronted, assaulted, sucked in"; and Kaprow insists that "to grasp Pollock's impact properly, one must be something of an acrobat, constantly vacillating between an identification with

the hands and body that flung the paint and stood 'in' the canvas, and allowing the markings to entangle and assault one into submitting to their permanent and objective character. . . . The artist, the spectator and the outer world are much too interchangeably involved here."[11] Kaprow thus echoes Merleau-Ponty's contemporaneous observation that subject and object are *intertwined* in the reversibility of perception and expression, in the *chiasmus.* For Merleau-Ponty, the subject *includes the other* and "authorizes its authority as also a subject."[12]

The "author function" Pollock—that is, not the "individual" Pollock but Pollock as a "plurality of egos" put into play by the cultural text, "a function of discourse"[13] spoken both as modern and then, increasingly, as postmodern—thus serves as an important site of contradictions. The figure of the artist (the author function within art history) in general is a particularly striking—and strongly ambivalent—example of the normative subject in Western culture; that is, the artist has conventionally figured within art criticism and history both as an exaggerated example of the coherent, fully intentional, Cartesian subject *and* as the problematization of this subject. The artist has commonly both been strongly differentiated from the perceived norms defined by society in general and, especially in the modernist period, received authority from this very normative subjectivity. As the figure of the artist is defined discursively and self-defined in the high modernist period, he (the artist being implicitly male) represents both an extreme case of the modernist desire to unify the subject as a source of intentional meaning and a conduit of divine inspiration (an earthly god among mere mortals), and a subjectivity that attempts to define itself in *opposition to* what is perceived to be mainstream, bourgeois culture.

The conflicts that emerge in discourses about Pollock thus expose contradictions deep within modernism, contradictions that eventually ruptured modernism from within, producing a revised conception of the artist and the subject in general. The speaking of Pollock as performative opens the art historical author function to the unpredictable vicissitudes of intersubjective engagement. The author function Pollock thus exemplifies the contradictions within modernism (which modernist art history and criticism, especially in their formalist guises, have labored to conceal) and suggests that the shift that occurs toward a new conception of the subject as fragmented, decentered, and intersubjectively defined is not a shift in the "essence" of the subject (for this would be in itself a contradictory claim) but, rather, a transformation in the way in which these contradictions are managed or understood through art historical discourse. The "postmodern," performative Pollock could be seen, in this sense, as simply a speaking of Pollock that *acknowledges* rather than *suppresses* the undecideability of this art historical figure.

Examining both the ways in which Pollock has been conflictedly constructed through discourse (photographs and text) and the ways in which younger artists responded to Pollock and rearticulated his act as explicitly postmodern, this chapter provides a further foundation for understanding what I am attempting to identify as body art's insight: the dramatic shift in the conception of artistic practice, meaning, and subjectivity itself in the post-1960 period. For, one could argue, body artists in one sense simply took the Pollockian performative (the author function of Pollock articulated as *in performance*) one, albeit large, step further than those writers defining the meaning of Pollock's work in the 1950s. The body artists of the late 1960s and early 1970s speak themselves and are spoken as their work; their actions open and even exacerbate the circuits of desire between the artistic subject (here *as* the work itself) and the receptive subject that condition and inflect the meanings determined for the work. Body artists, then, *perform* rather than *suppress* the dislocation of the subject, and this, indeed, could be said to be what constitutes "postmodernism": the awareness of the impossibility of determining meaning or identity in any final way and of the contingency of the subject (here the artist as well as the interpreter) on the particularities of the interpretive exchange.

PERFORMATIVE POSTMODERNISM: AN ALTERNATIVE VIEW/THROUGH THE BODY

To say that mortals *are* is to say that *in dwelling* they persist through spaces by virtue of their stay among things and locations. . . . I am never here only, as this encapsulated body; rather I am there, that is, I already pervade the room, and only thus can I go through it.
—MARTIN HEIDEGGER[14]

[I]t is not the body-object described by biologists that actually exists, but the body as lived in by the subject.
—SIMONE DE BEAUVOIR[15]

The word 'body', its danger, how easily it gives one the illusory impression of being outside of meaning already, free from the contamination of consciousness-unconsciousness. Insidious return of the natural, of Nature. The body does not belong: it is mortal-immortal; it is unreal, imaginary, fragmentary. Patient. In its patientness the body is thought already—still just thought.
—MAURICE BLANCHOT[16]

I am nature.
—JACKSON POLLOCK[17]

In addressing Pollock, I am, again, addressing the socially articulated *body* (of the artist) as it takes its meaning ("in dwelling" and as "lived by the subject" and in exchange with others) and becomes a "subject" of meaning (becomes a body/self). The body, as all of these writers suggest, is always already thought: the body has no fixed, "material" truth preexisting its relations with the world and with others, and we know our own bodies only through our own thought, conditioned by our perceived relations with others. Specifically, taking Blanchot's warning seriously, I am viewing the body of Pollock not as a return of a masculinized version of "Nature" (as both Pollock and his modernist interpreters would apparently have wanted) but as "unreal, imaginary, fragmentary." I am taking Pollock's performative body to be what it is said to be, variously, by Rosenberg, Clement Greenberg, Kaprow, then by Yves Klein and beyond: it is an always already thought, always already social and cultural body/self, articulated within the modern or postmodern. Pollock is definitely not to be understood here as singular "origin" (influence or inspiration) for postmodernism.[18]

At the same time, it will be clear that I depart from histories of contemporary performance art that pose performance as part of the hidden strain of modernist avant-garde practice that went underground with the rise of abstract expressionism and its accompanying formalist, object-oriented model of artistic practice and is thus purely oppositional to Pollock.[19] Tracing the shifting meanings of particular bodies/subjects such as Pollock, I diverge from the common tendency to place performance or body art, when it is discussed at all, within a narrowly defined lineage of avant-garde performance. Originating in futurist, dada, and surrealist performance from the teens and twenties, then leading up through John Cage's 1952 "event" at Black Mountain College in North Carolina to the triumphant apotheosis of performance in the Judson Dance Theater, the Living Theater, and the Happenings and Fluxus events of the late 1950s and 1960s, most histories of performance (such as RoseLee Goldberg's useful *Performance Art: From Futurism to the Present*) then pose body art of the 1970s and theatrical performances of the 1980s as the logical extension of this lineage.[20] Within this logic of progression, body and performance art are celebrated as climactic moments in the long development of an alternative modernist avant-garde posed against formalist lineage of modernist critics such as Clement Greenberg and "formalist" artists such as Pablo Picasso and Jackson Pollock. Thus, it is argued that Happenings extend the radical antiformalism of dada, valiantly merging art and life to counter Pollock's example and the neurotic claims of autonomy put forth by formalist modernism.[21]

In Sally Banes's informative book *Greenwich Village 1963: Avant-Garde Performance and the Effervescent Body,* for example, she posits a lineage from John Cage

(through his classes on experimental music at the New School for Social Research in New York City in the late 1950s and early 1960s) to practitioners of the Happenings and Fluxus movements such as Allan Kaprow, George Brecht, Dick Higgins, and Al Hansen (artists who either explicitly posed themselves in relation to Pollock's example or who were positioned as such by art historical texts) and the Judson Dance Theater (which was closely linked to the art world in New York).[22] Banes states that Cage, in his classes at the New School, drew on the newly published anthology entitled *The Dada Painters and Poets* (edited by Robert Motherwell) and "provided historical models for a nontheatrical performance style by informing his students about the Futurist and Dada movements." Banes concludes that one can "trace a line of descent from Cage through Kaprow, Hansen, and [Jim] Dine to the Happenings; [and] through Higgins and Brecht to Fluxus." Banes's account, while useful and rich in historical information, evacuates this history of its conflicted, discursive dimension, alerting us to the dangers of reducing an immensely complex history to a paternal lineage in a typically simplistic model of historical "influence."[23]

I do not, strictly speaking, want to argue that this lineage is *false* (there are too many obvious reasons to retain its convincing map of interconnections and it would be impossible to deny its narrative and historical force).[24] Rather, following Michel Foucault and any number of other poststructuralist thinkers, I want to insist that such linear narratives tell only one part of the story, failing to account for the biases, ambivalences, and dense contradictions informing how such stories get told (including decisions about who is included and what gets left out). Such narratives leave out the function of *discourse* in conditioning how we understand particular histories. My reframing of body art, then, does not retell the history of who knew whom and how the idea of performance or body art was transformed from movement to movement, artist to artist. My "story" is necessarily particular and local, focusing on particular cases of body-oriented practice in the hopes of attaining the combination of specificity and generality designated by Foucault's conception of *genealogy*, which, borrowing from Nietzsche, "opposes itself to the search for 'origins,'" and, not incidentally, understands the role of the *body* in articulating the traces of genealogical descent:

> The body is the inscribed surface of events (traced by language and dissolved by ideas), the locus of a dissociated Self (adopting the illusion of a substantial unity), and a volume in perpetual disintegration. Genealogy, as an analysis of descent, is . . . situated within the articulation of the body and history. Its task is to expose a body totally imprinted by history and the process of history's destruction of the body.[25]

Expanding on Foucault's insights, I propose here to situate a *particular* genealogy of the performative subject through readings of Pollock's body/self, Pollock's "author function" (which is understood *through* images of his body in action), as performed within art discourse and as negotiated through the body art works of other artists. I have already suggested that Pollock's author function be seen as pivotal in the turn from a modernist to a postmodernist conception of meaning and subjectivity (a "turn" that is still far from complete or unequivocal). Thus, the posing of Pollock (as exemplary of formalist modernism) as antipodal to the performance lineage, and to the resurgence of performance and body art in the 1960s, is already complicated *discursively* by Rosenberg's articulation of Pollock as performative in 1952 (not to mention by Kaprow's citation of Pollock as inspirational for the Happenings). Pollock, then, is an ambivalent figure—both quintessential modernist, formalist genius, and origin of the performativity of postmodernism; and performance, too, has a conflicted, often ambivalent history.

I want to perform the author-function Pollock here as what Foucault or Jacques Derrida might call a *dispersed* origin: a discursive field that, as a hinge between modernism and postmodernism, can productively be interrogated in order to uncover the complex ideological and historical "foundations" of the performative postmodern. Moving away from the linear model of influence and origins, so central to art historical practice, I explore Pollock as one particularly compelling, multivalent, contradictory site among other sites (rather than "origins," since an earlier moment can always be found) of the emergence of the performativity of subjectivity in modernism and postmodernism.[26]

While the accounts of Pollock's performativity (as interpreted by younger artists such as Kaprow) may tempt us to think that we have found the "origins" of the performative critique of the modernist artist as divinely inspired and unified origin of works of art, the performative body of the artist did not emerge in an original and unprecedented way with Pollock's first drip painting in 1946 or 1947—no more than it emerged fully formed from Allan Kaprow's first Happening in the late 1950s, from John Cage and Robert Rauschenberg's theatrical event at Black Mountain College in 1952, or even reaching further back, from the performances of the Zurich dadaists at the Café Voltaire in 1916. While Pollock can be engaged with as a performative function and while the performative body of postmodernism thus expresses itself within modernism (often in veiled and ambivalent forms), I argue in this book that it is only in the period after 1960 or so that performativity becomes the dominant mode in the articulation of the self (marked thus as contingent and unfixed). Saying that aspects of what we consider to be radically postmodern have always existed within

modernism is not to say that there is no such thing as postmodernism or that history itself has no meaning (a charge that is commonly and, in my view, mistakenly leveled against poststructuralist critiques of the discourse of originality). It is rather to recognize the complexity and density of history's "taking place," always referring itself (performatively) to its previous incarnations (and the word is carefully chosen) in order to proclaim itself as new but, in so doing, emphasizing its dependence on the old.

THE VICISSITUDES OF SELF-REPRESENTATION: THE PHOTOGRAPHIC PORTRAIT OF THE MODERN ARTIST

In exploring Pollock as a pivot between a modernist and postmodernist conception of artistic subjectivity, it is important to understand the relationship of the images of Pollock to conventional models of artistic subjectivity in the earlier modernist period (before the 1950s). The photographs of Pollock, which gained extraordinary cultural power through their mass reproduction in *Art News* and other venues, surfaced the body of the artist-at-work in an unprecedented way. While the artist's portrait was common before this time, the idea of presenting the artist in the act of creation—which, in Pollock's case, involved the depiction of an athletic and radically revised process of throwing industrial paint on a floor-sized horizontal canvas—was relatively new.[27]

Typically, within the texts and the visual representations that comprise every art historical study, the body of the artist, by definition (until recently) male, has been veiled: both central and hidden, both represented yet, on the surface of things, ignored. Within conventional modernist art history and criticism, based on loosely Kantian models of formalist aesthetic judgment, this male body, with the prerogative assigned to it in patriarchal culture, must be both *present* and *absent*. The modernist genius must have a body that is visible as male, and yet this body must be naturalized (made invisible) in order for the rhetoric of transcendentalism to do its work successfully: the artist as divinely inspired is effectively disembodied, and ostensibly desexed, in the art historical or critical text.[28] The artist must be embodied as male in order to be considered an artist—placed within a (patri)lineage as originary and divinely inspired—but his embodiment (his particularity as a gendered and otherwise vulnerable, immanent subject) must be hidden to ensure his transcendence *as* disembodied and divinely inspired. In Lacan's psychoanalytic terms, the phallus must be veiled in order to avoid its exposure as mere anatomical appendage subject to removal (the body's castration).[29]

Paradoxically, modernist criticism and art history *rely on* the (male) body of the artist to confirm their claims of transcendent meaning—with the

critic or historian acting as "priest" transmitting this transcendence (as read through the art work back to the divine [invisible] body of the artist)—and yet insist on the occlusion of this body. In conventional modernist discourse, before Pollock's performative image increasingly confused the closed circuits by which art critics and historians secured their privilege (as "disinterested" interpreters), the veil was ultimately the work of art itself.[30] If the (male) body of the artist were to be made visible (that is, unveiled as the central force compelling the [male] critic's or historian's [homoerotic] desire-in-interpretation), the supposed disinterestedness of this critical project would be completely shattered. The unveiling of the body of the artist through her or his visible rendering in the act of making (or, in the case of body art, enacting) the work of art, as the remainder of this book will suggest, entails the radical exposure of the interestedness—the erotic investments—of the interpretive project.

As much is suggested in Barbara Rose's evaluation of the impact of Hans Namuth's photographs and film of Pollock:

> Suddenly, the secrecy and mystery of the creative act— . . . challenged by the images of Pollock at work—were laid bare for all to see. It was as if tribal secrets were unveiled for the first time, as the public at large became witness to sacred rites to which they had never before been admitted. In this respect, Namuth's photographs aided the process of breaking down the boundary between art and its public that has been a primary phenomenon of our time. . . . As photographed by Namuth in the heat of the moment of creation, Jackson Pollock projected . . . a kind of animal magnetism.[31]

Further, Namuth "stalks" his subject, who is gripped by impulse and "driven by inner forces." Rose's language, itself adulatory and hero-worshipping, betrays the intense anxiety generated by Pollock's unveiling (which becomes an act of seduction and sexual conquest—a heated display of animal magnetism then caught in film by Namuth, the stalker). Rose acknowledges that the breaking down of the boundary between artist and viewer is profoundly unsettling, noting that "Namuth's images of Pollock in action altered the popular conception of the artist" as well as the course of art criticism and art history. She also presciently observes that the moment of Pollock's broadly publicized theatricalization marked "the conversion of reality into myth, the essence of media culture," which we now associate with the rise of postmodernism (with Warhol's artist-as-celebrity and beyond).[32]

Language as well as imagery contribute to this equivocal en-gendering of the conventional masculinist trope of the modernist artist. Rose's own am-

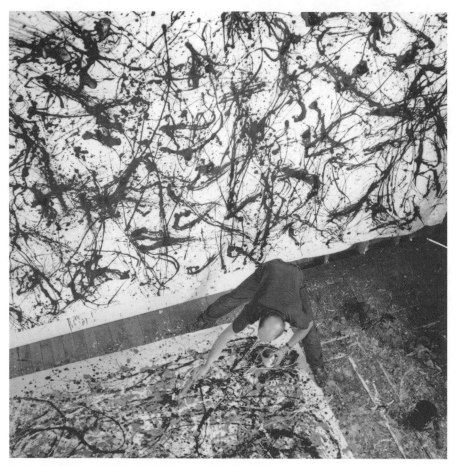

HANS NAMUTH, POLLOCK PAINTING, 1950. PHOTOGRAPH © 1990 ESTATE OF
HANS NAMUTH.

bivalence (her simultaneous acknowledgment of the dramatic shift signaled by
Namuth's display of Pollock painting and adherence to clichéd tropes of his
genius) marks a broader conflict underlying art critical paradigms in the post-
war period. Jackson Pollock's description in modernist criticism as a "demi-
urgic genius" who paints in ejaculatory "paroxysms of passion" testifies not to
his possession of the phallus but to his lack (which must be simultaneously
veiled and confirmed through such hyperbolic rhetoric confirming its "pres-
ence").[33] The case of Pollock makes clear that this "present/absent" body of
the male artist is performed in particular and highly motivated ways that make
the body of the male artist both visible (allowing it to signify) and invisible
(rendering it in the naturalized, and so seemingly transparent, codes of mascu-
line genius). Changing conceptions of artistic identity and of masculinity in

general can be inferred through the performance of the artistic subject in the photograph.[34]

From modernism to postmodernism, a central concern of the male artist and those photographers, painters, and sculptors who represent him has been the rather blatant signaling of "creativity" as his key attribute (after all, it is creativity that differentiates him—in his genius—from the gauche cultural pretensions of the bourgeoisie). Because of shifting conceptions of artistic subjectivity and changing relationships between the artist and the social, creativity, however, is signified differently from period to period. As Raymond Williams has argued, the identity adopted by the artist—who, he stresses, is invariably masculine within modernism—not only stresses "creativity" as its basis, but operates through a rejection of bourgeois culture and of the femininity associated with bourgeois domesticity. Increasingly throughout the nineteenth century and particularly with the rise of the early-twentieth-century avant-gardes, "the bourgeois was the mass which the creative artist must either ignore and circumvent, or now increasingly shock, deride and attack."[35] However, given the contradictory attitudes—the "diachronic range"—of the bourgeoisie, the artist's resistance could be expressed in one of two very different modes: through an elitist stance opposed to the "vulgar, hidebound, moralistic, and spiritually narrow" bourgeois subject or through a populist position, in which the artist would align himself with the exploited worker and expunge from his purview the feminizing domestic allure of bourgeois commodity culture.[36]

Before the 1950s, the photographs and written descriptions of the artist tended to illustrate one of these two options: from Nadar's portrait of Eugène Delacroix and Edouard Manet as dandified, almost aristocratic alternatives to the muted and dull appearance of the bureaucrats representing bourgeois class interests to textual descriptions of Vincent Van Gogh, dressed in rags and trundling his canvases into the open air. In fact, it is no accident that the artist as a unique, divinely inspired individual (as well as the individual in general as a subject of free will, centered in his own cognition, in the Cartesian sense) arose coincidentally with the development of photographic technologies (from the physiognotrace in the eighteenth century and beyond). The photograph itself marked the dramatic democratization of portraiture: the photograph substantiated subjects who, in the prephotographic era, had no means by which to picture themselves.[37]

The massification of society (this democratic leveling through photography and other industrial technologies and demographic shifts) brought with it a concomitant need for the creation of a new "unique" subject. As photography gave members of the growing bourgeois class access to self-imaging, it

became increasingly urgent for those aristocrats and artists who wished to differentiate themselves from the *arrivé* tastes of the bourgeoisie (and from, in a more profound sense, the very poses, fashions, and discourses by which the bourgeoisie projected themselves as subjects) to adopt attitudes and vestimentary effects that marked them as *different from* conventional middle-class style. Accordingly, and in consonance with Williams's argument, artists tended to align themselves with the working class, taking on the sartorial signifiers of the peasant or laborer (used jackets, rumpled fabrics, messy hair, or, in the case of Van Gogh and Paul Cézanne, actual peasants' clothing) or to construct themselves through the aristocratic codes of the *dandy* or his peripatetic colleague, the *flâneur*.[38]

Through these "alternative" codes, the nineteenth- and early- to mid-twentieth-century artist performed himself as *different from* the taste of the bourgeoisie;[39] and yet, crucially, this artist did not rupture the bond between the photograph as supposedly transparent indexical marker of identity and the putative meaning and value of his work. That is, I will argue here that, while the modernist artist can be seen as performing himself in the sense of actively (but largely not self-consciously) constructing an antibourgeois persona for himself, he still performs himself and is performed through modernist criticism as being identical with his work: the image of the artist/of the work (the index/signifier) and meaning (the signified) are assumed to be inextricably bound or completely conflated.

Modernist critical discourses surrounding Jackson Pollock typify such a conflation. Rather than viewing his performative painting style as challenging the fixity of the artist/subject through its opening of the (act of) painting to interpretive desire, the modernist art critic or historian (as in the case of Rosenberg) has typically described Pollock as literalizing the equivalence of the trace of paint with the deep psychological impulses motivating the artistic subject. The violence and spontaneity of Pollock's "trace," in this formulation, confirm his virility, as well as the divinity of his inspiration. His (male) body is both necessary to the evaluation of his genius and necessarily veiled (that is, the dependence of such formulations on the image of his body, in all of its potential vulnerability and desirability, is never acknowledged).

The *postmodern* performative artistic subject, conversely, is articulated as enacting a subjectivity that is fundamentally contingent and particular—as might be expected given her or his social context within a culture of late capitalism with its increasingly alienated modes of production and explosion of categories of gender, sex, race, and class.[40] The postmodern artistic subject performs and exacerbates the *gap* between appearance and significance, between index (the

image or trace of the artist) and that subject's "meanings" for her or his others. This postmodern performativity, then, is marked by a mode of exaggeration: the artistic subject is not presented via the photograph as trustworthy document of identity but is self-consciously *performed* through new, openly inter-subjective contexts (including video or ironicized modes of photographic display) which insist upon the openness of this and all subjects to the other.[41]

THE EQUIVOCALITY OF (MASCULINE) GENIUS

The figure (or "author function") of Marcel Duchamp complicates further the position of Pollock as alternatively the quintessential figure of modernism in postwar discourse and an integral moment in the articulation of a *post*modernist mode of performative subjectivity. A comparison of two *Life* magazine articles—"Jackson Pollock: Is He the Greatest Living Painter in the United States?" from 1949, and "Dada's Daddy," a tribute to Marcel Duchamp published in 1952—opens up this complexity, raising questions of national specificity and what Judith Butler has termed the "heterosexual imperative": the performative reiteration of "regulatory norms of 'sex'" that bolster the privileging of masculinity (*as* heterosexual) in Western culture.[42] The article on Pollock opens with the now infamous image of the artist, arms and legs crossed in a hostile and aggressive closure of the body against spectatorial curiosity and desire, in dark worker's clothing, smoking a cigarette and leaning nonchalantly against one of his drip paintings. Alternatively, "Dada's Daddy," while obviously invoking the masculine trope of paternity, begins with a time-lapsed image of Duchamp descending a staircase (a reference to his famous painting *Nude Descending a Staircase*, 1912)—his body multiplied into an ambiguous, diaphanous "pioneer of nonsense and nihilism."[43]

The imaging of these two artists, one constructed as quintessentially and normatively masculine in terms of the values of American culture at the time, the other (an "exotic" French immigrant to the United States) rendered through the U.S. media as elusive and ambiguously gendered, is telling. Duchamp is thus both father/daddy and feminized (his body equated with that of the female nude in his painting).[44] This feminization is highlighted for the reader who peruses the second part of the article, where a column of text with a picture of Duchamp playing chess is sandwiched between advertisements for "poirette" corsets and Arrow shirts, including images of women's lips and a woman encased in a girdle. Like Pollock, Duchamp is feminized too simply through the exhibitionism of his presentation within this popular mass-media venue (reminding us that, as Lacan argued, the phallus can only play its role as veiled: Pollock's studied macho in some ways simply self-implodes through such aggressive display.)[45]

67

The example of Duchamp complicates my positioning of Pollock as an originary trope for the performative subject of postmodernism, since it appears (as I have argued extensively elsewhere)[46] that Duchamp works even more clearly as a performative, antimodernist and antimasculinist author function within U.S. art discourse. However, it is precisely these gaps and incoherences— this strange ambiguity among these "fathers" of contemporary art (Pollock's reiterated masculinity, which, displayed in the pages of a popular magazine, serves to feminize him; and Duchamp's presentation as virile "pioneer," his body invaded by feminine signifiers)—that enable the "speaking" of both artists, in spite of their vastly different masculinities, for modernism as well as postmodernism. Pollock, being an American and the hegemonic force to be reckoned with by subsequent artists, was the "father" offered by critics such as Rosenberg to be reformulated as performative, ambivalently masculine, by younger generations of artists. Duchamp, who was taken up as an example by younger generations of male artists seeking to break Pollock's influence (specifically artists such as Robert Rauschenberg, Jasper Johns, and Andy Warhol, all of whom in one way or another transgress the "heterosexual imperative"), is an alternative "father" spoken within the codes of an antimasculinist and, in the U.S. context, potentially (if subtextually) homosexual artistic subjectivity.[47]

Warhol is perhaps the most obvious example of the dramatic performance of the artist against the grain of the masculinized, heterosexualized codes of artistic genius.[48] For Warhol, acting "swish" was a strategy aimed directly at unhinging the hyperbolically masculine figure of the abstract expressionist genius:

> [A]s for the 'swish' thing, I'd always had a lot of fun with that—just watching the expression on people's faces. You'd have to have seen the way all the Abstract Expressionist painters carried themselves and the kinds of images they cultivated, to understand how shocked people were to see a painter coming on swish. I certainly wasn't a butch kind of guy by nature, but I must admit, I went out of my way to play up the other extreme.
>
> The world of the Abstract Expressionists was very macho. The painters . . . were all hard-driving, two-fisted types who'd grab each other and say things like 'I'll knock your fucking teeth out' and 'I'll steal your girl.' In a way, Jackson Pollock had to die the way he did, crashing his car up, and even Barnett Newman, who was so elegant, always in a suit and monacle, was tough enough to get into politics. . . . The toughness was part of a tradition, it went with their agonized, anguished art.[49]

Like Duchamp, Warhol not only performed his own career as a crucial component of his work (thus enhancing the performative dimension of the artist's identity), he also he mobilized his body/self within exaggerated images that undermine or parody the trope of the artist as worker or dandy. Throughout his career, Warhol inserted himself aggressively into the field of meaning surrounding his work by making himself highly visible on the New York art scene through the antics of the Factory and his filmmaking activities.[50] In his numerous interviews and published recountings of his role in the pop art movement, Warhol projected an ambiguous subjectivity whose most salient aspect seemed to be its emptiness: its dependence on the *other* to confirm its meaning. His famous deadpan self-performances in interviews typify the way in which his persona evacuated the notion of the artist as an intentional "individual," uniquely capable of transcending the brute corporeality of everyday existence through pure creativity. Warhol's "act," as it were, pivoted precisely around the refusal to gel as a definable artistic subject in any coherent way in relation to what was expected of him by others. Warhol's appearance in Emile de Antonio's documentary film *Painters Painting* is exemplary in this regard; in spite of all of de Antonio's attempts to force Warhol to define himself as a painter, Warhol continually throws this identity back at de Antonio (as he would time and again, through his work and self-presentational strategies, in interviews). The following engagement is typical:

> DE ANTONIO: When I first knew you, you weren't painting, and then you did become a painter. Tell me why that happened and when it happened.
>
> WARHOL: Well, you made me a painter.
>
> DE ANTONIO: Let's have the truth.
>
> WARHOL: That is the truth, isn't it? You used to gossip about the art people, and that's how I found out about art. You were making art commercial, and since I was in commercial art, I thought real art should be commercial, because you said so. That's how it happened.[51]

While Duchamp skirted the sexual/gender implications of the dandy, whose aristocratic masculinity perhaps parlayed him too close to the domain of the feminine (as Jules Barbey D'Aurevilly wrote in 1844, for dandies "as for women, to *seem* is to *be*. . . . [A dandy] is a woman on certain sides"),[52] Warhol's activities in the 1980s, including his role as impresario of *Interview* magazine and his involvement with the fashion and celebrity worlds in New York, more and more overtly enacted the specifically queer potential of the dandy. His

equivocal enactment of his body/self was a key component of his confusion of conventional gender/sex codes, especially as these congeal in relation to the artistic subject.

Linked to Duchamp's well-known images of himself as the bourgeois matron Rrose Sélavy in the photographs taken by Man Ray in 1920–21,[53] a series of photographs entitled *Altered Image* taken by Christopher Makos in 1981 exemplifies Warhol's equivocal self-imaging, depicting the artist in various states of drag.[54] Warhol wears one of a selection of wigs—a cute black pageboy, a Farrah-like mane of brown, a blond wave—his coarse, middle-aged face caked with layers of obviously overdone makeup. And yet, even in its more convincing appearances, this theatrically feminized face (an aging doyenne trying to look young?) is contradicted by Warhol's rather conventional, masculine outfit.[55] In almost every case, he sports a conservative white button-down shirt with plaid tie, and blue jeans with a striped belt are sometimes visible—not exactly the typical garb of either the worker-artist or the artist-aristocrat. In a few of the images he is shirtless, his pale, hollow upper chest and wrinkled neck clearly visible.

Ingrid Sischy has remarked provocatively, "I've always thought that in one way or another Warhol was always in a kind of drag"; but Sischy misses the point when she goes on to say that "[h]e was like a chameleon who could move from circumstance to circumstance and always fit in, but still be himself."[56] Warhol's self-performance insists upon the dispersal of the self rather than on its coherence as "Warhol the chameleon" (though it is a paradox of art history and criticism that we always end up writing the latter).[57] The Warhol author function performed for the world, increasingly *visibly* queer in its 1980s manifestations (though his "swish" behavior was in place by the early 1960s), is blatantly antimasculinist; like Duchamp's author function, Warhol's drag persona complicates any attempt to align it with the conventional codes of genius mobilized around artists such as Pollock and Picasso.

Although the worker-artist persona transgresses the boundaries of class to situate the artist as opposed to mainstream bourgeois masculinity, the queered or feminized persona adopted by Warhol (linked back to earlier dandies such as Oscar Wilde and Barbey D'Aurevilly)[58] confuses the borders delineating conventional gender and sex roles. Warhol's challenge to both bourgeois and working-class masculinity and its stylistic closeness to feminine or homosexual self-presentational modes threatens the bases of interpretation built into modernist art history and criticism.[59] Thus, while Pollock can be spoken as performative, Warhol is potentially a far more highly threatening figure in relation to traditional art critical and historical models of artistic subjectivity (even if this potential can be recuperated through reiterative proclamations of Warhol's "genius").[60]

CHRISTOPHER MAKOS, PORTRAIT OF ANDY WARHOL FROM *ALTERED IMAGE* SERIES, 1981. PHOTOGRAPH © CHRISTOPHER MAKOS.

POLLOCK AND THE ALTERNATIVE BUT STILL MODERNIST
WORKER-ARTIST

It is thus not surprising that the worker-artist has become the mainstay of traditional narratives of modern art history from Van Gogh, trundling his canvases dutifully out into the fields, to Jackson Pollock, depicted in the now famous

series of photographs in jeans and T-shirt, straining to fling paint energetically across a wide expanse of canvas. The worker-artist epitomizes—one might even say *embodies*—the very *disembodiment* called for in modernist criticism: it is the worker-artist's veiled virility (his veiled phallus) that both substantiates and de-stabilizes the modernist artistic subject, who, paradoxically, is performed (that is, in process) as fixed in his masculine genius.

The warring descriptions of abstract expressionism by Harold Rosenberg and Clement Greenberg are highly instructive in this regard. For Rosenberg, an earlier Marxist who developed a strong existentialist bent after World War II, abstract expressionism is "action painting"—it is an act of performance within the "arena" of the canvas. As I suggested at the beginning of this chapter, action painting as Rosenberg conceived it had everything to do with the angst-ridden, expressive body of the artist. Invested with personal emotion, this body leaves traces testifying to the integrity and uniqueness of the individual: "At a certain moment the canvas began to appear to one American painter after another as an arena in which to act—rather than as a space in which to reproduce, re-design, analyze, or 'express' an object, actual or imagined. What was to go on the canvas was not a picture but an event."[61] Rosenberg's action painting is about the intrusion of *the body of the artist* at the expense of subject matter, and the act of making a mark through the movement of this body enacts, performs, *makes into representation,* or *indexicalizes* the subjectivity of the artist:

> The apples weren't brushed off the table in order to make room for perfect relations of space and color. They had to go so that nothing would get in the way of the act of painting. . . . A painting that is an act is inseparable from the biography of the artist. The painting itself is a 'moment' in the adulterated mixture of his life. . . . The work, the act, translates the psychologically given into the intentional, into a 'world'—and thus transcends it.[62]

In his exaggerated attention to the artist's physical act of painting, Rosenberg might initially appear to contradict my claim that modernist criticism seeks to veil the body of the artist. And yet, while the body is essential to the act of painting in Rosenberg's formulation, it is also clearly only a rhetorical function—it takes place in his discourse only as a conduit for the pure being of the action painting genius. Rosenberg purged existentialism of the phenomenological insights that complexified the Sartrean notion of individual freedom, which describes a subject (implicitly male), as "condemned" to freedom: both propelling *him*self into the world through a responsible and intentional project of action, and inexorably alienated through the gaze of the other (inexorably,

then, *embodied* [and feminized] as object).[63] Rosenberg's popularized, romanticized version of the (male) artist, a *creative* subject, as the paradigmatic instance of the existentialist subject becomes an apology for the naively celebratory ideology of autonomous individualism that fueled U.S. cold war politics during this period.

It is also notable, in relation to Rosenberg's seeming attention to the body of the artist, that his account of abstract expressionism (except for the powerful image of the painter—clearly Pollock—flinging paint within the arena of the canvas) quickly became subordinated to the definition of the movement offered by Greenberg. Also, while Rosenberg insists upon the centrality of the artist's body in transmitting his "biography" into the indexical loops of paint on his canvas, he never questions the heroic, unified masculinity of this body (which is apparently a transparent vessel through which pure intentionality passes onto the canvas). The importance to abstract expressionism of this ideology of masculinity—and its heroic effects—become clear in Pollock's well-known description of his painting technique:

> My painting does not come from the easel. . . . *I need the resistance of a hard surface.* On the floor I am more at ease, I feel nearer, more a part of the painting, since this way I can walk around it, work from the four sides and literally be *in* the painting. . . . I continue to get further away from the usual painter's tools such as easel, palette, brushes, etc. *I prefer sticks, trowels, knives and dripping fluid paint.*[64]

Pollock's conception of painting as an act of *penetration*, involving the ejaculatory activity of "dripping paint" from sharp, phallic objects onto a "resistant" (but ultimately yielding) surface exposes what is at stake in the particular embodiment of the artist (of Pollock) laid out by Rosenberg.

Finally, Rosenberg's artist—who, paradoxically, appears to have been made transcendent through his embodiment—is never named in the "Action Painting" essay.[65] The artist is thus "embodied," but only in the most abstract and metaphysical sense: the body of the action painting artist is not the particularized enactment of the subject "Pollock" (in our terms, the visible articulation of the author function Pollock) but, rather, is dematerialized into a universalized trope of individualist "freedom." In this way, showing that existentialist phenomenology can be deployed toward ends that are definitively not politically radical (as Sartre would have desired), Rosenberg transforms the alienation of the subject into a guarantee of authenticity through the simultaneous reliance upon and veiling of the tormented body/self of the artist. The veiling of this body enables and entails an erasure of the body's social speci-

ficity (*as* the [author function] Pollock, particularly in his cultural and "indi-vidual" contextualization).

In a later essay—titled, portentously, "The Mythic Act"—Rosenberg specifically references the body and name of Pollock as photographed and recorded in the "mythic act" of painting: "In photographs of the artist at work, he wears an expression of extreme concentration, on occasion almost amount-ing to anguish, and his body is poised in nervous alertness as if he were expect-ing signals from above or behind." While he describes this body, however, he also emphatically, once again, veils it; for Rosenberg it is crucial to describe the heroic, emotionally driven action of the body—in consonance with the activist materialism of existentialism—but simultaneously to stress the way in which the act of painting/the work of art transcends this body:

> With his paint-saturated wand, he will draw lines in the air, letting flecks of color fall on the canvas as traces of his occult gesticula-tions. His consciousness is directed not toward an effect determined by notions of good painting but toward the protraction and intensi-fication of the doing itself, of the current that flows between the artist and his marked-out world and whose pauses, drifts, detours, and tides lift him into 'pure harmony'.
>
> From these apprehensions of presences and energies in nature Pollock passed into union with them through releasing paint in flu-ids that directly record his physical movements.[66]

It is the body of Pollock that, for Rosenberg, both ensures and endangers the transcendence of his art. But, ultimately, this body is fully subsumed into an image of Pollock merged with his painting in a "pure harmony" of disembod-ied creation. Art history's metaphysical narrative of art making as an act of bodily transcendence is thus confirmed.

Greenberg's formulation of Pollock provides a strong contrast to Rosenberg's but ultimately leads to much the same ends. In the account of Greenberg, whose formalist conception of abstract expressionism has become hegemonic and whose philosophical roots are in the works of Marx and Kant (with the latter emerging triumphant and the former slipping more and more into the background in Greenberg's later writings),[67] the body of Pollock is scrupulously suppressed. In its mystified Kantianism, Greenberg's tale of ab-stract expressionism as the triumphant climax of great European modernist painting takes its authority directly from his denial of the body, of subjectivity, of sensuality and desire. In "'American Type' Painting," written in response to Rosenberg, he argues that abstract expressionism is "truly alive" and "vital" be-

cause it works through the medium's "process of self-purification"—a process that, I would argue, entails purging the embodied subjectivity of the artist.[68]

Elsewhere, Greenberg more directly implicates Pollock's body yet effectively veils its role in securing the meaning and value of his works: "Pollock's superiority to his contemporaries in this country lies in his ability to create a genuinely violent and extravagant art without losing stylistic control. His emotion starts out pictorially; *it does not have to be castrated and translated in order to be put into a picture.*"[69] Pollock is the best American artist because his emotion *is pictorial* and *"does not have to be castrated"*: that is, it does not need to be transmitted through a body—a body with a penis that is in danger, if exposed, of being removed—but appears directly on the canvas. (Thus, Greenberg situates Pollock as the natural heir of the impulse of French modernism, arguing that his work "dwells in the lonely jungle of immediate sensations, impulses, and notions.")[70] The implication of the body is itself a castration, for it disempowers the divinely endowed artist of his transcendence. By acknowledging the body, the critic acknowledges *desire* (the artist's, the critic's own); by acknowledging her or his own desire, the critic explodes the mythic disinterestedness that gives modernist criticism its authority.

I have already suggested in psychoanalytic terms that it is crucial for the masculinist critic to avoid unveiling the anatomical masculinity of the artist (that is, the visible attributes of masculinity through which the artist and, by extension, his supporters are given at least provisional or apparent access to the phallus of artistic authority).[71] In philosophical terms, the stakes of maintaining this myth of disinterestedness are embedded in Greenberg's strategic use of Kant's theory of aesthetic judgment, which must, by definition, be "devoid of all interest," since desire marks a judgment as mere liking: "Everyone has to admit that if a judgment about beauty is mingled with the least interest then it is very partial and not a pure judgment of taste."[72] Instantiating the now infamous Enlightenment opposition between mind and body (that opposition most often associated with the thinking of René Descartes), Kant clearly distinguishes between rational, contemplative, disinterested aesthetic judgment and embodied, sensate, interested, contingent, and therefore individualized and nonuniversal judgments. Pure aesthetic judgment ("pure judgments of taste") must not be sparked by interested desire: "Both the agreeable and the good refer to our power of desire and hence carry a liking with them, the agreeable a liking that is conditioned pathologically by stimuli [i.e. is sensate in nature]. . . . A judgment of taste, on the other hand, is merely *contemplative*."[73]

The removal of the desiring, sensate body (of both artist and interpreter) from the project of pure aesthetic judgment is crucial to this absence of

interest and to the requirement of universality implicit to aesthetic judgments of taste, for if the individual, desiring body were implicated in these judgments, they would clearly be "subjective," interested, particular rather than universal. Aesthetic judgment is precisely the mode of logic through which "man" exerts control over the uncodifiable, asserting himself as one whose particular knowledge privileges him as a higher class of being, fit to enlighten the masses. Finally, then, the judgment of taste is contemplative or cognitive rather than influenced by bodily sensations and desires: "a judgment of taste must involve a claim to subjective universality . . . if [he who judges] proclaims something to be beautiful, then he requires the same liking from others; he then judges not just for himself but for everyone."[74] Paradoxically, given the role of vision in such judgments, it is, again, the *sensate body* that must be suppressed or eradicated from the picture in order for the claim of purely disinterested, "universal" aesthetic judgment to function.[75]

Furthermore, Kant's system requires a formalist logic: "A *pure judgment of taste* is one that is not influenced by charm or emotion . . . and whose determining basis is therefore merely the purposiveness of the form."[76] Hence, disembodiment is the necessary corollary of formalism (the paradigmatic contemporary example being Greenberg's model of judgment), which itself follows from a Kantian system of aesthetic judgment. Formalism, the judgment of objects through a disembodied vision and according to supposedly pure relations of form (with the object understood as autonomous from its social, political, personal, and other contexts), both entails and ensures "disinterestedness," which, in turn, confirms the "universal" authority of the judgments of the art historian or critic.

In this way, the removal of content (as opposed to ostensibly pure form, design, composition, or structure) is tied to the removal of the body of the artist as well as the interpreter: both seal the interpreter's claim to disinterestedness, a claim that confirms pure judgments of taste as universal (thus endowing the interpreter with the power to state meanings and values that are supposedly universally true) and indeed inherent to the objects themselves (i.e., translated through the formal structure of the object). It is in this way that Greenberg's Kantianism becomes authoritarian: he assures the reader that his interpretations, which are ostensibly disinterested, are "pure" judgments that merely translate to the reader what the divinely inspired author embedded within the forms of the work of art. The *ideological dimension* of his judgments is always occluded through such a system, which disembodies precisely in order to veil the particularities, biases, and investments of the body/self of the inter-

preter; in particular, the *masculinist* investments of Greenberg's judgments are always efficiently covered over through this system.[77]

The seamless tautology of Greenberg's judgments ensures both Greenberg's authority (as unquestioned arbiter of universal meanings) and Pollock's transcendence (as central yet invisible [disembodied] conduit for these divine messages). The body of Pollock *must be veiled* for this schema to operate: that is, the highly invested masculinity through which Pollock is made to mean as a subject of production and is valued as the best American artist must be naturalized through the effacement of Pollock's "real" (that is, apparently real but always mediated) body. If the potent symbolic body of Pollock (that which informs Greenberg's claims of genius for the artist) were to be exposed as an actual body/self (loosely speaking, the nonrecuperated yet fully mediated, traumatized, weak, often inebriated and obnoxious male body/self of the artist who painstakingly produced the drip paintings), the carefully constructed tautological model of judgment would collapse. The charged *interestedness* of Greenberg's judgment (the implication of interpretive desire in the relation between the interpreter and the artist in/as his work) would be exposed and the authority of the (modernist) art critical project inexorably compromised.[78]

(POLLOCK'S) EQUIVOCAL MASCULINITY

Pollock's normative (if somewhat hyperbolic) masculinity, insistently reiterated by modernist discourse, draws its power from the specific tropes of American manhood codified in the post–World War II period. Anxieties about the dangers of mass culture–induced conformity (also linked to perceptions of the effects of totalitarian regimes such as the USSR) were common in U.S. popular culture and academia at this time; conformity, or what Greenberg himself in 1947 termed the "levelling out and rationalization of culture," was viewed as a threat to American individualism as well as to American masculinity, with its claims of original, transcendent, coherent subjectivity. While the quintessential historical example of the mass-oriented man was surely to be found in the very recent history of Nazi Germany, Americans refigured this anxiety to fit what they perceived to be the rising threat of Soviet communism and consumer culture and a general "crisis in masculinity."[79]

Anxieties about the feminization of the American male were increasingly frequently voiced and illustrated on all levels of American culture from the end of the war onward. Thus, Greenberg links his disdain for the vulgarities of "mass taste" in the 1947 article directly to mass culture audiences he specifies as particularly female.[80] And, as I noted in chapter one, David Riesman, in his best-selling sociological study *The Lonely Crowd: The Changing American Character*

J. ROBERT MOSKIN, "THE AMERICAN MALE: WHY DO WOMEN DOMINATE HIM?," *LOOK* MAGAZINE, FEBRUARY 4, 1958.

(1950), argues that the mass-oriented, "outer-directed" postwar man is enfeebled (one might argue *emasculated*) in his dependence on others—including and especially women—for cues regarding proper bourgeois tastes and behaviors.[81] Mass culture breeds a conformity whose danger Riesman calculates in terms of its threat to American masculinity.

These anxieties increase as the 1950s progress and, by 1958, two companion articles in *Look* magazine—entitled "The American Male: Why Do Women Dominate Him?" and "The American Male: Why Is He Afraid to Be Different?"—dramatically surface the perceived threat to American masculinity.[82] J. Robert Moskin, author of "Why Do WOMEN Dominate Him?" (the offending term in all capitals on the opening spread of the article), states definitively that "since the end of World War II [the American male] . . . has changed radically and dangerously; . . . he is no longer the masculine, strong-minded man who pioneered the continent and built America's greatness."[83] In Moskin's terms: "How did the American male get into this pit of subjection, where even his masculinity is in doubt?"[84] Who is to blame for this horrifying condition? Clearly, the American female, whose overbearing mothering, short haircuts and blue jeans, voracious appetite for sex, and "extraordinary and often frustrating economic demands on her husband" have deprived him of his virility. To make the point absolutely clear, the article opens with a full-page image of a woman holding the strings on a helpless male "puppet" who appears to be signing a

check (and is totally constrained in what, probably inadvertently, looks to be erotic bondage).

The second article, written by George B. Leonard Jr., and illustrated with a string of identical paper dolls, commences with the following anecdote (tinged, as Barbara Ehrenreich has pointed out, with an "ominous"—[perhaps Rosenbergian?]—mixture of existentialism and anticommunism): "One dark morning this winter, Gary Gray awakened and realized he had forgotten how to say the word 'I' . . . He had lost his individuality. In the free and democratic United States of America, he had been subtly rooked of a heritage that Communist countries deny by force."[85] Echoing the terror of Kafka's *Metamorphosis*, in which the individual (even with his traumatic transformation into a large insect) is completely invisible in relation to the corporate machine, here "Gary Gray" reflects on the "faceless authority" of contemporary urban life which sucks away at his insides, sapping him of individuality. While Gary's wife, Martha, is not blamed for this condition, her individuality is never discussed or questioned; it is Gary who is emasculated by what Leonard calls the mentality of "The Group" (including corporations and, oddly enough, psychologists).

Within this historical framework, it is compelling to think that Pollock's suffering—his angst, his acts of physical excess, and the increasingly excessive emotional labor supposedly required to complete the monumental drip paintings—is articulated (perhaps by Pollock himself as much as by his supporters) as a corrective to this passivity and loss of individuality in American masculinity. Hence Rosenberg's earlier description of Pollock as transcendently laboring: "His consciousness is directed not toward an effect determined by notions of good painting but toward the protraction and intensification of the doing itself, of the current that flows between the artist and his marked-out world and whose pauses, drifts, detours, and tides lift him into 'pure harmony.'" Or Alfred Barr's description of abstract expressionist painting as a reformulation of Descartes's centered individual: "Many feel that their painting is a stubborn, difficult, even desperate effort to discover the 'self' or 'reality,' an effort to which the whole personality should be recklessly committed: I paint, therefore I am." Or Pollock's self-projection into the "I" of individualism in his infamous claim that "I am nature."[86] All of these heroic "I"s work to counteract Gary Gray's terrified realization that he has "forgotten how to say the word 'I.'"

Pollock's "I am nature," however, does not simply project him into the transcendence of the eye/I of masculine artistic authority (and out of the conformist "outer-directedness" endemic of commodity culture), since he paradoxically enunciates his "I" *as nature*, and thus, in conventional terms, as Mother Earth. In Luce Irigaray's terms, Pollock's statement enacts the very process by

which male subjects attempt to transcend otherness (attempt to be the "sun" to woman's nature, earth, or immanence). This process is paradoxical in that, through the very enunciation of superiority, transcendence, and independence, the male subject inevitably reinscribes the interdependency of the sun on the earth (which gives its life force meaning and value):

> [B]y wishing to reverse the anguish of being imprisoned within the other, of being placed inside the other, by making the very place and space of being his own, he becomes a prisoner of effects of symmetry that know no limit. Everywhere he runs into the walls of his palace of mirrors, the floor of which is in any case beginning to crack and break up. This in turn serves, of course, to sublate his activity, leading him to new tasks which for a time will distract him again from his specular imprisonment.[87]

The legends of Pollock's final, hysterical fall into immanence (his emotional "crash" after Hans Namuth filmed him late in the summer of 1950 for the movie *Jackson Pollock*) describe him descending into alcoholism, exposing himself and pissing in public (what could be a more direct expression of his "immanence" than such a literal unveiling of a "phallus" that pisses rather than sprays ejaculate?).[88] Crouching above a sheet of glass to paint for Namuth's camera hovering below, Pollock, in Andrew Perchuk's words, "became self-conscious that the tremendous strain was not directed toward producing authenticity but a masquerade [of masculinity]." At this point, he "saw himself as a performer" and all of the ejaculatory effects of his process of painting "became histrionics."[89] In Irigaray's terms, Pollock's immanence (his reciprocal intertwining with the other), formerly transformed into transcendence through his "action painting," could not at this point overcome his "specular imprisonment" in the eye/I of the other (metaphorized here through Namuth's camera shooting through the glass).[90] The attempted transformation of a threatened American masculinity through the display of a hypermasculinized Pollock had, in these terms, failed (only to be swiftly recuperated by art history's mechanisms of hero worship, which thrive on such histrionic dramas of the individual's ultimate emotional depletion [*viz.* Van Gogh]).

Pollock's hysterical self-performance, his contingency on the representational capacity of Namuth's photographic eye/I, made it all the more crucial that the embodied aspect of Pollock's "self," as well as its interpretive dimensions (the role of interpretation in determining its various cultural values), be occluded.[91] As we have seen, dominant accounts of abstract expressionism worked from the premise that the (divinely inspired) selfhood of the artist

was in some way *represented* or *expressed* in the tortured structures of his abstracted forms, his corporeal immanence transcended through creative activity (in Irigaray's terms, "sublated").[92] The artist's subject matter was now seen to be derived entirely from within (from his disembodied "soul"?), such that painting came to be seen as an unmediated expression of pure intentionality, of the true "self" of the artist (the meaning of which, of course, could only be discerned by the putatively disembodied and disinterested eye/I of the trained art critic or historian). Thus, Jackson Pollock asserted: "The thing that interests me is that today painters do not have to go to a subject matter outside of themselves. . . . They work from within."[93]

Furthermore, as art historian Michael Leja has argued, the conception of self driving these artists and their supporters was informed by a historically specific model of alienation, linked conceptually to the unknowability of the subconscious. While, again, Pollock's body had to be both present (available for projected fantasies) and absent (veiled), the *embodied* self available to public view—in Pollock's case a brutish, cowboylike persona—was often at odds with the fantasized subconscious Pollock, divinely inspired, interior, yet capable of transcendence. This formulation led to the assumption of a rather contradictory notion of the artistic subject as simultaneously pure cogito (pure creative thought) and, per the influential model of surrealism, disembodied subconscious. This pure thought and/or automatic and direct expression of the unconscious were both seen to be "illustrated" in the charged, abstract forms of action painting.[94] And the "pure" forms of the painting were understood as indexical traces of divinely inspired artistic subjectivity. It is crucial to stress the "divine" aspect of this subjectivity since it is its assumed inspiration from God (its Cartesian transcendence of the human body through pure thought/creation, here paradoxically filtered through the unconscious) that legitimates the special nature of the artist as subject and, in Kantian terms, raises his works above the mere sensual enjoyments of the domestic arts or crafts (not coincidentally, modes of production usually associated with nonmale, nonwhite subjects).

Pollock's portrayal and self-performance as macho worker-artist operated specifically within U.S. culture (with its anxiety about art making as itself an effeminate activity)[95] to differentiate him both from the effete, Europeanized aesthete (Duchamp?) and the conformist middle-class (feminized) subject. But, at the same time, as Pollock was being spoken of as quintessentially masculine and modernist, his "nonconformist" masculinity was always already compromised. Thus, Leja's observations return us to Irigaray's feminist critique of the Western logic of subjectivity, where the subject (who is, by definition, male) projects himself outward into identification with the divine (the "sun")

in order to claim transcendence (his existential freedom from immanence). Yet, as noted, it is precisely the insistent *representation* of Pollock's body in sites such as *Life* magazine and through Hans Namuth's films and photographs that (as Perchuk argues Pollock himself recognized) dissolved Pollock's transcendent masculinity even as it was being visually and textually constructed (in Irigaray's terms, confirming his "specular imprisonment" in his own image). The photographic and cinematic staging of Pollock *as* masculine genius paradoxically aligns him psychically with the unveiled, "phallus"-less body of the immanent female; it also aligns his body/self (his imaged author function) with the bodies of the masses represented in the portraits churned out by the photographic portrait industry and, in the case of the *Life* story, directly with the bodies of women used to sell products in the advertisement-laced venues of popular culture.

This paradox is highlighted by comparing Pollock to popular culture "rebel hero" figures of the time, such as James Dean and Marlon Brando, whose nonconformist hypermasculinity was manufactured and marketed by Hollywood. The artist George Segal's reading of Namuth's photographs of Pollock immediately invokes this trope:

> I had an image of Marlon Brando's brooding pouting profile looking down while Stella ripped his tee-shirt from his sloping shoulders with gouging fingernails. But Pollock's creased forehead in his photographs intrigued me. He had the agonized look of a man wrestling with himself in a game of unnameable but very high stakes. I was reeling under a barrage of words when I first saw Pollock's paintings. The words said, You can't talk about me. You can't explain art.[96]

And yet, as feminist ethnographer Gayle Rubin has argued, this leather-clad hypermasculine figure of action and few words was almost immediately appropriated by underground gay male subcultures in the 1950s. According to Rubin's study, urban gay men adopted the vestimentary tropes of conventional working-class masculinity purveyed through Hollywood representations (especially Brando's leather-clad rebel in *The Wild One*) in order to differentiate themselves from the mainstream stereotype of gay men as effeminate by performing a new, perhaps more empowered, gay male subject.[97] Thus, ironically, the artistic subjectivity of Pollock, which Greenberg, Rosenberg, and Namuth labored to fix within the (visible/invisible) tropes of a seemingly secure heterosexual masculinity, hovers always in the realm of the feminine and/or the queer, marking the artist as an open-ended self/other (author function) through which the interpreter negotiates and articulates personal and collective desires.

POLLOCK AS PERFORMATIVE

As a performative and discursively defined artistic subject (or author function), then, Pollock is multiple. Within the codes established in relation to his self "performance" by Greenberg, Rosenberg, Namuth, and other contemporaries, Pollock is a richly contradictory figure, both quintessential, even exaggerated, male modernist (disembodied in creation) and commodified, excessively displayed, and fully embodied site of art interpretive desires—as Kaprow argued, he opens the circuits of audience involvement such that "[t]he artist, the spectator and the outer world are much too interchangeably involved here." Pollock confirms Greenberg's tautological (supposedly disinterested and emphatically disembodied) interpretations of abstract expressionist painting as the apotheosis of modernism's self-containment and autonomy from the world of politics and sociality. At the same time, the veiled body of the Greenbergian Pollock becomes the "origin" of the performance art practices developed in the late 1950s and 1960s. Pollock, then, exemplifies the way in which certain elements of modernism can be made to figure (often as "originary") within a postmodern narrative of artistic meaning.

One way to look at this conjunction of issues is through the question of indexicality, which Pollock's practice insistently raises. Richard Shiff has deployed the notion of indexicality in attempting to differentiate previous modernist painting from abstract expressionism (comparing contesting definitions by Clement Greenberg and Leo Steinberg):

> [W]hen Manet painted, he and his viewers conceived of (and saw) a surface that could picture an external world of appearances even as it became the ground on which the performance of the artist was acted out, leaving its traces; whereas, for Pollock and his audience performance became so central that there was little concern for the representation of appearances. This is not to say that a painting by Pollock would be valued only for its effect as an event, that it would be a free happening and not an organized picture. Rather it is to indicate that performance itself would be pictured; performance, as opposed to appearance, would *appear* as represented in an Abstract Expressionist picture. On a certain level, such art thus remains a matter of appearance, of mere representation, of one thing indicating something it cannot be.[98]

Pollock, then, in this sense marks a transition between the iconicity still prioritized by nineteenth-century modernist painters and what one might call the pure indexicality of performance art (itself always already corrupted by

performance art's reliance on photographic and filmic documentation, which turn it back into a dual icon/index).[99] While Manet's painting, as Shiff points out, is necessarily structured through the indexical trace of his brush stroke (which confirms his having "performed" the act of painting), the emphasis is on iconicity (the "story" that it tells); or, perhaps more accurately, with due respect to the generations of formalist critics who have privileged the radical breakdown of the picture surface argued to have been initiated by Manet, his painting works in the tension between iconicity and indexicality. Pollock's drip paintings, conversely, fall clearly on the side of indexicality: the gestural loops of paint first and foremost tell the "story" of Pollock's body in action. But they are still insistently iconic: they still narrate a previous temporal action after all; they *represent* and insist on being, in Shiff's terms, "organized pictures."

As I will explore here, those body artists who produced performances in response to Pollock's drip-painting persona—such as Happenings artist Allan Kaprow, Yves Klein, the Japanese Gutai group, and Georges Mathieu—exacerbate the indexicality of the Pollockian act of painting to the point where iconicity threatens to dissolve or self-implode. Most notably, these indexical moments destroy the promise of legibility and singular meaning afforded by the seeming stability of the jointly iconic/indexical system of signs that is the conventional work of art (in this case, painting). If we could imagine these performances existing without textual, oral, or visual documentation (which, of course, would make it impossible for them to function discursively and historically), then we could imagine an indexicality so pure it would no longer be indexicality: where the body in action simply "is" what it presents and there is no trace left over.

But, as I explored earlier, phenomenology and psychoanalysis tell us that this idea of pure indexicality is a myth. The drive to achieve pure indexicality is strong, however, and has certainly informed artists' attraction to performance and body art (an attraction that, among other things, was often motivated by the desire to move outside of the commodity system, where the traces of the artist's actions are marketed and, thus, presumably debased through the evacuation of their indexical "authenticity"). As Shiff argues in relation to Pollock, "[t]he modernist sees himself as struggling to regain his culture's lost indexicality in a world formed by such excessive iconicity. He desires to recapture an authentic sense of self and individual act, to intensify the here and the now."[100]

By the 1960s, working in a context inflected by the ideas of John Cage and Merce Cunningham and by the radical experiments of the Living Theater and the Judson Dance Theater, artists began to perform works before and among

audiences, as if yearning to stress the materiality and authenticity of the body even more directly than Pollock by obviating the final work of art (that set of reified signs that serves to veil the body of the artist and mystify the mode of production). In works performed by the Judson group, for example, the body became a means of democratizing art production. Through embodied performances, the performers ostensibly removed the mediating factors of art market and interpretive structure: the body as "pure index," it seemed, could purvey the artist's intentional meanings *directly* to the viewer, who became a participant in the performance rather than a passive observer to be instructed by the modernist critic.[101]

This participatory dimension of performance was expanded by Allan Kaprow in his conception of the "interchangeabl[e] . . . involve[ment]" of artist, spectator, and outer world through Pollock's performativity. For Kaprow, in his essay "The Legacy of Jackson Pollock," Pollock enables an initiation of a new, indexical rather than iconic approach to making art; he describes Pollock's practice in precisely the terms of intersubjectivity that I have argued to be constitutive of the performative body art work. Here and in his important early history of performance and related installation and conceptual works, *Assemblage, Environments, Happenings,* Kaprow claims Pollock for what I am identifying as a postmodernist conception of artistic subjectivity. Thus, at the beginning of the book, following a series of photographs of Happenings, an image of Pollock surrounded by his drip paintings serves to illustrate the origins of what will become performance and body art. This claustrophobic picture, which merges Pollock with his work (Pollock leans broodingly over one painting on the floor with another pressing in behind him), is labeled "Little Man in Big Sea / Environmental Painting."[102]

Kaprow's use of photographic images of Pollock in his articulation of a narrative history for what I am calling postmodern body art exposes the contradiction embedded in the desire for pure indexicality. For it is only through the *illustration* of this supposed immediacy of indexicality (that is, through the *mediation* of Pollock as artist/imprint) that Kaprow can communicate Pollock's importance for Happenings and other performance works. Art historically, we can only ever experience performance (or, in this case, Pollock's flinging of the supposedly pure, indexical trace) as thoroughly mediated—through photographic reproductions and textual descriptions as well as the painterly mark itself (which, after all, is also culturally overdetermined in its material as well as psychological effects). It is all of these mediating factors that enact the author function Pollock for history—for younger generations of artists as well as art historians and critics. In turn, younger artists (from Kaprow to Yves Klein and

beyond) enact new versions of the "Pollockian performative," often comment-ing ironically on the paradox of the desire for pure indexicality and emphati-cally unhinging the particular exclusions built into the mythic figure of genius Pollock came to represent.

THE POLLOCKIAN PERFORMATIVE SUBJECT ON AN INTERNATIONAL STAGE: KLEIN, MATHIEU, GUTAI

If the traces of performativity can be found laced throughout the modernist period (if we can speak of modernist artists such as Pollock as performative), then what differentiates modernist performativity from postmodernist? A look at a number of artistic projects that specifically interrogate and extend or exag-gerate the Pollockian performative gives a sense of what is at stake in what I ar-ticulate as a "postmodern" mode of performing the modernist artistic subject. In general, the postmodern performative (and its correlative practice, body art) might be said to be characterized by what I engage as a consciousness of the self as *intersubjective* (performed or enacted in relation to others), and of the self as *particularized* such that the "universality" presumed to be expressed through the privileged body/self of Pollock is dismantled. Primarily, the assumed *masculinity* of this subject (which is implicitly aligned in Western culture with whiteness, heterosexuality, and an ambivalent antibourgeois positionality) is opened up through a recontextualization of this subject via the (*unveiled*) artis-tic body itself.

An early and particularly charged case of this extension of the Pollock-ian performative is that of Yves Klein, who, like Duchamp, provides an interest-ing, and from the point of view of the Americanized model of artistic mas-culinity afforded by Pollock, especially complex negotiation.[103] In the famous *Anthropometries* performance at the Galérie internationale d'art contemporaine in 1960, at which he instructed several nude women to cover their bodies with paint and lay them, like live brushes, across sheets of paper laid across the floor, Klein directly negotiated the Pollockian trope of the ejaculatory genius flinging paint aggressively onto the "resistant," horizontal plane of the canvas. In the *Anthropometries*, Klein replaced Pollock's brushes with women's bodies, Pollock's house paint with patented "YKB" (Yves Klein Blue) paint, Pollock's supposedly solitary studio (with only Namuth present to document!) with a gallery full of well-dressed spectators, the silence of Pollock's photographic performance with a string orchestra playing Klein's "Monotone Symphony," Pollock's workers' garb with aristocratic tuxedo and white tie.[104]

Klein thus dramatically shifted the terms of the Pollockian performa-tive toward the overtly theatrical, the aristocratic, the ironic.[105] At the same

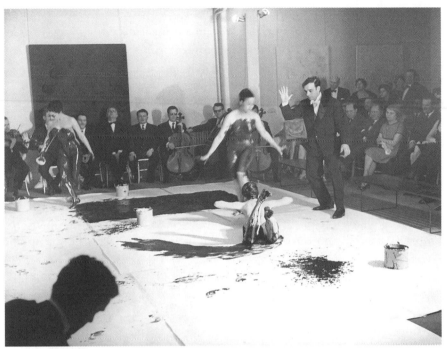

YVES KLEIN DIRECTING *ANTHROPOMETRIES OF THE BLUE PERIOD*, GALÉRIE
INTERNATIONALE D'ART CONTEMPORAINE, 1960. PHOTOGRAPH BY HARRY SHUNK.

time, like any number of subsequent artists, Klein (with his *Anthropometries*
series) insisted upon the *act of painting and viewing as constitutive of the piece itself:* the
best-known photographs documenting the 1960 performance include his well-
dressed audience, lips pursed or gaping in dismay. While the photographs and
descriptions of Pollock largely use his display as a means of confirming his
angst-ridden subjectivity at the origin of his works' meaning and value, Klein's
work opens up the processual aspect of making and viewing art (with the
engagement of spectatorial desire as part of the experience and meaning of the
work). In so doing, whether consciously or not, Klein begins to open the (male)
body of the artist to the destabilizing effects of interpretive "interestedness."

At the same time, Klein's aristocratic exaggeration of masculinity, which
responds to the dominance of U.S. postwar art, including Pollock, on the con-
temporary scene, is equally ambivalent. Drawing on well-established historical
tropes of artistic genius, Klein seemingly could not resist attempting to gain
access to the prerogatives naturally given to the male artist in Western society
(an especially fraught venture for a French male artist working in the face of
France's loss of cultural hegemony to the United States after World War II).
The son of two painters (his mother quite successful after World War II), Klein

took most of his brief life of thirty-four years to decide he was an artist, only doing so after careers pursuing Rosicrucian spiritualism, through the writings of Max Heindel, and practicing judo professionally.[106] Once decided, Klein adopted Delacroix (the quintessential dandy, per Charles Baudelaire)[107] and Van Gogh (prototypical worker artist) as models, employing their romanticized personae and conceptions of artistic creativity to shift the transcendent spiritualism of his religious training as a Rosicrucian and his extensive judo expertise into modernism's more practical spiritualism of artistic genius.[108] And yet Klein's reiteration of genius was revisionist in that it confused the terms established in discourses privileging U.S. postwar art as the heir to European modernism. Klein merged seemingly incompatible modes of artistic subjectivity: the labored spiritual intensity reminiscent of Van Gogh and Pollock[109] and the ironic, distanced, and cerebral attitude we now associate with Duchamp and Warhol (and postmodernism).

As is typical of the work I am calling body art, Klein's body was central to the action of the piece, as he directed several women to cover themselves with YKB colored paint and to stain canvases with their paint-smeared bodies.[110] And yet, as overtly dandified as Klein's formally dressed body was, the photographs of the event show that he effectively *veiled* it behind the classic— and, within patriarchal culture, more readily visible—trope of modernist painting, the naked female form. He kept himself clean, hovering among the women to direct their movements and in fact exaggerated this "veiling" as part of his own access to cultural privilege (as a European male artist in the postwar period).[111] As Klein himself wrote of this event:

> At my direction, the flesh itself applied the color to the surface, and with perfect exactness. I could continue to maintain a precise distance from my creation and still dominate its execution. In this way, I stayed clean. I no longer dirtied myself with color, not even the tips of my fingers. The work finished itself there in front of me with the complete collaboration of the model. And I could salute its birth into the tangible world in a fitting manner, in evening dress.[112]

Klein's adoption of formal dress served to distinguish him from the highly invested emotionalism of 1950s abstract painting and to ironicize the notion of the painter as worker/genius. While his *Anthropometries* images, like Pollock's paintings, were produced by the application of paint onto a canvas that was usually laid on the floor, Klein, in fact, was explicit about his desire to differentiate himself from the action painters: "I would like to make it clear

that this [*Anthropometries*] endeavor is opposed to 'action painting' in that I am actually completely detached from the physical work during its creation."[113] Klein thus opposed himself definitively to the Pollockian worker-artist model, separating himself from the physical act of painting, with its ooze and sweat (Klein remarked, "I would rather put on my tuxedo and wear white gloves . . . [than dirty] my hands with paint").[114] In this light, the *Anthropometries* performances seem to have been parodic assaults on the by then internationally celebrated and reified figures of Pollock and Willem de Kooning, the latter of whose paintings directly integrated the abstract expressionist brush stroke with the objectified female body central to modernist practice.

Klein's self-performances are equivocal reiterations of the norms of masculine genius set forth in the author function Pollock. In Judith Butler's terms, the mode of bodily construction through which subjects are identified and identify themselves in terms of gender and other particularities is "a temporal process which operates through the reiteration of norms." Sex, Butler concludes, "is both produced and destabilized in the course of this reiteration."[115] While the dominant discourses constituting the author function Pollock have largely been reiterated so as to *produce* the norm of a revitalized postwar U.S. masculinity, Klein's reiteration of the norm of postwar masculinity (filtered through Pollock's U.S. example but articulated via French conventions) is, especially from a U.S. point of view, more ambiguous—both productive and destabilizing of this norm. More like Warhol or Duchamp than Pollock, then, Klein's self-performance points to the male artistic genius as a construct while still getting mileage out of it. The extent to which the gesture of reiteration is or was "critical" depends on one's point of view and on how the gesture is and was contextualized (that is, in comparison with some of the radical feminist body art of the 1970s, Klein looks inescapably reactionary, especially with his exploitation of nameless nude women and his production and marketing of pictures documenting his actions but in the context of Pollock and 1950s art discourse, he appears self-knowingly parodic, radically dislocating).[116]

Klein, with his reformulation of the Pollockian performative, was in close dialogue with the somewhat older French abstract painter Georges Mathieu, one of the primary promoters of a Rosenbergian model of Pollock on the Parisian art scene in the 1950s. Mathieu forms a sort of bridge between the veiled performativity of Pollock and the flamboyant performativity of Klein: he created large-scale paintings in public performances yet he was and continues to be known almost exclusively in relation to these "organized pictures" (while Klein is most notorious for the performances, known through their photographic documentation). Nan Rosenthal has noted that Klein's response to

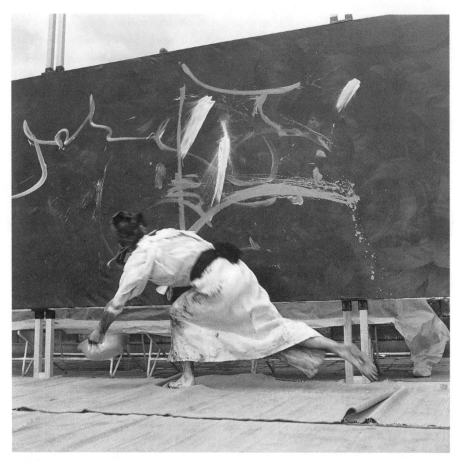

GEORGES MATHIEU DRESSED IN A KIMONO DEMONSTRATING ACTION PAINTING,
DAIMARU DEPARTMENT STORE, OSAKA, 1957. PHOTOGRAPH COURTESY ASHIYA CITY
MUSEUM OF ART AND HISTORY, JAPAN.

Pollock was filtered through Mathieu, himself a kind of father figure in Paris among younger artists such as Klein, and that Klein's generation of artists in Paris were well aware not only of the *Life* article on Pollock, but also of Hans Namuth's portraits of Pollock painting.[117]

 Mathieu (who traveled to Japan in 1957 to "perform" his paintings) and the documentation surrounding Pollock provide yet another conceptual bridge—to the Japanese Gutai ("concreteness")[118] group, founded by Jiro Yoshihara, a well-known oil painter in Japan, and a group of students in 1954. Gutai, initiated by Yoshihara as a way of breaking out of the boundaries of entrenched European-style academic art by using unconventional materials and modes of expression, was appropriated into French attempts to negotiate Pollock's larger-

than-life mythology of performativity.[119] Thus, Yoshihara argued for an art that would draw on Japanese traditional arts such as Zen calligraphy and promote a new attitude toward the nature of material (an attitude that, on the surface, seems strikingly close to Klein's borrowed Zen and Rosicrucian spiritualism). In his "Gutai Art Manifesto" of 1956 Yoshihara proclaimed: "Gutai does not alter the material. Gutai imparts life to the material. . . . [T]he human spirit and the material shake hands with each other, but keep their distance."[120] Gutai works ranged from elaborate, mechanized installations (such as Kanayama's remote-control painting of around 1957)[121] to paintings that resulted from various actions to the actions themselves.

As initially conceived, then, Gutai was not a response specifically to Pollock or Western art; nor was it limited to performances. However, as historian Alexandra Munroe has pointed out, for Yoshihara, in his search for alternative models of artistic production (as freeing rather than constrained by bureaucratic regulations), Jackson Pollock "provided the catalyst" to overcome the inertia of the postwar Japanese art scene. In his manifesto, Yoshihara specifically praised Pollock's drip paintings in terms of "the scream of the material itself, cries of the paint and enamel."[122] Pollock's works were first shown in Japan in the international section of the 1951 *Third Yomiuri Independent Exhibition*, and Namuth's images of him painting were broadly circulated through the *Art News* issue and other venues. Encouraged by visiting figures such as Mathieu and, also in 1957, French critic Michel Tapié, Gutai artists began to expand their "action events," which, in Munroe's terms, promoted their own form of "'action painting' as an explosive rite to stomp out the dark orthodoxies of prewar Imperial Japanese culture and usher in the liberal American-style 'democracy'."[123] By 1958, Gutai had been effectively internationalized both within and outside of Japan: a 1958 exhibition in Osaka, *The International Art of a New Era:* Informel *and Gutai,* included works by Pollock, by several of the French *Informel* artists supported by Tapié, and by Gutai artists, and Gutai's *Sixth Gutai Art Exhibition* took place that same year at the Martha Jackson Gallery in New York.

One historical essay on the group, by Osaki Shinichiro, explores as it also heightens the problematic link (especially within Western art history) between Pollock and this specifically Japanese exploration of Western artmaking through action. Shinichiro begins his essay by citing William Rubin's statement about Jackson Pollock: "Myths are easier to grasp than new and original abstract art."[124] At the same time, stressing the temporal and theatrical aspects of Gutai as well as the "violent physicality involved in Gutai works," Shinichiro rereads Pollock, much as Kaprow did, enunciating him within the performative dimension of Gutai: "Action Painting . . . deals far more with the problem of

the time element during which the painting is being made than with the form of the final product. This is true of the great action paintings of both Gutai, Pollock and all of their contemporaries."[125]

Perhaps even more effectively than Klein, Gutai artists such as Shozo Shimamoto and Kazuo Shiraga literally *threw* into relief the heroized action painting artist figure epitomized by Pollock (as experienced primarily, it is worth remembering, through still photographs in *Life* and art magazines). Shimamoto's violent performance of the act of painting, where he hurled bottles of paint onto paper, and Shiraga's act of painting with his feet, both executed at the Second Gutai Art Exhibition held at the Ohara Kaikan hall in Tokyo in 1956, dramatize the histrionic physicality that we associate with Rosenberg's celebration of Pollock.[126] And yet, while the Shiraga piece suggests an antimasculinist approach to painting (as dancing), Shimamoto's aggressive hurling of paint at the canvas certainly has, at least for Western eyes, a heroically masculine cast. Public statements made by the group suggest a strong adherence to conceptions of originality that align with Western modernism; in the issue of *Gutai* magazine covering the first Gutai exhibition, Yoshihara states: "We do have esteem for originality and revelation."[127]

Both Klein and the artists in the Gutai group struggled to articulate a new mode of artistic expression in the face of rising U.S. dominance (while France had, nominally, "won" the war, it experienced a deflating loss of cultural hegemony; Japan had lost to the United States). Both Klein and the Gutai artists constructed themselves performatively in relation to the then dominant Pollockian model of artistic genius—and thus confirmed the centrality of this model on the international scene as well as its relevance to the articulation of a more self-critical and open-ended mode of artistic subjectivity.

THE POLLOCKIAN PERFORMATIVE FEMINIZED AND HOMOSEXUALIZED

Other artists, too, negotiated the photographically and cinematically rendered Pollockian performative in the 1960s and 1970s. These alternative projections of self suggest that Greenberg's disembodied Pollock was gradually replaced with the performative Pollock of Kaprow and beyond such that, by around 1970, the artistic body-in-performance became absolutely central to artistic practice. Even in the discipline of art history, it is rare to find an unquestioning acceptance of the heroic conception of Pollock that was initially formulated in the 1950s (although the Pollock biography industry is still chugging along, reiterating a largely unquestioned, heroic "Pollock" for a less specialized public).[128]

A number of artists have executed body-oriented projects that explic-

SHOZO SHIMAMOTO MAKING A PAINTING BY THROWING BOTTLES OF PAINT, SECOND
GUTAI ART EXHIBITION, OHARA KAIKAN HALL, TOKYO, 1956. PHOTOGRAPH COURTESY
OF THE ARTIST.

itly reference the trope of Pollock painting first introduced in the early 1950s. In
particular, artists who have a stake in interrogating the aggressive *masculinism* of
Pollock (again, with the whiteness, heterosexuality, and class implications at-
tached to this privileged subject position in modernism) have produced power-
ful body art projects that reiterate the histrionic model of Pollock painting
through nonnormative artistic bodies that unhinge the values associated with
the author function Pollock. With the Gutai group, the presentation of non-
Western (and in the case of Atsuko Tanaka and Tsuruko Yamasaki, female)[129]
bodies within the "Pollockian performative" mode served (at least when viewed
by Westerners) to dislocate the "reiteration" of the codes of masculine genius
by denaturalizing the bodies to which these are conventionally attached. It is

perhaps for this reason that while Gutai was introduced to the United States in the mid 1950s, it has never been written into histories of contemporary art.[130] In a similar fashion, with women artists such as Niki de Saint Phalle and Lynda Benglis, and, more recently, queer artists such as Keith Boadwee, the reiteration of the image of Pollock painting, known largely through Namuth's photographs, becomes a dislocating rather than a confirmatory act.

Niki de Saint Phalle's *Tir* (shooting) performances of the early 1960s can be read as much in relation to Shimamoto, with his violent act of throwing paint, as in relation to Pollock.[131] The photographs documenting her *Tirs* of 1961, made by her own avowal in the context of her work among the Nouveaux Réalistes (of which Klein was the most visible member until his death in 1961), show the artist aiming and shooting at a lumpy surface (the lumps being sacks or bags of pigment, as well as objects such as dolls, shoes, and toy cars) with a rifle.[132] The violence of the bullets ripping through the surface of the painting caused the captured paint to break free, dripping down like blood across the ornate frame. The final image shows Saint Phalle standing proudly and nonchalantly, arms crossed, in front of the "painting," an "alternative to action painting" that removes the connection between the artist's arm and the traces of paint entirely (except in the once-removed sense of the arm and finger launching the bullet that causes the liquid to explode and run).[133] The existential, heroic aspect of the gesture is definitively removed in this performance that results in a violated surface and an uncontrolled mess of color.

The intensity with which Saint Phalle and Klein, among other Europeans, grappled with, mimicked, parodied, and assaulted Pollock's legacy is testament to, among other things, the centrality of American art on the international Western cultural scene (and, in broader terms, the U.S. hegemony politically and socially in the Western world and beyond). Lynda Benglis's relationship to Pollock, expressed in a series of photographs taken ten years after Klein's *Anthropometries*, typifies a newly feminist and highly parodic view of the "old master" on the U.S. art scene, where Pollock was still the dominant market force to be reckoned with. Mimicking Pollock's construction by Namuth as ejaculatory worker-artist twenty years earlier, Benglis was photographed making her work by Henry Grosinsky; these photographs were published in conjunction with an article by David Bourdon entitled "Fling, Dribble and Dip" in *Life* magazine in 1970 (marking the popular cultural recognition of the ascendency of women artists at that time).[134] This *Life* story provides a third link in the Duchamp/Pollock axis of popular conceptions of artistic genius, indicating that, by as early as 1970, the popular consciousness was becoming more open to

Le Tir

Il y a des idées qui donnent des émotions.
Mon "tir était une émotion qui a provoqué
une idée. Alors ma rage est devenue un rite
mortuaire sans victimes.

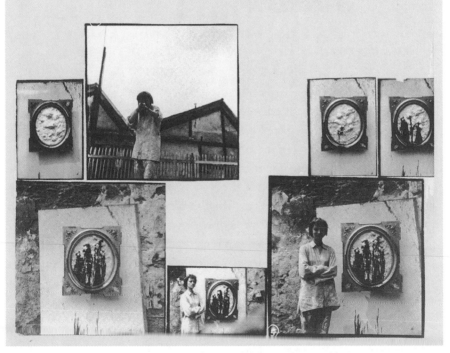

NIKI DE SAINT PHALLE PERFORMING A *TIR* (SHOOT) PIECE, C. 1961. FROM *NIKI DE SAINT PHALLE,* RETROSPECTIVE EXHIBITION CATALOG, CENTRE GEORGES POMPIDOU, MUSÉE NATIONAL D'ART MODERNE, PARIS, 1980. PHOTOGRAPH COURTESY OF HARRY SHUNK.

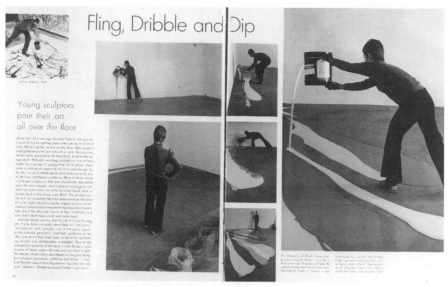

DAVID BOURDON, "FLING, DRIBBLE AND DIP," *LIFE* MAGAZINE, FEBRUARY 27, 1970.
PHOTOGRAPH BY HENRY GROSINSKY, © TIME INC., REPRINTED BY PERMISSION.

the concept not only of an artist nonnormative in terms of U.S. masculinity (Japanese, French), but of an artist who was female.

Benglis, who is depicted pouring synthetically colored pools of latex onto the floor (she hovers within her "painting" as if it is an "arena in which to act"), is clearly mimicking Namuth's Pollock (the article, in fact, juxtaposes the photographs of Benglis with one of the early photographs of Pollock flinging paint onto the canvas). As with Klein, Benglis's parody of or homage to Pollock (it might be viewed as both) raises performativity to a new level. By staging Benglis within the tropes of well-known representations of Pollock performing the act of painting, these images reference him *as* representation, *as* body in action rather than transcendent, veiled creator of the masterly drip paintings; at the same time, he is even more obviously produced as "origin."

Within the context of 1970 U.S. culture, Benglis's gesture—because she is a woman—had strikingly different effects from those of Klein's performances. While Klein could parody Pollock and still retain the authority of the "male genius" (through the authority that accrues to the anatomically male [veiled, phallic] body in Western patriarchy), Benglis clearly sustained a vastly different relationship to artistic authority. By reiterating the codes of normative artistic subjectivity but through the body of an other, Benglis denaturalizes the usually assumed link between these codes and the male body.[135] More simply, since artistic authority has never been easily accessible to women in Western cul-

ture, Benglis's act has the effect of a liberating, transgressive appropriation, especially when viewed in the context of her numerous self-promotional advertisements (the culmination of which was her infamous 1974 *Artforum* advertisement, in which she poses nude, her body greased and slick, holding a huge pink dildo upward from her crotch).[136] The images of Benglis producing her large-scale sculptures (which, themselves, negotiate male-dominated minimalism in interesting ways) aggressively stage the act of production—here *by a woman artist*—as a performance to be commodified through photographic representations.

The pieces that Benglis created through this "fling, dribble, and dip" process, too, seem directly and humorously to refer to abstract expressionist "masterworks," with their critically determined baggage of trace, gesture, presence, and transcendence. In a piece such as *Fallen Painting* (1968), for example, Benglis—who herself referenced this work in terms of the notion of "frozen gesture"[137]—shifts the Pollockian drip painting, still displayed in the conventional rectangular, vertically hung format of the modernist painting on canvas, to a smear of Day-Glo "paint" (actually highly synthetic-looking rubber) running for a good thirty feet across the gallery floor. Through the title, Benglis invokes the depravity of the "fallen" woman or brash and flashy woman of the streets (who might, in feminist terms, be interpreted as a prone victim of phallic male desire); Benglis's debased horizontal "picture" is never raised to the vertical as Pollock's were.[138] Benglis shifts the romanticized "spontaneity" of the abstract expressionist gesture (not to mention the masculinist industrial fetishism of minimalism) into a spilled mess reminiscent of the goo 1950s and 1960s housewives would have had to confront on their kitchen floors with scrub brush in hand (except here, it is the woman who makes the mess,[139] which the art market "cleans up"). Gesture, then, is linked not to a transcendentalized and masculinized concept of hard work but to *domestic labor*, and the (female) body is invested openly in the process of making.[140]

A number of other works by feminist artists specifically negotiate the patriarchal effects of Pollock's veiled performativity—that is, the structure by which he is both aggrandized as the origin of the divine painterly trace (a "presence" confirmed by the publicly disseminated images of him painting) and critically veiled as a material, embodied subject of making (and object of our gaze) in order to confirm this privileged status. In 1965 Shigeko Kubota performed *Vagina Painting*, a piece that shifts Pollock's heroic ejaculatory, flinging gesture (certainly as filtered through the exaggerated flamboyance of Gutai) into a specifically feminist "stroke," at the Perpetual Fluxfest in New York City. After placing paper on the floor, Kubota, an artist who had recently moved to the United States and who, like fellow Japanese expatriate Yoko Ono, was active

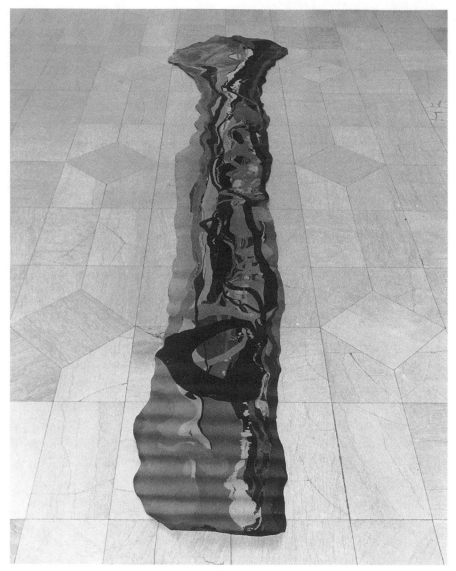

LYNDA BENGLIS, *FALLEN PAINTING*, 1968; PIGMENTED LATEX RUBBER,
355 X 69¹/₄ INCHES. ALBRIGHT-KNOX ART GALLERY, BUFFALO, NEW YORK,
MICHAEL GOLDBERG, LYNDA BENGLIS, AND PAULA COOPER, 1992.

in Fluxus, proceeded to paint red strokes on it with a brush attached to the
crotch of her underwear. Action painting (as a conglomeration of visual and
verbal metaphors supporting masculinity) is thoroughly subverted in this exag-
geratedly "female" process of menstrual gestural creation on the paper as
"arena in which to act."[141] While Klein had used the female body (perhaps iron-

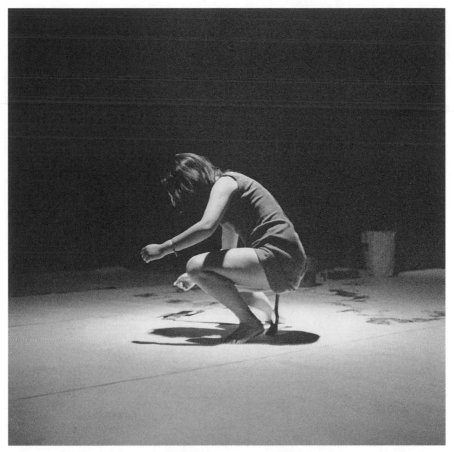

SHIGEKO KUBOTA PERFORMING *VAGINA PAINTING*, 1965, PERPETUAL FLUXFEST, NEW YORK. PHOTOGRAPH BY GEORGE MACIUNAS, COURTESY THE GILBERT AND LILA SILVERMAN FLUXUS COLLECTION FOUNDATION.

ically but nonetheless blatantly) as a tool (a "living brush") on behalf of male genius, Kubota mobilized her own body (specifically her sex) as the source of artistic production. Kubota activates the site of the vagina itself—the paradoxical locus of "lack" that supposedly dooms women forever to an alienated state of objecthood—as the originary point of the meaningful painterly gesture.[142]

The Pollockian performative has reemerged in recent years to become a central impetus for practices returning to the politics and phenomenology of the body. Thus, in 1995, in a definitive "queering" of the Pollockian performative (and one that is heavily informed by these feminist predecessors in its motivations, strategies, and effects), Keith Boadwee produced two video loops documenting his highly charged and highly ambivalent negotiation of Namuth's

filmic and photographic production of Pollock as performer. Needless to say, Boadwee's work, which links up not only to 1970s feminist critiques of the action painting paradigm but also to numerous 1990s feminist projects rearticulating this critique (including performative pieces by Rachel Lachowicz, Cheryl Donegan, and Janine Antoni), is inflected by a set of concerns very different from those motivating artists in the 1960s and 1970s.[143] The *queering* of the subject is a dislocating strategy—a critique of the *heterosexual imperative* securing the privilege of normative masculinity in Western culture—that has become increasingly activated and surfaced in the past ten years. Boadwee's overt, aggressive queer performativity contrasts markedly with the veiled gay identification of Rauschenberg or Johns in their more ambivalent negotiations of Pollock.[144] Boadwee's videos, which are installed in the gallery along with the finished products of his painterly efforts,[145] show the artist, completely "unveiled," crouching indecorously over canvases spread along the floor and ejecting streams of paint out of his anus.

Reiterating the Pollockian trope of masculinized action painting genius, but through a body explicitly performed as abject, anal, and homosexual, Boadwee exposes the homoerotic as the hidden threat that motivates the construction of normative (heterosexual) masculinity, which is essentially a set of codes, behaviors, and regulations prohibiting male to male sexual bonding. The anus—*not the penis/phallus*—becomes the site through which male creativity takes place; and yet, far from being phallic and so "transcendent," this site is itself *an orifice* (and one connected in mainstream culture with the most debased aspects of human functioning, as well as with homosexual erotics).

Far from definitively distancing Boadwee from Pollock through a radical gesture of critique, however, his project exposes the interdependency of queer subjectivity (and, for that matter, feminine subjectivity) on the normative codes of masculinity Pollock represents. As queer theorists such as Judith Butler and Michael Warner have suggested, the homosexual exists precisely to ensure, in Warner's words, "*the construction of heterosexuality as such*" (much in the same register as Beauvoir's immanent female, who determines the "norm" of transcendence).[146] But by exaggeratedly *unveiling* the male body of the male action painting artist (and performing it as overtly queer), Boadwee's project also points to the dependence of a Pollockian, normative masculinity on the excluded other (the female, the gay man). The overt enactment of the male anus as (penetrable) orifice, here leaking and spewing the very "matter" of action painting itself, also highlights the fact that the prohibition securing the impenetrability of the masculine is a kind of homosexual *panic*. This prohibition, installed at the center of Western, metaphysical conceptions of the subject, is adopted as a means

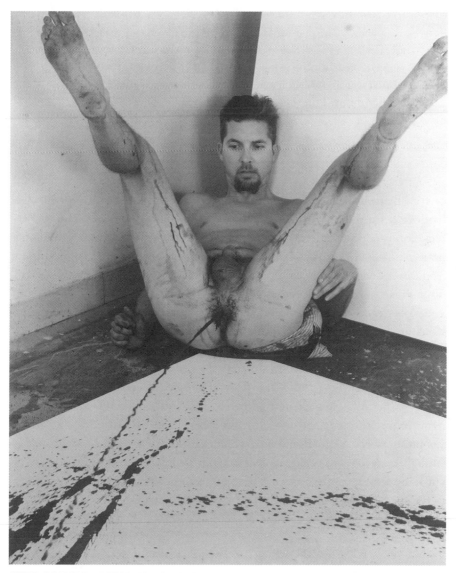

KEITH BOADWEE, *UNTITLED (PURPLE SQUIRT)*, 1995; DURAFLEX PRINT, 48 X 60
INCHES. PHOTOGRAPH COURTESY ACE CONTEMPORARY EXHIBITIONS, LOS ANGELES.

of warding off (feminine/homosexual) immanence and securing the hierarchies
of (heterosexual) sexual difference.[147]

Viewed through Boadwee's anal excretory negotiation of the Pollockian
performative and through Butler's model of the heterosexualization of gender
domination, the normative male body instantiated by the modernist artist dis-
solves in an ideological sea of (postmodern?) contradictions. This body of "man"

is a figure of disembodiment, but one which is nevertheless a figure of a body, a bodying forth of a masculinized rationality, the figure of a male body which is not a body, a figure in crisis, a figure that enacts a crisis it cannot fully control. This figuration of masculine reason as disembodied body is one whose imaginary morphology is crafted through the *exclusion of other possible bodies*. This is a materialization of reason which operates through the dematerialization of other bodies . . . [which have no contour and are undifferentiated] . . . yet . . . this body of reason is itself the phantasmatic dematerialization of masculinity.[148]

By mimicking Pollock, but through a body that is enacted as penetrable, Boadwee deflates the "masculine's claim to originality"[149] and assists in the articulation of a postmodern subject that is fully particularized rather than normative. Boadwee's project, like those of Benglis, Saint Phalle, and Kubota, produces a body that opens a negotiatory spectatorial relation accommodating homoerotic and other forbidden desires. Needless to say, one of the consequences of this detumescence of the myth of phallic plenitude (this simultaneous unveiling and dematerialization of the phallic body of the modernist artist/genius), would be a dislocation of the entire mythology of creation as ejaculation, interpretation as "disinterested" reading of transparent meanings, and the work of art as a static repository of the artist's intentionality.

The following chapter addresses the body art work of a straight-identified white, male artist—Vito Acconci—to explore the ways in which this presumably "normative" body, when enacted as *intersubjective* and *contingent* through body art projects, can also be seen to interrogate the structures by which modernist art discourse has both taken authority from and given authority to the (veiled) male body/self of the artistic genius.

THE BODY IN ACTION:
VITO ACCONCI AND THE "COHERENT" MALE ARTISTIC SUBJECT

In historical terms, the period of the late 1960s and early 1970s, the most productive moment in the history of body art, was a time of great social upheaval. Long-brewing challenges to white imperialist patriarchy—via agitation in black power, gay and lesbian, women's, students' rights, and new left antiwar movements—came to an explosive head in the United States and Europe. Normative subjectivity and its privileges were profoundly and publicly challenged, and, as Russell Ferguson has noted, whiteness, maleness, and heterosexuality could "no longer . . . be taken as the ubiquitous paradigm, simultaneously center and boundary."[1]

Body artists participated in this dislocation of normative subjectivity, reconfiguring identity politics (the ways in which the subject comes to meaning in the social) and the very parameters of subjectivity itself. Vito Acconci's work from this period exemplifies the potential of body art projects both to interrogate the normative values inscribed in the trope of the artist genius epitomized by the modernist Jackson Pollock and to subvert formalist modernism's closed systems of "disinterested" interpretation by insisting on the intersubjective, highly invested, and processual (rather than static or finite) dimension of the experience and interpretation of works of art.[2] Acconci's ambivalent, self-exposing yet self-confirming body art works point to the dilemma faced by male artists in the post-1960 period in the United States and Europe.[3] Staged in relation to the hegemonic Pollockian performative, the body art works of this younger

103

generation ironicize the heroic elements of this phenomenon but also maintain many of its legitimizing aspects.

Paralleling the effects of numerous feminist body art projects during this period, Acconci's body art works open to question the previously assumed authority of the implicitly heterosexual, white, male artist by multiplying the effects of his body-on-display. Acconci *performs* himself as open-ended and con- tingent on spectatorial desire, pointing up the incoherence of masculinity itself (as simultaneously authoritative and vulnerable, penetrating and receptive, con- trolling and at the mercy of the viewing "other"). And yet, the performative must not be understood in any simple way as necessarily dislocating the male norm of subjectivity active in Western cultures. Such a norm—which always al- ready assumes a heterosexual, white, middle- or upper-middle-class masculin- ity—is itself confirmed through *performative reiteration.* The body of the straight white male artist is, in Judith Butler's terms, given form through the "identifica- tory projections" of normative subjectivity—as "cited" from multiple sources: Pollock's self-performance, Greenberg's hidden investments, Namuth's photo- graphs, my construction here (which solidifies the notion of Pollock as quintes- sential trope of masculine genius).[4] The Pollockian performative comes to *mean* the norm of artistic subjectivity through the art historical citation of Pollock; it lends itself to antinormative practices (Kubota's *Vagina Painting,* for example) through its very designation as norm against which other works stage themselves.

Any performative act is always recuperable to its nonparodic baseline effects (in the case of a male body art project, that of conventional masculinity as inscribed and exaggerated in the figure of the artistic genius). Here, however, I invest myself openly in Acconci's body art works, reading them such that they enable (but never ensure) a critical reading of masculinity and Cartesian subjec- tivity in general. I argue in particular that Acconci's pathetic masculinity bla- tantly fails to cleanse itself of the "feminine" and the "homosexual"; Acconci's flaccid, hysterical body/self histrionically wallows in its own flawed corporeal- ity and fails in the most dramatic way to attain the seemingly self-evident au- thenticity of the modernist figure of genius. (An important aside: Acconci, like most white artists active at the time, has done less well in opening the implicit *whiteness* of the artistic genius to question; his work deals with the en-gendered or sexual subject, not with the raced one.)[5]

In his now infamous *Seedbed* of 1972, Acconci enacted in the most literal fashion the structures by which the institutions of art veil the modernist genius; hidden under a ramp at New York's Sonnabend Gallery, he responded to the footsteps of visitors by masturbating, transmitting his verbal fantasies and moans of pleasure back to them via a sound projection system.[6] Through Acconci's

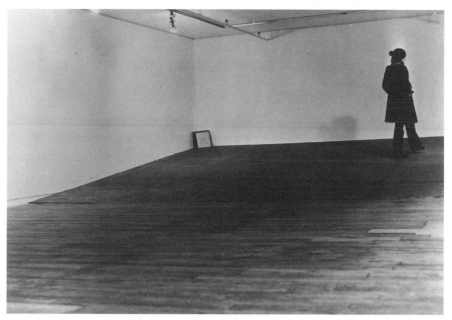

VITO ACCONCI, *SEEDBED* (VIEW OF GALLERY), 1972; PERFORMANCE/INSTALLATION
(WOOD RAMP, LOUDSPEAKER SYSTEM) AT SONNABEND GALLERY, NEW YORK.
PHOTOGRAPH COURTESY BARBARA GLADSTONE GALLERY, NEW YORK.

act, the visitor would have been inexorably involved in the intersubjective ar-
ticulation of "artistic" meaning (as well as the meaning of artistic subjectivity).
This is an articulation, moreover, that Freud described in terms of *transference*
(an intersubjective exchange of identities); transference, "invariably rest[ing]
ultimately on an erotic basis," marks the struggle for meaning as necessarily an
erotic exchange ("we [know] none but sexual objects").[7] In *Seedbed*, as in all of
his body art work, Acconci exaggeratedly performs the chiasmus—the inter-
subjective erotic intertwining—of the interpretive exchange.

Through body art projects such as this, Acconci himself became one of
the most important theorists of the reembodiment of art production and, cor-
relatively, art reception as a radical challenge to modernist formalism. By involv-
ing his own body in his work, Acconci insisted on, in his words, "art . . . as ex-
change between artist and viewer" (one that is, as noted, explicitly erotic); he has
explained his obsession with his own body/self as stemming from his desire to
interrogate art not as a "unique object" but as a "distribution system" involving
the phenomenological "interchange" of subjects within the social.[8] Staging art
as a communicative exchange between desiring subjects—a phenomenological
intertwining or psychoanalytic transference/countertransference involving an

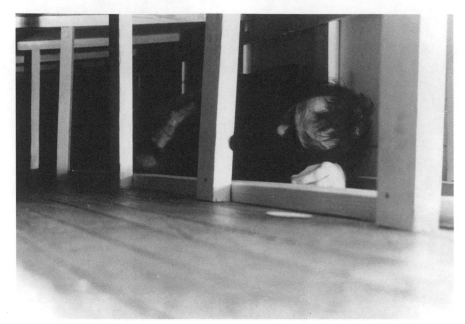

VITO ACCONCI, *SEEDBED* (VIEW UNDER RAMP), 1972; PERFORMANCE/INSTALLATION
AT SONNABEND GALLERY, NEW YORK. PHOTOGRAPH COURTESY BARBARA GLADSTONE
GALLERY, NEW YORK.

exchange of codes, behaviors, expressivities, and *embodied, erotically invested subjectivities*—Acconci's body art unveils the privileged male body of the artist/genius (even as, in *Seedbed*, it literally, if parodically and exaggeratedly, veils it).

As I suggested in chapter 1, body art projects explicitly stage the phenomenological model of intersubjectivity, in which the *exchange* of subjectivities (their *intertwining*) takes place through the engagement of bodies/subjects as well as, more specifically, the *reversibility* of expression and perception (as well as of subject and object) through which we constitute ourselves in the world. In Merleau-Ponty's terms, "the body proper is a premonition of the other person," a spatial and temporal projection.[9] By opening the embodied artist/subject to the other, body art also opens the embodied other (as interpretive *self*) to the artist; each projects onto the other—*each taking its place there as subject* while simultaneously authorizing the other as subject.

Acconci's project extends this process of exchange through an exaggerated performance of the self-other interpretive relation (with himself *as* the object of art, the usual mediating term of the exchange, as well as its "origin"). In this way Acconci highlights how the masculinity of the artist (with its assumed coherence as heterosexual, white, and heroically antibourgeois), conventionally

secures the supposedly intentional meanings discerned by the interpreter. [10] Acconci's masculinity is not articulated as an essential privilege of his fully intentional (transcendent) subjectivity but as an exchangeable attribute assigned through the interpretive relation: the phallus, his authority as a masculine subject/artist, is unveiled, its ideological rather than essential relationship to the anatomically male body exposed. Furthermore, as body art Acconci's projects expose the fact that his "phallus" is both determined from the outside (by critical discourse, which demands it) and self-adopted or *performed*. Acconci's "phallus," his masculinity, is a "*corporeal style*" that crafts a body to which accrues the cultural privilege of genius. [11]

Notably, accounts of Acconci's work from the 1970s attempt to recuperate the contingency of the subject/artist through heroizing, universalizing terms reminiscent of Harold Rosenberg's discourse; my *performance* of Acconci must thus be differentiated from the dominant constructions of his body art work in the early 1970s. Hence Cindy Nemser's claim, in her 1971 article "Subject-Object Body Art," that body artists such as Acconci "make coherently structured images out of our fragmented, alienated society," that they aim to "bring the subjective and objective self together as a totally integrated entity." [12] Informed by a phenomenologically inflected feminist poststructuralism, I stress again here that the presentation of the body/self in body art marks not the immediacy, unity, and presence of this body/self but its radical interdependence with the other. This is so, crucially, *whether or not body art's phenomenological disturbance is experienced "in the flesh" or through visual and textual documentation.*

The body art project initiates an "infinite chain" of supplements—the body "itself," the spoken narrative, the video and other visuals within the piece, the video, film, photograph, and text documenting it for posterity—all of which work to produce the sense of the very thing they defer: "the mirage of the thing itself, of immediate presence, of originary perception." [13] Rather than confirming the metaphysical coherence of the body-in-presence, the "body" in body art exacerbates its own supplementarity; we remember that in Peggy Phelan's terms, "performance uses the body to frame the lack of Being promised by and through the body—that which cannot appear without a supplement. . . . Performance marks the body itself as loss. . . . For the spectator the performance spectacle is itself a projection of the scenario in which her own desire takes place." [14]

ACCONCI'S "OPENING" TO (EF)FEMINIZATION

Acconci's work goes far beyond that of most of his male contemporaries in dramatically enacting this lack in terms of a definitive *feminization* or homosexu-

VITO ACCONCI, *OPENINGS*, 1970; FOUR STILLS FROM SUPER-8 COLOR FILM.
PHOTOGRAPH COURTESY BARBARA GLADSTONE GALLERY, NEW YORK.

alizing *effeminization* of the male subject as always already also an object of inter-pretive desire. Nonetheless, as he himself admitted, the effects of his self-(ef)feminization were and remain equivocal. For example, in 1970 Acconci pro-duced a Super-8 silent film entitled *Openings,* in which the camera focused closely on the immediate area around his navel as he carefully plucked out all of the hairs hiding it from view. "Opening" his hairy male body to the penetration of the spectatorial gaze—giving himself a surrogate cunt and assigning him-self the specularized vulnerability that conventionally aligns with femininity—Acconci seems willfully to transgress his masculinity: "I'm opening up part of my body . . . [such that n]avel becomes vagina."[15]

Acconci's *Openings* flamboyantly performs the historical alignment of the theatricalization of the body with femininity (in Nietzsche's infamous for-mulation: "In the theater, one becomes people, herd, female, pharisee, voting cattle, patron, idiot").[16] And yet there is a problematically appropriative aspect of his gesture as well. Acconci wants both to open himself to us and to protect himself from our gaze. He wants to (ef)feminize himself through performances that open his body to view while also controlling the artist-viewer relationship and confirming the coherence and impenetrability of his body (Butler: "one might read this prohibition that secures the impenetrability of the masculine as a kind of panic, a panic over becoming 'like' her, effeminized").[17] Acconci

could be said both to *stage* this heterosexual panic by presenting an orifice that is definitively closed and invulnerable, and to *critique* it through this very exaggerated reiteration of the codes of bodily containment that aim to confirm masculinity's impenetrable transcendence. As Klaus Theweleit has suggestively argued, "the man holds himself together as an entity, a body with fixed boundaries. . . . He defends himself [from the flood] with a kind of sustained erection of his whole body."[18]

Thus, while Acconci's work activates a chiasmic circuit of intersubjective desire that confuses the boundaries conventionally staged to confirm the authority of the modernist artist and interpreter, it simultaneously restages these boundaries—if apparently in the most parodic way. The dissolution of the male artistic self is equivocated by Acconci's insistent reinscription of his own authority at the site of artistic production. Acconci admitted that in the performative body art pieces, "it was always announced, I was always the artist, it was very much—'I'—'I-as-art-star' meet you, the viewer. . . . So it wasn't these two people meeting, but very much a viewer almost taking this journey towards me. . . . I was setting myself up, really, in a very traditional stage kind of position."[19]

Lea Vergine has accused male body art of a "ferocious misogyny" that "functions as a kind of exorcism of the terror of openly competing with the female genitals."[20] But in his attempt to approximate the female sex, Acconci makes his competition with the female body "open" (as it were)—and certainly at least partly facetious. In feminist terms, his piece could be viewed alternatively as either an egregiously "gynophobic" (in Vergine's terms) attempt at short-circuiting women's special relationship to *re*production (and, in fact, to absence or lack), or as a radically antimasculinist attempt to expose masculinity's anxiety about the vagina as a "true" hole, capable of issuing forth life. *Openings* could also be viewed as a staging of masculinity through a suggestively homoerotic signifier of potentially male-to-male desire, an orifice that echoes the other "real" orifice of the male genital region: the anus. I would argue that it is certainly all three.

I interpret Acconci's ambivalence as suggesting that he is both eager to expose himself, to solicit spectatorial desire (the "opening" as orifice), and desperate to reclaim his authority and coherence as a male subject of artistic production (the "opening" sealed off from flow). First of all, while he wants to display his vulnerability, the mute closure of the navel and its conventional desexualization in Western culture seem to confirm his "coherence"; literally "jerking off" the hirsute, masculine veil protecting his navel/orifice, Acconci hardly "opens" himself to the penetratory gaze in a manner that puts him at

risk in the same way as a woman with her legs spread.[21] As Mary Douglas has pointed out, "the orifices of the body . . . symbolize its specially vulnerable points. Matter issuing from them is marginal stuff of the most obvious kind. Spittle, blood, milk, urine, faeces or tears by simply issuing forth have traversed the boundary of the body."[22] No longer does anything penetrate or issue from Acconci's closed hole thus opened to view.

Acconci's return to the navel (his desire to reopen it to the flow of fluids) also betrays a certain nostalgia for a state of physical union with the (m)other lost in the infant's brutal entry into the social. And the fact that Acconci restricts the sites in which he enacts and documents this compromised masculinity (basically to art venues) suggests that he is still invested in artistic authority. As Judith Butler has pointed out, in the official performance setting "one can say, 'this is just an act,' and de-realize the act. . . . Because of this distinction, one can maintain one's sense of reality in the face of this temporary challenge to our existing ontological assumptions about gender arrangements."[23]

Given this recuperability of Acconci's body art, how can I reconcile my attempt to assert its radically dislocating effects—not the least within a format (the monographic art historical text, here a chapter) that continues to cohere him as originary subject of the works? My point is precisely that by performing Acconci against the grain of Nemser's recuperative discourse or Vergine's harsh but equally unequivocal critique (or, for that matter, against Acconci's or my own continual tendency to reinscribe his prowess as dislocator of masculinity), any fantasy that Acconci is definitively either "misogynist" or "feminist" (!) can be dispelled. In spite of his sutured orifice and his continual recuperations of his own authority, this authority itself must be seen in its own contingency (just as my authority, my justification for reading it this way, depends in turn on my identification with Acconci's [contingent] authority). Acconci thus becomes both more and less readable (through an infinite regress of interpretive acts), always implicated in but never secured as a stable anchor of his works' effects.

This complex dynamic can be formulated usefully, through the work of film theorist and phenomenologist Vivian Sobchack, at the level of the apparatus itself. Filming himself in *Openings*, Acconci acts as both body-camera-eye (the conventional subject of making) and body-projector-navel (the object, with navel as dead-end orifice or blind eye, of his own and our gaze). The film consists of what Sobchack terms both "viewing view" (a "gaze" that views us) and "viewed view" (a viewed scene). Sobchack argues that the author of this "viewing view/viewed view that is the film is the *filmmaker-camera embodiment relation;* the *spectator-projector embodiment relation* is author of the expression of the film that they *together* enable and enact."[24] Extending my observation that the body

art "document" (here the film) is itself a body/supplement, Sobchack suggests that the spectator/film/filmmaker relation itself entails an embodied inter-subjectivity that marks the radical contingency of Acconci's "vaginal" body on my *expression* of the film/body (not to mention the contingency of my reading on his filmed body/self).

Acconci's obsessive need to project himself into femininity is thus not deconstructive of masculinity and its privileges in any simple way, not the least because he is quite clearly obsessed *not* with femininity, as might be the case with a feminist (or, for that matter, with a transsexual or more radically conceived bigendered subject), but with *masculinity.* Ironically, however, it is Acconci's continued fascination with masculinity that makes his works potentially so destabilizing to the norm. While, as Butler notes, "the authors of gender [often] become entranced by their own fictions," Acconci's maintenance of these fictions takes place within the body art format and thus exposes hetero-sexual, white masculinity *as an intersubjectively determined construct,* a fiction of its own.[25] Acconci's body art works thus suggest that the very need for the continual performance of masculinity—the repetitious restaging of its boundaries to keep out that which is not *it*—testifies not to its durability and coherence but, rather, to its radical instability.

MICHAEL FRIED: EXCORIATING THEATRICALITY

Returning to the masculinist determination of theatricality as itself a feminine mode of presentation, it is worth stressing again that performance and body art are in themselves potentially dangerous modes of exploration for the male artist concerned only with reiterating in as unambiguous a way as possible the codes of masculinity (as is clear from the instability Pollock's performative mode of painting, and the photographic and filmic documentation of this mode, puts into play). As Nietzsche's formulation suggests, the participant in the spectacle of theater is feminized, democratized, and uneducated ("idiotic")—and thus definitively opposed to the refined, firmly "erect" masculine elite of high culture.

The alignment of theatricality (or related phenomena such as kitsch and popular culture) with a feminized inauthenticity has been a strategy of long-standing durability within modernism, and it reveals much about the assumptions built into the formalist model of modernist criticism.[26] Several historians of performance and body art have noted the importance in this regard of Michael Fried's well-known argument in his 1967 article "Art and Object-hood," where he combines a moralistic attitude condemning theatricality with Greenbergian formalism to defuse the threat posed to modernist criticism by minimalist art (which Fried terms "literalist art").[27] By as early as the late 1970s

the "threat" of performance to modernist practices was being recognized by artists and theorists of the postmodern. Douglas Crimp noted in 1979 that Fried's essay signaled the crucial importance of "performance" (broadly construed as "all those works that were constituted *in a situation* and *for a duration* by the artist or the spectator or both together") in 1970s art; and Maurice Berger, in addressing Fried's argument, has more recently asked, "Why was 'theatrical' space and time so important for artists in the 1960s?"[28]

Theatricality—a specifically *feminizing* debasement of the virility of "pure" modernism (as Nietzsche and other modernists have recognized)—is in this sense constitutive of the performativity of the subject characterizing the shift from a modernist to a postmodernist cultural episteme. And of course it is performance and body art that deploy the corruptive effects of theatricality in the most exaggerated way. An analysis of Fried's argument thus sheds light on what Acconci's self-performance *means* in relation to the "coherent," masculine modernist subject.[29]

For Fried, invested in Greenberg's Kantian model of "disinterested" interpretation of artworks based on their supposedly inherent formal qualities, the minimalist work defies the pure spectatorial relationship instantiated by the modernist painting or sculpture. It is "antithetical to art" because it "*includes the beholder*" and is thus theatrical (again, per Nietzsche, theater is the opposite of art).[30] Acknowledging the viewer, the literalist work breaks the primary rule ensuring the authority of modernist criticism, which, we recall, legitimates itself as "truthful" through its claim to the *disinterestedness* of aesthetic judgment. The acknowledgment of the viewer exposes her or his relationship to the object as one that is specific, contingent, and above all "interested."

Fried's condemnation of minimalism, not surprisingly, brings us directly back to the performativity of body art: "*art degenerates as it approaches the condition of theater*," and minimalism, because it "*lies between the arts*," is theatrical.[31] While modernist painting and sculpture "defeat theater" in their "presentness" ("*at every moment . . .* [they are] *wholly manifest*") the presence of the literalist work is disquieting in that it is uncontainable and not purely present in itself. The literalist "preoccupation with time— . . . with the *duration of the experience*" of the work—is "paradigmatically theatrical."[32] Furthermore, Fried is highly critical of the "latent or hidden naturalism" that he sees lurking within "the core of literalist theory and practice." It is the anthropomorphism of minimalist sculpture—its overt appeal to the *body of the spectator*—that (as "theatrical") also threatens the closures of modernist criticism: for the solicited body of the spectator (called upon *as a body/subject* by the human-sized literalist object) destroys the illusion of mastery that Fried wishes to sustain in his "disinterested" approach to artworks.[33]

Just as the crowd-pleasing opulence of Wagner's operas inspired Nietzsche to flamboyant levels of misogynistic dismissal, so (ironically) the metal slabs of Donald Judd and Robert Morris, as well as their theories of minimalist form, drove Fried into paroxysms of art critical anxiety over the need to maintain "authentic art" by expelling (feminizing) theatricality. The mute "anthropomorphism" of Morris's rigid, monumental *Untitled (L-beams)* of 1965, which, placed directly on the floor, compelled the spectator to circumambulate the ungiving forms and refused to stage the representational or narrative effects common to modernist and premodernist sculpture, produced a spectatorial relation that involved, in Morris's words, "the entire situation" of the piece, including (Fried remarks), "the beholder's *body*."[34] Such a relation was profoundly phenomenological and thus transgressed the two-dimensional logic of modernist formalism, with its assumption of a unified interpretive subject relating to a fully apprehensible artistic object.[35]

Fried—who seems unaware of or uninterested in developments in dance and performance that had already been initiated in Fluxus, the Judson Dance Theater, and other areas (and that were crucial, especially through the work of Robert Morris, to the development of minimalism's "theatricality")—could hardly have imagined the ways in which body art would soon exacerbate minimalism's subversion of "authenticity" through its blatant, "feminizing" theatricality, activation of phenomenological relations of intersubjectivity, and often explicit unveiling of the body of the artist. Acconci's obsession with the theatrical relation—his insistent need to perform his body/self in ways that solicited and often also repelled the spectatorial other (as well as, in certain cases, the other he would write into the narrative of his performance)—positions him as a crucial example of the perverted theatricalization of the Pollockian performative. Acconci's body art exaggeratedly performs the anthropomorphism (embodied intersubjectivity) of minimalism that Fried recognized as a threat to modernist criticism.

NARCISSISM AND THE AMBIVALENCE OF MALE THEATRICALITY

Theatricality—here, via the performance of the male body—is thus in at least one context aligned ideologically with the feminine. By displaying his body, the male body artist *unveils* it, exposing to view the body as locus of interpretive desire that must be hidden for modernist criticism to play its "disinterested" (and ultimately masculinist) game of aesthetic judgment. At the same time, it is obvious that male performance is hardly necessarily feminist (or even feminizing) in its effects. As I have explored elsewhere, the "dis/play" of the penis, while exposing the male body to the harsh violence of the spectatorial gaze, often

simultaneously takes place as a means of aligning this organ with the phallus of artistic authority.[36] Thus, we have seen that Yves Klein's *Anthropometries* ameliorate the feminizing effects of his own bodily display by both clothing this body in the unrevealing sheath of evening clothes and by exaggerating its continued authority over the also (and more fully) displayed bodies of naked women models/paintbrushes.

Performative masculinity in male body art often continues to work under the assumption of a bipolar, heterosexist gender model: when it is clothed (as with Pollock and Klein), the body is veiled and so at least ideologically if not inherently "phallic"; when it is exposed, the male body is almost always aggressively signified as "virile," "heterosexual," and otherwise normatively masculine. Too, it is telling that male body art has been almost exclusively practiced by *white* men (indicating that the stakes in exposing the penis are far higher for men not already privileged within Western culture); in terms of their class affiliation, it goes almost without saying that, whatever their class origins, the men performing in the art world establish themselves within its educated ranks of social privilege.[37]

Robert Morris's infamous body art poster from 1974, in which he poses rigidly in army helmet, sunglasses, and chains, exemplifies the way in which parody can both challenge and reinforce dominant codes of masculinity. Morris's self-constructed image plays on S/M codes that confirm a working-class *hypermasculinity* to the art viewing crowd, but one that is also aligned with homosexuality (working-class leather and military gear have since the 1950s been appropriated by many urban gay men to "pervert" and/or to claim for themselves the attributes of such hypermasculinity).[38] A comparison of the reception of this image to that of Lynda Benglis's 1974 centerfold in *Artforum* (a glossy color photograph of her hoisting a gigantic pink dildo against her greased, naked body) is revealing.[39] Thus, while Morris's self-fashioned portrait is, typically, an example of Morris's "undermin[ing of] the notion of a foundational identity in gender,"[40] Benglis's image (made in dialogue with Morris, as they were partners at the time) has served until its recent feminist recuperation only to raise anxious commentary (as in the virulent attack on Benglis's parodic performance in the following issue of *Artforum*, which labeled it "an object of extreme vulgarity").[41] This example suggests that through such parodic "masculine masquerade,"[42] masculinity is clearly unhinged but still tends to maintain its place as the hyperbolic *self* to the feminine's *other.*

But often the elements of play and exposure involved in male body art practices (whether intentionally or not) highlight areas of contradiction in masculinity, "opening," as it were, areas of rupture and penetrability that are resis-

ROBERT MORRIS, POSTER FOR CASTELLI-SONNABEND EXHIBITION, 1974; EDITION
OF 250. PHOTOGRAPH BY BRUCE C. JONES, COURTESY OF THE ARTIST.

tant to the usual discursive attempts to recuperate it and ensure its coherence, aligning the male artistic subject with an insistent narcissism that Freud associated with homosexuality and femininity.[43] The self-involved male body artist baldly exposes his inability to attain transcendence: his feminine/homosexual fixation on himself *as others see him* profoundly destabilizes masculinity's self-sufficiency and claim to internal coherence. The very narcissism through which body art takes place (the display of the artist's body as the work of art and the artist's self-orientation and desire to be desired) returns the male subject, no matter how "macho" in his actions, to the very stage of autoeroticism that Freudian psychoanalysis aligns with an effeminate homosexuality.

The male body artist is narcissistic but also, very often, specifically masochistic in his submission of himself to an other (the female collaborator [as in a number of Acconci's pieces], the wounding partner, the omnivorous gaze of the spectator).[44] In this masochistic submission he plays out the ambivalence that many theorists (including, perhaps inadvertently, Freud) have traced through the dynamic of masochism itself, where the "subject" of masochism is the object of another's violent acts. Such a performance offers the male body/self to the intersubjective relation of self/other, on at least one level instantiating the contingency of the male subject—the implication of the "other" in the constitution of his identity as "self/same" (in this case, the supposedly self-sufficient, transcendent genius of modernism is unveiled for his dependence on the "theatrical," [ef]feminized other).[45]

Acconci's work is especially charged and obvious in its narcissistic ambivalence—pointing both back toward infancy (as in *Openings,* with its emphasis on the navel) and forward toward a mythical norm of completely self-sufficient, controlled, and authoritative masculinity. Acconci poses himself as both desperate to reclaim his authority and coherence as a male subject of artistic production and eager to expose himself, to solicit spectatorial desire. This ambivalence suggests that his work is about the failure of the masculine to exclude otherness—femininity, homosexuality, physical or ideological (racially or economically implicated) vulnerability, penetrability—from itself, or to ensure its coherence: in fact its strict dependence on such otherness to claim its priority as self/same. We remember Beauvoir's insight into the way human difference is mapped into gender through the projection of lack (or immanence) onto the other, with masculinity privileged as "transcendent" and femininity aligned with "immanence," passivity, and corporeality. Thus,

> humanity is male and man defines woman not in herself but as
> relative to him. . . . Man's design . . . is to take control of the instant

VITO ACCONCI, *PUSH-UPS*, 1969; NUMBER 10 IN A SERIES OF 10 PHOTOGRAPHS
DOCUMENTING ACTIVITY AT FAR ROCKAWAY, NEW YORK. PHOTOGRAPH COURTESY OF
THE ARTIST AND BARBARA GLADSTONE GALLERY, NEW YORK.

> and mold the future. It is male activity that in creating values
> has made of existence itself a value; this activity has . . . subdued
> Nature and Woman. . . . [Woman is defined] as *flesh* . . . doomed to
> *immanence* . . . [t]he *Other* [who is] particularly defined according to
> the particular manner in which the *One* chooses to set himself up.
> Every man asserts his freedom and transcendence.[46]

Acconci's earliest body art pieces employed the photographic index
toward narcissistic ends—to corroborate the "presence" of Acconci as an active
subject in the world: in *Push-Ups* (1969), Acconci performed 100 push-ups,
photographing the marks his body made in the sand after each one. Writing of
this exercise, he stressed his "attempt to visibly take to—take over—my sur-

roundings. Imprints as the body's representative."[47] Such an attempt to take over the environment through the imprints of one's body is aggressively narcissistic, harking back to the early stages of a child's development.

As Rosalind Krauss has suggested in her essay "Notes on the Index," in works such as *Push-Ups* Acconci retraces the formative, narcissistic moment of the self/other relation as mapped by psychoanalyst Jacques Lacan in his essay "The Mirror Stage."[48] Here, Lacan describes the quintessentially narcissistic moment in an infant's life when the infant first acquires an image of herself or himself as a subject and thus begins to formulate a body image and ego in relation to her or his discrete existence (via the image) in relation to others. As Krauss puts it, "the child recognizes himself as a separate object (a psychic *gestalt*) by means of his mirrored image. . . . [T]he child initially recognizes himself as an other, [and] there is inscribed in that experience a primary alienation. Identity (self-definition) is primally fused with identification (a felt connection to someone else)."[49]

The contingency of subjectivity, which Merleau-Ponty articulates in terms of the *intertwining* and Lacan in terms of its ultimate basis in lack, is a primary aspect of all of Acconci's body art work.[50] Paralleling Lacan's more pessimistic formulation, Acconci frequently enacted his body/self in terms of its profound alienation, specifically performing the *failure and insufficiency* of his anatomical masculinity (his penis) to ensure his coherence and authority as a subject (his access to the phallus). In a performance piece called *Trappings* (1971), for example, Acconci sat naked surrounded by toys, cloth, bits of string, wood, and foam in a closet inside a warehouse in Germany. Withdrawing into this private space within the public realm (a veritable "womb" within the cavernous site of commodity accumulation, protecting Acconci from the dissociation threatened by unbounded space and the endless flow of commodities), Acconci withdrew also into himself. In his words, he aimed to "divid[e] myself in two—turn my penis into another person" by dressing it in doll's clothes and talking to it in order to "see my penis as separate from the rest of my body." Crucially, Acconci admitted his desire to recohere himself through this very division: "I've divided myself in order to work myself back into a unity—I can act on, with, myself while becoming someone else."[51]

Acconci's objectification of his penis (notably, through its sartorial feminization) enacts exactly the method through which, as Beauvoir describes it, men achieve transcendence: by projecting their alienation onto their penis so as to transform it into a "transcendent" external force, the phallus. But Acconci's formulation of his penis/other as an object hardly lifts him unproblematically beyond corporeality and the contingency of intersubjectivity. Acconci's acknowl-

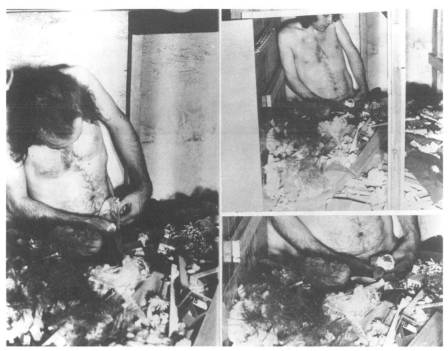

VITO ACCONCI, *TRAPPINGS*, 1971; PERFORMANCE/INSTALLATION IN MÜNCHENGLAD-BACH. PHOTOGRAPH COURTESY BARBARA GLADSTONE GALLERY, NEW YORK.

edgment of his alienation through the gaze of the other (of his—in Beauvoir's terms—inevitable failure to project his anxious lack onto the thus transcendent penis, much less onto the spectator/other) exposes his flamboyant attempt to return to the "womb" (to preoedipal wholeness) as a fraud. In fact, the viewer rudely pulls him back to earth, reunifying his penis with his entire—now objec-tified and crudely immanent—body, short-circuiting his attempt to cohere his body by excluding his castration-endangered appendage, the penis, as other. For the spectator, Acconci's pathetic penis-wielding body/self becomes "some-thing to withdraw from"; the spectator abandons Acconci's body/self to its *intra*subjective fragmentation.[52]

Acconci's articulation of the spectatorial relation thus performs the alienation of the subject in his or her own existence as image/object for an-other. Thus, as Sartre states, "I grasp the Other's look at the very center of my *act* as the solidification and alienation of my own possibilities."[53] Or, in Lacan's terms, this relation confirms "the pre-existence of a gaze—I see only from one point, but in my existence I am looked at from all sides."[54] Paradoxically, rather than confirming his fullness through his splitting off of his penis as other, Acconci confirms only what Lacan and Sartre would view as his radical lack

and what Merleau-Ponty would insist upon as his mutual implication in and dependence on others. Either way, he enacts rather dramatically the pathetic incoherence of (his) masculinity and stages narcissism as a fundamentally ambivalent self-relation common to all subjects in their alienation, confirming neither "masculinity" nor "femininity" nor "homosexuality" as the Freudian model would have it.

THE (MALE) BODY-IN-ACTION AS A CONFIRMATION OF TRANSCENDENCE?

Just as Acconci's attempt to cohere himself through projection inevitably (and perhaps intentionally) fails, so the traces of his action in the sand—in *Push-Ups*—substantiate his "presence" in a limited way analogous to the fragmenting dynamics of the Lacanian mirror stage. The child's image in the mirror seems to confirm her or his selfhood, and yet also simultaneously profoundly challenges its internal coherence by showing its claim of presence to be dependent on an external imago of self—an alienation later compounded by the child's recognition of self in relation to the other through the imago of the other, a projected, imaginary "residue" of the not-self.[55] Thus, from the first identification of self, the "total form of the body . . . is given to . . . [the subject] only as *Gestalt,* that is to say, in an exteriority. . . . [T]his *gestalt* . . . symbolizes the mental permanence of the *I,* at the same time as it prefigures its alienating destination." Acconci's work explores what Lacan examines as the function of the image itself—or, more precisely, the imaginary image or imago—to "establish a relation between the organism and its reality" through a narcissistic dynamic.[56]

In fact, Acconci's return to the umbilical region in *Openings,* and specifically the "opening" of this region to view and the imaging of it as hole, is a particularly narcissistic activity in dialogue with the earliest stages of this logic of identification by which the individual is formed into history (the original fragmented image of the body that propels the subject into the "lure of spatial identification" that affords her or him the fantasy of [reflected] wholeness), while *Push-Ups* marks a slightly later moment (the projection of the self outward to affect the environment), and *Trappings* a later moment still (the retroactive yearning for a mythical pre-mirror-stage wholeness). Such a trajectory is traced explicitly by Lacan: "The *mirror stage* is a drama whose internal thrust is precipitated from insufficiency to anticipation—and which manufactures for the subject, caught up in the lure of spatial identification, the succession of phantasies that extends from a fragmented body-image to a form of its totality that I shall call orthopaedic—and, lastly, to the assumption of the armour of an alienating identity," and, with the end of the mirror stage, the "deflection of the specular *I* into the social *I.*"[57]

Acconci's body art works from the late 1960s (such as *Push-Ups*) oper-
ate largely within the narcissistic framework of the mirror stage itself (and his
use of photography during this period, per Krauss's argument, is crucial to such
a focus); it is only in 1970–71—with works such as *Trappings* and beyond—that
Acconci expanded his narcissism to incorporate the other (within both the per-
formance and the audience), and this work primarily explores the state of alien-
ation in the other that Lacan identifies as post–mirror stage. These works often
involve women partners within the performance and the use of video within the
piece as well as for documentation. Acconci himself explained this trajectory in
his work: "Sometimes when I look back, it seems like I was a child growing up.
First a person looks at himself/herself, then realizes there's another person
there and interacts with him, then that there's a mass of people and interacts
with *them*, then realizes the entire world exists, and so on."[58] (After his body art
period, Acconci moved to large-scale public projects, fulfilling the final stage of
his development.)

In the earlier photographic body art work, Acconci employs the indexi-
cal photographic image through a "mirrorical return" to confirm the "having
been there" of his body and so the existence of his self (as image).[59] However,
as Craig Dworkin has argued, Acconci's use of multiple photographs to retrace
the movement of the body, rather than "proving" the substantiality of his
"having been there" in his full physicality as photography promises (falsely) to
do, in fact sets into play a relation of profound nonplenitude, of what Jacques
Derrida has termed *différance:* "Each photograph in the series differs only
slightly from the others, and any photograph has meaning within the series—
an early push-up, a later push-up—only in relation to the others."[60] In this way,
each element of "proof" (each photograph showing the change his movement
produced in the sand) is shown simply to have meaning in relation to (as differ-
ent from) the other elements, to which it defers in an endless "systematic play
of differences."[61] In this way, Acconci's apparent desire to ensure the effective-
ness of his body-as-subject-in-action through the photographic index points
up the inevitable failure of performance and its documentation to do so.

Acconci's focus on *activity* in his body art work—his interest in "per-
forming the body . . . completing the body . . . bringing the body about"[62]—is
common among male body artists of this period and contrasts dramatically
with the tendency among women body artists, who (as we will see in the fol-
lowing chapter) by and large explored questions of aesthetics, signification, iden-
tity, and sexualized subjectivity through the rhetoric of the still *pose* (even while
in performance, their bodies in motion). The frenetic activity of the male body
artists such as Acconci clearly works to ameliorate the objectifying effects of

their narcissism. As Iris Marion Young has suggested in her feminist phenome-nology of body motility, the body in action can claim a kind of transcendence as enacting an arc of intentionality.[63] The body is the "first locus of intention-ality," and the motion of the body orienting itself in its surroundings is the "most primordial intentional act," one that female subjects, projected into im-manence, have difficulty accessing. Thus the (male) body in action "organizes the surrounding space as a continuous extension of its own being," while the still (female) body is reduced to passive imago (the the female subject is encour-aged to "take . . . up her body as mere thing").[64]

At the same time, the paradox of such an attempt at, literally, *enacting* or *performing* transcendence is marked by the male body's failure to sustain such activity or to ensure its transcendence in the eyes of the other: just like its female counterpart, male body art is inevitably experienced as supplemental in performance and is immediately thereafter reduced to still traces and theatrical poses. One could even argue, as I will in chapter 4, that by taking on the pose rather than attempting to escape it (they had no choice, really), women body artists more directly interrogated the fundamental alienation of subjectivity-as-projected-image than did the majority of men body artists. Acconci is unusual among the latter in that he seems to have courted and actively explored rather than attempted to avoid the objectifying effects of the rhetoric of the pose.

Most obviously, the difference in effects and strategies between male and female body artists can be attributable to men's and women's different expe-rience of themselves in Western culture: as suggested by Young's phenomeno-logical formulation, women commonly experience themselves as objects or pas-sive recipients of action in patriarchy, whereas men attempt to activate their subjectivity as a way of proving or confirming their masculinity. While male body artists from this period tended to project themselves outward, *acting on* other participants and audience members as if to prove their self-sufficiency as subjects, their female colleagues tended to explore their immanence, their con-tingency on others. Women have been inscribed as image and identify them-selves in relation to how others view them; men strive to locate themselves as transcendent, somehow mythically cohering independently of the other.[65] While both women and men certainly fail in obtaining any stability in their existence as subjects (their body/self coherence), men have traditionally in Western patriarchy been given every opportunity to sustain the illusion of such stability while women have been robbed of such a chance.[66]

Krauss suggests that the body's movement "speaks of a literal mani-festation of presence," and I am arguing that it is just this manifestation of presence (which I insist is illusory) that motivated male body artists' obsessive

bodily activity.[67] Thus, Acconci claimed in a 1974 interview that "I'm the activator, I develop a set of reasons for my presence in a particular space."[68] Through the activity of his body in space, Acconci proves his selfhood, making his environment *mean* in relation to himself. The sand in *Push-Ups* is thus forced to signify Acconci's having been there, the trace of his body—but specifically in its transformative action, its capacity to change its environment. The movement and orientation of Acconci's body, in the phenomenological terms of Merleau-Ponty, proves the efficacy of its materiality in that it shows its ability to organize its spatial environment as an extension of its own emotional and physical existence: "it is clearly in action that the spatiality of our body is brought into being."[69]

But such activity, as I have already suggested, ends up undermining rather than confirming the transcendence of the male-subject-in-action. Not only does this subject-in-action show its ability to transform its environment, it also exposes its own contingency. Far from accepting the body and its surroundings, in a metaphysical, Kantian sense, as "systems of qualities, linked by some intelligible law, as transparent entities, free from any attachment to a specific place or time," Merleau-Ponty insists upon the contingency of the body/self on this environmental projection through movement: "It is never our objective body that we move, but our phenomenal body. . . . [O]ur body surges towards objects to be grasped and perceives them." Bodily movement highlights the nonunitary nature of the bodily subject: the phenomenal body—which begins as a vehicle for movement directed toward someone or something in the world only to become the end of such movement—is always dual: simultaneously "for me" and "for others," at once both subject and object.

For Merleau-Ponty, the body's movement in space traces its existence as consciousness, binding the physicality of the flesh to the consciousness that gives it meaning and form. Acconci's sequential, indexical "proofs" of his activity in the sand illustrate the striving that Merleau-Ponty's phenomenological model implicitly describes—in which the embodied subject *enacts* itself in the world to substantiate its existence as consciousness. While both Krauss and Merleau-Ponty outline a bodily relation to the world that is ostensibly gender neutral, in fact, their descriptions imply a masculine perspective.[70] And, as Judith Butler has pointed out, Merleau-Ponty's descriptions of perceptual phenomena are underscored by an implicitly normative logic driven by heterosexual male desires.[71]

Challenging Merleau-Ponty's gender-blind description of the way in which the sexual body is not simply the repository of the self but its enactment, the site where perception, cognition, desire, feeling, and materiality merge, Young

stresses that this role of the body in organizing space is played out quite differently by women and men.[72] Young extends Beauvoir's insights regarding the differently experienced tension between transcendence and immanence for men and women to suggest that the modalities of feminine bodily comportment, motility, and spatiality lean toward an "ambiguous transcendence" laden with immanence that inhibits them from projecting themselves in an uninhibited way into space. Because, per Merleau-Ponty, motility is an enactment of intentionality, such an inhibition limits women in their ability to connect aim with enactment, positioning them in "discontinuous unity" with their surroundings.[73] While male subjects are able to achieve a momentary unity by projecting themselves into outlying space, women experience themselves as *positioned in* space, as spatially constituted, thus negating or downplaying the potentially "transcendent" aspects of their ability to *constitute* space through movement.[74]

The tendency of the woman to "take up her body as mere thing" (she "gazes at it in the mirror, worries about how it looks to others, prunes it, shapes it, molds and decorates it"), itself born of her fear of being seen and fear of having her bodily space invaded, forces her to take a distance from her own body and "exist in discontinuity with her body."[75] But Young's argument tends to imply that men, then, sustain a mythical continuity with their spatial surroundings, a fulfilled exteriority that takes them cleanly out of their immanence. What Acconci's work shows us, in contrast, is that, in fact, this "continuity" and "transcendence" are elaborate performances that themselves must be continually enacted in order to confirm their privilege *as* masculine (in Butler's words, they are reiterated as codes of normative masculinity that attempt to secure its privilege). In *Push-Ups*, we have seen how Acconci—through his very attempt to indexicalize his body and so assert its fullness as acting force capable of changing its environment—performs the *différance* of the body's attempt to make meaning and confirm its presence through documented action: its embeddedness within the continuum of its own actions, each moment of which takes its significance only in relation to the others (each photographic trace of Acconci's impression and shifting of the sand thus, in Dworkin's terms, means nothing on its own).

The plenitude of text surrounding each of Acconci's performative acts confirms this slippage, which Krauss attributes to the vacantness of photography's indexicality. Acconci writes, "Imprints as the body's representative: the body moves into and, gradually, through the place. . . . I can adhere to the terms of my body, push against the boundaries, make the space adhere to the terms of my body (the space takes my shape—place as body)."[76] Acconci's attempt to anchor the piece's achievement of bodily and subjective plenitude through the

supplementary text subverts its aim, showing up the very insufficiency of the index (the photograph, the body in motion) in confirming such plenitude. In a number of other works, Acconci enacts an aggressive masochism as a means of exploring the boundaries of the body/subject. Like his ambivalently narcissistic self-display in *Trappings* and his insistent self-imprinting in *Push-Ups*, however, Acconci's masochism takes him into ambiguous gender territory.

MASOCHISM: THREATENING OR REINFORCING THE MALE BODY?

Typically of male body art from the early 1970s, much of Acconci's work from this period explores masculinity through sadomasochistic behavior. This fixation on the sadomasochistic relationship by male body artists (who, in relation to the Pollockian performative, have a stake in confirming the ways in which power accrues to subjects in relation to the objects of their actions) seems to confirm Leo Bersani's observation, through Michel Foucault, that sexuality is the ground of the effects of power that are inherent in the relational itself. It is in the sexual relation (both within and between subjects) that what Foucault calls the "divisions, inequalities and disequilibriums" present in every relation are polarized into oppositional positions of mastery and subordination. In this sense, Bersani suggests, masculinism or phallocentrism can be said to be above all the denial of the *"value* of powerlessness" (the pleasure afforded by the "radical disintegration and humiliation of the self" in sex) and sexuality itself "may be a tautology for masochism."[77]

While many male body artists—from Chris Burden to the Viennese actionists (especially Rudolf Schwarzkogler) and more recent S/M artists such as Bob Flanagan and Ron Athey—have subjected themselves to the masochistic violence of others, Acconci is strikingly unusual among them for the extent to which he pushed the sadomasochistic dialectic of self/other, masculine/feminine, as a means of interrogating (but also, as we have seen, recohering) his own subjectivity and masculinity. Acconci, unlike most of these other artists, frequently took on both sadistic and masochistic roles in rapid oscillation or simultaneously. In doing so, he radically undermined the bipolar model of S/M, masculine/feminine, self/other that characterizes the popular conception of sadomasochism, which reduces Freud's complex, if ambivalent, schema to an association of masochism with a feminizing desire for subjection on the part of male subjects.

In 1969 and 1970, Acconci's exploration of masculine subjectivity took place through simple formats in which he took on the role of aggressor—often, masochistically, against himself: in *Trademarks* (1970), Acconci bit into his body (to "build . . . up a biography, a public record"), using his own self-

VITO ACCONCI, *FOLLOWING PIECE*, 1969; FROM *STREET WORKS IV*, SPONSORED BY THE ARCHITECTURAL LEAGUE OF NEW YORK, NEW YORK CITY. PHOTOGRAPH COURTESY BARBARA GLADSTONE GALLERY, NEW YORK.

aggression to confirm his selfhood once again through the leaving of traces of his action, but this time on himself rather than on his environment;[78] in *Following Piece* and *Performance Test* (both 1969), Acconci sadistically inflicted himself on others—respectively, through a literal act of stalking (by following unknowing people until they entered private space) and through the violent agency of the gaze (by staring at each person in the audience one by one).

In all of these cases, Acconci sets up a dynamic of aggression and victimization—with himself variously as victim or masochist (in *Trademarks*) and sadistic aggressor (in *Trademarks, Following Piece,* and *Performance Test*). In all of these cases, such violence enables Acconci to discover or recover "himself" from the post-mirror-stage self/other relation: of *Trademarks,* he writes tellingly, "Finding myself . . . the attempt is to reach, mark, as much of my body as possible./ Turning in on myself . . . a way to connect, re-connect my body . . . / Stake a claim on what I have."[79]

The solipsistic nature of Acconci's exploration of the sadomasochistic character of self/other relations is highlighted if one compares his *Following Piece* with a similar, but explicitly feminist, piece by Yoko Ono from the same year.[80] *Rape*, directed by Ono in collaboration with John Lennon, enacts the gender-specific orientation of the predatory impulse that Acconci explores exclusively in terms of his own subjectivity (in spite of his interpellation of an other).[81] Acconci's strategic act of following is motivated, as he himself admits, by a desire to define himself *through* a relation with the other rather than by any need to explore the other for her or his own sake: "If I pick someone to follow, then I can be tied into this other person. I can be dragged into another person. . . . [In *Following Piece*] there was no viewer or, if anything, I was the viewer. I see myself as the audience of people walking in the street."[82] Here, Acconci allows that what he really wants is to incorporate the other, to *become* the viewer, not to explore her/him in her/his difference. The other is nameless and genderless in Acconci's written account, serving simply as a "feminized" object of Acconci's following activity.

Ono, on the other hand, specifically traces the violence and gendered specificity of precisely such a desire, which in patriarchy motivates men's predatory relationships with women. In *Rape*, Ono's 1968 script directs, "[a] cameraman will chase a girl on a street with a camera persistently until he corners her in an alley, and, if possible, until she is in a falling position."[83] Both *Following Piece*, with Acconci following people only as long as they remained in the public sphere, and *Rape* clearly address the vulnerability of the subject to the omnipresent gaze of the "Other" (Lacan's other with a capital O: "At the scopic level, we are no longer at the level of demand, but of desire, of the desire of the Other").[84] Ono's piece is clearly about the sadistic violence of the embodied gaze (here projected through its most efficient apparatus, the camera, which enacts its embodiment by literally cornering the woman or infantilized "girl," making her fall down), and the way in which the human subject in general becomes objectified and violated when exposed to the public eye (as Ono had been since her relationship with Lennon had begun). But it is also just as clearly about the fixation of this gaze on the bodies of women, and the specific ways in which such objectification demobilizes women in the public sphere.[85] In a poem essay "On Rape" written around the same time, Ono writes to a hypothetical male reader: "What would you do if you had only one penis and a one-way tube ticket and you wanted to fuck the whole nation in one come?"[86]

The comparison of these two pieces raises interesting questions about the different relationships men and women living in patriarchy have had to the violent alienation of subjectivity and, in Bersani's terms, what we might awk-

127

YOKO ONO (DIRECTOR), PRODUCTION STILL FROM *RAPE (FILM NO. 5)*, 1969; NIK
KNOWLAND (CAMERA), EVA MAJLATA (ACTRESS), AND CHRISTIAN WRANGLER (SOUND).
PHOTOGRAPH © 1969 YOKO ONO LENNON.

wardly call the "sado-masochisization" of the self/other relation. While Ono
experiences such alienation and violence as gendered, as motivated by a mas-
culinist desire for phallic transcendence (a desire to "fuck the whole nation in
one come"), Acconci's work at this point explores this alienation always in rela-
tion to himself as an ostensibly gender-neutral stalker. Recognizing the in-
evitable failure of his desire for transcendence (and hence powerfully exposing
the misalignment between penis and phallus), Acconci appears to seek out and
perform relationships of sadomasochistic violence because he yearns for a means
of cohering himself in relation (first) to his own alienated imago and (second)
to the other. For Acconci, again, enacting his body is precisely a way of at-
tempting to transcend its cumbersome, immanent specificity: "'performing
the body' could mean going through the body's form—completing the body—
finishing with it."[87] And yet, as noted, Acconci's penetratory woundings of
himself as well as his stalking or gazing of the other ultimately point to the
profound failure of his attempts to secure self-coherence.

The prevalence of, especially, masochistic strategies in male body art
suggests that such attempts at transcendence continue—even (or especially?)
in the "post-Pollockian" era—to be fundamental motivating factors for male
artists. The ambivalence of much of this work can be located in part as an ef-
fect of its obsession with the hegemonic Pollock myth.[88] Thus, it is precisely

Pollock's image of ambivalent transcendence that is both countered and in some ways reinforced by the riven, punctured, suffering body of the masochistic male body artist: Acconci biting his arm; Chris Burden having himself shot; William Wegman jamming toothpicks into his gums and tying up his tongue; Barry le Va ramming his body over and over again into the walls of a gallery until he splatters them with blood; Skip Arnold jamming his body between two boards leaning against a wall; Bob Flanagan lacerating, nailing, and sewing up his penis; Stell'Arc having his body hung from huge meat hooks; Dennis Oppenheim placing himself in situations of extreme physical danger; Terry Fox pushing his body harder and harder into a corner; Paul McCarthy "wounding" his body with ketchup while parodically enacting the heroic boxing feints of Rocky; even the faked masochism of Klein's heroic *Leap into the Void*.[89]

Male artists have thus obsessively staged themselves in masochistic scenarios. Kathy O'Dell has explored this phenomenon in some detail, although she does not discuss masochistic strategies as being particular to male body artists, as I do here. O'Dell argues suggestively that

> [t]he masochistic artists of the early 1970s pointed out the *dematerialization* of accountability on the part of society-at-large through a *materialization* of the vulnerability of the body-as-object. By putting the material objecthood of the body at risk in acts of masochism, they showed that it is this bottom-line status of the body which is at stake when negotiation over the body's many dualistic identities is elided. . . . In choosing masochism, artists betrayed their own enslavement to and tried to free themselves from (to 'cure' themselves of) modern contract.[90]

In these terms, Acconci's masochism could be seen as an attempt, motivated by the insecurities unleashed by the massive social upheavals of the late 1960s, to materialize his own vulnerability and reclaim its specificity as resistant to the social contract (for O'Dell, this is the contract younger generations saw as voided by the role of the United States in Vietnam).

And yet, masochism, I would insist, is gendered and sexualized in its deepest structures. In the psychoanalytic framework it is the *male* masochist who subjects himself to the agency of a *female* dominatrix, subverting the active/male alignment that secures for masculinity its claim to transcendence. While the male artists' masochistic acts are carefully staged for viewing audiences (masochism in their case, then, is most often metaphoric rather than clinical), they nonetheless enact specific aspects of clinical masochism.[91] According to Freud, masochism is a perversion experienced by the male subject, one characterized by a passive atti-

tude toward the sexual life, or a narcissistic and feminized relation toward sexual pleasure (a dynamic that would, of course, correspond to Acconci's "feminization" as described here).[92] The masochistic subject fantasizes being beaten or tortured, the object of another, usually female, subject of violence. For Freud, male masochists "invariably transfer themselves into the part of a woman; that is to say, their masochistic attitude corresponds with a *feminine* one."[93]

Such a willful subjection of the masculine body to the violence of an other might seem in a direct and simple way to unhinge male subjectivity's normative link to the active wielding of power. And yet, as other theorists of masochism have argued, this "perversion" of masculinity can also function as a means of ensuring the coherence and power of the masochistic subject. Theodor Reik, for example, writes that "the masochist . . . cannot be broken from the outside. He has an inexhaustible capacity for taking a beating and yet knows unconsciously he is not licked."[94] Hence, the masochist's self-induced mutilations serve to reinforce the impenetrability of the heroic male body, its survivability under any violent circumstance.

Paralleling Reik's observation, Gilles Deleuze argues in his study of masochism that the masochist hardly relinquishes power, as Freud's model of passivity would suggest: "[t]he masochistic hero appears to be educated and fashioned by the authoritarian woman whereas basically it is he who forms her . . . [and] prompts the harsh words she addresses to him. It is the victim who speaks through the mouth of his torturer."[95] The masochist, then, *commands* the very action by which he suffers. With Acconci's *Trademarks*, this action was primarily self-inflicted. With Chris Burden—an exemplary practitioner of masochistic body art and an interesting contrast to Acconci's far more ambivalent forays into sadomasochistic relations—Deleuze's model follows more directly, since he usually ordered others (but usually male friends)[96] to perform violent acts upon his body. Thus, in the infamous *Shoot* (1971), Burden stood in a gallery and ordered a male colleague to shoot him; the bullet grazed his upper arm.[97]

Burden's work is exemplary of Reik's and Deleuze's point. Through his self-subjection to a masochistic relation Burden seems clearly to reiterate normative codes of masculine artistic subjectivity—specifically through what Max Kozloff identified as a tendency toward "martyrology"—rather than to challenge them, at least if the largely celebratory reception of his work can be taken as "proof" of its alignment in this regard.[98] In *Trans-fixed*, performed in 1974, Burden ordered a colleague to nail his palms into the roof of a Volkswagen, which was then pushed halfway out of Burden's garage in Venice, California. The engine, Burden's explanatory text reads, "was run at full speed for two minutes," then the car was pushed back into the garage. The relics from this piece

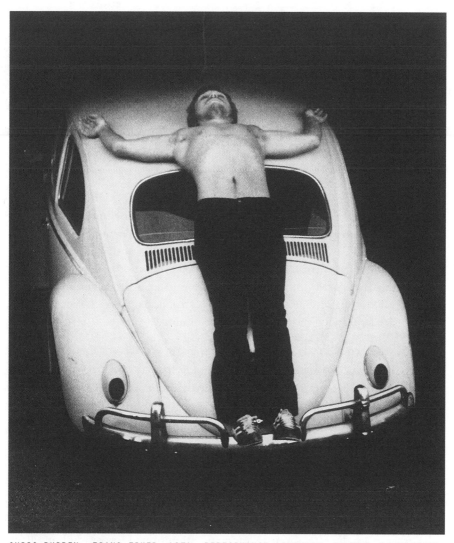

CHRIS BURDEN, *TRANS-FIXED*, 1974; PERFORMANCE ACTIVITY, VENICE, CALIFORNIA.
PHOTOGRAPH COURTESY OF THE ARTIST.

were, appropriately enough, the two nails used in attaching Burden's hands to the car. Of course, as with the bloody ritual performances of Viennese Actionists Hermann Nitsch and Rudolf Schwarzkogler, *Trans-fixed* evokes the crucifixion of Christ and the martyrdom of his saints, positioning Burden metaphorically within the ranks of divine artistic sacrifice attained by the suicided Jackson Pollock.[99]

Burden's dry and direct presentation of documentation, his deadpan submission of himself to the violence of others (who are ordered and/or

scrupulously controlled and framed by Burden), reiterate normative codes of masculine artistic genius-as-transcendent; and yet the reiteration is so insistent and so exaggerated, Burden might also be interpreted as unhinging these codes through parody.[100] Acconci, contrastingly, continually exposes his own vulnerability in his performances and statements, in which he reveals an unusual sensitivity to this double bind for male artists exploring the masochistic elements of masculinity in the shadow of the Pollockian performative. Acconci also frequently evinces a deep awareness of the contingency of meaning and the elusiveness of his own intentionality:

> I didn't think [my early work] . . . was masochistic. . . . But . . . yeah . . . I might have wanted to deny those masochistic elements. . . . [T]here are ways of reading [this work] . . . which I might not have intended but which I can't deny. They imply a funny notion of artist as sacrificial victim. I thought I was doing exactly the opposite, thought I hated that notion of artist as priest, art as religion, artwork as altar. I think, now, my work was confirming those notions in a lot of ways whether I wanted it to or not.[101]

While I experience Burden's work as leaning toward a confirmation of male privilege vis-à-vis artistic production, I read Acconci's work as exposing the complicated and ambivalent codings of the masochistic in relation to artistic genius. Acconci's far more pathetic masculinity highlights rather than occludes the way in which the veiling of Pollock's masculine body served, paradoxically, both to legitimate the claim of him as transcendent genius and also to position him as desired (if hidden) "object" of art historical or art critical desire.

In his body art works that include another person (usually Kathy Dillon, his partner in the early 1970s), Acconci stages what first appears to be a classic sadomasochistic relation, exhibiting an extraordinary fixation on controlling the self/other, masculine/feminine relation and attempting to position himself on the side of sadism. And yet it is precisely his continuing *vulnerability* to the female other in the piece (Dillon) as well as to the audience he attempts to control (his failure, in fact, successfully to exert such control) that exposes the convergence between the sadistic and the masochistic drives: the coextensiveness of one's subject- and objectivity, in spite of whatever oppressive violence is projected outward.

MASOCHISM AS SADISM AND THE SELF-OTHER RELATION IN BODY ART

In 1971 Acconci executed a number of performances in which he discarded the masochistic role for one of explicit sadism vis-à-vis both his audience and,

VITO ACCONCI, *CLAIM*, 1971; PERFORMANCE AND VIDEOTAPE, 93 GRAND STREET
GALLERY, NEW YORK. PHOTOGRAPH COURTESY BARBARA GLADSTONE GALLERY, NEW YORK.

increasingly often, a female collaborator within the piece. In his performance-
video piece *Claim,* for example, Acconci posed himself as oppositional to his
audience through sadistic speech and violent actions, aggressively rejecting the
masochistic role of desired object in which the veiled body of the male artist is
subtextually placed within the formalist modernist critical system. A video
monitor at the head of a stairway in the 93 Grand Street Gallery in New York
showed Acconci sitting blindfolded at the base of the stairwell, brandishing a
metal pipe and screaming threats at his potential visitors: "I want to stay alone
here in the basement. . . . I'll stop anyone from coming down here."[102] By
projecting his vulnerability and victimization (as artist/performer subjected
to the desiring and critical gaze of the other) definitively onto the audience,
Acconci enacts the painful ambivalence of the post-Pollockian male artist.
Again, Acconci has admitted that his desire to challenge the unspoken violence
of the male artist's authority by *performing* rather than *veiling* his power had am-
biguous effects: "What that piece really does is confirm a kind of art world
hierarchy in which the artist is on a higher plane than the viewer. . . . I chose a
very grandiose position for myself."[103]

Just as his early photo works had failed to guarantee the presence or
the having-been-there of Acconci's full embodied subjectivity, so his 1971 inter-
subjective performances mark Acconci's inability to construct the other in a

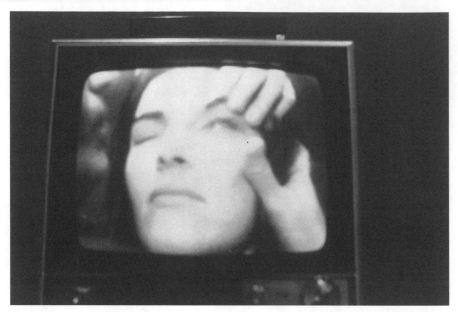

VITO ACCONCI (WITH KATHY DILLON), *PRYINGS*, 1971; PERFORMANCE AND VIDEOTAPE, EISNER AND LUBIN AUDITORIUM, NEW YORK UNIVERSITY. PHOTOGRAPH COURTESY BARBARA GLADSTONE GALLERY, NEW YORK.

fully masochistic—fully subordinate—position, or himself in a situation of transcendent power. In *Pryings* (1971), a seventeen-minute video in which Acconci is shown brutally mauling Dillon's face as he tries to pry open her tightly closed eyes, Acconci's frustration and failure to "penetrate" her visage, in spite of his superior strength, deflates the very violence of his actions. Dillon repudiates his attempt to make her react to him and thus to confirm the effectiveness ("transcendence") of his activity.[104] In *Remote Control*, a one-hour video performance (which includes two simultaneous videotapes), Acconci and Dillon sat in separate rooms, each in a box watching a monitor showing instant feedback of the other. Through the distanced (if indexical) agency of the videotape, Acconci attempts to control Dillon; describing himself tying her up, he wants to convince her to comply with his description. Once again, however, Acconci recognizes that his desire to control Dillon is about his desire to cohere himself: "my aim is to convince, control myself—in so doing, I can convince, control, Kathy."[105]

Shortly after completing these intersubjective videos, performances, and films in the early 1970s, Acconci moved away from using himself in his work altogether, frustrated with the way in which his (male) body continually became recuperated into a normative masculinity that he insisted he had wanted

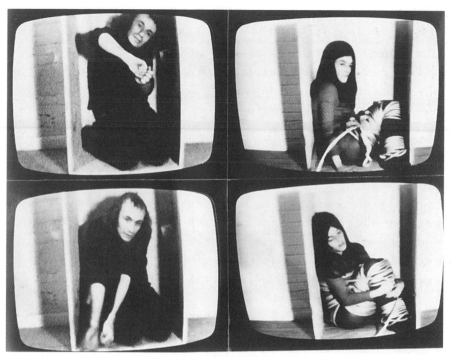

VITO ACCONCI (WITH KATHY DILLON), *REMOTE CONTROL*, 1971; FOUR STILLS FROM
VIDEO INSTALLATION WITH TWO SIMULTANEOUS VIDEOTAPES. PHOTOGRAPH COURTESY
BARBARA GLADSTONE GALLERY, NEW YORK.

to throw in question. Thus, in regard to *Remote Control* and *Broadjump,* another
work from 1971, he later admitted that "they are really sexist. It's pretty clear
that they are about dominance and submission in a relationship and I was the
dominant one. . . . I hate maleness and I hate male domination, but because it is
so culturally embedded, I can readily fall into it. . . . My work had become cen-
tered on this personality that was acting like a priest at the high altar of art and
I hated it."[106] Turning his masochism and narcissism outward toward Dillon (as
sadism), he had only served further to exaggerate his own yearning for transcen-
dence. And yet, I would argue that it is just such an exaggeration that allows one
to read these works, through their enactment of the pathetic failure of the male
subject to achieve such transcendence, as troubling to norms of masculinity
(as, in this sense, successful in achieving the critique of artistic genius Acconci
ambivalently strove to implement). In this way, Acconci exposes the powerful
ambivalence of male masochism, which turns the male subject both toward his
immanence (his fleshy, pain-responsive corporeality) and yet also outward to-
ward a violence-resisting sadism/transcendence.

GENDERING MASCULINITY: THE AIM TOWARD COHERENCE AND THE
DUALISTIC LOGIC OF THE HETEROSEXUAL GENDER MATRIX

As my discussion of Acconci's 1971 body art projects with Dillon indicates,
the stakes of the body art project in general are highlighted in works that in-
volve explicit explorations of the gendered coding of intersubjective relation-
ships. Acconci's body art projects encourage us to interrogate the dynamic by
which normative masculinity requires the expulsion of otherness to sustain its
mythical claim of coherent plenitude and empowerment. Acconci's internally
intersubjective pieces (that is, those including an other within their initial
performance) suggest that the very need for the continual performance of
masculinity—the repetitious restaging of its boundaries to keep out that which
is not *it*—testifies not to its coherence but, rather, to its radical interdependence
on the otherness that it attempts to exclude; at the same time, his very reit-
eration of gender norms in this performance of masculinity can easily be expe-
rienced (as Acconci acknowledged) as regressively reconstituting his phallo-
centric privilege as a male artist.[107]

In looking at several of his most aggressively intersubjective and sexual-
ized pieces, however, it becomes equally clear that Acconci's obsessive need to
project himself into femininity is not dislocating of masculinity in any simple
way. Once again it is the ambivalence toward masculinity performed in Acconci's
work that makes it potentially so radically destabilizing to the norm. Acconci's
Seedbed exemplifies this destabilizing ambivalence toward the comforting bi-
polarism of sexual difference. While there is no other performer within the
piece for Acconci to harass or seduce, in *Seedbed* he specifically addresses the
highly charged sexual *chiasmus* of the artist-art work-spectator exchange: the in-
terconnection of the artist/self and the viewer/other within the field of experi-
ence that, in Merleau-Ponty's phenomenological terms, marks the world "as
flesh"—the "openness through flesh," the chiasm or "doubled and crossed situ-
ating of the visible in the tangible and of the tangible in the visible." "My body
as a visible thing," Merleau-Ponty continues, "is contained within the full spec-
tacle. But my seeing body subtends this visible body, and all the visibles with it.
There is a reciprocal insertion and intertwining of one in the other."[108] This is
the interconnectedness that arises from the very "fundamental narcissism of all
vision" (whereby "the vision [the subject] . . . exercises, he also undergoes from
the things") that Acconci's self-involvement stages so dramatically.[109]

In *Seedbed*, Acconci, precisely, performs his narcissistic relation to his
own body *in order to interpellate the experiencing visitor* (because the aural register is
crucial while the visual register is stopped up, *viewer* is hardly an accurate term
here) within structures of sexual desire and sexual difference. As with *Trappings*,

here it is Acconci's narcissism and self-involvement that paradoxically open him to the other: it is his yearning to cohere himself that inexorably leads him to initiate numerous interpersonal relationships; in this way he (as paradigmatic of the masculine artistic subject) proves he is the "self" (the subject who acts, who initiates, in relation to the passive other) but also proves his dependence on this other. Acconci's performance suggests that narcissism is paradoxically, for masculinity, the very mode by which it regulates, excludes, and/or incorporates the other: this is the "law of the self-same" through which, as Luce Irigaray argues, masculinity enacts itself *as* the norm of subjectivity, decreeing that women "lack" in relation to the original guarantor of coherent subjectivity (the phallus/penis) defined (solipsistically) from the masculine point of view. Woman is "well and truly castrated from this economy," which draws on the very anatomical attributes of the masculine to define what a full, noncastrated subject is.[110]

Acconci's *Seedbed* plays out the solipsistic narcissism at the root of masculinity's privileged relation to power. In his published statement about *Seedbed*, Acconci states, "Whenever I happen to reach climax, the viewer might want to pick himself or herself out of the crowd; the viewer might want to think: he's done this for me, he's done this with me, he's done this because of me."[111] On the one hand, in specifying the interpellated visitor as female *or* male, it would seem that Acconci further opens the subject/object exchange of artistic production to a radicalizing, polymorphous erotics of intersubjective experience. On the other hand, Acconci's statement makes clear the narcissism his interest in intersubjective exchange involves: "he's done this *for me*," and so on. While he is enthralled by the observer's response to him through the chiasmic link of self/otherness, Acconci's fascination returns to himself (per Merleau-Ponty's observation: "since the seer is caught up in what he sees [in this case, Acconci seeing his penis] it is still himself he sees" even though he addresses his audience about his desire)[112]—and particularly to the power of seduction he can wield, as an artist, over a gallery audience.

Once again, then, this performance can be interpreted as being both masculinizing—in its empowerment of the performing male subject as he who defines the circuit of desire—and feminizing—in that his performative, masturbatory act positions him as desiring of the viewer's desire, exposing a "desire to desire" on his part that aligns him with the female subject in patriarchy.[113] As object of the male or female viewer's desires (themselves anticipated and projected by Acconci), Acconci feminizes himself, staging an oscillatory circuit of bisexualized desires between himself and his audience.

In contrast to this reading, Mira Schor's 1988 essay "Representations of the Penis" discusses Acconci's piece as exemplary of the way in which male

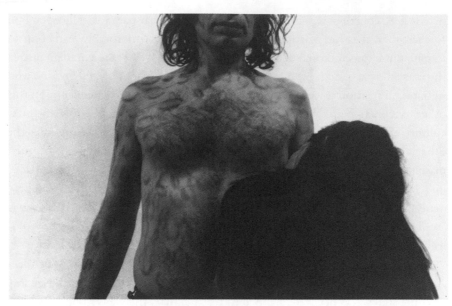

VITO ACCONCI (WITH KATHY DILLON AND DENNIS OPPENHEIM), *APPLICATIONS*, 1970; SUPER-8 FILM OF PERFORMANCE AT ART INSTITUTE OF CHICAGO. PHOTOGRAPH COURTESY BARBARA GLADSTONE GALLERY, NEW YORK.

artists explored masculinity in the early 1970s only to reaffirm its privileges. She argues that in determining his goal as "the production of seed," Acconci makes the gallery "the site for the production and display (although unseen) of male sexuality. . . . There is reference and allusion to the penis, but the artist and his penis . . . remain hidden in a mantle of art."[114] And yet, couldn't one argue that through his obsessive handling of his penis in relation to the visitors he cannot see and who cannot see him Acconci is surfacing the erotics of the marketing of art: the commodification of male procreative prowess via a hidden mechanics of transference, whereby masculinity is most valuable when it is carefully hidden behind (and conflated with) the objects of art?[115]

Acconci executed several other internally intersubjective performances that explicitly address the chiasmic, sexually charged mechanics of transference involved in the making and viewing of art. In *Applications* (1970), with Kathy Dillon and Dennis Oppenheim, Acconci used his own chest and arms, which acted as mediating templates to transfer the lipstick that Dillon had kissed on to his body onto Oppenheim's back. Through physical contact with a woman, Acconci *transfers* significant form onto the receiving body of Oppenheim, who acts as "canvas" bearing the traces of this "divine" intervention. In *Transference Zone* (1972), Acconci locked himself in a room with a group of photographs and objects owned by seven significant people in his life. One at a time, he let in

VITO ACCONCI, *TRANSFERENCE ZONE,* 1972; INSTALLATION/PERFORMANCE,
SONNABEND GALLERY, NEW YORK. PHOTOGRAPH COURTESY BARBARA GLADSTONE
GALLERY, NEW YORK.

visitors who knocked on the door, transfering his feelings about these "prime" people onto the unsuspecting recipient. In a Ouija-like game involving the mediumistic transference of codes of "identity," Acconci again poses himself as the intermediary locus for a kind of metaphysical intersubjective force. Playing out Freudian notions of transference—a dynamic involving the projection of one's subconscious conflicts and desires onto an other—Acconci's piece opens out the contingency and performativity of identity and subjectivity itself: the presence of the prime people, he states in notes accompanying the piece, "is embodied in the visitors to the gallery. . . . I try to react to [the visitor] . . . as if he were one of the prime persons. (I . . . transfer his image and my feelings for him to the viewer). It's close here, crowded—the viewer . . . sinks into the prime person's clothes, on the floor. . . . [T]he viewer might feel himself falling into the prime person."[116]

The effects of the ambivalence of Acconci's approach—his staging of intersubjectivity in terms of his precarious masculinity—become clear if one compares *Applications* and *Transference Zone* with the "Relation Works" by a male-female artist team—Marina Abramović and Uwe Laysiepen (known as Ulay/ Abramović)—who conceived and executed their works as equal partners.[117] While Acconci stages himself as the aggressor, trying to seduce, project onto, or physically manipulate the woman and/or audience member (in *Pryings* and *Transference Zone*), Abramović and Ulay produce (or, more accurately, *co*-produce) virtually symmetrical performances that are all the more striking for the ways in which, in spite of the artists' attempt to transcend gender, power always already becomes unbalanced. In *Relation in Space* (1976), their naked bodies assault each other repeatedly for one hour: "In a large, empty space, repeatedly two bodies touch each other frontally at high speed."[118] In *Imponderabilia* (1977) they stand naked, face to face, in the doorway of the Galeria comunale d'arte moderna in Bologna, forcing visitors to pass between them to enter the gallery and, in the process, to choose which artist to face in doing so.[119]

These pieces would seem to have everything to do with the staging of sexual difference: with *Relation in Space*, the collision of a female and a male body suggests a metaphoric performance of the stubbornness of this difference; in the case of *Imponderabilia*, the visitor is forced to confront, rub against, and/or identify with the anatomically gendered body of either Ulay or Abramović. As Kathy O'Dell has pointed out, however, in their statements Ulay/Abramović propose a universal notion of subjectivity ("we negate the general idea of man and woman") that tends toward "a totalizing conception of gender that would erase a more complicated notion of sexual difference."[120] I experience Ulay/ Abramović's practice as signaling a radical opening out of the way in which

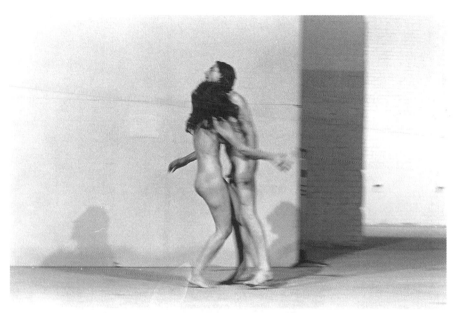

MARINA ABRAMOVIĆ AND ULAY, *RELATION IN SPACE,* 1976; PERFORMANCE AT VENICE BIENNALE. PHOTOGRAPH BY JAAP DE GRAAF, COURTESY OF THE ARTISTS.

heterosexual gender is structurally determinative of the ways in which the inter-subjective relation conditions meaning in the interpretive relation. But, on the level of their own discourse, the very egalitarianism with which Ulay/Abramović attempt to stage their relationship to each other and the audience aligns their body art works with a universalizing conception of sexuality and gender that ultimately veils the privileging of masculinity in what is in effect experienced as a bipolar model of gender.

Acconci's body art works, on the other hand, stage the asymmetry of gender relations and expose masculinity in its contingency and deformity. Notably, Acconci does not mention gender at all in the *Transference Zone* piece, which generalizes the effects of transference. It is written into Freud's account of the transference, however, that this relationship is always sexualized (as noted, it consists of an exchange of feelings that "invariably rest ultimately on an erotic basis"). Certainly, too, without Freud's having admitted it, his inability to come to terms with his own (counter)transference in various well-known analytic cases shows the threat that such a sexualization of intersubjectivity has on the "integrity" of masculinity.[121] Transference is not only a sexualized exchange, it is, in fact, the site of the unbinding of gender: in transference, "the whole interplay of identifications is given free reign to develop and to become 'unbound.'"[122] Or, as Eve Kosofsky Sedgwick has felicitously put it, "erotic iden-

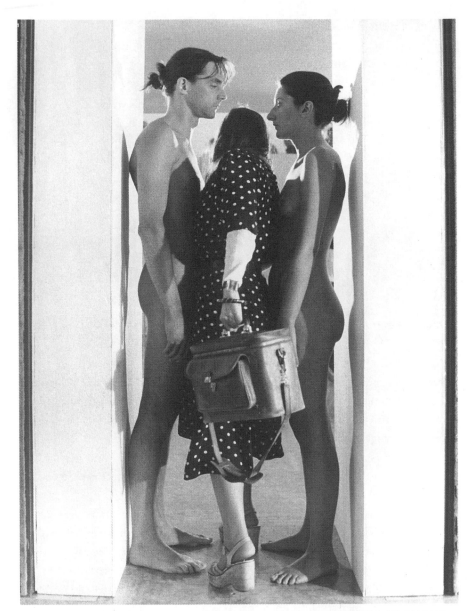

MARINA ABRAMOVIĆ AND ULAY, *IMPONDERABILIA*, 1977; PERFORMANCE AT GALERIA
COMUNALE D'ARTE MODERNE, BOLOGNA. PHOTOGRAPH BY GIOVANNA DAL MAGRO, COUR-
TESY OF THE ARTISTS.

tity, of all things, is never to be circumscribed simply as itself, *can never not be relational,* is never to be perceived or known by anyone outside of a structure of transference and countertransference."[123]

Seedbed is radical not simply because it brings the undecorous onanistic act into the gallery but also because it enacts, through the artist's open sexualization of himself, the very eroticism at the foundation of not only the self/other and artist/viewer relations, but also of the very structures of interpretation through which art and artist are experienced and given value. It is through the open-ended structures of transference and countertransference that meaning takes place. But the open-endedness of these structures is highly threatening to the systems by which meaning and aesthetic value are secured within the art critical system, where the "artist-hero . . . is . . . revealed as a filter or aesthetic mediator . . . a distillator of the Essential from the world," the artwork is "framed as a record or trace of the artist's originality and individuality," and the "art historian or critic is the implied practitioner or operator of a revelatory machinery, working at the recuperative task of reconstituting for a lay audience an originary fullness of meaning and reference."[124] Through the specific *masculinization* of the "artist-hero," meaning and aesthetic value are saved from the threatening morass of sexualized intersubjectivity.

As I have suggested here, Acconci's internally intersubjective body art works from 1971 (those that include other bodies/subjects within them) deploy the sadomasochistic relation to interrogate the dynamic by which normative masculinity requires the expulsion of otherness to sustain its mythical claim of coherent plenitude and empowerment. Acconci's intersubjective hysteria—his desire to mimic the feminine in order to explore the masculine—is dramatized in *Conversions,* a performative Super-8 film from 1970-71. First Acconci takes a candle and burns off his chest hair, in his published statement explaining that "once my chest is hairless . . . I pull each breast in a futile attempt to develop a woman's breast." Here, Acconci brutalizes his hairy, clearly masculine body directly, ostensibly in an attempt to transform it into a feminine one: to forsake the transcendence that is his "right" as a white male artist for a kind of fleshy immanence (where the male body is stripped of its hirsute "armor"). The antithesis of a coherent, veiled masculine body/subject, Acconci's body becomes a series of sites of feminization. The second part of *Conversions* thus consists of Acconci "walking, running, jumping, bending over . . . all the while," he explains, "attempting to keep my penis 'removed,' held between my legs." Finally, in *Conversions III,* a woman kneels behind him and he pushes his penis back into her mouth. Acconci describes this act as follows: "When I'm seen from the

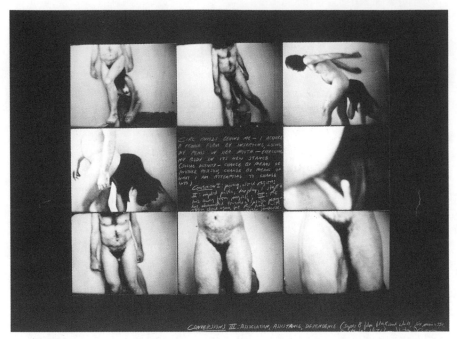

VITO ACCONCI, *CONVERSIONS III*, 1971; STILLS AND CHALK ON BOARD DOCUMENT-
ING PERFORMANCE ACTIVITY FILMED IN SUPER-8 BLACK AND WHITE. PHOTOGRAPH
COURTESY BARBARA GLADSTONE GALLERY, NEW YORK.

front, the woman disappears behind me and I have no penis, I become the
woman I've cancelled out."[125]

Again, Mira Schor has interpreted Acconci's piece negatively, writing,
"The phallus reinscribes itself over the erased/lacking woman, even as the penis
is hidden, as usual."[126] But Schor's formulation of Acconci as simply misogy-
nistic is, I think, reductive. In its effacement of both masculinity (the hiding of
his penis, which serves perhaps only to highlight its importance and, as a felici-
tous aside, gives Acconci sexual pleasure) and femininity (the "cancelling out" of
the woman) couldn't this ritual be said to enact the reciprocity of gender iden-
tity and the fundamental lack installed at the core of all subjectivity? Even *as* he
egregiously appropriates the feminine (per Schor's critique), Acconci proffers
the penis as a *transferable* attribute, suggesting that the *idea* of masculinity both
relies on and secures the privileged meaning of the body-with-a-penis, which in
turn both depends upon and legitimates the figure of the artistic genius and, by
extension, his works of art as masterpieces. With the exchange of the penis/
phallus, Acconci opens his body/self/artwork to the radical contingency of
intersubjective identification and desire.[127]

Acconci's *Conversions* explores the way in which the male body legiti-

mates but also is legitimated by its continual (and always already failed) staging of plenitude, the way in which the privilege of artistic genius accrues to the body-with-penis in modernism. Acconci's intersubjective body art in general enacts the *fragility* of this system by which masculinity ensures its privilege.[128] The male's aggression against the other is about his own lack; and this failed attempt to control the female/other parallels the artist's attempt to control his audience. As the artist is purveying his work (here, coincident with "himself") he loses himself to his others/interpreters. While we are "free" in a limited way to articulate ourselves within the constraints that configure our embodied existence, meaning takes place as a negotiation between the embodied subjects involved in the cultural exchange: in Merleau-Ponty's eloquent formulation, "we are collaborators for each other in consummate reciprocity."[129]

Acconci projects himself as ejaculating yet victimized, the directing subject *of* the action *and* the receptive object of spectatorial desire—marking the ultimate exchangeability and interdependence of each element in the supposedly oppositional categories of viewer/viewed, male/female, subject/object. Acconci's "artist-hero" is chiasmically contingent, his masculine claim of transcendence deflated by the open enactment of the "intertwining" of the seeing body and the body that is seen. The penis itself in Acconci's piece becomes a *transferable* attribute, marking that, in Judith Butler's terms, "the ambivalence at the center of any construction of the Phallus belongs to no body part, but is fundamentally transferable and is . . . the very principle of erotogenic transferability."[130] The *idea* of masculinity ("the idea . . . emerges simultaneously with the phenomenologically accessible body, indeed . . . guarantees its accessibility")[131] that both relies on and secures the meaning of the body-with-a-penis, which in turn both depends upon and defines artistic genius, is opened up to the radical contingency of intersubjective identification and desire. Butler, again, performs this idea, enacted by Acconci through *Conversions,* in a theoretical register:

> As a projected phenomenon, the body is not merely the source from which projection issues, but is also always a phenomenon in the world, an estrangement from the very 'I' who claims it. Indeed, the assumption of 'sex,' the assumption of a certain contoured materiality, is itself a giving form to that body, a morphogenesis that takes place through a set of identificatory projections. That the body which one 'is' is to some degree a body which gains its sexed contours in part under specular and exteriorizing conditions suggests that identificatory processes are crucial to the forming of sexed materiality.[132]

145

Body art in general traces the "indissolubility of the psychic and the corporeal," the way in which the male body legitimates but also is legitimated by its continual staging of its coherence.[133] Acconci's intersubjective body art enacts the fragility of this system by which masculinity ensures its privilege ("the Phallus is installed as an 'origin' to suppress the ambivalence" produced in the slippage between its claim as originary and its reliance on the staging of continual anatomical examples).[134]

DISSOLVING THE "PRICK" IN A "SEA OF TIT"

Traveling to Los Angeles for the first time, Acconci in 1975 produced a piece to reflect what he viewed as the specificity of Angeleno urban experience ("Third Stop, Los Angeles. I'd have to keep glitter in mind. . . . Smog, flesh, perversity.").[135] Entitled *Pornography in the Classroom*, the piece consisted of a pornographic film projected into the corner of a room: "oozing up from the floor onto the walls—the film is like a sea (close-ups of breasts, cunts, asses—the camera moves from one body to another, the bodies melt together—'a sea of tit')." On a video monitor, as Acconci described it at the time, "my prick rises up from the bottom, my prick 'talks.'"[136]

On the face of it, this piece—whose very structure and content literalize the disruption of modernism (film/New York) by postmodernism (video/Los Angeles)—would seem to project an extremely predictable masculinity: the male artist, represented by his erect prick, inserts himself through a "transcendent," penetratory action into the pornographic scene of representation. But, as Acconci himself pointed out at the time, rather than confirming his transcendence, the piece enacted his lack: "I wasn't drowning in bodies, I was hiding in them—I was using them to anchor myself down, to keep my own body whole, safe from the pull of the wave around me."[137]

Pornography in the Classroom, which, as Acconci explained, aimed to project the abstracted, peeled apart bodies of futuristic and, many have argued, quintessentially postmodern Los Angeles (with the prick—on the grainy video screen—as the least coherent body [part] of all), once again explicitly enacts the spectacularly failed attempt of the male body to throw itself into a phallic transcendence. The radical fragmentation of the body/subject that we have begun to acknowledge as endemic to the "postmodern condition,"[138] and that Acconci experienced in an urban environment with which he was not familiar, proves the impossibility of this dream. Acconci's whining, self-involved body/ self projects masculinity backward into a narcissistic and fundamentally infantile relation to itself and to others.[139] Far from successfully transcendent, Acconci's masculinity is continually thrown back into its own lack, its failed at-

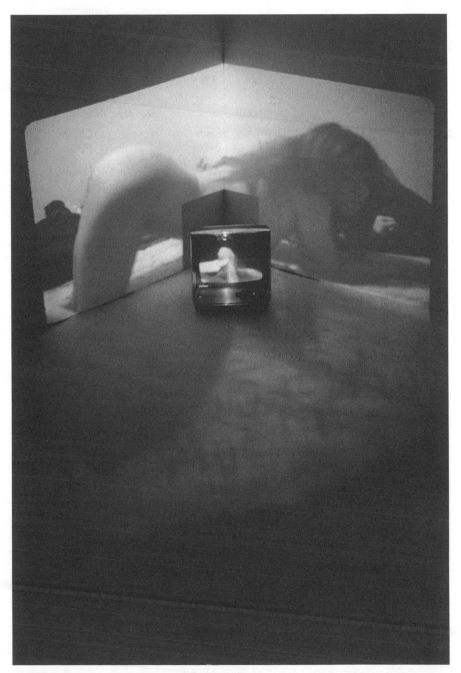

VITO ACCONCI, *PORNOGRAPHY IN THE CLASSROOM,* 1975; INSTALLATION (FILM, VIDEO, SLIDES). PHOTOGRAPH COURTESY OF THE ARTIST AND BARBARA GLADSTONE GALLERY, NEW YORK.

tempt at projecting its corporeal lack (what Beauvoir would call its immanence) onto the other insistently reiterated.[140]

In Acconci's work, masculinity begins to dissolve in a sea of contradictions (the bodies "melt together," after all) and the boundaries normally staged and policed between masculine and feminine, hetero- and homosexual, through the corporealized rhetoric of gender and sexuality are broken down into a dangerous flow of unpredictable desires. It is this "deterritorialization" of masculinity, in the terms of Gilles Deleuze and Félix Guattari—its fragmentation through the dispersal of "desiring production" across bodies—that establishes Acconci's work within a specifically postmodern understanding and experience of subjectivity.[141]

Imaginatively speaking, I am reading Acconci's body/self through this piece as having traced the postmodern dissolution of the oedipalized (implicitly masculine) subject of modernism and, by extension, of the nuclear family that sustains and is sustained by this subject. Even as it reiterates as well as challenges an authority that is embodied as white, heterosexual, economically privileged, and male, Acconci's work thus offers a vital corollary to the explosive political transformations initiated in the social sphere by the rights movements of the late 1960s and early 1970s. By shifting the very parameters of the "distribution systems" of art (by, in fact, staging *art itself* as a distribution system among subjects), Acconci can be counted as an important contributor to what in the 1990s we clearly experience as postmodernism's radicalization of social life.

In closing, I would like to reiterate my argument that one can approach and interpret each of these practices in a number of ways. Far from being simply radical and subversive, or simply regressive and phallocentric, each of these pieces both strategically unhinges the masculinist modernist paradigm of artistic subjectivity (the conflation of phallus/penis/artist) and in some ways reinforces it. I am arguing here that for me the moments that are the most eroticizing and disruptive of the penis/phallus conflation are those in which a charged relationship with the interpreter is allowed to surface (these are moments that I hope to have traced convincingly here through my own invested readings).

One could argue provisionally along the lines of a model offered by Kaja Silverman that these moments mark instances of "heteropathic identification," a situation in which a radical transference of subjectivity is encouraged, such that the self is intersubjectively articulated in relation to the other.[142] As I have interpreted Acconci's body art work, it encourages our exchange with it, promoting rather than suppressing or obscuring the dynamic circulation of desire among and between the witnesses of these masochistic acts and their

subject/object, the (male) artist; *we* become overt and activated participants in the sadomasochistic transference through which works of art are given meaning in the social. Acconci's body art works encourage a dynamic of heteropathic identification.

This situation contrasts with what Silverman calls moments of "idiopathic identification," in which the self swallows the other, incorporating this other in order to build up a sense of integrity and power. Idiopathic identification might be exemplified by the structures of conventional modernist interpretation, where the interpreter makes seamless attributions of meaning and value by "incorporating" the artist and thus claiming to "know" the artist's intention; the interpreter identifies in an incorporative way with the artist's role, striving to become, like the artist, a subject divinely inspired, a "subject supposed to know."[143] As we have seen, such incorporation, which enables the veiling of the interpreter's investments in the body/self of the artist, facilitates this interpreter's claim of "disinterested" interpretation.

As I discuss in the next chapter, body art from this period enables an exploration of how, while both men and women are radically alienated, they are radically alienated in different ways; at this point in history, they experience their bodies and subjectivities differently within patriarchy. Thus male body artists, even if they confuse and complicate masculinity as Acconci does, tend to flirt with the coherence promised if always deferred by the Pollockian performative. It is rare for male body art projects to stage a potentially heteropathic rather than an idiopathic relationship of identification with their others (their audience and/or other participants within each piece). Male body artists—like male subjects in general—tend to experience their subjectivity from a position of yearning toward its coherence, toward a definition of their selves that takes place through either the incorporation or the exclusion of otherness, while women body artists—doubly alienated in patriarchy[144]—tend to explore their body/selves from their experience of their alienation in their image *as other* (to be experienced by the masculine subject). Heteropathic identification could be said to be a survival strategy constitutive of conventional femininity in Western culture: women necessarily view themselves intersubjectively, as they have no access to the myth of Cartesian coherence.

As Hannah Wilke's work suggests, women are construed as lacking in relation to phallic transcendence and thus are forced to perform themselves in the world through the *rhetoric of the pose;* women are made to acknowledge that they "exist" through the perceptive experience and desires of the other. Feminist body artists have enacted themselves through a radical narcissism that is also profoundly (if also still asymmetrically) intersubjective: they examine the

simultaneous immanence and transcendence of their bodies/selves (and the related impossibility for any subject of actually attaining transcendence). Feminist body artists have enacted the sexualization of the body/self, the penetrability of the body/self, the incoherence and contingency of self on other: the body/self as given and known only through signification.

4

THE RHETORIC OF THE POSE: HANNAH WILKE AND THE RADICAL NARCISSISM OF FEMINIST BODY ART

Exhibiting oneself is difficult for other people who don't feel good about their bodies. I could have been more humble—but if I'd been more humble, I wouldn't have been an artist.
—HANNAH WILKE, 1985[1]

There's something female about performance itself, I think because of how it is ephemeral and close to the unconscious—involving display, use of the self.
—CAROLEE SCHNEEMANN, 1989[2]

When men like Acconci, Nauman, and Burden began to work with the body, it was with a focus on its behavior and permutations. They used their bodies as tools for self-discovery with a kind of self disengagement. It seemed to me that they were exploring things in a quasi-scientific way but not really exploring maleness.
—BARBARA SMITH, 1990[3]

 In the previous chapter, I engaged Vito Acconci's works to explore the ways in which men's body art practices in the late 1960s and early 1970s typically involved a dual narcissistic compulsion: to repel the other in order to cohere the artist as phallic, post-oedipal, masculine "self," and, alternatively (and contradictorily), to merge with or incorporate the other to return to a mythical, pre-oedipal wholeness with the (m)other. As I began to suggest there—and as three feminist body artists claim in the statements quoted here—feminist body artists have sustained a vastly different relationship to narcissism and to subjectivity. I want to argue in this chapter, through the practice of Hannah Wilke, that feminist body artists have tended to explore the gendering of (artistic) subjectivity by enacting their bodies/selves in a way that opens out the self-ascribed "plenitude" of Narcissus (who would love no one but himself) to the radical contingency of self/other relations.[4]

Reading polemically through Wilke's work, I argue here that, when it is engaged with through an aggressively feminist and phenomenological model of

reading, feminist body art can be seen as eroticizing the interpretive relation to potentially radical ends. Precisely *because* feminist body artists enact themselves in relation to the long-standing Western codes of female objectification (what Craig Owens has called the "rhetoric of the pose"),[5] they unhinge the gendered oppositions structuring conventional models of art production and interpretation (female/object versus male/acting subject).[6] And precisely *because* Wilke obsessively produces herself as her work through the rhetoric of the pose, reiteratively exaggerating it beyond its veiled patriarchal function of female objectification, her body art works provide an exemplary case study.

Through the exaggerated eroticization of the circuits of art production and interpretation, feminist body art can be seen as undermining the claims of disinterestedness authorizing modernist criticism, profoundly threatening the value systems underlying art critical models of interpretation (Acconci was, as noted, quite unusual among male artists in his willingness to "open" himself to the erotics of the interpretive exchange). In this view, feminist body art crosses over subjects and objects of cultural production in a *chiasmic* interweaving of self and other that highlights the circuits of desire at play among them (and refuses the notion of an "objective" aesthetic judgment). Thus, while Acconci attempts to make his (male) body vulnerable in order to open it to intersubjectivity, facetiously enacting (and perhaps benefiting from) the transcendence that patriarchy has (impossibly) promised him as a male subject, Hannah Wilke explores her body/self as always already not her own and enacts femininity as, by its very definition in patriarchy, inexorably performed (in process rather than "coherent"), doubly alienated, removed from the lure of potential transcendence.

As we have seen, Simone de Beauvoir suggests in *The Second Sex* that patriarchy works to separate women's immanence from any possibility of cognition, selfhood, or transcendence; the woman's body is folded into the patriarchal regime as fundamentally objectified and alienated from the woman's "self." As Beauvoir makes clear, this is in no way to suggest that *any* subject, male or female, achieves successful transcendence (pure cognition and uncompromised intentionality); rather, it is to emphasize that women are *doubly* removed from such a possibility while, within the facilitating myths of patriarchy, the singular alienation of male subjects can be elided or occluded such that they appear to sustain such mythical transcendence (as in, for example, the modernist articulation of Jackson Pollock). Even then, however, such a "coherent" figure is riven with contradictions—the very display that confirms Pollock's ejaculatory male genius always already produces him as "feminine"—which can destabilize it at any moment through changed interpretive frameworks (such as those provided by Alan Kaprow and the body artists).

Perhaps more to the point, given body art's recourse to psychic/corporeal structures of intersubjectivity, the doubled alienation that Wilke explores through her reiterated narcissistic self-display can be understood through psychoanalytically and phenomenologically based models describing the constitution of sexual difference within patriarchy. These are models that address the *psychic* patterns by which femininity is construed as other within the logic of patriarchal culture.[7] As Laura Mulvey writes in her well-known essay "Visual Pleasure and Narrative Cinema," through the structure of the "gaze," whereby women's bodies are positioned as objects of scopophilic or fetishistic (and in Mulvey's model inexorably male) voyeuristic pleasure, the female body in Western culture connotes "to-be-looked-at-ness."[8] In a parallel formulation to Beauvoir's more phenomenological model, this body, with its apparent anatomical "lack" (which betrays the male subject's anxious fear of losing his "present" penis-as-phallus) is forced to act *as* phallus/fetish in order to palliate this anxiety.[9]

While, as Acconci's work suggests, male body artists begin from an assumption that their embodiment brings with it the potential for transcendence (the promise of penis-as-phallus), the female body artist must grapple with her assignment, within the visual logic of heterosexist patriarchy, to passive immanence (lacking body-image as phallic substitute). Conventionally speaking, men act and women pose. At the same time, drawing again on the provocative terms of Judith Butler, I will argue here that by perverting this logic of the "gaze" through its very deliberate *reiteration*, the feminist body artist (Wilke) can expose the gaze in its insufficiency (Butler, we remember, argues that performativity is not a singular act but "a reiteration of a norm or set of norms" whereby one's "sex is both produced and destabilized").[10] The Hegelian turned existentialist master/slave dynamic through which, in Beauvoir's theory, "masculine" and "feminine" are oppositionally defined to the advantage of male subjects in patriarchy is unmoored from its conventional assumption of a priori fact and *reiterated* as conditional, motivated, and explicitly patriarchal. This radical exposé takes place through the rhetoric of the pose, which both solicits and confronts the "male gaze" (and, arguably, opens the female body/self to *other* desires and identifications).[11]

THE "RHETORIC OF THE POSE"

Even in my sleep I was posing.
—HANNAH WILKE, 1992[12]

The pose is always present.
—TRINH T. MINH-HA[13]

> Stand up for what you want to do. . . .
> Stand up and be your own cliché. . . .
> Stand up for women to decide
> stand up, they're bodies you're inside
> —HANNAH WILKE, "STAND UP," 1982[14]

All of her life, Hannah Wilke conceived herself in relation to the world through the pose.[15] Producing her work as herself and herself as her work, Wilke instantiated the tendency among post-1960 artists that I have identified as indicative of a postmodern articulation of subjectivity as fundamentally decentered and contingent (non-Cartesian) yet particularized in relation to others. In her lifelong series of self-portraits, which she called "performalist," organized into artworks, and occasionally distributed as postcards, Wilke displayed her body for innumerable photographic, film, and video "portraits" that together provide a cumulative but fundamentally incomplete rendering of "Wilke"/"Butter"/"Hannah"/"Arlene."[16]

As I have noted, Craig Owens fully develops the notion of the "rhetoric of the pose" in a 1984 article, which focuses on Barbara Kruger; his discussion is directly relevant to Wilke's obsessive project of posing and self-portraiture. Drawing on the work of Lacan, Owens provocatively suggests that "to strike a pose is to present oneself to the gaze of the other as if one were already frozen, immobilized—that is, *already a picture.* For Lacan, then, pose has a strategic value: mimicking the immobility induced by the gaze, reflecting its power back on itself, pose forces it to surrender. Confronted with a pose, the gaze itself is immobilized, brought to a standstill."[17] Presenting herself as already a picture, Wilke's self-presentation through exaggeratedly erotic, "feminine" poses, then, could be said both to succumb to the "gaze" (reiterating the normative tropes of femininity) and, though such "submission," to *immobilize* it (like Medusa), forcing it to "surrender."

Such performances of the feminine body/self explicitly open out the tautological logic of modernist art history and criticism whereby the (veiled, male) artist is *produced* through disciplinary maneuvers as an origin for the meaning of the work of art, which itself is *produced* as an originary site of the meaning of the author: the teleological system by which, in the terms of Donald Preziosi, "the-man-and-his-work" and "the-man-as-a-work" (of art) are conflated in a "theophanic regime" that ultimately functions to "situate the art historian or critic as sacerdotal . . . diviners of intentionality on behalf of a lay congregation."[18] By adopting the rhetoric of the pose as the work itself, Wilke

both insistently unveils the artist and unveils the artist *as female* (anatomically female, and so culturally feminine, and yet also clearly "masculine" in her artistic authority). By exposing the models through which art history and criticism legitimate (male or masculine) critical and artistic subjects in a closed and exclusionary circle of masculine privilege, Wilke's body art works proffer the possibility of a radical critique of these disciplines (suggesting and encouraging the formation of an alternative feminist interpretive practice) and provide a feminist mode of production that itself performs a woman-as-artist in an empowering way.

A typical example of Wilke's obsessive self-imaging is her *Art News Revised*, a performalist portrait made during an exhibition of her *Ponder-r-rosa* series of latex wall sculptures at the Ronald Feldman Gallery in 1975 (and reproduced in the catalog accompanying Wilke's retrospective at the University of Missouri in 1989).[19] While the "revised" image shows Wilke posing shirtless, her jeans provocatively open, leaning against the wall of labial flaps of latex, another almost identical image, showing a fully clothed Wilke in the same pose, was reproduced in Gerrit Henry's essay on artists in their studios published in *Art News*.[20] Typically, in the revised image Wilke unveils her body/self among her works to instantiate herself as both their "subject" and a parodic imitation of woman as conventional "object" of artistic practice (the female [here almost] nude). In doing so, she collapses the incompatibility between the functions male/artist/subject and female/object.

While Wilke in both pictures enacts the body that is the hidden focus of art historical objectification and projects herself through the pose as a picture, in the *Art News Revised* photograph, where her nudity more emphatically renders the codes of art historical objectification and the artist (in her case, as beautiful art star). In this way, she takes away from the "male gaze" its covert, strategic function of reducing the woman (even the woman artist) to the "to-be-looked-at-ness" of her body-as-image. At the same time, it is important to note the ambivalence of her gesture. Just as Acconci, in his oscillation between base abjection and flirtation with transcendence, both critiqued and got mileage out of masculinity's claim to artistic authority, so Wilke both exposes and makes use of the conventional codes of feminine display to increase her notoriety (and her desirability) in the male-dominated art world.[21]

Through the very performance of their bodies through the feminizing rhetoric of the pose, feminist body artists begin to complicate and subvert the dualistic, simplistic logic of these scenarios of gender difference by which women are consigned to a pose that is understood to be unself-reflexive, passively pinioned at the center of a "male gaze." We recall that Maurice Merleau-

HANNAH WILKE, *ART NEWS REVISED*, 1975; PERFORMALIST PORTRAIT MADE AT
RONALD FELDMAN FINE ARTS. PHOTOGRAPH BY EEVA-INKERI, COURTESY RONALD
FELDMAN FINE ARTS, NEW YORK. COPYRIGHT ESTATE OF HANNAH WILKE.

Ponty recognized the efficacy of physical movement in tearing the body/self
away from pure objectification: "It is clearly in action that the spatiality of our
body is brought into being." [22] By *acting*—as artists in general but also more
specifically as performers, literally viewed "in action"—feminist body artists
insist on having access to the same (always failed) potential to transcendence
that men have traditionally had in patriarchy. They strategically perform in

order to become singly rather than, as is typical for women subjects in our culture, doubly alienated from their illusory, coherent selfhood.

Through her naked posing, Wilke not only solicits the male gaze, she also circumvents its trajectory in advance by performatively merging her exterior (body image) and interior (cognitive, emotive) selves—selves that are strategically dichotomized in Western patriarchy (dominated by Cartesianism) as a means of situating women always already on the side of immanence. As I interpret them, feminist body art works produce the female artist as both body and mind, subverting the Cartesian separation of cogito and corpus that sustains the masculinist myth of male transcendence.

Wilke's project *So Help Me Hannah* is exemplary in its dynamic merging of body (the rhetoric of the pose) and mind (the "I" of cultural production): Wilke, like many feminists of the period, projects herself forward in physical action, but also explicitly lays claim to her intellectual capacity as body/self. *So Help Me Hannah* initially existed as a series of photographs taken in New York's raw alternative exhibition space, P.S. 1, in 1978. The photographs show Wilke, naked, in high heels and holding a gun, captured in various poses with overlaid quotations from texts primarily by male philosophers and artists—from Edmund Burke, Marx, and Nietzsche to Daniel Buren and David Smith—regarding the relationships among individuals, art, and society.[23] The piece only secondarily became a performance (executed several times between 1979 and 1985 and videotaped each time), and even the performances (as documented on video) are about the rhetoric of the pose: Wilke's moving body, accompanied by a sound track of her own voice reading extensions of the quotations excerpted on the photographs, moves slowly, freezing periodically into still poses.

In the performative photograph *What Does This Represent/What Do You Represent (Reinhart)* (1978–1984) from *So Help Me Hannah*, Wilke sits dejectedly, legs spread, in the corner of a desolate, seemingly empty room, the gun in her hand echoed by the array of toy guns before her on the floor.[24] The words of the title—those of a male modernist painter (Ad Reinhart)—are printed on the image in an abrupt, polemical fashion to disrupt any comfortable objectification of Wilke as image; they also point to the way in which the rhetoric of aesthetics has been deployed at the expense of women, whose bodies are usually the unspoken *objects of representation* (another quote in the *So Help Me Hannah* performance is from Harold Rosenberg: "The photograph leads the mind to the actual world. . . . If it is a nude, it will make one think of women, not art").[25] Wilke's appropriation of Reinhart's statement reconfigures it toward a feminist critique. *What Does This Represent/What Do You Represent (Reinhart)* in this context implies a Barbara Krugeresque admonition of the male making and

157

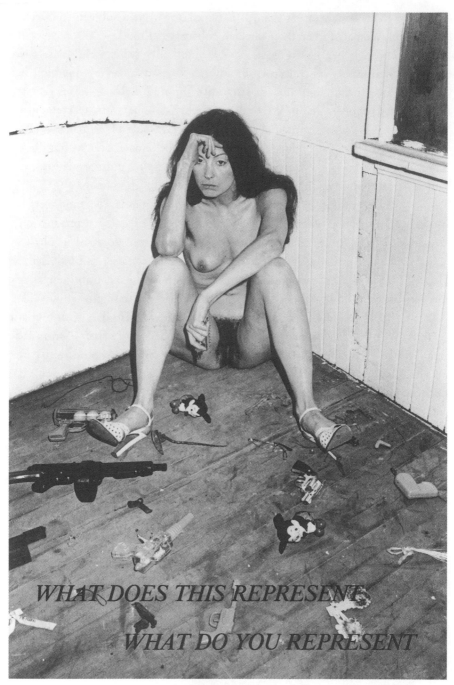

WHAT DOES THIS REPRESENT

WHAT DO YOU REPRESENT

HANNAH WILKE, *WHAT DOES THIS REPRESENT/WHAT DO YOU REPRESENT (REINHART)*,
FROM *SO HELP ME HANNAH* SERIES, 1978–84; BLACK AND WHITE PHOTOGRAPH,
60 X 40 INCHES. PHOTOGRAPH COURTESY RONALD FELDMAN FINE ARTS, NEW YORK.
COPYRIGHT ESTATE OF HANNAH WILKE.

"gazing" subject, though Wilke's tone is less accusatory than that of the younger-generation Kruger. The Western tradition of the female nude ("What does *this* represent?") is implicitly about male (castration) anxiety ("What do *you* represent?")—about the projection of male immanence (lack) onto women, not about *female* "lack."

In the Ad Reinhart image from *So Help Me Hannah*, Wilke performs her body as object: she constructs herself as literally "cornered" by the gaze. And yet, her genitals offered to view and her body slack, disinterested, and self-involved, Wilke unveils that which both beckons and threatens the castration anxious male (in Owens's terms, Wilke forces the gaze to surrender by "mimicking the immobility induced by the gaze [and so] reflecting its power back on itself"). In this crossing of visual codes (she's naked but desexualized), Wilke is deobjectified (while, of course, still an "object" to be seen). Wilke's reversal of the gaze is linked to her strategic appropriation of the words of male intellectuals; speaking them herself, she merges the conventionally diametrically opposed functions of "woman/body/object" and "man/mind/subject." Naked and frozen as a "picture" through the agency of the gaze (abjectly soliciting spectatorial engagement), Wilke simultaneously speaks herself through the language of male authority and explicitly interrogates the function of the gaze through the appropriated question.

As I have already noted, in the taped performances Wilke's movements are stuttered: she frequently freezes her movements as if enacting her status as always already a picture—in contrast to Acconci, whose activity, as in *Claim*, becomes more and more violent and frenetic as he becomes more invested in affecting the audience.[26] Extending the language of photography into moving pictures, Wilke performs the way in which *action* as a claim toward transcendence, for women as well as for men, is an always failed proposition (always freezes into objectifying moments).[27] For the body/subject is, in phenomenological terms, always both a picture and a thinking subject at the same time: "The subject poses as an object *in order to be a subject*."[28] Or, in the words of body artist Eleanor Antin, "the notion of the body is itself an alienation of the physical aspect of the self. . . . But what if the artist makes the leap from 'the body' to 'my body'? 'My body' is, after all, an aspect of 'my self' and one of the means by which my self projects itself into the physical world."[29]

While Wilke's entire oeuvre could be said to pivot around this subversive dynamic of posing (which, as I discuss later, takes as its psychocorporeal core the narcissistic structure of self/other), Carolee Schneemann's body was always in action.[30] A comparison between Wilke's rather obsessive focus on the pose and Schneemann's more dispersed self-articulation is instructive. Expressing an interest in subverting the "taboos against the vitality of the naked body

in movement" in her work, Schneemann recognizes that it is in part the *move-ment* of the sexualized body in performance that is so threatening to interpretive systems,[31] She voices an explicit concern with projecting her body into the realms of action and cognition, exploring the phenomenological effects of per-formance on conventional conceptions of the sexual self. Her work enacts an understanding of the interdependence of body-in-action and body-as-intellect: "Movement cannot be separated from the body, the eye or from language. In order to perceive 'correctly' I want to feel that my musculature is responsive, vivified. My work is physical, visceral and conceptual."[32]

Schneemann recognizes the capacity of body art, through its tem-porality and spatiality, to complicate the mechanics of the gaze outlined in Mulvey's essay and expanded by Owens (in art critical terms, the structures by which interpretation takes place via the interpreter's visual apprehension and verbal translation of the art work through art historical discourse). As noted, body art activates, in Merleau-Ponty's terms, the "temporal structure" of the body, playing out subjectivity and objectivity as performative rather than fixed and so complicating viewers' attempts to locate themselves as coherent in rela-tion to the work of art.[33]

In *Naked Action Lecture*, executed at the Institute of Contemporary Art in London in 1968, Schneemann explicitly performed the interdependence of subject and object, in her words, "using the nude as myself" and "swinging between intellection/perception/action" to undermine the tendency among other performance artists to stage the (female) nude as *only* an object.[34] While the audience sat before her, Schneemann walked among them introducing an "art istorical" lecture (dropping the *h*, she repudiates the *his* in *history*), distribut-ing oranges from inside her undershirt and oversized overalls.[35] As the lights dimmed for the beginning of the lecture, Schneemann undressed and then re-dressed, using art historical pedagogical tools such as slides and a pointer and discussing issues of aesthetics and perception. She continued to dress and un-dress into the question and answer session of the lecture. Afterwards, she asked for volunteers (two men came forward); they all undressed, covered each other with paste, and leapt off the stage into a mound of shredded papers. Finally, Schneemann returned to the stage and finished her lecture with a brief discus-sion of the collage process. A screening of her erotic film *Fuses* (1967; a literal visual fusing of male and female bodies through heterosexual lovemaking) ended the evening.

Schneemann herself viewed *Naked Action Lecture* as posing a number of pointed questions about the disjunction between the sexual female body (un-clothed) and intellectual authority:

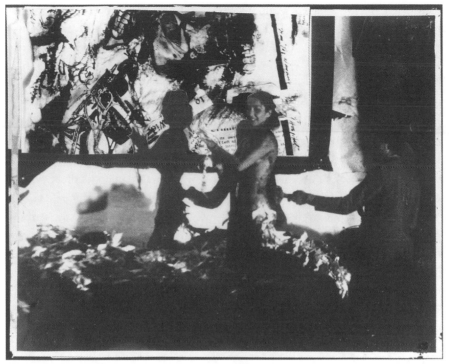

CAROLEE SCHNEEMANN, *NAKED ACTION LECTURE*, 1968; PERFORMANCE AT THE
INSTITUTE OF CONTEMPORARY ART, LONDON. PHOTOGRAPH COURTESY OF THE ARTIST.

> [C]an an artist be an art istorian? Can an art istorian be a naked
> woman? Does a woman have intellectual authority? Can she have
> public authority while naked and speaking? Was the content of the
> lecture less appreciable when she was naked? What multiple levels of
> uneasiness, pleasure, curiosity, erotic fascination, acceptance or re-
> jection were activated in an audience?[36]

Not only does the piece interrogate the way in which this disjunction has func-
tioned to disempower women as intellectual subjects in patriarchy, it also links
this question into the problematics of representation itself. Thus, like Wilke's
question "What does this represent/What do you represent," Schneemann's
construction of herself *as collage* (not to mention her doing the same with two
naked male bodies) goes beyond the question of artistic agency to the very re-
lationship between the artist's body/self and the way in which this body/self
is conflated, through art historical interpretation, with the object-of-art (the
"man-as-his-work" of art, in Preziosi's terms). From a feminist point of view,
such a gesture has potentially profound effects: it both interrogates the general
process by which art objects are assigned value and, through the very intel-

161

lectual activity of a naked woman (artist), exposes this process as deeply informed by patriarchal biases. "[T]o use my body as an extension of my painting-constructions," Schneemann wrote, "was to challenge and threaten the psychic territorial power lines by which women were admitted to the Art Stud Club, so long as they behaved *enough* like the men, did work clearly in the traditions and pathways hacked out by the men."[37]

Adrian Piper's *Food for the Spirit* (1971) also opens up the possibility of a *cognitive* (and so active and potentially "transcendent") female artistic subject. Lorraine O'Grady has described this piece as "a private loft performance in which Piper photographed her physical and metaphysical changes during a prolonged period of fasting and reading Immanuel Kant's *Critique of Pure Reason*."[38] This project was not made public until 1981, when Piper published a series of photographs documenting the original performance; in a 1987 retrospective catalog of Piper's work, a single photograph, showing Piper nude and looking into a mirror with her camera held just under her breasts, is published.[39] It is this image that, O'Grady argues, defines the piece as "the catalytic moment for the subjective black nude."[40] For a *black* woman (who is also a philosopher by profession) to pose naked in the act of incorporating Kantian theory as well as in the act of taking a picture is a multivalently radical act.[41] Like Wilke and Schneemann, Piper lays claim to speaking intellectual discourse even as she poses nude: she is both intellectual, grappling alone with complex philosophical problems (fasting and practicing yoga, she projects herself into transcendence à la Yves Klein), and embodied woman (the Kleinian "brush"); she is both embodied woman-as-object of the camera's "gaze" and photographer-subject of the image.

But Piper is also African American, and her self-revealing performance exposes the assumption of whiteness implicit in the "rhetoric of the pose" defining (white) women as objects for visual delectation in Euro-American culture. As a black woman who could pass for white, and a philosopher who doesn't "look like one," Piper is dangerous to the regime of visibility by which identity is defined in post-Enlightenment Western culture, dislocating the self-assured trajectory of the "male gaze": "I am the racist's nightmare, the obscenity of miscegenation. I am a reminder that segregation is impotent; a living embodiment of sexual desire that penetrates racial barriers and reproduces itself. . . . I represent the loathsome possibility that everyone is 'tainted' by black ancestry: If someone can look and sound like me and still be black, who is unimpeachably white?"[42] Piper has taken the ambivalent racial/sexual identities forced on her by an anxious white patriarchy and attempted to use them to expose the threat she "poses" to this system (the threat of unmasking white masculinity's contingency on her body as its projected other).

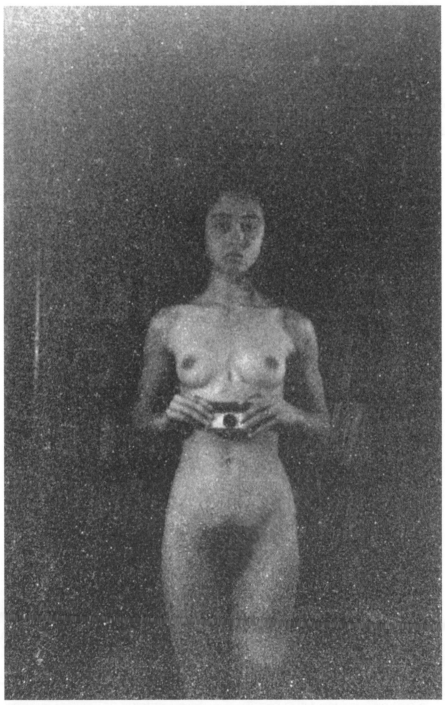

ADRIAN PIPER, *FOOD FOR THE SPIRIT*, 1971; PRIVATE LOFT PERFORMANCE.
PHOTOGRAPH COURTESY JOHN WEBER GALLERY, NEW YORK.

While Wilke's and Schneemann's practices dynamically align the naked (white) female body with cognition and action through the rhetoric of the pose, Piper's work even more aggressively unhinges the very logic by which vision is privileged in Western culture as the site of knowledge (since one will not necessarily "see" that Piper is black).[43] The male gaze, in Mulvey's Freudian terms, operates to comfort castration-anxious male subjects by pretending to deliver the female body as "phallus" (replacing her lacking organ); through this dynamic, woman is relegated to her "to-be-looked-at-ness"—as the other that defines man as origin of the gaze in terms of what Luce Irigaray describes as a logic of the "self-same."[44] Piper's self-performance violently exposes the failure of the gaze to secure such a structure of identity. Peggy Phelan has articulated such failure in the following way:

> Identity cannot . . . reside in the name you can say or the body you can see. . . . Identity emerges in the failure of the body to express being fully and the failure of the signifier to convey meaning exactly. Identity is perceptible only through a relation to an other—which is to say, it is a form of both resisting and claiming the other, declaring the boundary where the self diverges from and merges with the other. In that declaration of identity and identification, there is always loss, the loss of not-being the other and yet remaining dependent on that other for self-seeing, self-being.[45]

Through the rhetoric of the pose—through the very reiteration of the making of the woman's body/self into a picture (an object doomed to its own immanence)—Wilke, Schneemann, and Piper complicate the conventional alignments of femininity with passive objectification and masculinity with "transcendent" cognition and action in the world. Adrian Piper turns the rhetoric of the pose inside out by forcing it to accommodate not only the sexual difference that is constitutive to it but also *racial* difference. Through the doubled alterity of her not-male, not-(quite)-white body, Piper de-com-poses the pose, throwing into question its implicit assumption of vision as providing knowledge of the body-in-representation as well as its insistent reduction of difference to the register of gender. Feminist body art suggests that vision cannot secure sexual or other differences, which must, rather, be experienced through an exchange of corporeal subjects.

HANNAH WILKE'S CHIASMIC THEATRICALIZATION OF THE SELF

In a 1973 performance called *Line-Up,* Vito Acconci took on various roles before the audience in an attempt to work through the demise of his lengthy relation-

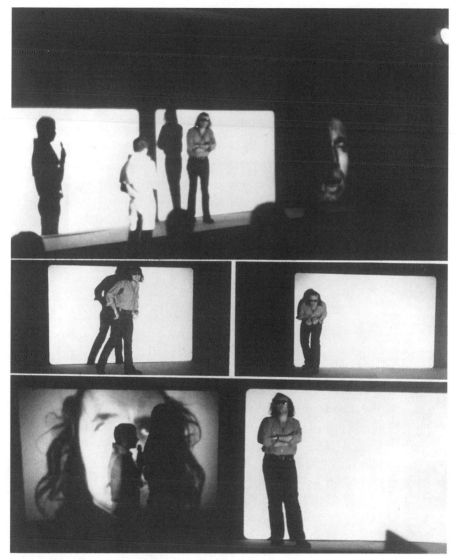

VITO ACCONCI, *LINE-UP*, 1973; PERFORMANCE WITH SLIDES AND VIDEOTAPE AT
THE FESTIVE D'AUTOMNE, MUSÉE GALLIERA, PARIS. PHOTOGRAPH COURTESY BARBARA
GLADSTONE GALLERY, NEW YORK.

ship with Kathy Dillon (he had become involved with another woman). First
cocky and overbearing, he spoke of her inability to understand him ("Kathy
doesn't know what she's talking about . . . she has no idea who I am"), then gave
in to a childlike dissolution of ego: "she knows what I am, she knows I'm
only a child. . . . I just needed someone to depend on. . . . [S]he had to be
stronger than me. . . . [J]ust one more time, please, help me . . . just this

once . . . then I'll change . . . you'll see."[46] Once again, Acconci performs himself in such a way as both to open himself up to otherness and to expose the structures by which heterosexual male subjects attempt to *incorporate* the (female) other and thus diffuse her threat, through what we identified in the previous chapter as a kind of idiopathic identification. While Acconci certainly exposes his own contingency (his pathetic inability to project himself uniquely and separately into the world without Dillon), he also speaks for, to, and of Dillon in her absence. He performs himself away from her to recohere himself now that she is gone (and, just as clearly, performs his failure to do so).

Contrastingly, in a 1977 performance made for video, *Intercourse With . . .* , Hannah Wilke plays tapes of her lovers, family members, and friends speaking to her in absentia on her answering machine. Accompanying this audio track, Wilke strikes various contemplative poses, then strips off her clothing to reveal her flesh, covered with the names of these loved ones.[47] She then slowly takes off each name, peeling away these "others" that have spoken her as "self." While Acconci's relationship to his loved (now rejected) other entails his continual reiteration of himself and incorporation of Dillon, Wilke's (which allows the loved one to speak) involves an enactment of herself as always already implicated in these voices, open to them, *constituted through them.* Wilke's project exemplifies the tendency among feminist body artists to perform themselves in deeply intersubjective ways: as contingent on relations with others (the audience, lovers and friends, the "male gaze").

I have suggested that the eroticized intersubjectivity of feminist body art projects such as Wilke's *Intercourse With . . .* (even the title of which opens up, if it also delays, the question of the other: with . . . whom?) engages the interpreter in a deeply invested process. Wilke offers herself flamboyantly to her audience, opening up the circuits of desire that motivate art production and reception and that are scrupulously veiled in modernist art history and criticism, which frame the art object within a masculinized rhetoric of "disinterested" interpretation (with the female nude a common object of this connoisseurial or formalist delectation). This disciplinary logic of framing and its corollary suppression of interpretive desire is informed by specifically sexual investments.

Jacques Derrida, in his deconstruction of Kantian aesthetics in *The Truth in Painting*, points out that within Western metaphysics, "[i]n order to think art in general, one . . . accredits a series of oppositions (meaning/form, inside/outside, content/container, signified/signifier, represented/representer, etc.) which, precisely, structure the traditional interpretation of works of art." This structuring or framing is a means of containing and regulating that benefits the art historian or critic. Discourses of aesthetics, such as Hegel's *Lectures on*

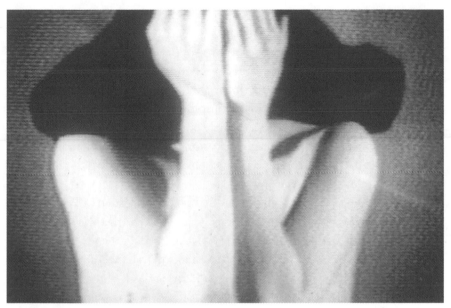

HANNAH WILKE, *INTERCOURSE WITH* , 1977; VIDEOTAPE OF PERFORMANCE AT
LONDON ART GALLERY AND MUSEUM. PHOTOGRAPH COURTESY RONALD FELDMAN FINE
ARTS, NEW YORK. COPYRIGHT ESTATE OF HANNAH WILKE.

Aesthetics "exclude—(that) which then comes to form, close and bound them
from inside and outside alike."[48] Derrida's insight, while studiously blind to is-
sues of gender, can be extended to an understanding of this framing operation—
this structuring of the experience of art via a series of oppositions—in terms
of sexual difference. The operative opposition that Derrida omits is that of
viewer/viewed or interpreter/interpreted, which—within patriarchy—is played
out in terms of the opposition masculine/feminine. In relation to Schnee-
mann's work, Kristine Stiles has argued that Schneemann's project takes its force
from her "focus on the interrelation between corporeal vision and empathy in
the play of human vitality";[49] this formulation highlights feminist body art's
radical *embodiment* of the female subject, who both gazes and is gazed upon but
never simply objectified. In this way, the framing categories of viewer/viewed
(along with the ideologically linked opposition masculine/feminine) are strate-
gically collapsed.

Drawing on this Derridean model of the discourse on the frame,
Lynda Nead has argued that Kantian aesthetics, which works to regulate the art
object such that a "coherent viewing subject" can attempt to constitute himself
comfortably in relation to it, serves a masculinist function, with all of the racial,
class, and other privileges this entails.[50] Paradoxically, she argues, it is because

167

one of the central threats to the claimed coherence of the dominant (hetero-sexual, masculine) subject is the female body, which overtly elicits the interpre-tive desire that aesthetic judgment works to suppress, that the female nude be-came a central trope of modernist practice. Modernist painting represents the female nude *in an attempt to contain it.* In an always precarious enterprise, the co-herent subject of viewing works to establish his authority by situating himself in relation to a contained or *enframed* female body-as-object (a body that is ide-alized according to Euro-American conceptions of beauty and desirability and that is presented as transcending class, race, and, in the "fine art" tradition, the crude pleasures of genital sexuality).

Extending Nead's insight, I would like to argue again that Wilke's prac-tice, when engaged with through a feminist reading of the rhetoric of the pose, can be seen as eroticizing the interpretive relation to radical ends. What could be more threatening to the art historical system of framing and containment than art practices that insist on crossing over the subjects and objects of cul-tural production in what I have already described as a *chiasmic* interweaving of self and other and highlight the circuits of desire at play among them? Wilke's works exaggerate and so put stress on the link between sexual and other dif-ferences as fundamental components of subjectivity—including artistic subjec-tivity as well as the subjectivity of the spectator of art—and art history and criticism as systems of framing (and it is precisely because of this exaggeration that I have chosen Wilke's work for the focus of this chapter, rather than Schneemann's, which sustains a far more ambiguous, nuanced relationship to the rhetoric of the pose constitutive of femininity in western culture). Wilke's body art projects both elicit and perform the very desires and pleasures that the aesthetic works to contain through its supposedly "disinterested" acts of judg-ment. Insisting on the perverse and the obscene, works such as *What does this represent*/*What do you represent* from *So Help Me Hannah* perform the female sex and encourage a charged interpretive exchange that confounds art history and criti-cism as disciplinary apparatuses for legitimating one kind of cultural produc-tion over another; such performances of the erotic female body (a body that is also the artist herself) contaminate the "pure" interior of the discipline's care-fully regulated borders.[51]

In Wilke's 1974 thirty-minute video *Gestures,* she manipulates her face into sexually suggestive orifices—mobile rings of flesh—and denaturalizes its role as screen on which identity is written (performing, rather, its "faciality").[52] No longer the readable surface on which individual identity is apparently written, the face becomes the penetrable (female) body; with the female body-as-face, the reduction of woman to anatomical sexuality is parodically reiterated such that it

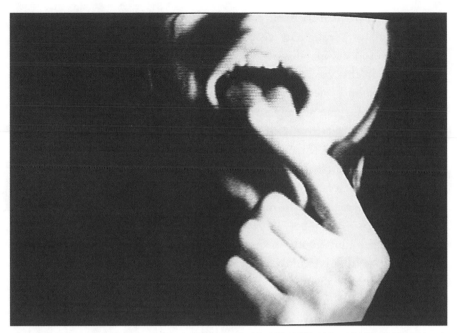

HANNAH WILKE, *GESTURES*, 1974; VIDEOTAPE OF PERFORMANCE. PHOTOGRAPH BY
EEVA-INKERI, COURTESY RONALD FELDMAN FINE ARTS, NEW YORK. COPYRIGHT
ESTATE OF HANNAH WILKE.

self-implodes.[53] The face (with its mouth/cunt) looks at us with a dead stare and
we look back, feeling our complicity in its objectification. This piece brilliantly
activates Merleau-Ponty's intersubjective "chiasm": the intertwining by which the
embodied other constitutes the gaze of the subject (i.e., the other is simultane-
ously the agent; the subject always already objectified). Nothing can offer itself
precomposed to the viewer; nor is there a seer who is first empty and then opens
herself or himself to the object. Rather, there is "something to which we could
not be closer than by palpating it with our look, things we could not dream of
seeing 'all naked' because the gaze itself envelopes them, clothes them with its
own flesh." Merleau-Ponty then asks, "Whence does it happen that in so doing it
leaves them in their place, that the vision we acquire of them seems to us to come
from them, and that to be seen is for them but a degradation of their immanent
being?"[54] In *Gestures,* as in *What does this represent,* Wilke unveils herself to implicate
our gaze in her constitution as "flesh," but also complicates our tendency to feel
ourselves thrown into pure immanence when we feel ourselves being looked at.[55]
It is definitively her flesh that looks at *me* as I attempt to decipher its significance
(what it is "saying" in its distortions and flaunted orifices).

Wilke's flesh—proffered to us through the rhetoric of the pose (en-

acted through performance, photographs, film, video)—both communicates her image to us through its visibility and yet exposes the radical insufficiency of vision, its inability to deliver the tangibility of the corporeal (the body/self). In this way, the image of a woman's body provokes the (conventionally masculine) viewer, propelling him into his own corporeal/scopic lack: he can gaze in an attempt to master the woman's body as phallic substitute, but his gaze (which is itself corporealized) will never "touch" the body/self that is enacted in the picture. The woman-as-picture exposes the "intertwining of the one [the seeing body] in the other [the body that is visible, gazed upon]": the contingency of the gaze on the (visible) body of he who wields it; the *immanence* of the male subject in spite of his projective claims to transcendence.

Wilke's cunt mouths in *Gestures* project her into a field of vision (of the other/the gaze) that is marked as corporeal; seeing is shown to be chiasmically intertwined with the tangibility whose reversibility is an effect of the body/self. Wilke's mouth-as-cunt and her cunt-as-cunt, in their very reified fleshiness, mark the "intercorporeity" of subjects, as well as instantiating the "flesh" (the "two leaves of my body and the leaves of the visible world") as the body's way of becoming visible (as a subject) in the world.[56]

FEMINIST NARCISSISM: RADICALIZING THE BODY/SELF RELATION

> Any woman who has had an orgasm has no need for penis envy. . . .
> Penis envy really equals venus envy.
> —HANNAH WILKE, 1985[57]

I have noted that, in the essay in which he discusses "The Intertwining," Merleau-Ponty argues that there is a "fundamental narcissism of all vision" since, although "the seer is caught up in what he sees, it is still himself he sees."[58] It seems, given my comparison of Acconci's and Wilke's body art projects, that Merleau-Ponty's assertion applies most accurately to the male subject in patriarchy, and less so to the female (who, doubly alienated, cannot "see" herself without traveling through the gaze of the [male] self/other). That is, if we can take Acconci's struggle to "see" the other by opening himself to us as indicative, by doing so he ends up confirming that "it is still himself he sees," whereas Wilke, because of the way in which she has been projected into immanence, does not effectively end up only "seeing herself"—or at least not in the same way. Wilke's seemingly narcissistic obsession with displaying her own body takes place through a structure of doubled alienation that prevents her

from ever "seeing" herself or cohering herself in the ways that Acconci continually attempts (as he fails) to do.

In this sense, again, I am privileging feminist body art for its activation of a particularly culturally coded (and dangerous) "feminine" relationship to subjectivity: one that perceives and enacts the body/self as always already implicated in otherness (both its own and the otherness/selfhood of the other). I read feminist body art here as enacting the fundamental incoherence of the self that the majority of the male body artists worked to counteract (although I have specifically situated Acconci's work as rupturing the myth of incoherence through its own ambivalence). Because women are continually forced to take account of their socially inscribed "lack," their contingency on intersubjective relations with others, their subjection to the "gaze," they have both a greater stake in challenging the myth of (male) subjective transcendence and a greater capacity to negotiate openly the inevitable incoherence of subjectivity.

Who, after all, really "is" Hannah Wilke? Her body art projects perform her multiply through the rhetoric of the pose: flashing her ass; cringing, nude, against a wall with a toy gun; flaunting her exquisite torso marked with bizarre cunt/cock-like kisses of chewed and twisted gum;[59] sculpting her voluptuous naked likeness in chocolate; sitting provocatively on a stool in a gallery selling herself as a "sculpture"; standing in high heels, chest exposed, in the pose of a Christian martyr; manipulating her face into erotic orifices and protuberances; lying naked next to her emaciated, sick, but still lively mother; posing—gorgeous, hair tousled amorously—in bed with a male lover lolling in postcoital satisfaction; stripping methodically behind Duchamp's *Large Glass*, her pubis aligned with the bachelor's impotent love gas. . . . We can only "fix" Wilke as an open-ended and unfixable performance of femininity. Or we can "fix" her as quintessentially narcissistic and so not worthy of serious attention.

Wilke's exposure of herself in and as her art—which I am aggressively reading here *as* feminist—has prompted numerous critics, including some feminists, to accuse her of a regressive feminine narcissism. The majority of articles on Wilke and her work begin with a comment about her beauty (she is "[v]isually arresting," a "very beautiful woman," "the most gorgeous face and body in town")[60] and critiques of her work, especially within feminism itself, often pivot around her supposed narcissism and too-beautiful body and face. Thus, Elizabeth Hess is suspicious of Wilke's "innumerable narcissistic poses [that enable her] to wallow in cultural obsessions with the female body," and Judith Barry and Sandy Flitterman disparage Wilke's self-portrait photographs: "In objectifying herself as she does, in assuming the conventions associated with a

HANNAH WILKE POSING BEHIND MARCEL DUCHAMP'S *LARGE GLASS* IN THE PHILADEL-
PHIA MUSEUM OF ART IN THE PERFORMANCE *HANNAH WILKE THROUGH THE LARGE
GLASS,* 1976–78. PHOTOGRAPH COURTESY RONALD FELDMAN FINE ARTS, NEW YORK.
COPYRIGHT ESTATE OF HANNAH WILKE.

stripper . . . Wilke . . . does not make her own position clear. . . . It seems her
work ends up by reinforcing what it intends to subvert."[61]

The dismissal of Wilke's work often goes hand in hand with a privileg-
ing of the work of other feminist artists, usually those identified with what I
have already discussed as antiessentialist feminism (practices dominant in the
1980s and employing more explicit theoretical tools to pose femininity as a cul-
tural construct to be deconstructed rather than reiteratively performed). Thus,
Hess's discussion of Wilke's work as obsessively staging her "'Hollywood' glam-
our" serves to confirm her unfavorable comparison of Wilke's project to the
photographic portraits of black women by Lorna Simpson. Unlike the implic-
itly trivialized Wilke, Simpson, Hess argues, "strips her figures of their identi-

ties, not their clothes."[62] Catherine Liu's negative 1989 review of Wilke's work poses a similar comparison:

> [Wilke's] self-exposure, which translates as some kind of rhetoric of sexual freedom for women, is too facile, too simple a formulation. The work of artists like Cindy Sherman and Aimee Rankin has shown female sexuality to be the site of as much pain as pleasure. The culturally acceptable forms of abuse of women have been giving way at a painfully slow rate, rendering Wilke's position both problematic and out of sync.[63]

The polemical value of such evaluations in supporting new, more clearly deconstructive work by a younger generation of feminist artists cannot be disputed (as many of these younger artists have attained the status of an alternative canon within New York art discourse). But such interpretations of Wilke's works ignore the complexity and potentially radical effects of her strategic, reiterative performance of the rhetoric of the pose (including her specific, and frequent, references to the woundedness of the female body/self in patriarchy). [64] At the same time, the pleasures that Wilke's works also openly encourage in relation to the (presumably heterosexual male) viewer are condemned in the rush to embrace a feminist practice informed by the avant-gardist theories of Bertolt Brecht (one that distances rather than seduces the viewer). [65] (As Wilke herself recognized, "[a]sking people to take pleasure in their own bodies puts them in fear more than anything else").[66] The generational politics of feminist criticism have involved the marshaling of a masculinist, negative conception of feminine narcissism to condemn Wilke's work (as too pleasurable, too invested in the seductive capabilities of the attractive female body). The trope of "narcissism" becomes a means of aligning Wilke with the very immanence that feminism aims to interrogate in its link to femininity.

Aside from my own investment in reading Wilke's works through a different, less antagonistic lens, I would like to stress the way in which such negative accounts of her work fail to acknowledge the very biases and investments of interpretation that I am arguing body art projects, when engaged with phenomenologically, bring to the surface. Comparing Wilke's flamboyantly performative presentations of the female body/self from the 1970s onward to those of Simpson or, especially, Cindy Sherman, one is hard pressed to differentiate them on the basis of anything but interpretive context and the supposed intentions of the artist: Wilke cannot be in any way "deconstructing" femininity because she is associated with early 1970s feminist practice (which has been labeled essentialist) and because she is too obviously beautiful and taking too much plea-

sure in her body/self; therefore, Wilke must have been naive—as a person—and so her work cannot be viewed as in any way critical of patriarchal values.

Wilke's project is clearly not definitively or didactically deconstructive of the objectification of women (neither, for that matter, is Sherman's or Simpson's).[67] Precisely because of its very seductiveness (its refusal to "distance" the viewer into a state of critical awareness), Wilke's work operates *within* the frame of aesthetic judgment to highlight its internal contradictions (its claim of disinterestedness); unlike the projects of Sherman or Simpson, Wilke's operates *within* the codes of "ideal" female beauty and deportment. Extending Judith Butler's model of the reiteration of codes, I suggest that Wilke reiterates a narcissistic femininity in such a way as to unhinge the conventional framing of the woman as object to be controlled through the disinterested judgments of art critical analysis (Wilke's "feminine" narcissism exaggeratedly solicits the viewer's "masculine" desires, clouding the picture of a disinterested criticism). Hess's and Liu's own judgments are in this light shown to be heavily *interested* in their repudiation of the potential pleasures and pains of female self-exposure (could Wilke be soliciting pleasures that are not necessarily heterosexual and male?).

While Sherman's self-imaging—through her aggressive adoption of costumes, props, and exaggerated poses—may thus seem to surface more directly the *falseness* of the picture (its obviously contrived projection of femininity as abject objecthood), Wilke's effectively perform this falseness through a *reiteration* of the visually installed tropes of femininity which crosses them with a complex system of signification that includes interviews, writings, videotapes, and other enactments of Wilke as performative (and profoundly mutable) subject and object of making.[68] Both projects interrogate even as they perform the rhetoric of the pose, and the relegation of women to the site of other/object, in powerful ways.

I would like to tease out Wilke's reiterated "narcissism" here, suggesting that these critical dismissals are less than satisfactory approaches to Wilke's work in that they unquestioningly apply conventional notions of narcissism as a regressive failure to attain coherent selfhood and an inability to sustain healthy relationships to others and the social in general. In *The Second Sex*, Beauvoir explores this popular conception of narcissism and remarks on its link to femininity, observing that "[i]t has sometimes been maintained that narcissism is the fundamental attitude of all women. . . . [W]oman, not being able to fulfill herself through projects and objectives, is forced to find her reality in the immanence of her person."[69] While this link between narcissism and a stereotypical, pathological femininity explains the easy dismissal of

Wilke's work (that is, her narcissism is discomforting to feminists who would like definitively to deconstruct the link between femininity and posing), her obsessive use of her own body in her work in fact produces a narcissistic relation that is far from conventional or passively "feminine," turning this conventional, regressive connection of women with narcissistic immanence inside out (even as it reiterates it).

Feminist critic Lucy Lippard's discussion of the question of narcissism in feminist art typifies the theoretical double binds characterizing the feminist approach to the representation of the female body, contradictions that came to a head with the antiessentialist feminist exhortations to avoid representing the female body altogether which became dominant in the 1980s.[70] Lippard, a vital force in the feminist art movement since its inception, recognizes the dilemma faced by women artists seeking to explore their own embodied subjectivity, acknowledging that narcissism is a particularly charged label in relation to women:

> Men can use beautiful, sexy women as neutral objects or surfaces, but when women use their own faces and bodies, they are immediately accused of narcissism. . . . Because women are considered sex objects, it is taken for granted that any woman who presents her nude body in public is doing so because she thinks she is beautiful. She is a narcissist, and Acconci, with his less romantic image and pimply back, is an artist.[71]

In spite of her recognition of the bias informing the narcissist label as applied to the work of women artists, Lippard nonetheless ends up condemning Wilke's work for exactly this offense. She describes Wilke, "a glamour girl in her own right who sees her art as 'seduction,'" as confusing the roles of "beautiful woman and artist . . . flirt and feminist," such that her work baffles, resulting in "politically ambiguous manifestations which have exposed her to criticism on a personal as well as on an artistic level."[72] Lippard—like many others—accepts without question the category of "beautiful," as if it carries some inherent value when attached to women in Western culture and implies that the fact that Acconci is *not* labeled narcissistic has to do with his "pimply back" (lack of "beauty").[73] Rather than examining the polarization of "beautiful woman" and "artist," or "flirt" and "feminist," Lippard accepts it and infers that, by confusing them, Wilke's art may not be successfully feminist.

I would like to suggest, rather, that it is through just such a confusion—enacted through a radicalized narcissism—that Wilke's work offers an alternative to traditional modernist prohibitions against the exposure of the body

175

of the artist and to the rather rigid antiessentialist feminist (in Wilke's words, "fascist feminist") condemnation of Wilke's and other feminists' uses of their bodies in their work.[74] The dismissal of Wilke as simply narcissistic veils a resistance within art critical systems toward acknowledging the ways in which the artist's body *means* within the circuits of art production and reception (not to mention the ways in which ideals of "beauty" are developed and sustained). Such a dismissal disallows the vicissitudes of intersubjectivity put into play through the body art work and ignores the ways in which narcissism can work, psychically and socially (especially when wielded by an artistic subject who is not apparently normative) to expose the classical mind/body duality still embedded in structures of artmaking and interpretation. Wilke's narcissistic performative body/self conflates not only *her* mind with her body as autobiographically invested maker of art but also confuses in fascinating ways her identities (as feminist subject/object) with those of her viewers.

Wilke's 1977–78 diptych *I Object: Memoirs of a Sugargiver* exemplifies her strategic use of narcissism to wrench open conventional alignments of the female body with a debased and quintessentially objectified self-love. Mimicking the position of the grotesque nude female body in Marcel Duchamp's *Étant donnés* (1946–1966), Wilke poses twice on her back on a rough rock, having herself photographed from above and below for the two respective images.[75] While Duchamp's nude (with its horrifying gash where the genitals should be) aggressively solicits and simultaneously repels the uncomfortable gaze of the peeping viewer (who is forced to place her or his eyes at the holes drilled in the wooden door in front of the nude), Wilke exposes herself openly and voluntarily, removing the obstacle of the door and encouraging the gaze to roam freely across her photographed body.[76]

Wilke, then, is "I," the subject/maker of the images, as well as "object" of the gaze; she proclaims her objection ("I object . . .") to, one infers, the rigid conception of the gaze common in feminism at the time (as necessarily male, necessarily oppressive, necessarily empowering) as well as to the gaze itself. Furthermore, Duchamp's presentation of himself as "Salt Seller" (in French, "Marchand du Sel," a play on the name Marcel Duchamp)[77]—the male promoter of commodities—is transformed into a feminine/feminist giver of "sugar." By giving her sweet body, Wilke proposes to circumvent the circuits of capitalist exchange—except inasmuch as the images inevitably participate in the commodifiable public image of Wilke (though she hardly became a millionaire with them). As Wilke stated, "objecting to art as commodity is an honorable occupation that most women find it impossible to afford."[78]

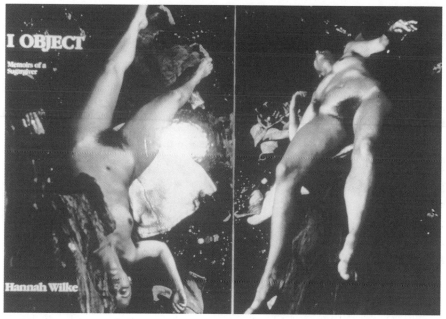

HANNAH WILKE, *I OBJECT: MEMOIRS OF A SUGARGIVER*, 1977–78; TWO CIBACHROME
PHOTOGRAPHS, 24 X 16 INCHES EACH. PHOTOGRAPH COURTESY RONALD FELDMAN FINE
ARTS, NEW YORK. COPYRIGHT ESTATE OF HANNAH WILKE.

THEORIZING FEMINIST NARCISSISM

> Woman . . . is narcissistic, in fact, but only by phallic mandate. . . . She
> is mutilated, amputated, humiliated . . . because of being a woman.
> —LUCE IRIGARAY[79]

> Asking people to take pleasure in their own bodies puts them in fear
> more than anything else.
> —HANNAH WILKE, 1983[80]

The ease with which the label "narcissistic" is deployed to condemn a par-
ticular cultural practice relates to its conventional link to a specifically femi-
nine degradation of the self. The term *narcissism* derives, of course, from the
classical myth of Narcissus, a beautiful man who was cursed by the goddess
Nemesis for his refusal to love any of his admirers (including the nymph
Echo). Upon seeing his image in a pool of water, "[s]pellbound by his own
self," Narcissus fell madly in love—pining away for himself until his body
withered away. Ovid describes this death from self-love: "his fair complexion
with its rosy flush faded away, gone was his youthful strength, and all the
beauties which lately charmed his eyes. Nothing remained of that body which

177

Echo once had loved. . . . [D]eath closed the eyes which so admired their owner's beauty."[81]

At once "seeking and sought," Narcissus, "because he could not lay hold upon himself" and yet perceived himself as other, expired through his delusory desire. He is both profoundly unified into a dangerous self-referentiality (as he who both "has" and "is" his desired object) and radically alienated (split into self and other, unable to obtain that which he is). This dilemma is summed up in his plaintive cry: "How I wish I could separate myself from my body! A new prayer this, for a lover, to wish the thing he loves away!"[82] He both *wants* himself and *is* himself (and yet becomes *not himself*—alienated from himself—through his own desire). Narcissus enacts the very dilemma that plagues the *male* subject in patriarchy: in particular, the deeply motivating desire to "separate myself from my body" that, as Beauvoir recognized and as Acconci performed, characterizes the male subject's compelling need to disavow his corporeal immanence.[83]

The original Narcissus myth is clearly about male subjectivity and, notably, about both heteroerotic and homoerotic desires (Narcissus is pursued by both male and female suitors and ends up loving a man—himself). But psychoanalytic accounts of narcissism, driven by patriarchal assumptions about gender difference, have deployed Narcissus, in his tormented, alienated yet conflated relationship to himself, as exemplary of a condition of *feminine* subjectivity. Expanding on Sigmund Freud's model, which defines narcissism as both a stage of development and a form of male homosexual neurosis, narcissism has come in everyday parlance to mean simply a kind of self-love epitomized by women's obsession with their own appearance (or, correlatively, by the effeminate self-ministrations of the fop-homosexual man).[84] Thus Narcissus has predictably enough glided into the pathological realm of feminine (or feminized) perversion. As Freudian psychoanalysis would have it, the collapse into the self epitomized by Narcissus is transformed for prototypically narcissistic female (or feminized homosexual male) subjects into a fundamentally alienated (nontranscendent) corporeality: the narcissistic subject is always too involved with her external image, confusing the boundaries patriarchy insists on staging between self and other.[85]

In a fascinating twist on the original myth—where it is Nemesis, the authoritative *and* female deity who is infuriated by Narcissus's self-sufficiency, condemning him to die through his unrequited self love—the female narcissist is dangerous to patriarchy because she obviates the desiring male subject (loving herself, she needs no confirmation of her desirability from him). In the case of an artistic practice that performs female narcissism (such as Wilke's), the threat lies in its making superfluous the arbiters of artistic value. Already presuming

her desirability, Wilke obviates the modernist critical system: loving herself, she needs no confirmation of her artistic "value."[86]

Acconci's performances are narcissistic in that they involved the continual restaging of himself vis-à-vis the other (the collaborator[s] in the piece and/or the audience). Acconci enacts a narcissism, paradoxically, *through the other* and in this way outlines in a paradigmatic fashion the ambivalent masculine relationship to the other, who is seen only through a "gaze" that takes its power by passing through the (male) "self" and by denying the immanence and corporeality such a passing entails. In Heinz Kohut's revisionist psychoanalytic model of narcissism, the other is for Acconci a "self-object," only partially differentiated from himself.[87] Acconci's practice seems to confirm the fact that, because of the way in which women experience themselves in the social, they are continually forced to experience male subjects not as other but as, in Irigaray's terms, "self-same": as having a claim to the mythical possibility of coherence that they do not have.[88] Conversely, Wilke enacts herself obsessively—*but always within an assumed intersubjective relation* (experiencing herself as feminine, she could hardly do otherwise).[89] For Wilke, the other is ideologically articulated (within patriarchy) as what Kohut would call a "true object": an "independent center of experience and initiative."[90]

In a sense, by drawing on such a model I am arguing that women have little choice but to explore their subjectivity through such a relation. At the same time, by drawing on Butler's useful notion of performativity as "assuming a sex," I suggest here that feminist body artists' adoption of such structures of femininity work through reiteration to unhinge them. The "bodily norm" of femininity (which instantiates the female psychic subject) is assumed by way of the (usually female) subject's identification with conventional, patriarchal, and heterosexist tropes of the feminine (in this case, women as "immanent," men as achieving "transcendence"); but it is also just such an assumption (or reiteration) that destabilizes as it produces (conventional) sexual identities.[91] Wilke's "beauty," her "narcissism," her hyperfemininity (her posing of herself obsessively *as a picture*) all raise the question of what and how these structures come to mean socially as well as culturally.

Wilke's reiteration, as I have already suggested, takes place through the very regime of the visible that has conventionally subordinated women to the reified politics of the "male gaze." In both the ancient and modern cases, the narcissistic relation takes place through the register of *vision:* it is the sight of the reflected image of himself that initiates Narcissus's suicidal self-love. Wilke's staging of herself in this normative regime of the visible (where the formulation "woman-as-object" is sealed through the suppression of the im-

manence of the male body/self) functions more subtly as well to interrogate profound issues of the embodied female subject as both artistic subject and object, as that which *exceeds* vision (or makes vision, phenomenologically speaking, definitively corporeal and reversible).

"BEYOND" VISION: WILKE'S EMBODIED NARCISSISTIC SUBJECTIVITY

While Wilke's negotiation of the rhetoric of the pose places her firmly in the regime of the visible, she explodes its boundaries by producing herself as well in the performative dimension. As *body art* (images contextualized within a complex array of performative works), Wilke's pieces engage us in the phenomenological constitution of Wilke as making subject/viewed object. As cited in chapter one, Lea Vergine recognizes as much in her linking of narcissism to the projective capacity of body art: "Projection expels an internal menace that has been created by the pressure of an intolerable impulse and thus it is transformed into an external menace that can be more easily handled. [In body art projects] the artists shift their problem from the subject to the object, or from the inside to the outside. . . . The work is the artist and his narcissism . . . [is] no longer invested in an art object but allowed to explode within his own body."[92] Wilke's body art works operate to project the self outward (through the visible body) but complicate this by also externalizing the internal wounds of female subjectivity.

On the one hand, in the narcissistic scenario it is the *image* (the reflection in the water) that allows the self to love the self, affording a *distance* between the self and the self-as-image, producing the self as other. This distance—like that required by aesthetics—is necessary for the self to master the other (the artist/the artwork). But, at the same time, in narcissism the image *is* the self, all distance is collapsed, and the borders of the frames of identity are imploded. In this sense, as I have already suggested, narcissistic self-love is radically endangering to Western subjectivity, which insists upon the oppositional staging of an other (who lacks) to legitimate the self (who ostensibly has); it is also radically dangerous to the structures of conventional aesthetic judgment (as congealed in modernist art criticism), whereby the critic takes his or her authority from a staging of boundaries (a framing) that contains the object (here, Wilke's body-in-performance) and controls it through a "disinterested" determination of value. Wilke can be controlled and dismissed (as unfortunately she generally has been) only through the further reiteration of the very codes that she has already adopted: narcissistic stripper, self-exposing glamour girl.

By performing a narcissistic relationship to herself, Wilke collapses the distinction between the subject who desires and she who is desired, between the

art object and the art "subject" (the artist), between the art object/subject and the subject of interpretation.[93] Because she is a female subject, her narcissism is all the more threatening to the norms of Western subjectivity, since, even while she solicits spectatorial desires through conventionally heterosexual codes of female desirability, she also excludes the heterosexual male subject altogether from her self-relation (we remember Nemesis's fury). Through her myriad, often contradictory presentations of herself, Wilke solicits this gaze, grafting it onto and into her body/self, taking hold of it and reflecting it back to expose and exacerbate its reciprocity. Too, while Wilke has, as we have seen, been criticized as constructing her body as obscene, desirable, and/or victimized object of an inexorable patriarchal gaze, she offered her body within a fully theorized array of expressions (objects, interviews, texts, music, performances, photographs) that articulated a proactive rather than reactive feminist subject.

Such strategic feminist narcissism stages as part of its own internal dynamic the desire of the viewer of the picture to possess the female-body-as-object. Literalizing this desire within her own self-relation, Wilke leaves no gap (except, as noted, that which she has already filled with her own reiterative narcissism) for the interpretive mastery that is crucial to the framing operations of conventional art history and criticism. I have noted that, while art historians and critics attempt to justify their interpretations as aligned with the artist's ostensible original intentions by conflating the artist with the work of art, the discipline also labors to *conceal* this conflation in order to avoid the appearance of entanglement in other egos, bodies, or points of view. As I perform her work here, it both obviates this concealment (by conflating Wilke with the work of art) and exacerbates the need for it by producing her as desirable subject of production and desire. I cannot extricate myself from Wilke's reiterative, hyper-feminine narcissism, repeating it here (and perhaps it is this dynamic that has been the most disturbing to feminist critics who want to dismantle modernism while simultaneously maintaining its promise of critical authority).

As Liu's critique suggests, in conventional leftist models of aesthetics, the collapse of the distance between spectator and object is seen as precisely that which renders a practice politically suspect. In terms derived from Brecht's theory of distanciation, this collapse is seen as, among other things, allowing for a too easy pleasuring, a too easy fulfillment of desire—as precluding a critique of the dominant systems of signification.[94] In the feminist argument derived from Mulvey's polemic in "Visual Pleasure and Narrative Cinema," the loss of distance encourages the sexist, predatory effects of the "male gaze"; or, in bell hooks's feminist and antiracist terms, closeness endangers by disallow-

ing difference and privileging the totalizing effects of "white suprematist [*sic*] culture."[95]

In Mulvey's or hooks's Brechtian terms, my analysis renders Wilke's work antifeminist and complicit with white hegemony. However, as I have suggested, such attempts to legislate the very strategies allowed in feminist art practice themselves put into place a framing enterprise. While it was obviously strategic to insist on a Brechtian approach at one point (the 1970s through the 1980s), this approach has just as obviously become reified and prescriptive. Feminist body art asks us to interrogate such critical strategies, which fail to implicate the interpreter in their determinations of value and perpetuate distinctly nonfeminist relations of mastery within interpretation. To this end, reading through Wilke's practice, I would like to propose that the collapse of distance between subject and object can be interpreted (and experienced) as complicating the framing apparatus of interpretation toward ends that are also (and perhaps *even more profoundly*) feminist in effect. Without distance, one has no "perspective," no vantage point from which to construct or reaffirm the borders of the frame—one is emphatically *not* disinterested but fully and pleasurably implicated in the processes of determining meaning. And this returns us to narcissism.

Narcissus's failure either to merge his image with himself or to attain himself as beloved object was his downfall, precipitating the dissolution of his flesh; in Freudian terms, he "feminized" himself through this failure, which placed him in an ultimately fatal oscillatory state of flux between conventional positions of subject and object. For a woman living in patriarchy such a state of flux is arguably empowering in that it confuses the conventional incompatibility between the standard construction of woman as object/picture and the potential for the alignment of woman as subject. Assigning both possible positions to Wilke at once (an effect exacerbated through her aggressive falsification and multiplicitous coding of her body/self through the use of props and exaggerated poses), her narcissism could be said to instantiate the radical unknowability of the subject in representation.

Wilke's *S.O.S.—Starification Object Series* (1974–79)—a group of pictures showing her in various poses with props such as toy guns and sunglasses, her hair coiffed in a variety of ways, her body nude or partially clothed—exemplifies her radically narcissistic approach to her own problematic femininity (Wilke: "how to make yourself into a work of art instead of other people making you into something you might not approve of").[96] Her flesh in each *S.O.S.* image is covered with tiny, cuntlike bubble-gum sculptures (these expanded on her interest in vulvar sculptural form from the late 1950s onward). As Wilke

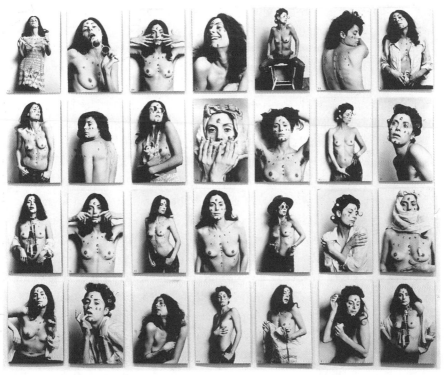

HANNAH WILKE, *S.O.S.—STARIFICATION OBJECT SERIES*, 1974; TWENTY-EIGHT
PHOTOGRAPHS FROM *MASTICATION BOX*, 6³/₄ X 4³/₄ INCHES EACH. PHOTOGRAPH BY
EEVA-INKERI, COURTESY RONALD FELDMAN FINE ARTS, NEW YORK. COPYRIGHT
ESTATE OF HANNAH WILKE.

insisted, these mark her body in its contingency and woundedness as "femi-
nine" but also as ethnically scarred:

> To also remember that as a Jew, during the war, I would have been
> branded and buried had I not been born in America. Starification-
> Scarification . . . Jew, Black, Christian, Muslim. . . . Labeling people
> instead of listening to them. . . . Judging according to primitive
> prejudices. *Marxism and Art.* Fascistic feelings, internal wounds, made
> from external situations. . . .
>
> I decorated my body relating to the African Scarification Wounds,
> of the Caste Systems (on my head), or, macho male photographs,
> with cowboy hats and guns, or little uniforms . . . maid outfits, and
> hair curlers; so, they were psychological poses that related to me, as
> emotional wounds . . . the internal wounds that we carry within us,
> that really hurt us. You know, having to "be pretty," or, being pretty,
> and being thought of as stupid.[97]

For Wilke, chewing gum is the appropriate medium for producing these scars: "I chose gum because it's the perfect metaphor for the American woman—chew her up, get what you want out of her, throw her out and pop in a new piece."[98] Wilke's genital scars work, like her process of self-imaging, to externalize the "internal wounds" by which women are made to conform to Western femininity (with the cunt itself stamped wound or lack); at the same time they parodically expose the limitations of a conception of identity that rests entirely in the visual register or, for that matter, rests on gender alone (assuming that one can "know" a woman solely through her external appearance).

By illustrating her "lack," Wilke thus exaggeratedly proposes the marks (themselves associated with Marx's gender-blind class critique) as signifiers of the meaning of her gendered identity. But the marks, which seem at first to be "obvious" signs of the female sex, ultimately emerge to view in a startling *androgyny:* in Wilke's words, "they can be seen as female and male, just as the head of a cock looks very much like a vagina. So they are really male-female gestural sculptures."[99] Elsewhere, Wilke notes that their androgyny is a product of *point of view,* a position that precisely emphasizes the unreliability of the visual signs of anatomical difference in determining sexual identity: "When you get down to very small scale, the chewing gum forms, are totally androgenous [*sic*]—from a woman's point of view, not from a man's point of view, cause if you look at the head of a cock, it has the same exact shape, frontally, as the shape I invented by chewing, folding, turning, and over-lapping my chewing gum."[100]

Wilke's externalization of the fundamental lack of subjectivity (aligned explicitly with femininity in Western culture) also links up with the Marxist critique in its interrogation of the ways in which the body is doomed to function as a wounded object (as "feminine") within the realm of commodity culture. Through the erotic and artistic performance of her body/self (as both subject and object of art)—and inspired by the sexual revolution of the 1960s—Wilke explores the Marcusean ideal of artists' ability to transform bourgeois capitalism via a desublimatory practice.[101] Wilke's "performalist" photographs negotiate the way in which the regime of the visual strips the body of its volume, putting into play a commodifying dynamic of objectification (prostitution aside, it is largely the body-as-image, rather than the embodied subject, that has the most fluid exchange value in our culture):

> Visual prejudice has caused world wars, mutilation, hostility, and alienation generated by fear of 'the other.' Self-hatred is an economic necessity, a capitalistic, totalitarian, religious invention used to control the masses through the denial of the importance of a

body language, which is replaced by a work ethic devised to establish a slavery of the mind burdened by that awful albatross—the body. . . . The pride, power and pleasure of one's own sexual being threatens cultural achievement, unless it can be made into a commodity that has economic and social utility.[102]

Unveiling her flesh and forcing it to symbolize the externalization of the (wounded) self, Wilke performs her body/self as radically excessive. Wilke's reiterative, narcissistic, performative body/self exceeds the framing apparatus of art critical judgment; the regulatory models of proper feminist practice; the "work ethic" and "slavery of the mind" put into place by capitalism's commodity system; the boundaries of my own engagement. Wilke performs herself *already* as narcissistic, as "essentialist," as "commodity," as "radical feminist body artist" such that we are exposed in our desire to frame her. She forces us to interact with her body (image) as a constitutive aspect of her multiplicitous self and so makes us complicit in formulating her significance.

THE BODY TURNED INSIDE OUT: CANCER AND NARCISSISM

Disease sometimes occurs because of loss. The environment creates
internal wounds that you aren't fully aware of.
—HANNAH WILKE, 1989[103]

Using myself is never narcissistic to begin with because I'm gonna
die and then the work will live on. So that I just become a figure
of a woman.
—HANNAH WILKE, 1989[104]

Wilke's radical narcissism culminates in *Intra-Venus*, the last project she completed—with the assistance of her partner Donald Goddard, who took the photographs as Wilke posed—before she died from lymphoma in 1993.[105] A series of life-sized color photographs of Wilke undergoing cancer treatment, self-portrait watercolors, medical objects-cum-sculptures, and images fabricated from the hair she lost during chemotherapy, *Intra-Venus* is a brilliant riposte to those who condemned her work as narcissistic and Wilke herself as exploiting her own beauty.

These images have had a powerful effect in the art world's perception of Wilke. Suddenly, after the posthumous exhibition of *Intra-Venus* in New York in 1994, the New York art world began to shower Wilke with encomiums, as if her loss of attractiveness and her death (and her aggressive introduction of

HANNAH WILKE (WITH DONALD GODDARD), *JUNE 10, 1992/MAY 5, 1992, #5* FROM *INTRA-VENUS*, 1992–93; TWO CHROMAGENIC SUPERGLOSS PERFORMALIST SELF-PORTRAIT PHOTOGRAPHS, 71¹/₂ X 47¹/₂ INCHES EACH. PHOTOGRAPH BY DENNIS COWLEY, COURTESY RONALD FELDMAN FINE ARTS, NEW YORK. COPYRIGHT ESTATE OF HANNAH WILKE.

illness/trauma into her formerly "beautiful" image) had somehow ameliorated the "narcissistic" effects of her earlier work.[106] While Wilke's project remains apparently the same—up to the end of her life she performs herself obsessively in relation to femininity through the rhetoric of the pose—her relationship to artistic subjectivity has inevitably transmogrified. Wilke is now both "unattractive" and dead, ready to be incorporated fully into a canon of postmodernism that could not accommodate the living Wilke—the artistic subject who refused to alleviate the social and psychological processes and effects of her objectivity, who so insistently reiterated normative femininity rather than compulsively occupying herself with repudiating the "male gaze."

Because Wilke continued to perform herself (posing rhetorically as "feminine") through illness, her body/self disintegrating in a harrowing process of physical decay, perceptions of her body art project shifted 180 degrees.[107] Wilke is no longer to be viewed as self-absorbed beauty queen but as suffering *artiste*, making art out of her pain. As with the work of other feminist artists who have examined patriarchal constructions of femininity by exploring the changes in their bodies through life-threatening illnesses, such as Jo Spence and Nancy Fried, Wilke's *Intra-Venus* forces the viewer to confront his or her expectations about the appearance of the female body in visual rep-

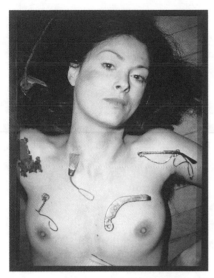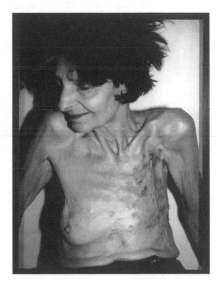

HANNAH WILKE, *PORTRAIT OF THE ARTIST WITH HER MOTHER, SELMA BUTTER*, FROM
THE *SO HELP ME HANNAH* SERIES, 1978–81; 40 X 30 INCHES EACH. PHOTOGRAPH
BY D. JAMES DEE, COURTESY RONALD FELDMAN FINE ARTS, NEW YORK. COPYRIGHT
ESTATE OF HANNAH WILKE.

resentation and the link between this appearance and the understanding of
the female subject so rendered.[108] One is precluded from approaching this
work without accounting on some level for the complexity, ambiguity, and
deeply theoretical (if embodied) nature of Wilke's relationship to her own
beauty. On literal as well as metaphorical and conceptual levels, *Intra-Venus*
deftly interweaves the medicalized/objectified body of illness (with its "intra-
venous" invasions) with the sexualized/objectified woman's body (signified as
"Venus," the quintessential sexual object of Renaissance to modern painting).

Wilke's compulsion to grapple with the trauma of illness through per-
formative photography first developed with the group of works she produced
of her mother struggling with cancer from 1978 until 1982 (the year her mother
died), including the diptych *Portrait of the Artist with Her Mother, Selma Butter*
(1978–81), part of the *So Help Me Hannah* series. Here, Wilke explores the shal-
lowness of our culture's conception of feminine appeal, which focuses on visual
appearance as beauty's guarantee. On the left, Wilke lies pale, perfect (according
to Western conventions privileging a "pure," white feminine flesh), her face,
rather opulently rouged and made up, serene if resigned; small metal objects
(fragments of utensils and other tools of the carcinogenic industrial era) dis-
turb the perfection of her snowy chest, ominously signaling the ephemerality of
the line between flesh as signifier of glowing health and erotic appeal and flesh

187

as diseased and rotting harbinger of death.[109] On the right lies Selma Butter: eyes closed, a bemused expression on her downturned face, her skin dark (cooked by chemotherapy) and a lively crest of black hair (a postchemo wig) that seems to try to outdo Wilke's luxurious dark mane. In stark contrast to Wilke's perfectly symmetrical, white-powdered chest, Selma's is divided between one sagging breast and a harshly scarred absence, the site of her mastectomy, already pitted again with cancerous growth.

With her ritual metal objects, Wilke attempts to ward off the disease that claimed her mother's life. While one could, rather simplistically, disparage her inclusion of herself in this piece as "narcissistically" diverting attention from her dying mother, I see this juxtaposition on a deeper level as insisting upon the traumatic intersubjectivity of self and other (especially child and parent): the very intersubjectivity that makes a parent's or child's death profoundly incomprehensible. In fact, as Beauvoir has argued, all love "requires the duality of a subject and an object" and thus precludes the negative kind of narcissism defined psychoanalytically as women's natural state of immanent being.[110]

By asserting her imbrication in her mother—as youthful reflection of her mother's expiring body/self—Wilke again subverts the assumption that narcissism necessarily entails a reactionary, "feminine" self-involvement and obliviousness to others. When viewed in this light of life and death, Wilke's "narcissism" is nothing less than a painful enactment of the fundamental contingency of the self on the other, a contingency, as Jacques Derrida theorizes, that is highlighted through the death of a loved one:

> [S]peaking at the death of a [loved one], we declare that from now on everything will be situated, preserved, or maintained in us . . . and no longer on the other side, where there is nothing more. . . . Everything remains 'in me' or 'in us,' 'between us,' upon the death of the other. Everything is entrusted *to me*; everything is bequeathed or given *to us*, and first of all *to* what I call memory—*to the memory*. . . . All that we seem to have left is memory.[111]

The memory—the psychic dimension of the others we love—is what continues to constitute them for us, even after their own death; they are in us (in-corp-orated idiopathically) and yet we are also conditioned through the aspect of them that structures our sense of body/self. Not coincidentally, then, Derrida (like Wilke) links the anguish of loss to an equivocal narcissism, opening out precisely the paradoxical incoherence of the self implicated in the narcissistic relation. Because what the dead loved one would say or be "remains hopelessly *in* us or *between* us the living," others would denigrate this relation as

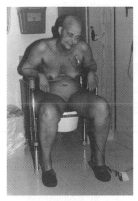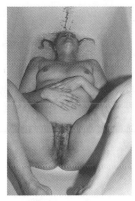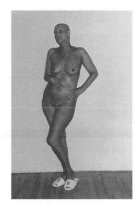

HANNAH WILKE (WITH DONALD GODDARD), *AUGUST 17, 1992/FEBRUARY 15, 1992/ AUGUST 9, 1992,* #3 FROM *INTRA-VENUS,* 1992–93; THREE CHROMAGENIC SUPER-GLOSS PERFORMALIST SELF-PORTRAIT PHOTOGRAPHS, 71½ X 47½ INCHES EACH. PHOTOGRAPH BY DENNIS COWLEY, COURTESY RONALD FELDMAN FINE ARTS, NEW YORK. COPYRIGHT ESTATE OF HANNAH WILKE.

"narcissistic." But, Derrida continues, "the narcissistic structure is too paradoxical and too cunning to provide us with the final word. It is a speculation whose ruses, mimes, and strategies can only succeed in supposing the other—and thus in relinquishing in advance any *autonomy*."[112] Wilke's "narcissistic" inclusion of herself in her piece about her mother's illness presupposes rather than deflects her lack of autonomy as a subject; it illustrates the agonizing interdependence Hannah and Selma sustained as mother and daughter (agonizing because it is experienced upon the death of one party as the sundering of the body/self or as an amputation from within).[113]

The *Intra-Venus* series eerily and traumatically seems to substantiate Wilke's having literally incorporated her mother, illness and all, with Wilke's ravaged, cancerous body now taking the place of Selma's. In her book *Illness as Metaphor,* Susan Sontag laments the fact that cancer is often viewed as a "disease of the failure of expressiveness";[114] with *Intra-Venus* Wilke conquers this failed expressiveness by forcing cancer to *read,* obsessively—as was her wont—imaging her body under its grip (or, more accurately and ironically, under the grip of its treatments: it is the bone marrow therapy, radiation, and chemotherapy that devastated her body and transformed it from ⌊too⌋ beautiful model of health into a bloated, bald odalisque).

In the *Intra-Venus* pictures, Wilke, who continues insistently to pose, still "exists" for us: beaming beatifically, looking like the Virgin Mary with her head wrapped in a blue cloth (auspiciously, a hospital blanket); laughingly holding her still-luxuriant mane of hair up to reveal a huge cancerous protrusion on

her neck as if it were a beauty mark; naked, her body bowed with exhaustion, sitting on a hospital toilet; standing elegantly like an Ingres odalisque, nude, completely bald, and wearing only a pair of slippers; staring into the camera, her face sagging with exhaustion under a white shower cap, breast and arms marred with huge wads of gauze and tape; or finally, marking the total debasement of the body and the loss of self-consciousness in extreme illness, lying naked with her head and remaining wisps of hair under the bathtub faucet, her legs spread towards the camera.[115]

The latter image is especially perverse and unsettling. Wilke's exposure of her sex in this image returns us to a rumination on how feminist artists have displayed their bodies through the rhetoric of the pose to circumvent the politics of the "male gaze." Such an overt enactment of the pornographic pose makes visible that which disrupts the masculine phallic economy (the female genitalia): that which must not be seen. By flaunting the female sex, feminist artists destabilize the very project of aesthetic judgment, since the obscene body functions as the debased "other" of the high art nude and must remain outside the frame of the aesthetic (as "pornography").[116] As a locus of desire, the female sex solicits the very gaze that hopes to stage it as object.

Furthermore, by activating the desire that must remain veiled in aesthetic judgment, this unveiled female sex "insists on being enjoyed" and thus annihilates the distance necessary for the viewer to suspend "animal attachment."[117] Through Wilke's obscene unveiling of her genitalia, opened to view in exhaustion and depletion rather than beguilement, the viewer's disinterestedness (repudiation of "animal attachment") is refuted—his or her inexorable implication in the othering of the female body as "art" is performed.[118] In other words, Wilke's sex *looks back* at the possessor of the "male gaze," exposing his insufficiency (his lack, if you will). Her cunt, in Lacanian terms, exposes the "level of reciprocity between the gaze and the gazed at," the fact that "it is not the annihilating subject . . . who feels himself surprised [by the gaze], but the subject sustaining himself in a function of desire."[119] The subject of viewing is confronted by the "eye"/"I" of the female sex.

But this image presents Wilke's sex as mediated through her illness. Bryan Turner describes the subject's relationship to illness as follows:

> Despite the sovereignty we exercise over our bodies, we often experience embodiment as alienation as when we have cancer or gout. Our bodies are an environment which can become anarchic, regardless of our subjective experience of our government of the body. The importance of embodiment for our sense of the self is threatened by

> disease but also by social stigmatization. . . . The body is a material organism, but also a metaphor; it is the trunk apart from head and limbs, but also the person. . . . The body is at once the most solid, the most elusive, illusory, concrete, metaphorical, ever present and ever distant thing—a site, an instrument, an environment, a singularity and a multiplicity.[120]

Wilke's life project involved exploring the metaphoricity of her body, its meaningfulness as a "picture" of her self—as a signifier of the "content" of her personality that could never be fixed or predetermined: by its very nature as a picture/object-of-desire, her body/self is always already implicated in the desire of the viewer. With *Intra-Venus,* she deploys her well-developed strategy of the pose to project herself outward: to *constitute* the alienation of herself from this growth eating her body from within.

The ultimate beaver shot, the picture is a harrowing remake of *What does this represent/What do you represent,* Wilke's body now rotated through the "mechanics of fall" (*bassesse*) into a surrealistic position of *informe*—"formlessness through deliquescence, putrefaction, decay."[121] Hovering, abjectly, within the objectifying purview of the gaze, Wilke's body is nonetheless deobjectified: it is turned horizontal and so (in the realm of *bassesse*) removed from the (vertical) province of the human. Its boundaries dissolved into the perspectively rendered space around it, Wilke's body is "noxious in its physical formlessness," and absolutely subversive to the logic of the gaze that would conventionally circumscribe the woman's body within its own immanence.[122] It throws into the gaze a cunt that is almost hairless (but through illness rather than through the cosmeticization of the pornographic tradition)—one that "speaks" with lips that align perfectly with the immersed head of the subject-in-pain.[123]

Complementing the large-scale *Intra-Venus* photographs are a group of pictures made of clumps of Wilke's hair, lost in chemotherapy (ranging from rat's nest wads to diaphanous wisps), and a group of dense, saturated watercolors, images of her face in one series, her hands (crippled with intravenous lines) in another. These objects testify again to her tenacious drive to render explicit the "inexpressible" ravages of cancer. The hair, displayed to substantiate (or repudiate?) the demise of the body/self, literalizes its loss; in life part of the body/self (not icon or index but the thing itself), in death the hair becomes an index of its having been there. Loaded in patches of color onto the paper (which puckers and crinkles under their weight), the tiny heads and gnarled hands of the watercolors wistfully and tenderly narrate cancer's message to the body/self: invasion from within and ultimately a loss of coherence that extends

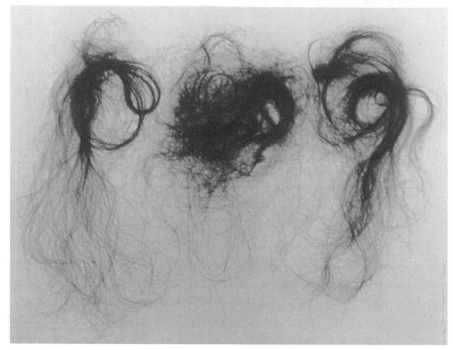

HANNAH WILKE, *BRUSHSTROKES: JANUARY 19, 1992,* 1992; ARTIST'S HAIR ON ARCHES PAPER, 33 X 25¹/₂ INCHES. PHOTOGRAPH BY DENNIS COWLEY, COURTESY RONALD FELDMAN FINE ARTS, NEW YORK. COPYRIGHT ESTATE OF HANNAH WILKE.

the confusion of human existence (the failure of the attempt to cohere the self) but outdoes it radically.

With these works Wilke extended her "narcissism" to literalize cancer as a signifier of the damage inflicted upon her body/self by patriarchy, externalizing these psychological wounds and seemingly attempting to expel the cancer eating her from within. By turning her self-relation outward, splitting off her body as an object of multiple (medical turned art world) gazes, Wilke emphatically rejected the conventional, psychoanalytic conflation of femininity with immanence and explored, rather, the convoluted merging/alienation of the self with/from the body that underlines the ancient Narcissus myth. The self, vis-à-vis its embodiment and imaging, is no simple, readable "thing" (whether from inside or out). Wilke's project illustrates cancer's capacity, through its evil multiplication of interior flesh into visible outer tumors, to exacerbate these constitutive disjunctions of inside/outside, selfhood/otherness.

Struggling with cancer, Wilke seems to have wanted to sever the intricate, but now surely agonizingly painful, bonds among her gaze, her body, her sexual identity, and her intellect, using photography to objectify her body *for*

herself (and thus inevitably for us), to make the signs of cancer and its treatments legible: to make sense of death. At the same time, just as her photographs of her mother certainly did not palliate the agonizing grief that Wilke must have felt at Selma Butter's demise, so these pictures fail to alleviate the loss of Wilke (as we might feel we "know" her through her work and certainly as she experienced herself). The photograph—indexical as it may be—and even the sad, lovely clumps of hair marking the passing of Wilke's flesh, are pathetically insufficient as replacements for the subject "Hannah Wilke." The project puts a lie to the art critical assumption that the artwork *is* somehow the artist, pointing to the failure of photography to confirm the "authentic" self and proclaiming indeed the impossibility of such authenticity *tout court.*

With the *Intra-Venus* pictures, Wilke plays out her "narcissism" to expose the transience and conditionality of her own beauty, performing a subject who is hardly as uncritically invested in her looks as her critics would have had it. Wilke stated in 1985: "People want others to be the objects of their desire. But I became the subject and the object, objecting to this manipulation. . . . People often gave me this bullshit of, 'What would you have done if you weren't so gorgeous?' What difference does it make? . . . Gorgeous people die as do the stereotypically 'ugly.' Everybody dies."[124] In *Intra-Venus,* that "gorgeous," lively face is sagging, unutterably tired, in some images bruised and swollen; that slim, luscious body is bloated from cancer therapies, helplessly attached to tubes, covered with the signs of biopsies and other intrusions—literally invaded both from within and without.

The medicalization of Wilke's body and its brutalization through illness turn it from sexual object (of her own and others' pleasures) to scientific object, and yet, while the regimes of medicine work to strip away individual identity, Wilke's sense of humor and compulsion to perform once again transform an objectifying practice into an opportunity for self-expression. Sickness continually works to alienate the cognitive, emotive self from the physical body by forcing the subject to externalize her pain as other, but at the same time (as with the narcissistic relation) points to the failure of such externalization: illness is "purely lived; there is no distance between the consciousness reflected-on and the pain nor between the reflective consciousness and the consciousness reflected-on. The result is that the illness is transcendent but without distance."[125] Finally, then, because the body/self-in-illness exacerbates both the isolation of the self and its profound dependence on the other (not to mention its coextensiveness with the body), Wilke's project can be mapped as a profound feminist negotiation of the boundaries between self and other through the image of the body/self.

FROM IMMANENCE TO "TRANSCENDENCE": NARCISSISM AS FEMINIST AND ANTIRACIST TOOL

As we have seen, Beauvoir's key argument in *The Second Sex* revolves around the fact that men in Western patriarchy have had access to (or at least have claimed a direct relation to) transcendence while women have been consigned to the immanence of their bodily existence (hence her connection of narcissism with the failure to achieve a relation to the world beyond the self). Along with Wilke's previous body of work, *Intra-Venus,* as I engage with it here, presents Wilke through a narcissistic self-relation, interrogating the objectification of women in patriarchy as well as "transcending" immanence by projecting her body into the world as a making subject. Following on Beauvoir's analysis, such an interrogation has been a constitutive impulse of the mainstream feminist art movement since its inception in the early 1970s; a powerful set of strategies, it has nonetheless rightly been faulted for its myopia vis-à-vis other aspects of identity such as race and class.

I would like to address this issue by highlighting the ways in which *Intra-Venus* enacts the very intersectionality of gender with ethnicity that white feminists—including Wilke—have been accused of ignoring.[126] In this way, Wilke's work "transcends" the limitations ascribed to white feminism as well as the immanence of narcissistic female subjectivity.[127] In the center of the installation one of Wilke's group of folded ceramic sculptures sits on the floor; arrayed randomly on a black wooden base, the charcoal black objects read ominously like a pile of burnt bones, a reliquary to the body that is no longer (Wilke having died before *Intra-Venus* was installed). Surrounding this deathly heap, Wilke's large-scale self-portrait photographs and the pictures made of her hair memorialize in the ancient sense of bearing witness. However, piles of blackened bones and loose human hair are signifiers not only of Wilke's cancer but also of the Holocaust that claimed millions of her people during World War II. Here, as elsewhere in her oeuvre, Wilke uses her own image to bear witness not just to the ravages of cancer or the objectification of women but also to the scarification of the body and soul by the intersecting evils of fascism, sexism, and racism.

Wilke's project points to the fact that Hitler used cancer to metaphorize his anti-Semitic conception of Jews swallowing up European, Aryan culture and returns us to Wilke's fascination with the "scarification/starification" of the Jewish/female body.[128] Wilke's exploration of feminine subjectivity did thus address aspects of her identity other than her experience of sexual difference, particularly her Jewishness but also her relative privilege as an educated daughter of a liberal second-generation Jewish-American family. We recall her comment, "[t]o

also remember that as a Jew, during the war, I would have been branded and buried had I not been born in America. Starification-Scarification . . . Jew, Black, Christian, Muslim. . . . Fascistic feelings, internal wounds, made from external situations." The wounds that scar her body/self are at once related to sexual, racial, and class oppression as these were interwoven in the experience of the subject Hannah Wilke.

Hannah Wilke's performance of herself— her staging of her "beautiful," Jewish, and ultimately fatally ill body as a witty, intelligent, and actively creative subject—radicalized narcissism, turning it into a phenomenological exploration of the constitution of the gendered, racialized, and sexualized self in relation to its others. While the visible body is a primary vehicle of this constitution, and its perceived gendered identity constitutive of the subject's placement within the patriarchal order, gender itself is inflected through ethnic, class, and other categories of identity formation. The "visible" codes of subjectivity (those Wilke flaunts through the rhetoric of the pose) are ultimately deeply elusive in their experienced (and complexly intersectional) effects. Although she is white (and "beautiful"), and thus the site of a conventionally mapped (white male) "gaze" of desire, her whiteness—like Piper's *apparent* whiteness—is dangerously corrupted, impure, Semitic (female nudity, Wilke's project suggests, reads very differently through a post-Holocaust body that is Jewish).[129] Wilke's self-performances engage the interpreter in an open-ended relay of identifications (generally heteropathic in effect) even as they enact the intersectionality of identity by opening out her own "whiteness" and (literally) marking it as non-Anglo.

Wilke's project performs her body as inexorably implicated in the emotive—and ultimately suffering—artistic subject, "Hannah Wilke." Artistic production in general can be characterized as a desublimatory narcissism (in psychoanalytic terms, the "artist is a narcissistic individual who transfers his narcissistic enjoyment to his artistic production").[130] Wilke's body art works intercut artistic narcissism (conventionally marked in phallic terms) with a revised feminist narcissism that externalizes and polemicizes the wounds inflicted upon the Jewish, nonmale body/subject in Western patriarchy.[131]

5

DISPERSED SUBJECTS AND THE DEMISE OF THE "INDIVIDUAL": 1990S BODIES IN/AS ART

The individual as an entity is invalid. . . . The individual as the end-product of heredity and environment is incomplete. Individualism is dead.
—HARRY GAMBOA, JR., 1987[1]

Technology is a force of nature and it can't be stopped.
—ANONYMOUS TECHNOFAN, *LOS ANGELES TIMES*, 1996[2]

[With new technologies] the self is no longer the projected object but the creation of the medium.
—BRUCE YONEMOTO, 1996[3]

 I have made claims in this book for the powerful historicity and political potential of body art: its implication of both productive and receptive bodies in history. Of primary importance in this particular history is the intersection between the effusion of body-oriented work in the 1960s and 1970s and the development of new models of embodied but also decentered subjectivity in the interwoven discourses of phenomenology, feminism, and poststructuralism. As the words of activist and artist Harry Gamboa suggest, this new experience of subjectivity as *embodied* rather than transcendental, as *in process,* as engaged with and contingent on others in the world, and as multiply identified rather than reducible to a single, "universal" image of the self intersects as well with the revolutionary challenges to patriarchal culture and cold war ideologies of individualism by the civil, new left, students', women's, and gay/lesbian rights movements from the late 1950s onward.[4]

As we have seen, while the rights groups put their bodies on the activist lines and mobilized new modes of discourse to challenge their marginalization and oppression, philosophical and theoretical critiques of Cartesianism reconceived the subject as simultaneously decentered (never fully coherent within herself or himself) and embodied (rather than pure "cogito"). At the same time, new communications, travel, and biotechnologies, the decolonization of

the so-called third world, and the massive shift toward global multinational capitalism began to shatter the illusory edifice of autonomous individualism subtending Western patriarchy, transforming the modernist subject (the "I" of the Cartesian *cogito ergo sum*) into a dispersed, multiply identified postmodern subject both in theory and in practice. The experience and understanding of subjectivity have been completely transformed, the universality and coherence of the mythical notion of the individual thrown in question—not least because it has become clear that this "individual" is hardly universal but has long implied a normative subject who is, in Audre Lorde's terms, "white, thin, male, young, heterosexual, Christian, and financially secure."[5] As Gamboa playfully suggests, the new mode of the articulation of subjectivity might be rendered as "I think, therefore I hesitate."[6]

As body artists have clearly recognized, this is a historical context in which the body—as activist, as multiply identified, as a social enactment of a subject who is particularized beyond norms and stereotypes—plays a central role. This activist body so central to social movements and to art practice in the 1960s and early 1970s faded from view, however, in the increasingly commercialized environment of the later 1970s and 1980s art world (centered in New York City). As I suggested earlier, mainstream art discourse in the 1980s was largely characterized by a turn away from the body—a refusal of the fetishizing effects of the male gaze by the majority of the most prominent feminist practices and writings about art, a refusal that oddly paralleled a return to large-scale (and eminently commodifiable) oil paintings in the higher echelons of the art market.[7] This turn away from the body was also in some ways unfortunately coincident with the disembodied politics of the Reagan-Thatcher era, characterized by political retrenchment and reactionary, exclusionary economic and social policies and by the scrupulous avoidance of addressing the effects of such policies on the increasingly large numbers of bodies/selves living below the poverty line.[8]

Conversely, the 1990s have witnessed a dramatic return to art practices and written discourses involving the body; while—once again—they are hardly universally or unequivocally progressive in their implications, these works do begin to acknowledge the deep implications of the politics of representation in relation to the embodied subject (as opposed to the abstracted—conceptual rather than engaged—subject implied by dominant theories of the 1980s). This final chapter will explore the historical and political implications of this return, engaging in a number of recent body-oriented projects to explore the new modes of body/self articulation in the increasingly technologized and urban environment in which we live.[9] I propose this chapter as an explicitly utopian finale, reading body-oriented practices in their most progressive light as radi-

cally opening out subjectivity beyond even the explored and perhaps exploded dualities of earlier feminist and other body art.

This recent body-oriented work is both linked to earlier body art works and distinct from the earlier practices in its strategies, contexts, and emphases. Most often, the artists who have come to the fore in the past decade deploy multimedia, installation, and photographic technologies, eschewing live performance altogether.[10] While the earlier artists had focused obsessively (if, in the case of the male artists, often unconsciously or uncritically) on the body's role in self-other relations through structures of narcissism and the rhetoric of the pose, these younger artists tend to explore the body/self as technologized, specifically *un*natural, and fundamentally unfixable in identity or subjective/ objective meaning in the world: indeed, they articulate the body/self as what some have called "posthuman."[11] This "posthuman" body/self is thoroughly particularized, its gender, sexuality, sexual orientation, race, ethnicity, class, and other identifications insistently enunciated within the intersubjective structures established by the body-oriented practice.[12]

This mediated, multiply identified, particularized body/self proclaims the utter loss of the "subject" (in this case the fully intentional artist) as a stable referent (origin of the artwork's meaning). Works by Gary Hill and James Luna are exemplary of the way in which 1990s body-oriented practices enact the dispersed subject of the contemporary era. The technologized bodies presented by artist Gary Hill are *literally* fragmented and dispersed across space, and their mediation through video technology is aggressively marked, while James Luna's ironic intersections of the modes of body art, video technology, and ethnographic display dramatically dislocate the notion of the particularly identified subject (in this case "the Indian" as well as the "male artist") as fixable in material or conceptual terms.

Hill's *Inasmuch As It Is Always Already Taking Place*, which was installed at the Museum of Modern Art in New York in 1990, consists of sixteen black and white monitors (varying from half an inch to twenty-one inches) embedded in a cavernous inset in the gallery wall; various abstracted life-sized body parts, each displayed on a single monitor, move almost imperceptibly to a barely audible voice accompanied by the rustle of turning pages and other ambient sounds.[13] The body is both abstracted and "documentary" (almost frozen in black and white parts, congealed via the photographic trace into indexical markers of a body in space) and yet "real," moving, alive, and seemingly directly observed (by hand-held camera). Each monitor, writes one observer, "is thus the site of the body which appears on the screens as immutably present and yet outside actual time. . . . Presence is brought to betray a haunting absence."[14]

GARY HILL, *INASMUCH AS IT IS ALWAYS ALREADY TAKING PLACE*, 1990: VIDEO
INSTALLATION AT THE MUSEUM OF MODERN ART, NEW YORK. PHOTOGRAPH BY ALISON
ROSSITER, COURTESY MUSEUM OF MODERN ART, NEW YORK.

Expanding on the practice of earlier video pioneers such as Bill Viola,
Hill produces work that typifies what is specific about 1990s body-oriented
work, especially in its move away from single-channel video (developed for
amateur and artistic use around 1965) and one-time performances toward tech-
nologies that multiply and fragment the body across spaces that are dramati-
cally nonperspectival and so anti-Cartesian.[15] No "original" body is assumed
at any point of such a project, no body to be "freed" from oppressive represen-
tations (as would have been the case in much early feminist body art and theo-
ries of representation). As Jacques Derrida has observed of Hill's work, it re-
veals "that there is not and never has been a direct, live presentation."[16] The
multiplied video images mark the body as having always been both an instantia-
tion of the self and yet never fixable or present in any securable way; further,
Hill produces the body/self as deeply inflected by and through technology: the
video screen *becomes* the skin/the body (the skin is "stretched across the screens
like a taut membrane").[17] There appears to be something nostalgic or melan-
cholic about Hill's body-oriented works, which, much like Viola's, present beau-
tiful, if ghostly, images of an embodied yet fragmented self.[18] But they also
fissure the body/self/other relation in complicated ways: rather than asserting
or reinforcing the "coherence" of the body as a repository for a unified cogito,
Hill's works scatter the body/self across video screens.[19] There is no graspable,
coherent subject to be ascertained from Hill's video installations, only frag-
mented bodily signs to be engaged by recognizing one's own incoherence.

James Luna has mobilized technology explicitly within a revised poli-
tics of identity, stressing the link between the technologized body/self (the
body/self dispersed through technology) and the particularized body/self. Ex-
panding on some of the ideas he explored in his provocative *Artifact Piece* of 1987
(where the artist laid himself in a display case at the San Diego Museum of

JAMES LUNA, *DREAM HAT RITUAL*, 1996; INSTALLATION AT THE SANTA MONICA
MUSEUM OF ART. PHOTOGRAPH COURTESY SANTA MONICA MUSEUM OF ART.

Man, posing as an "artifact" of "Indian" authenticity),[20] Luna presented *Dream
Hat Ritual* at the Santa Monica Museum of Art in 1996, engaging spectators
in an interactive formation of "American" identities.[21] This piece suggestively
performs, rather than "represents" or "presents," the Native American subject.
Artifacts—crutches floating in the air and cowboy hats adorned with patterns
taken from Native American weaving—and video imagery interrelate to enact
the "Indian" in a technologized ethnographic display as culturally particular
but never fixed, as both "self" (raised within modernized Native American
lifestyles and customs) and "other" (situated for the past five centuries relative
to dominant Anglo culture).[22]

The artifacts, while bizarre and unexpected, still draw on the codes of
"authenticity" necessary to the ethnographic display; at the same time, they
complicate the conventional usage of such codes (to confirm the primitive
status of the culture so referenced) through their absurdity and symbolic sug-
gestion of the crippling of the Native American spirit (both from internalized
self-conceptions and from external racism) in U.S. culture. The video monitors
stacked in the center of the exhibition (just where the average viewer would ex-
pect a tepee to be) confirm this point: on the monitors flickers the sad image of
a campfire, a "virtual" fire that has no warmth; meanwhile, on a sound track,
sounds of nature are interspersed with Marvin Gaye's 1971 hit "What's Going

On?" and on a screen, images of traditional Luiseño dances (Luna's tribe), the heavens, and Luna adopting various personas in previous performances are projected. Luna's piece makes a generational (intracultural) point as well as an intercultural one about the tensions between white and Native American ways of life. While the older generations of Native Americans could claim to have been born in a tepee (their status as "Indians" thus confirmed), Luna notes that his generation, raised within the sad accoutrements of suburbanized America (debased even further by the impoverished life of the reservation), was "born . . . in a T.V."[23]

In *Dream Hat Ritual* Luna ironicizes the very conception of a "Native American" while at the same time insisting that an exploration of such a potential subject (always pluralized) must continue. Elements from Native American rituals are combined with items signaling clichéd ideas of authentic Indianness— both explicitly marked as mediated through the inexorable effects of tourism and postmodern technology (the video screen replaces the campfire, and all of the lights, fans, cords, and wires powering the installation are exposed). Unlike Hill, who fragments and technologizes the embodied subject but does not explicitly explore its particularity (thus tending, like most white artists, to hover dangerously close to a suggestion of "universality"), Luna produces a site where particularity is both contested and affirmed. His subtle and ironic approach to stereotypes both dislocates outsiders' assumptions about Native Americans (as "primitives," or "alcoholics," and certainly not as intellectuals or artists) and refuses prescriptive notions expressed within his community of how Native Americans must be articulated or defined ("You're never Indian enough to some people," Luna has said).[24] The stereotypical Indian is shown to be both a phantasm (internalized and perpetuated by those who identify as such and projected outward as well as received by mainstream Anglo culture) and a politically strategic subject position (but one to be adopted only tactically and with an eye toward the inevitably partial and compromised nature of its cultural power). Luna's work articulates the particularized subject *through* technology, marking the way in which the dispersed subject is the effect not only of political changes (the challenges of the rights movements) but also of massive shifts in technology and institutional power.

Reading through Luna, I would like to look at the return to the body in 1990s practice and theory as a return to a notion of the embodied subject as necessarily particularized and engaged in the social: as necessarily politicized (if in a manner not recognizable by previous models of activist political engagement inflected by an instrumentalized Marxism) *through* its embodied and particularized relation to other subjects in the social arena. Artists in the 1990s

return to the body in such a way that they assist in the dislocation of the modernist, Cartesian subject or "individual" that has also begun to take place through technological and political transformations. (I am well aware that this claim is rather utopian; the *effects* of these works will of course depend on how they are contextualized and who experiences and engages with them.) As I have argued throughout this book, the interrogation of the Cartesian subject or "individual" is the single most pressing philosophical question of our time. The "individual," these artists (along with Gamboa) insist, no longer exists as such in this fin-de-millennial age of multinational capitalism, virtual realities, post-colonialism, and cyborg identity politics. In the words of Mark Poster, the "mode of information" characteristic of our era puts into question precisely

> the very shape of subjectivity: its relation to the world of objects, its perspective on that world, its location in that world. . . . [T]he subject is no longer located in a point in absolute time/space, enjoying a physical, fixed vantage point from which rationally to calculate its options. Instead it is multiplied by databases, dispersed by computer messaging and conferencing, decontextualized and reidentified by TV ads, dissolved and materialized continuously in the electronic transmission of symbols. . . . The body then is no longer an effective limit of the subject's position . . . [raising the questions] where am I and who am I? In these circumstances I cannot consider myself centered in my rational, autonomous subjectivity or bordered by a defined ego, but I am disrupted, subverted and dispersed across social space.[25]

This subject of what Poster calls the "second media age,"[26] in which technologies of communications are transformed beyond the unidirectional, hierarchized structures of broadcast journalism toward multidirectional informational exchanges (including the Internet and interactive CD-ROMs), is dispersed and technologically inflected. Phenomenologically speaking, in the words of Vivian Sobchack, communications and biotechnologies inflect the very "structure of meanings and metaphors in which subject-object relations are co-operative, co-constitutive, dynamic, and reversible." Technologies such as the computer have "profoundly changed the temporal and spatial shape and meaning of our life-world and our own bodily and symbolic sense of ourselves," transforming us as *subjects* and turning us into what I am calling particularized or technologized ("techno") subjects.[27]

As Luna's piece suggests, the technosubject is deessentialized and can no longer be conceived as definable in terms of fixed terms of identity relating

to the visual appearance of a singularized, so-called material body. This techno-subject is, as suggested, intimately connected to the multiplicitous subjectivities put into play by movements critiquing the modernist "individual"; it is embodied yet multiple and insistently *particularized* according to various shifting coordinates of identity that specify its cultural positioning (positioning that is never stable or determinable in advance but that has particular meanings from moment to moment). Through its particular corporeal enactments, in always *reversible* relationships to others, this deessentialized, dispersed technosubject is radically politicized and works to politicize these others it engages. The very means by which recent body-oriented art explores and enacts bodies *as* deessentialized and dislocated subjectivities (video, computerized modes of interactivity, installation, and other photographic technologies) confirm Poster's observations that the body/self is "disrupted, subverted and dispersed across social space." While some, still attached to older, Marxian models of social engagement (which rely on a conception of the subject as a fully centered and intentional "individual" capable of willfully producing social change), view this shift as unequivocally negative, I suggest that the recognition of the body/self as dispersed, multiple, and particularized has dramatically progressive potentialities, especially for women and other subjects historically excluded from the privileged category of "individual."

In her essay "A Cyborg Manifesto" Donna Haraway argued just this point in her description of the confluence of the destabilization of the modernist "individual" through explosive developments in technology and a radical politics of nonnormative subjectivity. For Haraway, the post–cold war period, in which a new kind of power (a "polymorphous information system") drives the emerging world order, is one of the "cyborg"—"a kind of disassembled and reassembled, postmodern collective and personal self." Part machine, part human, the cyborg marks the transition beyond the "plot of original unity" on which previous models of the subject have been founded by theories such as Marxism, psychoanalysis, and feminism. In the culture of the cyborg, "[i]t is no accident that the symbolic system of the family of man . . . breaks up at the same moment that networks of connection among people on the planet are unprecedentedly multiple, pregnant, and complex. . . . In the 'Western' sense, the end of man is at stake. . . . The dichotomies between mind and body, animal and human, organism and machine, public and private, nature and culture, men and women, primitive and civilized are all in question ideologically."[28]

As Félix Guattari has suggested, rather than participate in our own alienation by throwing up our hands in despair at the dependence of the subject on "a multitude of machinic systems," we might more productively explore

contemporary culture to look for "a way out of the dilemma of having to choose between unyielding refusal or cynical acceptance of this situation."[29] Recent body-oriented practices, like body art from the 1960s and early 1970s, I suggest, can be engaged to just such an end. By performing subjects that are embodied (if fragmented), artists have engaged with the social, embodying and so particularizing and politicizing self/other and self/world relations. By exploring some of this recent work through a model I will develop as a feminist "technophenomenology," I hope to provide a convincing and optimistically progressive way of understanding the dispersed body/self of the end of the millennium.

THE TECHNOPHENOMENOLOGICAL BODY: MAUREEN CONNOR AND LAURIE ANDERSON

Much ink has been spilled (or many pixels activated) over the effects of technology on human experience. As Guattari suggests, one tendency has been to lament the incursion of technological forces into a presumably previously unmediated and more wholesome state of human existence. Another, opposing, tendency that has been especially strong within technocriticism itself (that is, the body of writing specifically about technologies such as virtual reality) involves the theorizing of a metaphysical transcendence of the body through mind-extending machines. Thus, virtual reality and Web surfing are conceived as means of leaving the body behind through pure thought (or fantasy, as the case may be).[30] Even Sigmund Freud understood early on the psychic dimensions of this desire, writing in 1930 that technological development is driven by the yearning to transcend the human; not incidentally, Freud describes this desire in corporeal terms (through technology, man extends his body, becoming "a kind of prosthetic God").[31] Behind the development of advanced technologies is the age-old desire to extend the body in space and time (through machinic, communicational, and biotechnological tools) and thus to transcend it (to become "God").[32]

We have seen, via Beauvoir, that these desires also have a clearly conservative political and social dimension in that they form the basis of the structures of patriarchal, colonialist western thought (specifically, of metaphysics in its more reactionary aspects). In such a formulation, a simplified Cartesianism is extended such that the body is split from the mind: the body is "pure representation," and visual consumption replaces "experience."[33] The body is not only fantasized as expendable, it is apparently universalized and nonparticular. Such fantasies still revolve around some conception of the "individual" as the locus of comprehension, experience, and expression, making it all the more

dangerous to accept without questioning the idea that technology simply obviates the particularized, social body (or, in my terms, the body/self).

Through the work of Laurie Anderson, whose practice has come to epitomize the integration of the body and technology through a performative artistic practice, and Maureen Connor I would like to stress here that the fantasy of disembodiment entails a disavowal: "I know very well that I am embodied, but all the same. . . ." The supposed transcendence of the body through technology, like Sartre's dramatic myth of the subject's projection into transcendence (beyond immanence) through action, is unattainable if, as we have seen, ideologically structural to particular interpretations and configurations of technologies of representation and reproduction. As I interpret it, the work of Maureen Connor and Laurie Anderson exploits technologies of representation to insist upon the embodiment and thus the particularity of the subjects of making and viewing culture. While acknowledging, indeed exacerbating, the radical dislocations that technologies such as video and computers have introduced into the conception of the body/self, they also emphasize the *embodiment* of this subject *as*, in fact, a body/self (rather than a "transcendent," masculinized self of pure thought or an immanent feminine body). The subjects deployed and addressed by their complex, performative works (which extend earlier feminist video, performance, and installation practices by artists such as Joan Jonas and Valie Export) are dispersed and intertwined in one another and the social world.

In his essay "The Intertwining—The Chiasm," Maurice Merleau-Ponty asks the following question: "Where are we to put the limit between the body and the world, since the world is flesh?"[34] Maureen Connor's body of work can be thought of as an ongoing negotiation with "the flesh of the world," with that interconnectedness of the body, the mind, and the other (gendered, raced, and classed) bodies in relation to which we constitute our bodies as "ourselves." Connor's work enacts the phenomenological notion of flesh as connection rather than boundary, constructing and deconstructing bodies in such a way as to interrogate their psychic/material structuring of and siting within our relationships of self and other. Thus the experiencing subject's engagement with Connor's work is made analogous to this subject's relationship to her *others*—those who define her in an always shifting, processual way.

The "flesh," as Merleau-Ponty explores it, is simultaneously an ephemerally material and psychic support for the self. That is, it is definitively *not* a determinable, impermeable border between the self and the world (or the self and the other) that fixes this self in a final way. As a physical membrane that sheds and reconstitutes itself continually, the flesh is never always the same material

but always a contour in process; the flesh exists provisionally both as a permeable, shifting physical perimeter, a limbic surround of virtual containment, and as the visible trace of the human body (whose contours are never stable in one's own or an other's visual field). Metaphorically as well as materially, the flesh is an envelope, a "limit" inscribing the juncture between inside and outside but also the *site of their joining*.

Connor's play—like that of her coconspirators Luce Irigaray, Jane Gallop, Judith Butler, and other feminist gamesters of the corporeal—definitively feminizes the exploration of the flesh by asserting its role as hymen: the hymen, writes Jacques Derrida, is "a sign of fusion, the consummation of a marriage, the identification of two beings, the confusion between two. *Between* the two, there is no longer difference but identity."[35] Through the hymenal flesh, Connor's practice enacts an interrogation of sexual difference as hierarchical, presenting works that interrogate the sex-gender implications of the flesh as a joining (a site of exchange) and explore its vulnerability as a sign of the psychical openness to otherness that permeates the self and colors relationships between the self and the world. The hymen/flesh marks the interconnectedness of mind and body (both inside and outside, a liminal [anti]border within the self).[36]

In Connor's 1991 piece *The Senses*, for example, she presents five installations, each of which stages one of the five sensory experiences; taken together, they assert the interdependence of the senses within the individual body/self and between this particular flesh and that of the world. They also force the visitor to enact the structures through which sensory experience is hierarchized and vision privileged in patriarchal culture: in each of the installations, the visitor must push aside a long sweeping curtain in order to enter a space of experience. Most pointedly, in the portion devoted to the sense of sight (*Limited Vision*), the visitor pushes aside the curtain only to be confronted with a physically impenetrable but visually reflective wall of Mylar. Seeking to attain "knowledge" of the other/the object of art through the masculinist politics of the gaze, the "viewer"[37] is faced with the impossibility of this search: when she seeks this knowledge through vision, she always already sees only (through) herself.

Hearing is staged behind a second set of curtains in *Ensemble for Three Female Voices*. Here the visitor is surrounded by a dislocating cacophony of female voices (the sounds of a baby, and of a younger and an older woman laughing and crying) emanating from the abject forms of tongues and larynxes cast in red lipstick. Confronted on multiple sensory levels with the usually silenced voices of femininity (which typically, if they are heard at all, are perceived as being expressed only in hysterical tones), the visitor is made uneasy

MAUREEN CONNOR, *LIMITED VISION,* FROM *THE SENSES,* 1991; CURTAINS, MYLAR,
LIGHTS. PHOTOGRAPH COURTESY OF THE ARTIST.

MAUREEN CONNOR, *TASTE*, FROM *THE SENSES*, 1991; TABLE, CLOTH, FLATWARE,
VIDEO MONITORS. PHOTOGRAPH COURTESY OF THE ARTIST.

by the exaggerated irrationality of these *sounds* of femininity as conjoined with
the *vision* of the frozen, "cosmeticized" female voice (the grotesque but elegant
lipstick larynxes).

Two of the five installations rely on video imagery: *Taste* and *Smell* are
evoked visually, the former with circular video screens set as "plates" at a table,
with screen images of food being consumed and faces kissing the camera/visitor,
and the latter with hospital monitors mounted among operating equipment
and showing a doctor and nurse administering anesthetic. Taste is eroticized,
becoming (like smell) a matter of exchange among subjects in a social setting
(the moist lips seduce us even as they absorb their own food, suggesting both
the pleasures of eating/kissing and a kind of binge and purge response to
nourishment). In both cases "vision" is definitively corporealized: one views
these metaphors of taste and smell only by pushing aside the curtains and mov-
ing through the density of the installation space, with the monitors themselves
incorporated into this space as furniture or sculpture. As with Hill's work, the
flat, textureless screen of the video monitor is turned into "flesh" (seeming to
reach out to us with greasy, glossy lips or with hands holding scalpels and other
medical tools). It is the body/self of the visitor that is made to figure (as par-
ticularized in relation to Connor's solicitations) as subject within (as well as ob-
ject of) these sites of embodied experience.

Connor negotiates the "world as flesh" through interactive installations and sculptural pieces that restage the body in explicitly sexually coded ways and that compel the experiencing subject to engage corporeally/mentally/emotionally (for these are inextricably joined in the phenomenological universe) in their body politics. They also enable Connor to explore what Judith Butler has identified as the disjuncture—within the connectedness of *flesh*—between referent and signified. Connor's work, then, takes place in what Butler terms the "site where the materiality of language [the signifier] and that of the world which it seeks to signify [the referent] is perpetually negotiated."[38] The work is not simply visual (as this sensory experience is conventionally and restrictively understood) but also tangible and experiential: it stages and is about the interdependence of all of the senses and the continual state of suspension that characterizes our attempt to find meaning in things or in the actions and identities of other subjects.

It is this eroticized tangibility of Connor's art—the touch (taste, smell, etc.) implicated in a viewing of her work—that ultimately defines the extent of its feminism. Connor's works do not aim in any simple way to critique the construction of women's bodies as objects or to examine the negative effects of ideals of feminine beauty—as so many feminist artists (including perhaps Wilke) aimed to do. Rather, they perform and solicit and project the experience of an embodied and open-ended femininity in such a way as to encourage the experiencing subject to interrogate her or his own structures of selfhood and otherness, subjectivity and objectivity, masculinity and femininity. Connor's works probe the unlocatable "limit between the body and the world" that Merleau-Ponty explored as the *flesh of the world*, marking this flesh as specifically (but not inherently) gendered and its embodied experience as always highly charged, sexual, and—by definition—intersubjective.

Laurie Anderson's work (unfortunately quite unusually among women artists) shows an extraordinary mastery (or mistressy?) of complex visual and audio technologies, simultaneously insisting upon human experience as fully mediated and embodied, with all of the subjective specificity that this entails: "I am in my body the way most people drive," reads a text projected behind Anderson's violin-playing body in *Americans on the Move* (1979).[39] Active in producing body art works from the early 1970s on, Anderson has always integrated technology into her conceptualization of the gendered and classed subject through the body in performance.[40] Appropriating technologies developed almost entirely by and for men, Anderson has deployed them to dislocate the patriarchal conception of the subject as gendered either male or female, hierarchically situated relative to the privileged phallic signifier. Anderson invokes a

phenomenological subject, but one more explicitly technologized and fully dispersed (not to mention commodified) than Connor's still more or less dualistically rendered (if chiasmically intertwined) subjects and objects of perception and language.[41]

In her frequent use of a vocal modulator to transform her feminine voice into a masculine one (which Craig Owens has eloquently described as "a kind of electronic vocal transvestism" and Anderson herself calls talking in drag),[42] Anderson both thwarts the privileging of vision in determining gendered identities and throws herself into the "transcendence" of masculinity *through* a technology that specifically involves a voice that is embodied and otherwise seemingly obviously "female" (as this has come, rather ambiguously, to mean in punk rock culture). Her "talking styles," which she mutates according to the message and the receiver, mark the intersubjectivity of identity as we experience ourselves in the world.[43] Thus, in *Americans on the Move*, speaking in a deep baritone, Anderson describes the sign language we send into outer space, including the supposedly "universal" symbol of a man with his hand raised. Owens, criticizing his own gender-neutral reading of this moment in an earlier essay, notes in 1983 that "in this . . . image chosen to represent the inhabitants of Earth for the extraterrestrial other, it is the man who speaks, who represents mankind. The woman is only represented; she is (as always) already spoken for."[44]

Anderson speaks *as a man* of the "neutral" symbol of a man with his hand erect (asking, "do you think they will read our signs?").[45] Anderson calls this mode of speaking the "voice of authority" and states that "in addition to being male . . . is also technological."[46] Through its very capacity of (gendered) transformation, technology, in this case, dramatically marks the specificity of the (gendered) body/self as well as its contingency on how it is spoken, and how it comes to have authority (masculinity?) within the social. The meaning of the gendered body/self is inflected and given meaning through technologized vocal codes.[47] Anderson herself is no longer woman as object but man as speaker (or perhaps, more interestingly, she is both: the voice is split off from the anatomical gender of the body/self in question). The body/self is particularized but the *meanings* of these particularities are never fixed; they depend on their context of production and reception (even Owens marks this through his self-transformation from one reading to the next: *he* changes as do his readings of Anderson, according to his own interpretive assumptions).

Anderson's projects enact (through the body, through technology) a dramatic shift in our experience of meaning and subjectivity. N. Katherine Hayles has recently explored this shift in terms compatible with Anderson's work, addressing the linguistic register of subject formation. For Hayles, the

signifier still has meaning, but can no longer be understood as a single marker; rather, like the monitors of computer and video screens, the signifier is "flickering," becoming part of a flexible chain of markers that point to but never ensure particular meanings or identities, tending toward "unexpected metamorphoses, attenuations, and dispersions" (here, of "man" and "woman").[48] The subject of technologized, cybernetic culture is embodied and particularized but dematerialized (there is no singular link between the signifier of the "male voice" and the referent "anatomical male subject"). As Hayles argues, pattern and randomness replace the dialectic of presence and absence that previously structured Western thought and, correlatively, mutation (the "biological" alteration signified by the displaced vocal tone, which references Anderson rather than a phallic body) replaces castration. The dualism male/nonmale (penis/lack) is replaced by a continuum of human/posthuman, a symbiosis of human and machine that threatens to dislocate the modernist "individual" (a figure that depends for its own privilege on the formulation of the other-as-lacking) beyond recuperability: "subjectivity is dispersed throughout the cybernetic circuit."[49]

Anderson's enacted subjects flicker across particular identities as what Hayles calls "patterns rather than physical entities" who can be "proven" to be one gender, one type, over another (I strategically highlight her putative femininity to align her with my feminist project, but this "femininity" must be understood as nonessential and ultimately indeterminate in its effects). In a dramatic extension of the intersubjective and performative effects of earlier body art, it is through her very speaking of herself across genders and types that Anderson becomes multiply articulated ("She unfolds an identity that seems to have no bottom, no beginning or end").[50] Hayles's observation that "[w]e become the codes we punch" becomes Anderson's recognition that the various modes of the vocal modulator give her "different things to say."[51] While even her earlier 1970s body art works, typically enough of this period, addressed the "audience as performers," in the later, more hypertechnologized work, her body/self is *technologically performative*, mutable within its own technoarticulations as well as in relation to what she calls her "electronic" audience, expanded exponentially with the incursion of her work into mass media records and movies.[52] With an apparatus such as her dark video glasses, which have a tiny video camera that scans and photographs the audience to project it behind Anderson as she performs (making the audience unwittingly into performers), she enacts the reversibility of subject- and objectivity, which technology dramatizes and exaggerates.[53] Who are the subjects of art? Who its objects?

Finally, in one of Anderson's most recent projects, entitled *Puppet Motel*, she extends her explorations of the technologized body/self to the user's com-

puter through the interactive technology of CD-ROM.[54] In the CD-ROM, the participant engages with a virtual space that is dramatically unconventional in its antiperspectivalism and anti-Cartesianism; the participant uses her finger, hand, and arm to manipulate a cursor, which becomes a different kind of graphic representative of her body in each of the thirty-three contorted and alogical "rooms" of Anderson's virtual motel. For example, in one of the rooms, the participant manipulates the cursor, which appears as a hand on the screen, to pick up a violin bow (appropriately enough, given Anderson's well-known identity as a punk violinist). The participant then uses *her* hand (as a surrogate for Anderson's) to carry the bow to the violin and stroke it across the strings, which, in turn, are programmed to "speak" Anderson's modulated voice rather than the notes of a violin.[55]

Far from being disembodied in this conceptual/visual space, as much technotheory would have it, I insist that we are engaged through the tips of the most sensitive parts of our bodies to identify with Anderson herself as violinist/performer. Or perhaps, in the terms of technotheorist Margaret Morse, we are encouraged to be *incorporated* into "Anderson" as the persona whose public identities inform this particular imaginary.[56] As Anderson has noted of her CD-ROM, "I like the idea of collaborating with this new person who is no longer the passive reader, the passive viewer, but somebody who's making something with you."[57] Such an engagement through interactivity, obviously and exaggeratedly mediated through the technological apparatus of the computer, oddly mimics a major structural component of live performance, where *our* activity as audience/participants can potentially shift the terms of the performer's actions. While live performance is apparently more "authentic" because apparently more phenomenologically direct, it entails a relation of intersubjectivity that is, like the CD-ROM, both circumscribed by the terms staged by the performer (just as Anderson's programmed codes to a certain extent direct our seemingly freely chosen movement throughout the "motel") and thoroughly mediated as communication.

While body art from the 1960s and early 1970s (including Anderson's own) exaggerated the supplementarity of the body (the absence underlying all live performance) and the intersubjectivity as well as the particularity of the body/self, Anderson's later work emphasizes the always already technologized, mediated nature of the experience of the body/self (whether our own, moving as a floating hand through a virtual room in a phantasmagorical motel, or that of the others we engage). The touch of our fingers on the plastic of the computer mouse (virtually, on the violin bow) and our hearing of her voice, her music, and ambient sound in this virtual space, links our bodies (again, *as* cog-

nitive and emotional selves) to this atopic set of rooms randomly strung to-
gether and experienced in a narrative order apparently determined solely through
our choices and yet preprogrammed through *hers*. This is intersubjectivity in
its most profound technological dimensions (as understood through a revised
technophenomenology). Anderson's electronically rendered body/self (which
becomes our body/self through incorporation) is phenomenologically experi-
enced not as a "discrete . . . and bodily centered projection in space," as it would
have been experienced in a singular performance, but rather as an *overtly* "simul-
taneous, dispersed, and insubstantial transmission across a network."[58]

THE PARTICULARIZED, MULTIPLY IDENTIFIED BODY/SELF: LYLE ASHTON HARRIS AND LAURA AGUILAR

I have already noted that it is by no means a coincidence that Donna Haraway
stressed the coarticulation of the ethnic[59] and the technologized cyborg subject
of the 1980s and 1990s in her formative essay "A Cyborg Manifesto." As Har-
away writes, "Identities seem contradictory, partial, and strategic. . . . [P]ost-
modern identity [is constructed] out of otherness, difference, and specificity,"
and is definitively linked to the social upheavals of advanced capitalism, which
has destroyed the "individual" or Cartesian subject as previously understood.
Within this logic, the particularized, technologized cyborg—a kind of "dis-
assembled and reassembled, postmodern collective and personal self" whose
identities are aggressively particularized (or, in Haraway's words, "specific")—
replaces the "individual."[60]

Haraway's argument provides a corrective to much of the work I have
discussed in this book, which continues to explore and enact identities that
privilege gender as constitutive of identity and pivot around or assume white-
ness and heterosexuality. Challenging these assumptions, since the 1970s a great
number of nonwhite and gay and lesbian artists and writers have increasingly
insistently challenged the conception of identity as primarily determined by
sexual difference or gender.[61] This work is as diverse as the infinitely multiplici-
tous subjectivities it produces and contests, but much of it does successfully ex-
tend the dislocating effects of technology on the modernist subject or "indi-
vidual." As Harry Gamboa stated, "individualism is dead"; even as artists like
himself have attempted to produce sites of cultural enunciation for themselves,
this site is, in effect mobile rather than Cartesian (it does not speak for or de-
fine a singular point of view).

Within the contemporary rights movements, the body has always been
the site through which identities are both self-conceived and interpreted. For
this reason, body-oriented practices have been central to the exploration of

multiplicitous, dispersed, nonnormative subjectivities. At the same time, there is always a danger in putting the body forth as explanatory of identity (even if this is to be multiplied into the plural). As Trinh T. Minh-ha writes, "The Body, the most visible difference between men and women, the only one to offer a secure ground for those who seek the permanent, the feminine 'nature' and 'essence,' remains thereby the safest basis for racist and sexist ideologies. The two merging themes of Otherness and the Identity-Body are precisely what Simone de Beauvoir discussed at length in *The Second Sex*."[62] Trinh reads beyond simplistic conceptions of authentic "identity" (or "identities") as lodged within, and somehow readable through, the body. Identity is always already ruptured by difference (her example being the category "woman," which is as dispersed through racial, ethnic, class, and other differences as it is coherent) and there is never any "outside" (not to mention "inside") from which one's identity can be determined or defined in stable terms.[63]

Two artists—Lyle Ashton Harris and Laura Aguilar—have made use of photographic and video technologies to enact themselves in their particularity within the specific social context of late-twentieth-century U.S. culture, enacting the dispersal of the "individual" into a charged multiplicity, deeply challenging to the notion of a universal or normative subject who is transcendentally free from the technological, political, and social dimensions. Like Hannah Wilke, Harris—a gay black man—draws specifically on the rhetoric of the pose to perform a subversive narcissism that unhinges the politics of the heterosexual white male gaze. In *Constructs #12* (1988), a life-sized photomural, Harris performs himself in rich black and white, posing triumphantly like the goddess of liberty—hand raised, well-toned (and completely nude) body in firm, elegant contrapposto. The pillarlike muscularity of Harris's glorious body, whose obvious anatomical masculinity conflicts with his performance as "goddess," is further offset by his rather ill-fitting long-haired wig and demure expression. Harris projects himself into a space of multiple identifications that cross over expected categories of race, gender, and sexuality: the black male body as eroticized yet heroic spectacle, as "female" allegory, as symbol of grace and liberty—as well as black power.

As Kobena Mercer has suggested, Frantz Fanon's theoretical reformulation of Hegel's master/slave dialectic in terms of racial and ethnic identities (in their fully intersectional mode, as articulated through sex, gender, class, etc.) is central to the understanding of the exploration of otherness on the part of younger artists such as Harris. "Self and Other are always mutually implicated in ties of identification and desire," Mercer writes; Harris's work "dislodges the authoritarian demand for authenticity and purity" from within

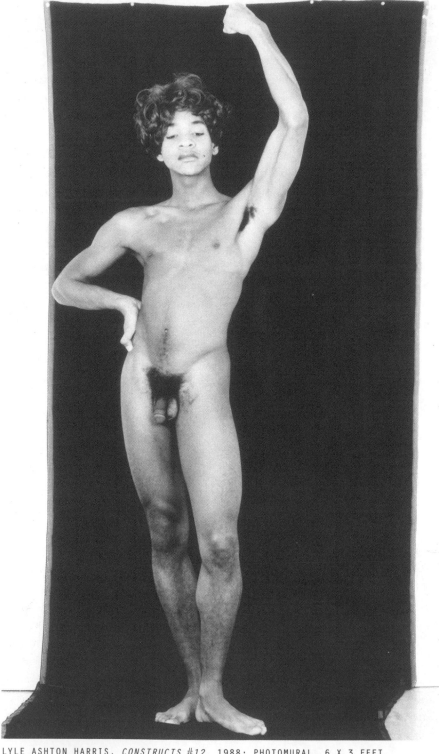

LYLE ASHTON HARRIS, *CONSTRUCTS #12*, 1988; PHOTOMURAL, 6 X 3 FEET.
PHOTOGRAPH COURTESY OF THE ARTIST AND JACK TILTON GALLERY, NEW YORK.

and without black culture, adopting the artifice of the pose (and in some cases, as in the 1990 *Secret Life of a Snow Queen* series, actual whiteface "masks") both to make literal "Fanon's metaphor of black skin/white masks" and to "evoke the masquerade of femininity as spectacle."[64] Yet Harris's "masquerade" is so obviously not simply "feminine": his cross-gendering is only fragmentary, his "feminine" characteristics still attached to his "masculine" attributes (themselves decidedly *queer*—deeply implicated in nonnormative sexual and racial identities). Harris doesn't simply cross over or reverse the masculine and the feminine; he encourages us to question the entire premise of gender as a binary and singular system of determining social and personal identities (in *Queen, Alias & Id: The Child* [1994] Harris's kerchiefed, diminutive "mother" with baby stands next to Renée Cox's commanding "father," purveying conflicting codes of gender: Harris's red lipstick is offset by a suit coat; the baby is offset by his very large, if "maternal," hands).

Rather than repudiating his body, then, submerging his narcissistic self-involvement in the conventional veiling gesture that spurred artists such as Pollock to the high ground of individualism, Harris revels in a feminizing narcissism that surfaces his "objectivation"[65] in relation to his subjectivity as author. His image also radicalizes Harris beyond singularity—and definitively beyond the normative conceptions of masculinity, blackness, *and* artistic subjectivity in our culture. Harris appropriates narcissism to impose his flagrantly nonnormative body on an aesthetic system that cannot accommodate it without changing its assumptions. In mobilizing the radical effects of the feminizing rhetoric of the pose, Harris as a black man reiterates the systemic but usually *veiled* objectifications of black people in American culture and thus opens to view the covert racism underlying this other kind of "gaze."[66]

Harris uses his own body within the photographic image in exaggeratedly sexualized and racialized poses that expose the gap between signifiers of identity and the cultural positions and attitudes they are assumed to entail. Through self-performance, he engages spectators in a self/other dialectic of identification, repulsion, and/or desire, making us aware of our relationship to the particularized, flamboyantly performative "identities" of Harris as displayed in his imagery—and thus of our own particularity. Harris's self-renditions split the "black male body" from its usual significations in dominant culture, suggestively proposing a multiplicitous black male subjectivity through a feminizing narcissism. This narcissistic body/self is, at the same time, well-developed, definitively black, obviously anatomically male. Thus Harris exposes the dominant culture's anxieties about unconventional black men and challenges the general tendency (perhaps especially within black nationalism) to pose black freedom

217

LYLE ASHTON HARRIS, *QUEEN, ALIAS & ID: THE CHILD,* 1994; UNIQUE POLAROID,
20 X 24 INCHES. PHOTOGRAPH COURTESY OF THE ARTIST AND JACK TILTON
GALLERY, NEW YORK.

in terms of attaining the goal of a noncastrated (implicitly male and hetero-
sexual) subjectivity.[67] Harris poses himself as well endowed but already symbol-
ically "castrated" (feminine, gay, black): yet *as the artist,* Harris is also at the same
time "phallic" in his artistic agency.

Harris's work will also inevitably call to mind the rather differently ar-

ticulated images of black men by Robert Mapplethorpe, who choreographed black male bodies into formalist and often explicitly erotic and/or sado-masochistic scenes, presumably propelled to do so through his own fantasies as a white gay man.[68] While Mapplethorpe could be said in his work to perform his own desire for the black male other through a kind of "racial romanticism,"[69] constituting his whiteness and thus his privilege through his fetishization of the black male body (*as* body/other, rather than as body/self), Harris performs his otherness in multiplicity. While Mapplethorpe's erotic and fetishized black men are beautiful objects, sculpted and still, Harris opens out the confusion of the erotic and the violent that gives black men a kind of negative power (to inspire fear) in dominant Anglo culture. Harris's images, while statically photographic, *move*, engage us in their proposed reevaluation of some of the possibilities of what a black male might be.

The exoticism of the black male body in Western representation is predicated on the frisson of its threat to white masculinity[70] (a threat that is precisely, as noted previously in relation to women's bodies, *contained* through such objectification). Harris simultaneously defuses this threat, by performing himself as feminine and so "disarmed," and exacerbates it by adopting tropes of "black male violence," as in the three-part *Brotherhood, Crossroads* series (1994). Here, not only does Harris homosexualize black masculinity, as Mapplethorpe does with his black male nudes, he is performing it in relation to an eroticized violence that both invokes the specter of the black gangster and defers it through the signifiers of erotic love. At the same time, this eroticism is itself highly taboo: the man Harris kisses is a mirror image of himself. The man Harris kisses is another Harris—Thomas Allen Harris—his brother (and an important independent filmmaker).[71] This single set of images, then, crosses over the boundaries of sexuality, race, and, perhaps the most dangerous line of all, that legislating proper and improper relations with one's own blood.

Of this radical rethinking of narcissism and the pose as an articulation of identity, Harris writes: "One cannot speak of narcissistic disturbance without its most critical variable: Redemptive narcissism, or self love as a form of resistance from the tyranny of mediocrity and as a site of solace."[72] Like Mapplethorpe, Harris uses a high modernist style of photography but not to aestheticize his body as object of (white male) desire. Rather, Harris enacts himself redemptively as a narcissistic subject, loving himself and loving bl⟨ ⟩ men, including his biological brother. Not only through the *pose*, with its f⟨ ⟩ nizing connotations, but also through its photographic reification, Harris ⟨ ⟩ ments the split between masculinity and the male body, the contingency ⟨ ⟩ der on its performance and status as representation (including the e⟨ ⟩

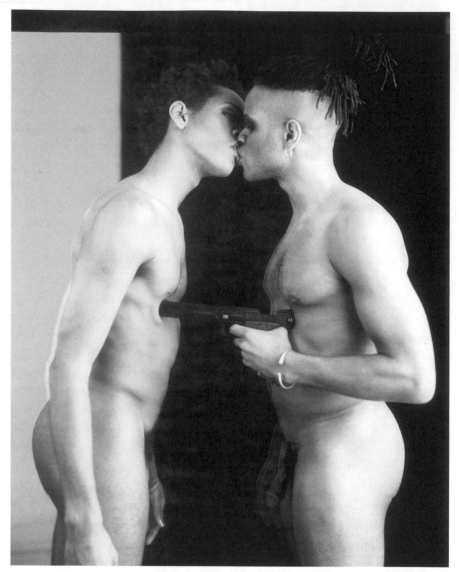

LYLE ASHTON HARRIS, *BROTHERHOOD, CROSSROADS II*, 1994; CENTRAL PART OF A TRIPTYCH, UNIQUE POLAROID, 20 X 24 INCHES. PHOTOGRAPH COURTESY OF THE ARTIST AND JACK TILTON GALLERY, NEW YORK.

signifiers of race and sexual orientation). Being black, feminized, incestuous, and homosexual, is he still a "man"? To think Harris's masculinity, one must deeply revise one's own conception and experience of gender and ask, "Where do I stand relative to *this* masculinity?"

Laura Aguilar, like Harris, employs photographic and video technolo-

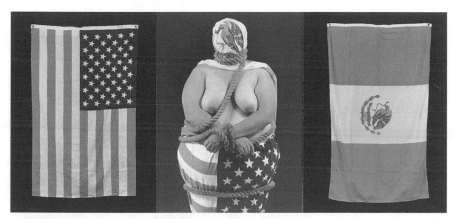

LAURA AGUILAR, *THREE EAGLES FLYING*, 1990; BLACK AND WHITE PHOTOGRAPH,
24 X 60 INCHES. PHOTOGRAPH COURTESY OF THE ARTIST.

gies to perform her body/self as individually particularized and as a signifier of
identities that refer fluidly to structures of identity and desire in the matrix of
information that constitutes contemporary life. Aguilar's work simultaneously
expresses anxiety about the incoherence of the self (proposing a multiplied but
still "authentic" voice for various oppressed subjects, such as Latina lesbians)
but also exuberantly plays out the dissolution of the notion of the "individual"
as codifiable in terms of a singular and universalizable identity. Aguilar's work
could, in fact, on first glance easily be placed within the context of 1970s art
informed by the celebratory and singularizing identity politics of the various
rights movements. In her *Latin Lesbian Series* (1990), she photographs Latina les-
bians and juxtaposes their portraits with first-person autobiographical texts
that appear to "authenticate" their particular claim (via bodies presented as
Latin/lesbian) to a politics of marginality. Already, as with some of the most
interesting artists from the 1970s, Aguilar is multiplying the components of
identity that she explores through these portraits; with her self-portraits, sub-
jectivity is more profoundly complicated.

Like her *Latin Lesbian Series*, Aguilar's self-portrait images employ "docu-
mentary" black and white photography (in this case usually without text), but
to different ends. The implied goal of authenticity disappears when Aguilar
uses her own body/self as a template (both ground and locus of expression). In
the self-portrait *Three Eagles Flying* (1990), for example, Aguilar poses between a
United States and a Mexican flag. Registered through the ostensibly unbiased
medium of black and white photography, Aguilar's large brown body is wrapped
in another U.S. flag; her head is suffocated by a Mexican flag; and her hands and
neck are tied by a thick, menacing, nooselike rope. Here, flags—supposedly

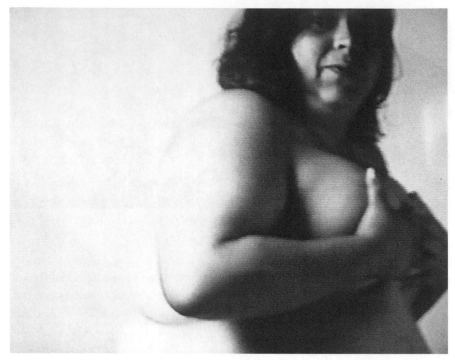

LAURA AGUILAR, *THE BODY: DEPRESSION*, 1996; STILL FROM COLOR VIDEOTAPE. PHOTOGRAPH COURTESY OF THE ARTIST.

transparent signifiers of national identity (which, in the recent anti-immigrant rhetoric of U.S. politics, has been increasingly conflated with *ethnic* identity[73])— take on a symbolic weight that goes far beyond their normative, celebratory signification. Too, as I engage with this image, the flags mark Aguilar's body *not* as "authentic" but, rather, as annihilated by the very signs that are meant to secure its ethnic identity and so its socioeconomic position in relation to the geopolitical mapping of power.[74] In the current climate, Aguilar's identity as "Chicana" thwarts her acknowledgment as "American," positioning her as "Mexican" in spite of her family's legal status and long history in this country; at the same time, her queer, overweight body reads against the grain of what proper "Chicana/o" identity is seen to be, both within and outside the Chicana/o community (as for Harris, her sexual nonnormativity gives her a marked relationship to the dominant as well as her own culture, which has its own sexual prohibitions).

In her experimental video piece *The Body: Depression* (1996) Aguilar's dispersed subjectivity emerges in its most radical and emotionally potent (yet "posthuman") form. As with her use of black and white photography, Aguilar

also deploys video for its testimonial potential—its seeming transparency to the signifiers of body and language that it purveys (apparently directly) to the viewer.[75] And yet, paradoxically, it is Aguilar's insistent self-revelation to the camera (which, whether we like it or not, becomes "us" as we view her) that dislocates video's claim to truth value. The camera is held in an extreme close-up during most of the piece, and Aguilar moves disconcertingly within and against the boundaries of the frame, asserting her embodiedness "beyond" the contours of the virtual world delivered on the monitor and yet simultaneously confirming the contingency of her body/self on such framing devices (which metaphorically and literally constitute her body/self). Aguilar appears both affirmed by the testimonial effects of the video and trapped by its rigid framing device.[76] As she moves back and forth, in and out of the frame, she speaks of unspeakable things: her psychic pain, her artwork and its therapeutic role, her alienation as a dyslexic whose body is overweight, and finally her desire to dissolve the boundary between life and death through suicide. At all times we are acutely aware of her body as it is instantiated through her thoughts about it— as it "becomes" a self for her, as she speaks her pain and depression (which she frequently articulates in relation to both her learning disability and the particularities of her organic body, rendered through the electronic screen of video).

Aguilar's project points to death as the stubborn "fact of life" that continues to expose the impossibility of the "individual" and his dream of transcendence. Death is the brute termination of the corpus/self that thus shows up the vulnerability and terrifying immanence of the flesh (and, as Aguilar's monologue stresses, the inexorability of the *embodiment* of the self). The medium of video is forced here to play the role of documenting Aguilar's continually failed striving for authenticity: her language is repetitive, halting, pained, harrowingly hesitant, her body and head constantly in motion, in contrast to the conventional blithe assertiveness and articulateness as well as the physical stasis of the professional talking head. Her body is terminable (and clearly a burden that she feels unable to bear at times) and yet, through this video testimonial, through her work (which, she argues, has saved her life), through *technology* will "live beyond" itself.

It is, perhaps, the fact that her body/self is not hers but, rather, is continually spoken, in its particularity, as inferior by dominant culture that seems to produce Aguilar's anguish. In a sense this self-portrait work is about attempting to *reclaim* herself for herself (in Harris's terms, a redemptive act). This is an attempt that, as Aguilar's own anguish makes clear, can never fully succeed as the body/self is defined and experienced through its relation to others. Aguilar speaks her own ambivalence: by doing self-portraits, she states, "I've

been able to find some comfort and peace through my own body. . . . I'm a large woman—I'm not supposed to be comfortable with myself. I wonder what people think."[77] She is both "one" with herself through the immediacy of her speech and her self-presentation and alienated from herself through this technologized projection of her body/self outward toward other "people" (which itself marks speech [or the pose] as always already mediated). Her body/self is both hauntingly particular (dyslexic, Chicana, lesbian, alienated, artist) and disarmingly extrapolable to a "posthuman" (or antihumanist) condition in general in its acknowledgment of the fundamental nonsecurability of the relationship between the body/object and the body/subject.

It is Aguilar's singularity that pains her and that she attempts to illustrate in her work. It is the failure of the illustration to signify her into coherence or to project her, transcendentally, beyond this pained and painful body/self (a failure endemic to the [post]human condition) that leads her to speak of death. Too, the work of Laura Aguilar enacts the female body as aggressively raced, sexed, and classed (especially according to the reading and writing skills that she lacks), dispersing "female experience" beyond previously dominant conceptions of this experience within feminism itself as necessarily white, educationally privileged, and heterosexual. There seems to be an intimate link between Aguilar's disruption of every aspect of normative subjectivity and her pain: she has internalized her own failure to perform properly vis-à-vis the cultural norm (in this case, the thin white woman as object of the gaze or the white man as subject of artistic production) such that, in her words, "I've thought that I have no right to be alive." Aguilar's project makes clear that it is no accident that it is those who have a special, failed relationship to normative subjectivity who have most dramatically and successfully articulated a technologized, deessentialized subject who radicalizes and subverts the category "individual."

Aguilar's and Harris's work makes clear that gender, sexuality, race, and class are not simply about taking on "masks" that effect or challenge singular identities as some 1970s and 1980s theories of identity would have it (and perhaps as Mercer's account of Harris's work might suggest), but about a continual system of intersubjective exchanges that take place across and through the body as it is articulated through technologies of (re)presentation. Gender is not about simply seeming to "be" masculine or feminine (whether anatomically or otherwise); race is not simply about appearing to "be" a particular color and thus to "have" a particular set of personality characteristics. Rather, as Peggy Phelan suggests in relation to Adrian Piper's work, "part of the meaning of race resides in the perpetual choice to acknowledge or ignore its often invisible markings," markings that, themselves, vary in meaning and significance accord-

ing to their interpretive evaluation.[78] And, I would stress, the social and psychological *effects* of such readings would vary even more widely according to their contexts and engagements.

Aguilar's and Harris's projects, it seems to me, radicalize the dispersal of the Cartesian subject in postmodern culture. I say "radicalize" because, rather than confirm traditional coalitional identity politics (where blackness, for example, would be defined as singular and definable in relation to dark-skinned bodies with African "blood") and bemoan the dislocating effects of technology and/or poststructuralism, Aguilar and Harris exacerbate this dislocation for its potentially positive effects in relation to nonnormative subjects who have never, in fact, been "individuals." *Exposing* rather than disavowing the fact that visible appearance or first person testimonial cannot guarantee any kind of behavior, social position, or metaphysical transcendence is the most crucial gesture in the 1990s. I cited Phelan's provocative argument in my discussion of Piper and it applies here too:

> Identity cannot, then, reside in the name you can say or the body you can see—your own or your mother's. Identity emerges in the failure of the body to express being fully and the failure of the signifier to convey meaning exactly. Identity is perceptible only through a relation to an other—which is to say, it is a form of both resisting and claiming the other, declaring the boundary where the self diverges from and merges with the other. In that declaration of identity and identification, there is always loss, the loss of not-being the other and yet remaining dependent on that other for self-seeing, self-being. [79]

Through their heightened particularization of their bodies/selves in representation, both Harris and Aguilar *exploit* visibility (the very visibility that functions to position them as "other") to produce ambivalent bodies/selves that engage the viewer in a complex, technophenomenological exchange. As I, a typical art-savvy viewer (white, well-educated) engage with the signifiers that produce Harris's anachronistic gay, black, male body or Aguilar's unconventional "female nude," my own stubborn embodiment is caught up in an exchange of representational identities, in a circuit of identifications, incorporations, and desires. My femininity, for example, is exposed in its contingency; my heterosexuality in my nagging attraction to both Harris and Aguilar (neither one an "appropriate" object of heterosexual female desire); my whiteness in its failure to situate Harris's blackness or Aguilar's Chicananess as entirely other. I could only guess at what possible readings would accrue to these fabulous

bodies/selves for other subjects. I would venture to say that all could be de-individualized, marked as both particular and ultimately dispersed (in relation to others). As Allucquére Rosanne Stone has written, "we make meaning by acts of reading. We read the body as a text; we attempt to render it legible, we develop elaborate location technologies to fix the body's meaning within a precise system of cultural beliefs and expectations; but the most interesting bodies escape this attempt to locate them within a predefined meaning structure."[80] Harris's and Aguilar's bodies/selves perform just such an escape, enacting subjectivity as a fluid system of identities and making evident that they are "readable" always only in relation to our projected desires.

THE BODY AS MEAT: ORLAN AND BOB FLANAGAN/SHEREE ROSE

As Aguilar's practice suggests, the body/self enacted in recent body-oriented practices is thoroughly mediated but also organic and mortal: this is a body that is mutable in its appearances, meanings, and effects, but inexorably *meat*.[81] Artists such as Orlan and Bob Flanagan (who worked in close collaboration with Sheree Rose from 1980 onward) turn the body inside out, enacting the stubborn corporeality of the self while refusing any conception of this corporeality as fixed in its materiality. Turning the body inside out, its reversibility (its coexistence with the *flesh of the world*) is made evident, the failure of the visual register to comprehend the meaning of the self (its "identity" or "identities") through the appearance of the body is made manifest. As Orlan, a French artist active in performative work since the 1970s, quotes during her performances, "The skin is deceptive . . . in life one only has one's skin . . . there is an error in human relations because one never is what one has . . . I have an angel's skin but I am a jackal . . . a crocodile's skin but I am a puppy, a black skin but I am white; a woman's skin but I am a man; I never have the skin of what I am. There is no exception to the rule because I am never what I have."[82]

In a different way from Aguilar and Harris, Orlan severs the link between bodily appearance and self-identity, threatening, in Stone's words, the "last remaining place in which the sovereign [Cartesian] self may take refuge" and thus calling into question "the way we ground identity in physical form."[83] While Aguilar and Harris multiply their visual appearance beyond legibility, and complicate the usually singularized "categories" of identity through intersectionality, Orlan literally has her physical appearance mutilated and transfigured. In the notorious *Omnipresence* (1993), Orlan has plastic surgeons slice into her flesh, literally lifting it from the muscles of her face to reconfigure its contours according to Western ideals of feminine beauty.[84] Through such acts, performed in carefully staged operating rooms while she is completely awake but

ORLAN, *OMNIPRESENCE*, 1993; SCENE FROM SANDRA GERING GALLERY, NEW YORK,
DURING LIVE TRANSMISSION OF SEVENTH PLASTIC SURGICAL OPERATION.
PHOTOGRAPH COURTESY SANDRA GERING GALLERY, NEW YORK.

numbed by a local anesthetic and projected by video around the world through satellite relay, Orlan produces a body of suffering, as Parveen Adams has argued, "in the spectator, if not in the patient," enacting the reversibility of self and other so eloquently theorized in phenomenology.[85] Enacting herself (and literally *rearranging* her body/self) through technologies of representation as well as medical technology, Orlan produces herself as posthuman: her body/self is experienced (both by herself and by her audience) in and through technology.

Having her skin peeled away from her "body," Orlan strips away the ideological assumptions underpinning the notion of the Cartesian subject (that this subject is pure interiority, her body simply a container that can be transcended through thought) or, alternatively, of the subject as determinable through her or his physiognomy (a belief dominant at the turn of the century).[86] Here, the subject Orlan is neither simply readable as "face" (for, per the psychology of plastic surgery, her face transmogrifies into different appearances apparently through her will to make it so), nor can she transcend the brute, bloody, *there*-ness of her body. The face is *detachable* and, in viewing it, we "find ourselves unhinged in a space that refuses to organise an inside and an outside."[87] Orlan's work points to the fact that plastic surgery, rather than allowing us to gain control over our bodies, exacerbates our subordination to their vul-

nerabilities and mortality—a subordination all the more dangerous for women, due to its long precedent in Western representation and thought. The more we attempt to reverse the signs of aging or supposedly misbegotten facial and bodily features, the more obviously we are obsessively driven by our corporeality (specifically, its visual appearance as psychically incorporated into our senses of self).[88] As Stone argues, Orlan returns us to the inexorable corporeality of the self, revealing the tenacious refusal to abandon the body as a site of interpersonal exchange and interaction, as a site for "authorising our own existence."[89]

Orlan's project, like that of the British-Palestinian artist Mona Hatoum, fundamentally confuses the boundaries between interior and exterior—those boundaries that differentiate the "body" from the "self" within the dualistic logic of Cartesian thought. While Orlan interrogates the way in which the external appearance of the subject is construed as representative of the self, extending body art to a kind of nth-degree interrogation of the body/self continuum, Hatoum, in her 1994 project *Corps Étranger* (strange body or foreign body), uses anthroscopic photography and ultrasound to transgress these boundaries in the most literal fashion.[90] A small circular room envelops the visitor with magnified bodily sounds (a heartbeat, breathing, etc.) and presents, at her feet, the video image of what the camera "saw" as it passed over, around, and through Hatoum's body. The image uncomfortably traces the continuity of the interior and exterior surfaces of the body as flesh, moving seamlessly from arm to head to throat, through intestines, anus, and vaginal canal. In Ewa Lajer-Burcharth's terms, Hatoum projects the otherness *within* the self by turning her body inside out.[91] Yet Hatoum's body/self is also about another kind of otherness—another kind of particularity. Hatoum's subject (her enacted body/self) is a "displaced" Palestinian woman living in Britain: she cannot successfully reiterate the codes of either "British" or "Palestinian" subjectivity but is always other to both (although, at the same time, her otherness is invisible in the piece, as her flesh is not particularly dark or otherwise marked as "not British"). Orlan's subject, conversely, is a French Catholic woman who negotiates the dominant tradition of modernist artistic practice in France: where women—saints or whores—are the objects of art.[92] Orlan takes her own more ambiguous otherness (which is tinged with privilege) and makes it dramatically, repulsively, theatrically available precisely at the moment of its transformation into the object/ideal.

Like Orlan, Hatoum presents a body that is medicalized, merging interior and exterior and fundamentally overturning the notion of the body as a *container* for self (as Christine Ross has argued, anthroscopic photography is closely linked to illness, as it was developed to document the dysfunctional

body).[93] Hatoum's and Orlan's bodies/selves are aggressively devouring: all hymen or flesh (in between space) and no boundaries; they suck observers into their opened skin, suck us into the abyss of their bodies/selves.[94] While Hatoum's moist, pulsating bodily parts plunge us into her flesh (via both our eyes and our feet, which hover over the video screen), Orlan draws us in through a visceral identification with flesh that is being rent (our face tingles and twists as we watch hers being dismantled). Both artists produce bodies/selves that are, in Ross's words, incorporating and incorporated:[95] we consume them as they "consume" us, compelling our deep identification with their raw flesh. As Orlan has stated, "I seek to make a visual work for which one has a strong bodily response, rather like one reacts physically listening to music."[96] Viewing Orlan's face being pulled away from her body on videotape is more than enough to secure such a violent response, as is the tunneling sensation conveyed in Hatoum's video clips of her body/self. Our engagement in Orlan's work, furthermore, most likely does take place through the bizarre distortions of satellite communications and/or video: the shattered body of the operational subject (that subject mutilated then reformulated by surgery) is itself rendered electronically to its audience.

Like all communications and biotechnologies, including anthroscopic photography, plastic surgery aims to confirm our ability completely to objectify our bodies (to view them as objects we can transcend). And yet, as I read it, Orlan's work points rather to the impossibility of such objectification (not the least because any object of plastic surgery must experience the physical pain that it entails and then must bear the often grotesque marks of the pulling and pumping of flesh).[97] As Vivian Sobchack argues, "there is nothing like a little pain to bring us back to our senses, nothing like a real (not imagined) mark or wound to counter . . . romanticism and fantasies of technosexual transcendence."[98] Furthermore, and not incidentally, the corporeal boundaries transgressed through medical invasion have profound psychic effects: even for psychoanalysts (who have a stake in maintaining the psyche as a separate entity from its embodiment), it is pain that most profoundly confuses the boundaries between, as Didier Anzieu writes, "the bodily and psychical Ego, between the Id, Ego and Super-Ego."[99]

Bob Flanagan suffered from cystic fibrosis his entire life (he died of the disease in 1996); unlike Orlan's or Hatoum's, his self-inflicted bodily transgressions had to do specifically with externalizing his pain and projecting it onto his observers with dominatrix Sheree Rose's help through brutal acts of S/M.[100] Too, like Orlan, Flanagan ritualized his pain through performances that borrow from and transgress the flamboyant fetishization of suffering and

martyrdom in the Catholic tradition.[101] As Anzieu theorizes through a revised Cartesianism, "[p]ain cannot be shared, except by being erotized [*sic*] in a sado-masochistic relationship. . . . Inflicting a real envelope of suffering on oneself can be an attempt to restore the skin's containing function. . . . I suffer therefore I am. . . . It is through suffering that the body acquires its status as a real object."[102] While pain cannot be shared, its effects can be projected onto others such that *they* become the site of suffering (per Adams's argument that Orlan's work produces "the body of suffering . . . in the spectator"), and the original sufferer can attain some semblance of self-containment (paradoxically, through the very penetration and violation of the body). An understanding of the body in pain is crucial in the age of AIDS and other autoimmune diseases that ravage the body and destroy its capacity for self-healing.[103]

In phenomenological terms, illness concretizes the body, forcing the subject to become hyperaware of her or his body-in-pain (Jean-Paul Sartre writes of the pain of illness as "revealing" or confirming the physical body of the subject).[104] Illness, then, can be said to force the subject to recognize her or his existence in relation not only to an other but also to the tortured self. Flanagan experienced intense pain through his illness. As a person disabled by illness and a practicing masochist, Flanagan sustained a relationship to his audience that could be seen as doubly imbricated and yet doubly distanced: his flamboyantly performed relationship to pain draws us in (paralleling our own psychic traumas) and yet removes him from himself and thus from us as we have identified with his pain. Just as Orlan both attracts and repels us through her medicalized, traumatized body/self (here, of course a self-inflicted condition), so Flanagan seduces us only to make us more aware of his singularity-in-pain.

Flanagan, who was a poet rather than a trained artist, is also unusual in that he entered the art world through performative sadomasochistic practices in private S/M clubs in San Francisco and Los Angeles; inspired by Rose's example (she is a photographer), he approached performance from the perspective of a clinical masochist apparently attempting to externalize his internal pain. Accordingly, his performative works are emphatically raw and explicitly sexual: Flanagan actually mutilated (or had Rose mutilate) his flesh, reducing the pain of illness—which excruciatingly scrambles the boundaries between the physical and the psychic—to the less ambiguous agony of the definitively physical. In turn, he and Rose enacted tortures that were reassuringly primitive in their effects as compared to the medical technologies that in some ways improved but in others distorted and debased Flanagan's lived experience.[105] By directing the pain outward, contriving a situation in which an identifiable (and

presumably stoppable) force causes it, Flanagan became momentarily (if illusorily) "unified" as the victimized object of the acts of an other and was able momentarily to ignore his dependence on medical technologies (in addition to taking heavy drugs, Flanagan had to carry around an oxygen tank for the last few years of his life).[106]

When he lacerated his own flesh, in performances such as *You Always Hurt the One You Love* (held in 1991 at a San Francisco S/M club, Q.S.M.), the masochistic strategy constructed him as both acting subject and receptive object of violence, merging subjectivity into objectivity for both Flanagan and his audience and thus confusing the security of either identification. In this performance, a variation of a routine performed before both S/M and art audiences, Flanagan chatted casually with the audience about his illness and his desire for physical pain while nailing his penis to a stool, then pinning it to a board. Flanagan's S/M pieces, such as this Q.S.M. performance, would be extremely confrontational were it not for his mode of presentation, which is closer to Acconci's ironic performance style than to the aggressive style of Hermann Nitsch or Chris Burden. Flanagan mitigates the horror of his suffering (as we perceive it through the humor and self-deprecating charm of a good stand-up comic). [107] As a performer, Flanagan is eminently likable—a "good hostess" rather than a Burdenesque "bad boy." Intertwining acts of piercing, laceration, and mutilation of the flesh with direct, personal narratives describing his close relationship with bodily pain, Flanagan breaks down resistance to the brutality of S/M practices through an amenably amateurish presentational style, approaching the audience intimately and congenially and drawing us in as collaborators in his masochism. While Burden and Nitsch affront, Flanagan confronts and cajoles, humbling and fragmenting himself before us.

Flanagan's self-mutilations are related to yet divergent from the masochistic strategy described by French psychoanalyst S. Nacht, in which parts of the body are mutilated to ward off the threat of castration, in that he cuts, burns, and pierces the very organ threatened by the castrating act in order to repel the threat of death itself.[108] Flanagan's masochistic performance works to de- and reconstruct his shattered body exhibitionistically: to prove to himself and to us that he still "exists." By sacrificing the physical integrity of his penis while simultaneously retaining a claim to its capacity for erection, Flanagan ensures his aliveness. Thus, in his poem "Why?" Flanagan begins to explain his desire for self-mutilation: "Because it feels good; because it gives me an erection . . . because I'm sick . . . because I say FUCK THE SICKNESS."[109] Flanagan's self-violating acts work to attain the state of deferral desired by the clini-

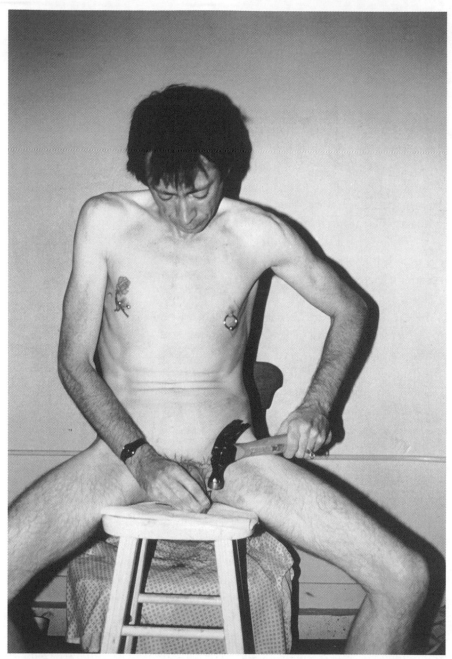

BOB FLANAGAN, *YOU ALWAYS HURT THE ONE YOU LOVE,* 1991; S/M PERFORMANCE AT Q.S.M., SAN FRANCISCO. PHOTOGRAPH BY AND COURTESY OF SHEREE ROSE.

cal masochist, whereby castration (the torture) is relegated to foreplay such that pleasure is always already incipient. (And yet, as Flanagan insisted, the pain itself produced pleasure for him.)

Flanagan himself was acutely aware of the paradox of masochism. While nominally the "slave" in his relationship to Rose (and the "object" of the audience's gazes in the artistic performance), it was he who directed every action and even motivated the S/M orientation of their relationship in the first place: "I am ultimately (this is what every masochist hates to hear, or admit) in full control."[110] The masochist *commands* the very action by which he suffers. And yet, Flanagan also stresses the consensual aspect of S/M practice: for Rose and Flanagan, the S/M confusion of passive and active positions becomes a confusion of gender polarities as well (as is clear in their performance piece *Issues of Choice*, in which Flanagan vehemently speaks the words of Randall Terry, leader of the anti-choice group Operation Rescue, while Rose safety pins plastic baby dolls to his flesh).[111]

In addition, the exhibitionism explicit in Flanagan's project (or, perhaps more accurately, lifestyle-turned-artwork) dislocates the usual link between the veiled, but conventionally male, body of the artist and the cultural authority of masculine production. In explicitly displaying and mutilating the flaccid penis, the exhibitionism involved in Flanagan's S/M performance project (an exhibitionism Theodor Reik connected to "Christian masochism")[112] makes his alignment with the phallus of artistic authority potentially difficult, to say the least. As Kaja Silverman has argued, "Christian masochism has radically emasculating implications, and is in its purest forms intrinsically incompatible with the pretensions of masculinity" because of its reliance on the spectatorial gaze.[113] It is perhaps to the point here that part of Flanagan's masochistic relationship with Rose involved being her slave: cleaning her house, cooking for her and her two children, and performing all other tasks she demanded, Flanagan took on the feminine role around the house. In his words, nothing less than "[g]ender demolition!" would do.[114]

Masochism has other particularly troubling effects within cultural representation. As Paul Smith has argued in his trenchant discussion of Clint Eastwood's periodic masochistic helplessness in Hollywood action films, "the masochistic stage of such narratives cannot be presented as a complete castration and . . . the possibility of transcendence must always be kept available. The masochistic trope in this sense must be no more than a temporary test of the male body."[115] In fact it is in suffering through the agency of paternal law (the phallus) that the male body emerges triumphant:

[T]he male masochist in important ways obeys and serves the phal-
lic law. . . . Male masochism is *at first* a way of not having to submit
to the law, but equally importantly it turns out to be a way of not
breaking (with) the law. . . . Male masochism might, finally, be seen
as another way for the male subject to *temporarily* challenge his desire
for the father and to subvert the phallic law, as ultimately another
step in the way . . . of guaranteeing the male subject as origin of the
production of meanings. . . . Masochism, grasped in this way, would
be a closed space where masculinity sets the terms and expounds the
conditions of a kind of struggle with itself—not a struggle neces-
sarily for closure, but a struggle to maintain in a pleasurable tension
the stages of a symbolic relation to the father—a struggle in which,
ironically, the body becomes forgotten.[116]

Finally, Smith points out that not only is the "masochistic moment" actually
antifemale, but it "is often crucially anti-homosexual in its significance."[117] That
is, with much male body art (including the work of Burden, and of Nitsch,
Rudolf Schwarzkogler, and the other Viennese Actionists) the masochistic mo-
ment aims to reassert the integrity of the male *heterosexual* body—an integrity
commonly secured through the conflation of the penis with the phallus of pa-
ternal law. Shorn of his illusory claim of bearing the phallus, the male artist is
feminized or homosexualized. In short, he is no longer an artist as this figure is
conventionally understood in Western culture.

However, Smith also argues that this continual process of reinforcing
phallic male subjectivity, which requires the suppression of the actual body of
the male subject, resides alongside "a residual, barely avowed male hysteria." In
every case, a "hysterical moment," he argues, "marks the return of the male
body . . . as it exceeds the narrative process."[118] Flanagan's project is hardly re-
cuperative of a privileged relationship to the father/phallus; it flamboyantly
resurfaces this suppressed male body—which is enacted yet just as dramatically
veiled behind the symbolic functions of artistic authority and art historical in-
terpretation. Castration, Flanagan asserted, "is the ultimate extreme of every-
thing I do or fantasize about. It's the ultimate way to go."[119]

Through Flanagan's overly hystericized (not to mention punctured, de-
flated, depleted, and otherwise materially shattered) body, the conventional
model of the male artist is definitively dispersed. As we have seen, Flanagan
projects his pain outward to produce a "body of suffering" in the spectator:
like Orlan, his agony solicits our deepest bodily/intellectual identification. The
production of pain across the body also confirms its "thereness," and yet opens
to question how such thereness signifies in relation to the self (and, by projec-

tion, other) who suffers. Thus, Flanagan claims that "[i]f there's anything in SM that comes close to an out-of-body experience, it's those kind of bondage feats . . . where you do something for long periods of time with no distractions, no bargaining—you're just *there*."[120] At the same time, Rose points out that "[w]hen people see Bob [performing] . . . it's Bob Flanagan they're seeing, but it's also Bob Flanagan *playing* Bob Flanagan."[121] I would suggest that Bob Flanagan is always *playing* Bob Flanagan (as documented in Rose's photography or as enacted in live performance), and that Bob Flanagan is always mediated and technologized. There is no essential "male subject" here (wielder of the phallus, as confirmed through the veiling of his anatomical penis); rather, through medicine as well as the masochistic acts of mutilation, not to mention death, the (male) body in all of its vulnerabilities and contingencies is made evident.

Orlan and Flanagan both en-gender and aggressively corporealize their bodies-on-display, pushing the eroticized body/self to its outer limits, performing (again, through technologies of representation) the body as flesh of the world, the body as meat, the body as coconstitutive of the self—the body/self as always already enacted in relation to others. The body is not "surface" representation to be performed with or against the grain of some core identity nor as pure immanence that can be transcended through thought or virtual technologies, but rather complex enactment of the mortal, and ultimately corruptible and finite, self. The body/self is technophenomenological: fully mediated through the vicissitudes of bio- and communications technologies, and fully engaged with the social (what Merleau-Ponty would call "enworlded"). The body/self is hymenal, reversible, simultaneously both subject and object.

CONCLUSION: TECHNOPHENOMENOLOGY

In this book I have attempted to move beyond what are ultimately still formalist or structural conceptions of postmodernism (defined through strategies of production such as allegory, Brechtian distanciation, and so on) to identify what I see as a profound shift in contemporary life: a gradual but dramatic change in the way in which we conceive and, indeed, experience the gendered, sexualized, racialized, classed, and otherwise particularized body/self (including our own) in its contingency on the other and the world.

I have suggested that we can engage with the body art works of Acconci, Wilke, and their contemporaries, and with the body-oriented practices developed more recently, to rethink the premises of art critical and art historical discourse, which still continue to read works of art (body art or otherwise) by imputing presumably intentionally embedded meanings to them and inferring a full subjectivity at their "origin" (the artist) as well as at their "destination" (the

BOB FLANAGAN AND SHEREE ROSE, *VIDEO COFFIN*, 1994, FROM THE *MEMENTO MORI* TRILOGY. PHOTOGRAPH BY AND COURTESY OF SHEREE ROSE.

interpreter herself). Such a feminist phenomenological engagement (one that acknowledges our own contingency, particularities, and vulnerabilities) would also entail a radical revision of the broader understanding of postmodern culture and of subjectivity and identity in the most profound sense. In this sense, art historians, theorists, and critics can learn from the very technologies that have informed and have been formed by younger generations of artists who present "posthuman," dispersed subjects in their work: high-tech media act via *interfaces* that mark the artwork as a site of the exchange between subjects, the site of joining between subjects and objects, the locus where intersubjectivity reverses into what Vivian Sobchack has called *interobjectivity* and vice versa.[122]

Like Aguilar, Flanagan and Rose explore the reversibility of intersubjectivity and interobjectivity in relation to death. A final *Memento Mori* trilogy involving three different casket installations—*Video Coffin, Dust to Dust,* and *The Viewing*—grapples with Flanagan's own mortality through technologies of representation that produce his body in relation to ours, projecting his image/his body outward to those who engage with the piece.[123] In *Video Coffin* (1994) the head of a casket (decorated with icons of death such as bullets and body parts) is laid open to show a text ("I was promised an early death, but here I am, some forty years later, still waiting") and to expose a video monitor with a loop of Flanagan's face. Approaching the flower-bedecked casket, the visitor is com-

pelled to move closer and closer to view the "dead" Flanagan, only to find her or his face *replacing* Flanagan's. The jarring effect of this replacement (the "dead" artist becomes the "dead" spectator) underlines one's engagement with Flanagan as profoundly, inextricably intersubjective *and* interobjective (we "experience" both Flanagan and ourselves through the technologized medium of video, which, in turn, places us in the position of the corpse—the body without "self"). Like all of Flanagan and Rose's works, this piece profoundly questions the assumption that death resides elsewhere, outside the subject, highlighting the fact that the luxury of this assumption is withheld from the chronically ill, such as Flanagan.

Neither of the two proposed additional "caskets" has yet been completed.[124] *Dust to Dust* would involve a simple pine box (like the one Flanagan was actually buried in) with the entire lid open to show a mound of confetti. On closer look, the visitor would realize that the "confetti" is actually thousands of minuscule photographs of Flanagan (taken primarily by Rose) from various stages of his life (in Flanagan's words, "viewers [could] . . . scoop up hand fulls [*sic*] of the tiny squares so that they are literally holding another person's life history in the palm of their hands"). Again, the intersubjective and interobjective domains are intertwined as the visitor experiences her or his own embodied subjectivity (which is simultaneously objectivity) in relation to tiny objects/images that represent Flanagan in his multiplicitous fragmentation. The piece would also literalize the dispersal of the subject that occurs with death and, viewed within the context of Rose's photographic work, would speak of the ontological function of photography in relation to human memory (we feel that with a photograph we can stave off the total loss—the feeling of emotional amputation—that occurs with a person's death).

Finally, *The Viewing* is almost impossible to fathom in its original formulation, developed before Flanagan's death (he died before it could be completed). As originally conceived, the piece was to document the decomposition of Flanagan's body through the placement of a video camera in his coffin underground.[125] The camera would be hooked into a monitor placed in a gallery or other public place, to be accessed at will by visitors apprised of its "contents" (that is, it would be up to the viewer whether or not to turn the monitor on, whether or not to engage with this body, bereft of a "self"). *The Viewing* (even the title highlights a visual relationship to the body/self of the other) proposes an nth-degree interrogation of the relationship of the body to the self: for it is only in death that the body is stripped of its inexorable role as instantiation of the *cogito*. Watching this body return to the earth, we would be compelled to acknowledge our dependence on the

flesh to sustain our existence (the fact that the self cannot survive the body is proof not of the self's transcendence but of its incontrovertible contingency on the body). At the same time, we might also become acutely aware that Flanagan does still "exist" in and through the others who have engaged him (in particular, Rose), marking the contingency and embeddedness of the self on/in the other.

In *The Viewing*, Flanagan takes body art to its extreme, "performing"— through video technology—after his living self is dead. The rotting of the corpse itself is the final enactment of Flanagan (and begs the timeless philosophical question, Is this dead body Flanagan at all?). Further, the trilogy surfaces the fact that, while death is experienced purely individually, it is the moment that most aggressively highlights the ways in which our embodied existence and self-understanding bears entirely on our relationships with others.

I note again, at some length, the eloquent observations of Jacques Derrida on this subject, returning us (through death and the body/self) to the narcissistic dimensions of body art and subjectivity in general:

> [W]hat do we mean by 'in us' when, speaking at the death of a friend, we declare that from now on everything will be situated, preserved, or maintained in us, only 'in us,' and no longer on the other side, where there is nothing more. All that we say of the friend, then, and even what we say *to him*, to call or recall him, to suffer for him with him—all that remains hopelessly *in* us or *between* us the living, without ever crossing the mirror of a certain speculation. Others would speak too quickly of a totally interior speculation and of 'narcissism.' But the narcissistic structure is too paradoxical and too cunning to provide us with the final word. It is a speculation whose ruses, mimes, and strategies can only succeed in supposing the other—and thus in relinquishing in advance any *autonomy*. . . .
>
> Everything remains 'in me' or 'in us,' 'between us,' upon the death of the other.
>
> Everything is entrusted *to me . . . to the memory.*[126]

Thus, it is the very *narcissism* of the performance of the self that inexorably engages the self in the other: our self-conception, our self-performance can only take place through our phenomenological assumption of subjectivity (or moments of subjective engagement) via others in the world. Flanagan's project, by evacuating the cognitive element of the self and leaving only the body as meat, begs the issue of intersubjectivity on the most profound level, enacting the very process by which we work through the death of a loved one: as we (in theory)

watch Flanagan's body decay, we extrapolate back to our remembrances of his live "subject."[127] The subject "is" only always in relation to the perceptions/ memories of others.

I have already explored at length how the earlier body art projects exacerbated this reversibility (this, in Merleau-Ponty's terms, chiasmic intertwining of subject and object). The work I have discussed in this chapter ultimately points to an expansion of the phenomenological relation to a technophenomenological relation that intertwines intersubjectivity with interobjectivity: we are enworlded via the envelopment of our bodies in space, the touch of our hands on a keyboard, the stroke of our gaze on the video screen. Seemingly paradoxically, given the conventional association of technology with disembodiment and disengagement from the world, recent body-oriented practices have increasingly mobilized and highlighted this reversibility, using the artists' own body/self as both subject and object, as multiplicitous, particular, and unfixable, and engaging with audiences in increasingly interactive ways. As I engage with it here, this work parallels what Sobchack identifies as "the dual structure of passion and the subjectively-grounded reversibility of body and world" that necessarily entails politicized subjects—subjects who acknowledge their own immanence, their own capacity for being objectified in relation to the world.

Rather than projecting immanence onto the *other*, such a practice embraces the flesh (but specifically as enworlded and intersubjectively determined rather than somehow "essential" or in itself transcendent). Sobchack cites David Levin on the flesh as "the elemental matrix, the texture, the field or dimensionality of our being: that 'medium' in the depths of which subject and object . . . mirror . . . each other" in a relation of reversibility.[128] While earlier feminists such as Wilke and Schneemann might be said to have recognized their own objectification vis-à-vis the world and to have attempted to reverse it into subjectivity (or at least to meliorate its effects by taking on a subjective stance), I would like to end by suggesting that more recent body-oriented works extend this radical project to make us increasingly aware of our own state of simultaneous intersubjectivity and interobjectivity, with the latter understood to be "a structure of engagement with the *materiality of things* in which we recognize *what it subjectively feels like to be objectively embodied*" in a highly technologized world.[129]

Such an acknowledgment forces us to experience ourselves as not only *in* the world, but as also *belonging* to it and thus *owing it something:* as fully contingent bodies/selves who are responsible for the effects our behaviors and perceptions have on others and aware of our reactions to other subjects and objects in

the world.[130] This technophenomenological understanding of the body/self poses it as deeply socialized and politicized. It urges us to rethink the ways in which we make sense of contemporary art and to expand our experience of postmodernism; as well, it encourages us to reevaluate the way in which we comprehend subjectivity itself.

NOTES

INTRODUCTION

1. Antonin Artaud, *The Theater and Its Double* (1938), tr. Mary Caroline Richards (New York: Grove Weidenfeld, 1958), 96; emphasis added.

2. Ibid., 122.

3. The shift from an investment in the modernist artist/genius to what we might call a *post*modern performativity of artistic subjectivity parallels what art historian Henry Sayre has described in terms of a new concern in postmodern culture with a "distinct performative and theatrical mode [in contemporary art, such that] . . . the objects of such a performative or theatrical production are not immanent. They are, rather, contingent, fragmentary, even disembodied. As such, they evoke, rather than an aura of full presence . . . their own *absence*." For Sayre, it is the performative act in contemporary art that most dramatically challenges the phallocentrism of modernism by exposing the contingency of artistic meaning on its conditions of interpretation; it will be clear later on that, while Sayre's initial insights are valuable, I do not feel his book follows them through. Henry Sayre, *The Object of Performance: The American Avant-Garde Since 1970* (Chicago and London: University of Chicago Press, 1989), 9.

For an interesting discussion of how performativity is enacted in relations of artistic production, particularly those centered in the site of the studio, see also Caroline Jones, *Machine in the Studio: Constructing the Postwar American Artist* (Chicago and London: University of Chicago Press, 1996); see too Robert Weimann's rather abstruse discussion of performativity, postmodernism, and questions of authority, "(Post)Modernity and Representation: Issues of Authority, Power, Performativity," *New Literary History* 23 (1992): 955–81.

4. Carolee Schneemann, miscellaneous notes; Getty Research Institute, Resource Collections, Carolee Schneemann Papers, box 21, notebook 21.3. On Schneemann's work, see also Rebecca Schneider, *The Explicit Body in Performance* (New York and London: Routledge, 1997); unfortunately, I became aware of this book only after completing mine.

5. Carolee Schneemann, *More Than Meat Joy: Complete Performance Works and Selected Writings*, ed. Bruce McPherson (New Paltz, N.Y.: Documentext, 1979), 52; see also her description of the piece and its relationship to "shamanic ritual" in "Carolee Schneemann," interview with Andrea Juno, *Angry Women*, ed. Andrea Juno and V. Vale (San Francisco: Re/Search Publications, 1991), 68, and Henry Sayre's analysis in *The Object of Performance*, 74.

6. Schneemann, *More Than Meat Joy*, 52. Kathy O'Dell's "Fluxus Feminus" suggestively argues that the uneasy relationship between women and male performance movements such as Fluxus had to do with women performers' insistence on writing the forbidden female body (as subject). Kathy O'Dell, "Fluxus Feminus," *The Drama Review* 41, n. 1 (Spring 1997): 43–60. I am indebted to O'Dell for sharing this and other, equally inspiring, works on performance with me. See also Kristine Stiles's provocative discussion of Schneemann's work as instituting a "breach of decorum" rather than intentional transgression in Stiles, "Schlagt Auf: The Problem with Carolee Schneemann's Painting," in *Carolee Schneemann: Up to and Including Her Limits* (New York: New Museum of Contemporary Art, 1996), 22.

7. Schneemann was directly negotiating and interrogating the treatment she had received within Fluxus and within early performance pieces such as Robert Morris's *Site*; see my earlier, more extended versions of this material in "Dis/Playing the Phallus: Male Artists Perform Their Masculinities," *Art History* 17, n. 4 (December 1994): 557–60; and "Feminist Pleasures and Embodied Theories of Art," *New Feminist Criticism: Art, Identity, Action*, ed. Cassandra Langer, Joanna Frueh, and Arlene Raven (New York: HarperCollins, 1994), 30–31. Rebecca Schneider discusses both *Interior Scroll* and *Site* in terms of race and the "primitive" in *The Explicit Body in Performance*, 31, 132. Schneemann was, from this early period into the 1970s, a painter and object maker, and an active figure in the Fluxus and other performance movements. See discussions of Schneemann's participation in these groups in Sally Banes, *Democracy's Body: Judson Dance Theater, 1962–1964* (Ann Arbor, Mich.: UMI Research Press, 1983), especially 93–97; and Kristine Stiles, "Between Water and Stone/Fluxus Performance: A Metaphysics of Acts," *In the Spirit of Fluxus*, organized by Elizabeth Armstrong and Joan Rothfuss (Minneapolis: Walker Art Center, 1993), 98, n. 80.

8. Schneemann, *More Than Meat Joy*, 234, 238. In a second version, Schneemann replaced paint with mud. The first version took place in 1975 at "Women Here and Now" in East Hampton, Long Island; the second in 1977 at the Telluride Film Festival in Colorado. The audience for the original performance was almost all female; see Moira Roth, "The Amazing Decade," in *The Amazing Decade: Women and Performance Art in America, 1970–1980* (Los Angeles: Astro Artz, 1983), 14.

9. The first poetic descriptions in this sentence are from a letter (dated November 22, 1992) sent to me by Schneemann, who encouraged me to revise my earlier, more blunt readings of her work; swayed by her powerful self-readings, I have done this in places. The term "translucent chamber" appears in *More Than Meat Joy*, 234.

10. "In some sense," Schneemann has stated, in this work "I made a gift of my body to other women: *giving our bodies back to ourselves*" (*More Than Meat Joy*, 194). I discuss the effects of Schneemann's use of the moving body (versus the static female body-as-picture) in chapter 4.

11. One of the motivations of this book is my frustration with the ongoing tendency to replicate the basic assumptions of this model of interpretation: the particular meaning

of the object is held to be implicit within its forms, which are seen to translate more or less directly the emotions and intentions of the making subject. The art historian/critic is situated as the privileged reader who possesses a special insight and a trained eye such that she or he can decipher this meaning and confirm this value. Even art histories that stage themselves as "new" tend to perpetuate this logic of judgment in that they continue to hierarchize practices and objects—though now generally through terms of "political" or "social" rather than aesthetic value—and to insist on particular meanings as "correct." The privileging of "good" postmodernism, then, continues to take place through an oppositional logic that poses it against "bad" or regressive postmodernism and the art historian or critic continues to gain authority through this very system of judgment by which she identifies with the privileged practices of her analysis.

Art history and criticism thus still work to frame a set of practices through interpretive acts that are legitimated through the suppression of the investments—the desires—of the interpreter (or, perhaps more accurately, through a projection of these onto the objects and their making subjects—an imputing of these desires to the artist herself or himself). This attempted suppression or reassignment aims to confirm the authority of the art historian: as I explore in this book, the Kantian notion of disinterested judgment requires a pose of neutrality on the part of the interpreter as well as a containment or regulation of the objects of art analysis, which otherwise threaten to destabilize the art historical and critical project through eliciting spectatorial desires that expose the interestedness of interpretation. While we will surely always fail in this project, we are motivated to veil the desires driving our judgments and interpretations in order to maintain the illusion of disinterestedness such that our judgments seem inevitable and "correct" and the qualities we assign to practices seem "inherent" to them rather than interpretively negotiated. On this illusion rests our role as cultural arbiters, authorized to construct a frame that defines quality at the cost of excluding that which ostensibly has no value. I discuss feminist body art's unhinging of this model of interpretation in "Interpreting Feminist Bodies: The Unframeability of Desire," in *The Rhetoric of the Frame: Essays Towards a Critical Theory of the Frame in Art*, ed. Paul Duro (Cambridge and New York: Cambridge University Press, 1996), 223–41.

12. From "Carolee Schneemann," interview with Andrea Juno, *Angry Women*, 72, 69.

13. This interest links to my initial engagement with body art through the numerous advertisements that began appearing in the late 1960s in art magazines such as *Artforum*—advertisements that include the *body of the artist*, often in facetious or ironic poses and humorous settings. In these self-performative advertisements, the body of the artist plays a central role in promoting the exhibition of the artist's work: the body of the artist is itself commodified but also dispersed across the field of meanings and values attributed to the works. These photographic performances respond to or negotiate earlier models of the artist, from Marcel Duchamp's rather coy self-construction in the public realm as Rrose Sélavy and beyond, to the critical formulation of Jackson Pollock as veiled genius (with the famous photographs by Hans Namuth and others). Examples of this phenomenon from *Artforum* include an advertisement for a Robert Rauschenberg exhibition showing the artist perched casually on a ladder in front of a large-scale lithograph in a checked suit (September 1970); Judy Chicago's advertisement for an exhibition at California State University, Fullerton (December 1970); and Ed Ruscha's coy promotional picture of himself lying in

bed between two naked women with the caption "Ed Ruscha says goodbye to college joys" (January 1967). I discuss these at greater length in "Dis/Playing the Phallus," 549–53.

14. Kris Kuramitsu, "Yayoi Kusama: Exotic Bodies in the Avant-Garde," unpublished paper submitted for Amelia Jones and Donald Preziosi's "Essentialism and Representation" graduate seminar, University of California, Riverside/UCLA, spring 1996, 1. This image resonates with Kusama's performative self-display in the poster for her "Driving Image Show" at Castellane Gallery, New York, spring 1964; reproduced in J. F. Rodenbeck, "Yayoi Kusama: Surface, Stitch, Skin," in *Inside the Visible: An Elliptical Traverse of 20th Century Art*, ed. M. Catherine de Zegher (Cambridge, Mass., and London: MIT Press, 1996), 148. See also the photograph taken by Rudolph Burckhardt of Kusama posing nude at the "Aggregation: One Thousand Boats Show" at the Gertrude Stein Gallery, New York, 1964, reproduced in Bhupendra Karia, ed., *Yayoi Kusama: A Retrospective* (New York: Center for International Contemporary Arts, 1989), 24; and Calvin Tomkins's recent article on Kusama, "On the Edge: A Doyenne of Disturbance Returns to New York," *New Yorker* 72, n. 30 (October 7, 1996): 100–103. I am indebted to Kuramitsu for introducing me to this aspect of Kusama's oeuvre and for leading me to the best sources on the artist; I am thankful also to Lynne Zelevansky, curator of an upcoming retrospective of Kusama's work at the Los Angeles County Museum of Art, for discussing Kusama's work with me.

15. Rodenbeck, "Yayoi Kusama," 149.

16. Kuramitsu, "Yayoi Kusama," 2.

17. See Alexandra Munroe, "Obsession, Fantasy and Outrage: The Art of Yayoi Kusama," in Karia, ed., *Yayoi Kusama: A Retrospective*, 29–30; and Rodenbeck, "Yayoi Kusama," 153.

18. Nul was the Dutch affiliate of the Zero group founded in 1957 in Dusseldorf by Otto Piene and Heinz Mack. See Otto Piene and Heinz Mack, *Zero* (1958/1961; reprinted Cambridge, Mass., and London: MIT Press, 1973).

19. The other artists in the portrait include Jiro Yoshihara, the founder of Gutai, Hans Haacke, Lucio Fontana, and Günther Uecker. See the labeled photograph in *Nul negentienhonderd vijf en zestig, deel 2 fotos* [Nul 1965, part 2, photographs] (Amsterdam: Stedelijk Museum, 1965), n.p. Kusama's mental illness has also functioned in her discursive construction, as in Munroe's "Obsession, Fantasy and Outrage," 11–35; Kuramitsu compellingly critiques this type of reading, which draws on a modernist conception of the mad genius, in her essay "Yayoi Kusama."

20. Yayoi Kusama, entry in *Nul negentienhonderd vijf en zestig, deel 1, teksten* [Nul 1965, part 1, texts] (Amsterdam: Stedelijk Museum, 1965), n.p.

21. This piece is described in Rodenbeck, "Yayoi Kusama," 152.

22. According to Munroe, Kusama deliberately competed with Warhol for press coverage ("Obsession, Fantasy and Outrage," 30).

23. Accounts of Kusama's work typically either attempt to dismiss her performative actions as puerile distractions from the minimalist thrust of the "Infinity Net" and "accumulation" works (the pieces with phallic knobs) or they surface these actions as exemplary of the insanity that naturally explains the obsessional quality of these repetitively patterned objects.

24. Among Kusama's many public performances from the late 1960s were the pieces she called "Self Obliteration" or "Body Festivals," activist protests against the Vietnam War

involving her arranging a meeting at a specific public site (such as the Museum of Modern Art sculpture garden or the New York Stock Exchange) with a number of dancers; the press would be alerted and Kusama, the "priestess," would organize a group strip session while painting the dancers' bodies with her signature polka dots as they danced. These are described at greater length in Munroe, "Obsession, Fantasy and Outrage," 29–30, and Rodenbeck, "Yayoi Kusama," 153. Kusama's work, in its obsessional, op-ish effects, either directly or indirectly shows the effects of the drug culture as well.

25. The poststructuralism of my position is as complex as the theories I draw from; I can only hope it is as compelling. Jacques Lacan and Jacques Derrida, usually thought of as the most extreme thinkers in terms of their conceptualization of how meaning and identity are construed, both clearly delineate the contingency of these determinations on the structures and contexts at hand. That is, a text cannot just *mean anything* (as Derridean theory is often taken as proposing) but, rather, has an infinite range of potential meanings ultimately linked in complex ways to the signifiers of the text (which, themselves, are never determinable in any fixed way but take meaning relative to the contexts of their production, display, and interpretation). See Derrida's discussion of context and intentionality in "Signature Event Context," in *Margins of Philosophy*, tr. Alan Bass (Chicago: University of Chicago Press, 1982), 309–30.

26. Thierry de Duve, *Au nom de l'art: Pour une archéologie de la modernité* (Paris: Minuit, 1989), 67–105. Jean-François Lyotard argues a similar notion in his essay "Answering the Question: What Is Postmodernism?" in *The Postmodern Condition: A Report on Knowledge*, tr. Geoff Bennington and Brian Massumi (Minneapolis: University of Minnesota Press, 1984), 71–82, as does Fredric Jameson in *Postmodernism; or, The Cultural Logic of Late Capitalism* (Durham, N.C.: Duke University Press, 1991), xiii. I discuss these texts and the idea of postmodern performativity at greater length in my book *Postmodernism and the En-Gendering of Marcel Duchamp* (Cambridge and New York: Cambridge University Press, 1994), 208–9.

27. In this sense, I hope I am avoiding the mistake that Henry Sayre makes in *The Object of Performance:* of wanting to privilege particular postmodern practices through the Derridean notion of "undecidability." He lauds them as "avant-garde" for their being "purposefully *undecidable*" (7) while, simultaneously, assigning each practice a fixed value (as either "purposefully *undecidable*" in meaning, and so politically privileged by the left, or as aligning with a modernist attempt to make the work full in its presence). The very notion of "purposeful undecidability" should alert Sayre that he is, in fact, still making recourse to putative intention to determine the meaning and value of the work (even while he argues that this meaning, in the undecidable work, is located within the audience rather than within the work itself [xiv]).

28. Although I would stress that I do not view these "personal" relationships as any less mediated or performative than the relationships staged purely through the performative projects of these artists in relation to myself as one who experiences them.

29. In this sense, as I note in chapter 1, I return to the phenomenological bases of poststructuralism (Lacan was deeply involved with Merleau-Ponty's work and, in terms of intellectual history, Merleau-Ponty, Sartre, and Beauvoir were key figures to be negotiated by the subsequent generation of philosophers who spearheaded what we now call poststructuralism).

30. I am grateful to Judith Mastai for emphasizing to me the importance of the drug culture in freeing artists to experiment publicly with highly charged aspects of their sexual/ social identities in body art projects.

31. Of course, as my own work on Duchamp attempts to establish, there has always been an exposed, performative strain of artistic subjectivity within modernism, but this performative aspect of Duchamp (and others such as Warhol) had been, not surprisingly, largely suppressed in U.S. art history and criticism until the very period I explore here. My book *Postmodernism and the En-Gendering of Marcel Duchamp* is one among a growing number of texts exploring this particular aspect of this formerly marginalized strain within modernism (which is now being performed within and as postmodernism). Body art, among other cultural phenomena, has assisted in creating an atmosphere in which such revised models of modernism and postmodernism can be articulated.

32. Michel Foucault, "Nietzsche, Genealogy, History," *Language, Counter-Memory, Practice: Selected Essays and Interviews*, tr. Donald F. Bouchard and Sherry Simon (Ithaca, N.Y.: Cornell University Press, 1977), 148.

33. Bryan Turner, *Body and Society: Explorations in Social Theory* (New York and Oxford: Basil Blackwell, 1984), 8.

34. Elizabeth Grosz, "Notes Towards a Corporeal Feminism," *Australian Feminist Studies* 5 (Summer 1987): 8.

35. See Willoughby Sharp, "Body Works," *Avalanche*, n. 1 (Fall 1970): 14–17; Cindy Nemser, "Subject-Object Body Art," *Arts Magazine* 46, n. 1 (September–October 1971): 38–42; Lea Vergine, *Il corpo come linguaggio (La 'body-art' e storie simili)*, tr. Henry Martin (Milan: Giampaolo Prearo Editore, 1974); François Pluchart, *L'art corporel* (Paris?: Rodolphe Stadler/Galerie Stadler, 1974); and Ira Licht, "Bodyworks," in *Bodyworks* (Chicago: Museum of Contemporary Art, 1975), n.p.

36. Henry Sayre has already made a strong argument for understanding portraiture itself—with its "theatricalization of the self"—as an aspect of performance; see Sayre, chapter 1, "The Rhetoric of the Pose: Photography and the Portrait as Performance," *The Object of Performance*. For linear histories of performance art, see Roselee Goldberg's canonical *Performance Art: From Futurism to the Present* (New York: Abrams, 1988), and Jorge Glusberg's excellent catalog *El arte de la performance* (Buenos Aires: Ediciones de Arte Gaglianone, 1986), which traces a more complex and more European-oriented history of performance art.

37. This particular description is Robyn Brentano's, in "Outside the Frame: Performance, Art, and Life," in *Outside the Frame: Performance and the Object, a Survey History of Performance Art in the USA since 1950* (Cleveland: Cleveland Museum of Contemporary Art, 1995), 31. The important work of Kristine Stiles, the scholar who deserves credit for her outstanding contribution of extensive archival work retracing the history of contemporary performance art proper, also tends toward such claims of redemption. In her essay "Performance and Its Objects," in which she savages Sayre's book for its vestigial authoritarianism and modernism and its historical inaccuracies, she ends by claiming rather grandiosely that "performance [is] . . . a concrete social practice that continues to redefine the meaning of the visual arts through the ways in which the presence of the body in real events provides a paradigm for social action" (Stiles, "Performance and Its Objects," *Arts Magazine* 65, n. 3 [November 1990]: 47). While I respect Stiles's work immensely, it will be clear that I differ

from her rendering of performance as triumphantly activist (a direct means of achieving activist intentions) and her assumption of "presence" and the "real" event. I insist that it is not intentionality that is the issue. It is not through any putative "intention" of enacting the body in a "concrete social practice" that body art is potentially radical but, rather, through the engagements that it encourages—and, in fact, its *ambivalence* toward the social (its narcissism as well as its radical opening to the other).

38. Max Kozloff identifies this potential in body art but turns it back in a conservative direction when he argues that in body art the "hidden instrumentality of the work becomes, not so much its visible motif, but the receptacle of the art action, the corporeal base that has been acted upon by the artists' process" ("Pygmalion Reversed," *Artforum* 14, n. 3 [November 1975]: 30). Thus, he recognizes the radical potential of body artists' unveiling of the "hidden instrumentality" of the modernist artistic subject but then negates this insight by describing the body as a "corporeal base" that is then "acted upon."

39. See my comments on Stiles in note 37.

40. Pluchart, *L'art corporel*, n.p.

41. Licht, "Bodyworks," n.p.

42. Karen-edis Barzman has eloquently explored what she terms the "signifying practices through which performative subjects themselves enter visual and textual culture," at a point where "distinctions between production and reception collapse"; see her essay "Cultural Production, Religious Devotion, and Subjectivity in Early Modern Italy: The Case Study of Maria Maddalena de' Pazzi," *Annali d'Italianistica* (special volume on "Women Mystic Writers," ed. Dino S. Cervigni) 13 (1995): 285.

43. Peggy Phelan, *Unmarked: The Politics of Performance* (New York and London: Routledge, 1993), 165. Phelan is using these terms to describe the effects of Sophie Calle's performative practice.

44. I am indebted in this particular formulation of a new feminist reading praxis to Caroline Jones, who generously read this material and improved it greatly.

45. Harold Rosenberg, "The American Action Painters," *Art News* 51, n. 8 (December 1952): 22–23, 48–50.

46. Allan Kaprow, "The Legacy of Jackson Pollock," *Art News* 57, n. 6 (October 1958): 24–26, 55–57.

47. Michel Foucault, "What Is an Author?" (1969), *Language, Counter-Memory, Practice*, 130.

48. Craig Owens, "The Medusa Effect; or, The Spectacular Ruse" (1984), reprinted in *Beyond Recognition: Representation, Power, and Culture*, ed. Scott Bryson et al. (Los Angeles and Berkeley: University of California Press, 1992), 191–200.

49. Vivian Sobchack, "The Passion of the Material: Prolegomenon to a Phenomenology of Interobjectivity," manuscript of essay forthcoming in Sobchack, *Carnal Thought: Bodies, Texts, Scenes, and Screens* (Berkeley and Los Angeles: University of California Press).

1. POSTMODERNISM, SUBJECTIVITY, AND BODY ART: A TRAJECTORY

1. Karen Lang's suggestions and comments were of invaluable assistance in the completion of this chapter.

2. M. Bénamou is cited in Régis Durand, "Une nouvelle théâtricalité: La perfor-

mance," *Revue français d'études américaines* 10 (1980): 203; see also M. Bénamou and Charles Caramello, eds., *Performance in Postmodern Culture* (Madison: Coda, 1977). Johannes Birringer discusses the fact that "performance today . . . is perceived as 'postmodern'" in *Theatre, Theory, Postmodernism* (Bloomington and Indianapolis: Indiana University Press, 1991), 47. On the link between performance art and postmodernism, see also Philip Auslander, *Presence and Resistance: Postmodernism and Cultural Politics in Contemporary American Performance* (Ann Arbor: University of Michigan Press, 1994); Sally Banes, *Greenwich Village 1963: Avant-Garde Performance and the Effervescent Body* (Durham, N.C.: Duke University Press, 1993); Herbert Blau, *To All Appearances: Ideology and Performance* (New York and London: Routledge, 1992); Marvin Carlson, *Performance: A Critical Introduction* (New York and London: Routledge, 1996); C. Carr, *On Edge: Performance at the End of the Twentieth Century* (Hanover, N.H., and London: Wesleyan/New England Presses, 1993); Sue-Ellen Case, ed., *Performing Feminisms: Feminist Critical Theory and Theatre* (Baltimore: Johns Hopkins University Press, 1990); Sue-Ellen Case, Philip Brett, and Susan Leigh Foster, *Cruising the Performative: Interventions into the Representation of Ethnicity, Nationality, and Sexuality* (Bloomington and Indianapolis: Indiana University Press, 1995); Jill Dolan, *Presence and Desire: Essays on Gender, Sexuality, and Performance* (Ann Arbor: University of Michigan Press, 1993); Lynda Hart and Peggy Phelan, eds., *Acting Out: Feminist Performance* (Ann Arbor: University of Michigan Press, 1993); Nick Kaye, *Postmodernism and Performance* (New York: St. Martin's, 1994); Peggy Phelan, *Unmarked: The Politics of Performance* (New York and London: Routledge, 1993); Janelle G. Reinelt and Joseph R. Roach, eds., *Critical Theory and Performance* (Ann Arbor: University of Michigan Press, 1992); and Henry Sayre, *The Object of Performance: The American Avant-Garde Since 1970* (Chicago and London: University of Chicago Press, 1989).

Of these texts, only Sayre's, Carr's, and Phelan's deal extensively with performance in an *art* rather than theater context; Carr's book is journalistic, and Sayre and Phelan both broaden performance to the issue of "performativity," encompassing work from Mira Schor's paintings of penises, in Phelan's case, to Earthworks in Sayre's. Banes's book is the most useful history of the early development of performance art out of experimental dance, the work of John Cage, and Fluxus. Kathy O'Dell's Ph.D. dissertation, "Toward a Theory of Performance Art: An Investigation of Its Sites" (City University of New York, 1992), is the only text I am aware of that deals intensively and theoretically with what I am here calling body art within an art historical context. I am indebted to this text, and to my ongoing discussions with O'Dell.

3. For a discussion about this shift in the 1980s vis-à-vis the Australian context, see Anne Marsh, chapter 5, "Performance Art in the 1980s and 1990s: Analysing the Social Body," in *Body and Self: Performance Art in Australia 1969–1992* (Oxford: Oxford University Press, 1993), 184–224.

4. To my knowledge, Italian, French, and German art discourse did not shy away from the body so radically during this period. But U.S. and British figures have dominated contemporary art criticism and art history (since the 1940s in the case of the United States, the 1970s in the case of England).

5. Mary Kelly, "Re-Viewing Modernist Criticism," originally published in *Screen* (1981), reprinted in *Art after Modernism: Rethinking Representation*, ed. Brian Wallis (New York: New Museum of Contemporary Art; and Boston: Godine, 1984), 95, 96.

6. See also "No Essential Femininity: A Conversation between Mary Kelly and Paul Smith," *Parachute* 37, n. 26 (Spring 1982): 31–35.

7. See Vergine's ecstatic and melodramatic utopianism in *Il corpo come linguaggio (La 'body-art' e storie simili)*, tr. Henry Martin (Milan: Giampaolo Prearo Editore, 1974); I discuss Vergine's text later.

8. See, for example, Kelly's "Re-Viewing Modernist Criticism," especially 95–97. While Merleau-Ponty's work was singularly important for many U.S. artists in the 1960s (including artists who did body art work, such as Robert Morris and Vito Acconci), art discourse from the early 1970s on mainly passed Merleau-Ponty by in its rush to embrace Lacanian psychoanalysis (often, though surely not in Kelly's case, through secondary models from film or literary theory). Along with Kelly's written and artistic work, Laura Mulvey's formative psychoanalytic critique of Hollywood films' objectification of women, "Visual Pleasure and Narrative Cinema" (first published in *Screen* in 1975), was also a key force in the turning against the body. Mulvey claims here that cinematic codes create an implicitly male "gaze . . . world . . . and . . . object, thereby producing an illusion cut to the measure of desire" that must be thwarted: "It is these cinematic codes and their relationship to formative external structures that must be broken down before mainstream film and the pleasure it provides can be challenged." The goal is to destroy "the satisfaction, pleasure, and privilege" of the spectator (who, again, is implicitly male for Mulvey). Mulvey, "Visual Pleasure and Narrative Cinema," in *Visual and Other Pleasures* (Bloomington and Indianapolis: Indiana University Press, 1989), 25, 26. Mulvey and many other feminists have subsequently reworked this rather narrow, polemical formulation since 1975, but it still has enormous authority (especially within art discourse).

9. To a certain extent, the coincident movements of minimalism and conceptualism also similarly but perhaps not as insistently engaged questions of the relationship between the body and thought, the object and the spaces it inhabits.

10. Mary Kelly, in "No Essential Femininity," 32.

11. See Laura Mulvey's "Visual Pleasure and Narrative Cinema." John Berger's polemical *Ways of Seeing* (London: British Broadcasting Corporation; Harmondsworth: Penguin, 1972), provides an earlier example of the British, Marxian approach to the convention of representing the female body as an object of the gaze.

12. This is especially true of U.S. feminists such as Lucy Lippard, whose anxiety about Hannah Wilke's self-display is discussed in chapter 4. Kelly's view on the authority of the female artist is quite different; she focuses more on the conflict experienced by women who are positioned as objects but attempt to be subjects of artistic production. See Kelly's "Desiring Images/Imaging Desire," *Wedge*, n. 6 (1986): 5–9; and Lucy Lippard's *From the Center: Feminist Essays on Women's Art* (New York: Dutton, 1976), and *The Pink Glass Swan: Selected Feminist Essays on Art* (New York: New Press, 1995).

13. There is a complex history behind the development of these theoretical models by British feminists in the 1970s and 1980s in venues such as the Marxist/Althusserian journal *Screen* and Edinburgh Festival publications. See Laura Mulvey's untitled article tracing this history in *Camera Obscura* 20–21, "The Spectatrix" issue, 248–52; Griselda Pollock, "Screening the Seventies: Sexuality and Representation in Feminist Practice—A Brechtian Perspective," *Vision and Difference: Femininity, Feminism and the Histories of Art* (London and New York:

Routledge, 1988), 155–99; and Griselda Pollock and Rozsika Parker, eds., *Framing Feminism: Art and the Women's Movement 1970–1985* (London and New York: Pandora, 1987).

14. I discuss the "antipleasure" paradigm of dominant 1980s feminist criticism and its effects at greater length in "Feminist Pleasures and Embodied Theories of Art," in *New Feminist Criticisms: Art/Identity/Action*, ed. Cassandra Langer, Joanna Frueh, and Arlene Raven (New York: HarperCollins, 1994), and in the unpublished essay "Pleasures of the Flesh: Feminism and Body Art." The prohibition of pleasure within this segment of the left can be counterposed to the Marcusian rush to confirm pleasure as an antidote to the repressive apparatus of capitalism. See Herbert Marcuse, *Eros and Civilization: A Philosophical Inquiry into Freud* (London: Routledge & Kegan Paul, 1956). Marcuse's model was extremely influential among U.S. artists in the 1960s and early 1970s, the heyday of the "free love" movement and youth and drug cultures. See Bryan Turner on the Marcusian ideal of the revolutionary potential of sexuality in *The Body and Society: Explorations in Social Theory* (New York and Oxford: Basil Blackwell, 1984).

15. Griselda Pollock, "Screening the Seventies," 163. Pollock's argument is intimately linked to the terms Mulvey uses in "Visual and Narrative Cinema," where, as noted, she argues that *the* feminist project vis-à-vis Hollywood representations of women is to "destroy . . . the satisfaction, pleasure and privilege of the [presumably male] 'invisible guest'" by breaking the voyeuristic structures of the film experience and freeing the "look of the audience into . . . passionate detachment" (26).

16. I have discussed extensively elsewhere the way in which works such as Judy Chicago's *Dinner Party* (1979), a piece that has been harshly criticized by Kelly, Pollock, and other British feminists, have disrupted modernist discourse in spite of their problematic, "essentializing" tendencies identified by these critics. See my "The 'Sexual Politics' of *The Dinner Party:* A Critical Context," in *Sexual Politics: Judy Chicago's* Dinner Party *in Feminist Art History*, ed. Amelia Jones (Los Angeles: UCLA/Armand and Hammer Museum of Art; Berkeley and Los Angeles: University of California Press, 1996), 82–118.

17. This latter insight, into the contingency of meaning on the social and political context, is one that Kelly and Griselda Pollock, as theorists committed to a Marxian point of view, have extensively developed in their work. In a sense I am using the very insights that feminists such as Pollock and Kelly introduced, but pushing them farther to argue that there is a contradiction in the wholesale rejection of a particular kind of practice.

18. For reproductions of a number of the *Silueta* works, see Mary Jane Jacob, *Ana Mendieta: The "Silueta" Series, 1973–1980* (New York: Galerie Lelong, 1991); Kelly's project is documented in Mary Kelly, *Interim* (New York: New Museum of Contemporary Art, 1990). Kelly's work is characterized by its inclusion of didactic as well as playful textual materials within the objects themselves and extensive critical texts, developed by Kelly and her supporters (such as Griselda Pollock), which lead interpretive accounts of the works toward a deeply theoretical, Lacanian/Marxian reading. See, for example, Pollock's "Interventions in History: On the Historical, the Subjective, and the Textual," in *Interim*, 39–51.

19. Mendieta was brought to the United States as a teenager under the auspices of the Catholic Church, which placed Cuban children in U.S. foster homes to "save" them from communism. Mendieta came from a home with servants, a number of whom were African-Cubans who practiced Santería. She returned to Santería in the early 1970s, combining this

tradition with her feminist interest in affirming women's power by studying and represent-
ing figures from goddess cults. See Jacob, *Ana Mendieta: The "Silueta" Series*, 3–8. On her interest
in the Taíno Indians of the pre-Hispanic Antilles (West Indies), see Bonnie Clearwater, *Ana
Mendieta: A Book of Works* (Miami Beach: Grassfield, 1993), 12–13. Clearwater documents
Mendieta's project *Rupestrian Sculptures*, a series of photo etchings of female goddess figures
Mendieta carved and molded into the walls of two caves near Havana in 1981; as in the later
Silueta works, Mendieta absents her body but forces the earth itself to "become" her, as
documented for audiences through the photographic trace. Mendieta viewed these caves in
female, corporeal terms, calling the goddess images "an intimate act of communion with
the earth, a loving return to the maternal breasts"; she stated that "the earth/body sculp-
tures come to the viewers by way of photos. . . . The photographs become a very vital part
of my work" (13, 41).

20. Mendieta's *Body Tracks* performance, executed at Franklin Furnace in New York in
1982, also marks the body emphatically as trace rather than "presence" (even in the act of
performance). Here, she covered her arms with blood, then faced a large piece of paper on
the gallery wall, dragging her arms downward to produce imprints of hands and arms in
bloody supplication. See Petra Barreras del Rio and John Perreault, *Ana Mendieta: A Retrospec-
tive* (New York: New Museum of Contemporary Art, 1987), 34–38. Rebecca Schneider dis-
cusses Mendieta's self-erasure as an effect of the "pressure she was under to conform, to
Americanize . . . to disappear" in *The Explicit Body in Performance* (New York and London:
Routledge, 1997), 119.

21. Ana Mendieta, unpublished statement quoted by John Perreault in "Earth and
Fire, Mendieta's Body of Work," *Ana Mendieta: A Retrospective*, 10; Mendieta's sense of having
been "cast from the womb" comes, she states, from "my having been torn from my home-
land (Cuba) during my adolescence." In other places Mendieta exalts the "primitive," writ-
ing, "It was during my childhood in Cuba that I first became fascinated by primitive art and
cultures. It seems as if these cultures are provided with an inner knowledge, a closeness to
natural resources. And it is this knowledge which gives reality to the images they have cre-
ated. . . . I have thrown myself into the very elements that produced me, using the earth as
my canvas and my soul as my tools" (Clearwater, *Ana Mendieta*, 41). See also Miwon Kwon's
interesting discussion of Mendieta's "process of self-othering . . . [and] self-primitivizing"
in "Bloody Valentine: Afterimages by Ana Mendieta," *Inside the Visible/An Elliptical Traverse of
20th Century Art/In, of, and from the Feminine*, ed. M. Catherine de Zegher (Cambridge, Mass.,
and London: MIT Press; Boston: Institute of Contemporary Art; and Kortrijk, Flanders:
Kanaal Art Foundation, 1996), 167–68.

22. Jacob, *Ana Mendieta: The "Silueta" Series*, 5.

23. On Kelly's use of Charcot's images, see Marcia Tucker, "Picture This: An Introduc-
tion to Interim," *Interim*, 19.

24. All of this is not by any means to level the obvious differences between the two
projects. Indeed, Kelly has spoken of *Interim* as, like *Post-Partum Document*, "problema-
tiz[ing] . . . the image of the woman not to promote a new form of iconoclasm, but to make
the spectator turn from looking to listening. I wanted to give a voice to the woman, to rep-
resent her as the subject of the gaze. . . . *Interim* proposes not one body but many bodies,
shaped within a lot of different discourses. . . . [T]he installation should be an event where

the viewer gathers a kind of corporeal presence from the rhythm or repetition of images." Kelly proposes, then, to represent "many bodies" particularized through many different discourses and argues that her work, indeed, is deeply invested in exploring the body. At the same time, however, she is clear about her attempt to avoid the spectator's *engagement* in the bodies she "represents" synecdochically, through clothing: "[W]riting for me is . . . a means of invoking the texture of speaking, listening, touching . . . a way of visualizing, not valorizing, what is assumed to be outside of seeing. This is done *in order to distance the spectator from the anxious proximity of her body*—ultimately, the mother's body—the body too close to see" (emphasis added); Kelly, in "That Obscure Subject of Desire," an interview by Hal Foster, in *Interim*, 54–55. This anxiety about ensuring the distance between the representation and the spectator (and perhaps the author/artist as well) is what concerns me here, and is what marks the radical difference between Mendieta's project and Kelly's as these works have been critically framed.

Norman Bryson's claim that "*Interim* is a work about identification" (in "Interim and Identification," *Interim*, 27), also complicates the reading of the piece. I am arguing that all works *entail* identifications, but it is certainly true that Kelly's work insistently attempts to direct the way in which these identifications take place. This, if anything, is the most striking difference between *Interim* and 1970s body-oriented work such as Mendieta's—while the latter works through a kind of intersubjective seduction that allows for open-ended possibilities of highly charged and loaded identifications, Kelly's work is perhaps paradigmatic of the impulse in 1980s practice to *direct* specific readings and identifications. Kelly is certainly just as (if not much more) aware of the possibilities of intersubjective engagement and, apparently, uses such awareness to produce the specific (Brechtian) effects she desires. The viewer/reader identifies with the "women" produced in these images/texts yet may feel curiously (but predictably) distanced from them in their rather clinical and didactic mode of address. It is interesting to imagine how the photographs of clothing alone, without the layers of directive textual and contextual materials (from the labels within the images as they appear in the piece to the text panels to the other components of *Interim* to the institutional settings in which it appears to the spoken and written commentary about it), would mean differently and perhaps engage us *too* closely from Kelly's point of view.

25. See the various essays in Jones, ed., *Sexual Politics*.

26. Again, I am speaking of *dominant* discourses, which came almost entirely from New York and the academic centers of England and, even then, I am necessarily being highly reductive in order to trace very broad patterns as I perceive them. An alternative discourse did develop during the 1980s—one that insistently referenced identity politics as a central concern. See Lucy Lippard, *Mixed Blessings: New Art in a Multicultural America* (New York: Pantheon, 1990).

27. Owens, "The Allegorical Impulse: Toward a Theory of Postmodernism," parts 1 and 2 (*October* 1980), reprinted in *Beyond Recognition: Representation, Power, and Culture*, ed. Scott Bryson, et al. (Berkeley and Los Angeles: University of California Press, 1992), 52–87; Benjamin Buchloh, "Allegorical Procedures: Appropriation and Montage in Contemporary Art," *Artforum* 21 (September 1982), 43–56.

28. As is common in dominant discourses of postmodernism in the 1980s, Buchloh's numerous essays on postmodernism, which are heavily indebted to Peter Bürger's concep-

tion of institutional critique from *Theory of the Avant-Garde* (1974; tr. Michael Shaw [Minneapolis: University of Minnesota Press, 1984]), posit postmodernism within avant-gardist terms. See also the writings of Hal Foster, another "Octoberist," including *Recodings: Art, Spectacle, Cultural Politics* (Seattle: Bay Press, 1985). While I single out the "Octoberists" here, it is more because of the vast influence and importance their work has had than because they are more egregiously modernist than the innumerable other codifiers of postmodern art in *Artforum* or other art magazines and journals.

29. On the essentialism of antiessentialist feminist criticism, see Andrea Partington, "Feminist Art and Avant-Gardism," in *Visibly Female: Feminism and Art Today*, ed. Hilary Robinson (New York: Universe, 1988), 228–49, and my essay "Feminist Heresies: 'Cunt Art' and the Female Body in Representation," in *Herejías: Crítica de los mecanismos*, ed. Jorge Luis Marzo (Canary Islands: Centro Atlántico de arte moderno, 1995), 583–644.

30. Craig Owens, "The Discourse of Others: Feminists and Postmodernism" (1983), in *Beyond Recognition*, 170; emphasis added.

31. The equivocality of my approach might be summed up philosophically by Martin Heidegger's observation that "[n]earness cannot be encountered directly," in "The Thing," in *Poetry Language Thought*, tr. Albert Hofstadter (New York: Harper & Row, 1971), 166.

32. On the left's disdainful view of pleasure and its alignment with capitalism, see Frankfurt School texts such as Theodor Adorno and Max Horkheimer, "The Culture Industry: Enlightenment as Mass Deception" (1944) in *Dialectic of Enlightenment* (New York: Herder and Herder, 1972), 120–67. See also Roland Barthes, *The Pleasure of the Text*, tr. Richard Miller (New York: Hill and Wang, 1975), 22; and Pierre Bourdieu, *Distinction: A Social Critique of the Judgement of Taste*, tr. Richard Nice (Cambridge, Mass.: Harvard University Press, 1984). Sally Banes discusses this prohibition in relation to 1960s avant-garde performance, which she sees as having been motivated by the desire to democratize culture and embrace sensual pleasure, which was identified by 1950s intellectuals as linked to popular culture, "consumption, passivity, ease of interpretation, realism, and narrativity" (*Greenwich Village 1963*, 105). And Fredric Jameson, who is not known for his sensitivity to feminist issues, nonetheless makes a strong point in favor of an antipleasurable stance for feminism when he argues that the most powerful statement of the puritanism of the left (as typified in Frankfurt School theories of culture) has been in the feminist movement: "the reintroduction of the 'problem' of pleasure on the Left (thematized by Barthes out of a whole French theoretical culture, most notably marked by Lacanian psychoanalysis) now paves the way for an interesting reversal, and for the kind of radical political argument *against* pleasure of which Laura Mulvey's 'Visual Pleasure and Narrative Cinema' is one of the more influential statements" ("Pleasure: A Political Issue," in *Formations of Pleasure* [London: Routledge and Kegan Paul, 1983], 7).

33. Laurie Anderson, "What Is Body Art?" from "Confessions of a Street Talker" (1975), reprinted in Laurie Anderson, *Stories from the Nerve Bible: A Retrospective 1972–1992* (New York: HarperCollins, 1994), 109; emphasis added.

34. Jed Perl, "The Art Scene: Vile Bodies," *Salmagundi*, n. 101–2 (Winter–Spring 1994): 22. While Perl's analysis of 1960s and 1970s body art is initially compelling in its focus on the works' concern for "strik[ing] a blow at the very idea of the completeness of art" (22), his accusatory dismissal of recent body-oriented practices (including the work of Kiki Smith) is

not convincing. He ends up suggesting that all body-oriented works are sermonizing and analogous to nineteenth-century academic painting, a judgment I interpret as a veil for the usual conservative argument against works that are overtly politicized; see page 26.

35. Sam McBride argues this point at great length in his Ph.D. dissertation, entitled "Performing Laurie Anderson: The Construction of a Persona" (University of California, Riverside, 1997). I am indebted to McBride for sharing this work and numerous references with me.

36. Anderson, "A Note on Documentation: The Orange Dog," *Stories from the Nerve Bible*, 109.

37. Ibid.

38. Ira Licht, *Bodyworks* (Chicago: Museum of Contemporary Art, 1975), n.p.

39. Rosemary Mayer, "Performance and Experience," *Arts Magazine* 47, n. 3 (December 1972–January 1973): 33–36; Cindy Nemser, "Subject-Object Body Art," *Arts Magazine* 46, n. 1 (September–October 1971): 42.

40. Chantal Pontbriand, "The Eye Finds No Fixed Point on Which to Rest," *Modern Drama* 25 (1982); cited by Auslander in *Presence and Resistance*, 44.

41. Catherine Elwes, "Floating Femininity: A Look at Performance Art by Women," *Women's Images of Men*, ed. Sarah Kent and Jacqueline Moreau (London: Writers and Readers Publishing, 1985), 165.

42. Kathy O'Dell, "Toward a Theory of Performance Art," 43–44.

43. Phelan, *Unmarked*, 150–51, 152. In this sense, Kelly's critique of body art implies that it *succeeds* in collapsing subjectivity into the body. I would argue that, although such a collapse was indeed often fantasized about in the texts describing this work at the time (and often by spoken or written statements by body artists), such a fantasy was never fully successful. I am interested in the failure to ensure presence that body art represents.

44. Again, Mendieta's own statements would seem to contradict my poststructuralist reading, but I explicitly engage the *Silueta* pieces otherwise, pulling out their less idealistic implications. Mendieta stated that "by using my self-image in my art, I am confronting the ever-present art and life dichotomy. It is crucial for me to be part of all my works. As a result of my participation, my vision becomes a reality and part of my experiences." Quoted in Nancy Lynn Harris, "The Female Imagery of Mary Beth Edelson and Ana Mendieta," unpublished M.F.A. thesis, Louisiana State University, Baton Rouge, 1978, 55; cited in Jacob, *Ana Mendieta: The "Silueta" Series*, 4.

45. I am indebted to Karen Lang, who suggested this formulation of the body becoming a subject.

46. Jacques Derrida, "That Dangerous Supplement," in *Of Grammatology*, tr. Gayatri Spivak (Baltimore: Johns Hopkins University Press, 1978), 154. Henry Sayre draws on Derridean theory throughout *The Object of Performance*, but in my view compromises Derrida's critique of presence by mobilizing the latter's notion of "undecidability" to assign definitive meanings to performance practices.

47. Derrida, "That Dangerous Supplement," 157.

48. Ibid., 163.

49. Derrida, *Speech and Phenomena: And Other Essays on Husserl's Theory of Signs* (Evanston, Ill.: Northwestern University Press, 1973), 35. This text is a critique of Husserlian phenom-

enology. Elsewhere, Derrida addresses the *performative* itself in similar terms: he argues that
J. L. Austin's theory of the performative in language unwittingly relies on a reductive notion
of intentionality as determining the meaning of the performative; see Derrida, "Signature
Event Context," in *Margins of Philosophy*, tr. Alan Bass (Chicago: University of Chicago Press,
1982), 321–27.

50. Kristine Stiles, "Performance and Its Objects," *Arts Magazine* 65, n. 3 (November
1990): 35; Sayre, *The Object of Performance*, 2.

51. Stiles uses the term "wholly fictive space" in "Performance and Its Objects," 37.

52. Sayre, *The Object of Performance*, 5. Carolee Schneemann recently offered an insight-
ful description of the role of the photograph of the body art event: "My photographs re-
main as source of investigation, quandary, conviction, retrieval and myth." Cited in *Action/
Performance and the Photograph*, curated by Craig Krull (Los Angeles: Turner/Krull Galleries,
1993), n.p.

53. Roland Barthes, "Rhetoric of the Image," *Image-Music-Text*, tr. Stephen Heath
(New York: Hill and Wang, 1977), 44–45. Rosalind Krauss discusses this aspect of Barthes
in "Notes on the Index, Part 2," in *The Originality of the Avant-Garde and Other Modernist Myths*
(Cambridge, Mass., and London: MIT Press, 1985), 217–18.

54. Krauss, "Notes on the Index, Part 1," in *The Originality of the Avant-Garde*, 209.

55. On photography and performance, see also *Photography as Performance: Message through
Object and Picture* (London: Photographer's Gallery, 1986); *Photography & Performance* (Boston:
Photography Resource Center, 1989); and *Action/Performance and the Photograph*. See also Kathy
O'Dell's discussion of the intersection of photography and performance in "Toward a The-
ory of Performance." I depart from O'Dell's conceptualization of the photograph as some-
how offering a kind of tactility that implicitly aligns it with the lost "presence" of the body
in postmodernism; see my discussion of this disagreement in "Dis/Playing the Phallus,"
Art History 17, n. 4 (December 1994): 546–84.

56. René Descartes, *Discourse on Method, Optics, Geometry, and Meteorology*, tr. Paul J.
Olscamp (Indianapolis: Indiana University Press, 1965), 28; cited in Martin Jay, *Downcast
Eyes: The Denigration of Vision in Twentieth-Century French Thought* (Berkeley, Los Angeles, and Lon-
don: University of California Press, 1993), 81.

57. Jay, *Downcast Eyes*, 81.

58. Merleau-Ponty, from *Primacy of Perception*; cited by Nemser, "Subject-Object Body
Art," 38.

59. In fact, Nemser herself hardly sustains the radical critique of Cartesianism that
Merleau-Ponty's text is generally understood to purvey. Her lingering conservatism, noted
earlier as signaled by her interpretation of body art as unifying the subject, brings her closer
to what Vivian Sobchack has termed the "transcendental phenomenology" of Husserl, who
attempts to return consciousness to a transcendent ego. Merleau-Ponty, on the other hand,
articulates an antimetaphysical "existential phenomenology," which understands the con-
sciousness always in relation to its others and the world. Meaning, Merleau-Ponty insists,
can never be exhaustively articulated or signified, and there is no transcendent or meta-
physical repository for the "truth." See Sobchack, *The Address of the Eye: A Phenomenology of Film
Experience* (Princeton, N.J.: Princeton University Press, 1992), especially 35–47.

60. Erving Goffman, *The Presentation of Self in Everyday Life* (Garden City, N.Y.: Double-

day, 1959), 252–53. See also Richard Poirer's *The Performing Self* (New York: Oxford University Press, 1971), a study of contemporary U.S. literature that explores the "self-discovering, self-watching . . . self-pleasuring" of the contemporary subject adjusting to the destabilizing pressures exerted on the self (xiii). Poirer is specifically interested in the narcissistic dimension of the staging of the self in the modern novel (87), a link that will be explored in my discussion of narcissism.

61. Kate Linker discusses Acconci's interest in the work of Merleau-Ponty and Goffman, as well as that of psychologist Kurt Lewin, in *Vito Acconci* (New York: Rizzoli, 1994), 30, 46–47. I note these biographic/bibliographic connections while departing from Linker's untheorized use of these models to explain Acconci's work; I believe it is more useful simply to trace intersections than to assume or assert cause and effect. Maurice Berger briefly mentions Robert Morris's interest in Merleau-Ponty in *Labyrinths: Robert Morris, Minimalism, and the 1960s* (New York: Icon, 1989), 11, 12, 65. It is Rosalind Krauss who has most convincingly elaborated the links between phenomenology and, in particular, minimalism, in *Passages in Modern Sculpture* (Cambridge, Mass., and London: MIT Press, 1977), 239–40, and, especially, in "Richard Serra: A Translation," *The Originality of the Avant-Garde*, 260–74. This latter essay argues that abstract expressionism adopted the existentialist dimension of French phenomenology without its deeper implications in terms of perception and intersubjectivity and that it was only with minimalism that these implications began to be explored fully (of course, I would argue that body art was an even more effective site for this exploration). Krauss is one of the few U.S. art historians, along with Michael Fried, who did not ignore the Merleau-Pontyan axis of 1960s practices, although Krauss had largely turned to Lacan as the predominant theoretical model in her work by the mid 1980s.

Interestingly, the fascination with phenomenology seems to have been largely gender-based. I have interviewed several feminist body artists active during the same period (Schneemann, Wilke, and others) who said they were not directly interested in phenomenology, although they were aware of many of these issues. Schneemann remembered that all of the "guys" were obsessed with Merleau-Ponty and Wittgenstein in the 1960s (interview with the artist, November 1992).

62. From the Cartesian point of view, Elizabeth Grosz has argued, the body is only a "vessel occupied by an animating, willful subjectivity"; the mind lodged within the body-as-vessel is ideologically aligned with the masculine while the contingent, immanent body signifies femininity as lack or otherness. See Grosz's critique in *Volatile Bodies: Toward a Corporeal Feminism* (Bloomington and Indianapolis: Indiana University Press, 1994), 8–10.

63. Merleau-Ponty, *Phenomenology of Perception* (1945), tr. Colin Smith (New York: Humanities Press, 1962), 146, 161.

64. See Alexandre Kojève, "Introduction to the Reading of Hegel," in *Deconstruction in Context: Literature and Philosophy*, ed. Mark C. Taylor (Chicago and London: University of Chicago Press, 1986), 98–120. I am specifically interested here in this French trajectory of phenomenology, informed by Kojève's introduction of Hegel and, of course, by German phenomenology (especially the work of Heidegger). Both Husserl and Heidegger had attacked the Cartesian separation between viewing subject and viewed object that secures the coherence of the self in dominant post-Enlightenment thought (acknowledging the role of human consciousness in constituting meaning and, in Heidegger's case, positing difference

and otherness as the condition of possibility of human existence). For a summary of Husserl's and Heidegger's contributions to phenomenology, see Mark C. Taylor, "Introduction: System . . . Structure . . . Difference . . . Other," in *Deconstruction in Context*, 10–13, 18–21, and Richard Kearney, introduction to *Dialogues with Contemporary Continental Thinkers* (Dover, N.H., and Manchester: Manchester University Press, 1984), 1–14. On the phenomenological critique of the Cartesian subject, see also Carolyn Dean, *The Self and Its Pleasures: Bataille, Lacan, and the History of the Decentered Subject* (Ithaca, N.Y.: Cornell University Press, 1992), and Martin Jay, *Downcast Eyes*, especially the chapter "Sartre, Merleau-Ponty, and the Search for a New Ontology of Sight," 263–328.

65. Phenomenological treatments of film and art have informed this section; see, for example, Eugene F. Kaelin, *Art and Existence: A Phenomenological Aesthetics* (Lewisburg, Pa.: Bucknell University Press, 1970); Sobchack, *The Address of the Eye*; Galen A. Johnson, ed., *The Merleau-Ponty Aesthetics Reader: Philosophy and Painting* (Evanston, Ill.: Northwestern University Press, 1993); and Mikel Dufrenne, *The Phenomenology of Aesthetic Experience* (1953), tr. Edward S. Casey et al. (Evanston, Ill.: Northwestern University Press, 1973). I am grateful to Jeremy Gilbert-Rolfe for alerting me to the Kaelin text and to Joanna Roche for suggesting the Dufrenne book.

66. Merleau-Ponty, *The Structure of Behavior*, tr. Alden L. Fisher (1963), cited in Jay, *Downcast Eyes*, 306. Sartre's *Being and Nothingness* retains a strong Cartesianism, as well as a privileging of vision as inexorably victimizing and, ultimately, a disembodiment of intersubjective relations. See especially Part 3 of *Being and Nothingness* (1943), tr. Hazel Barnes (New York: Washington Square Press, 1956), "Being-for-Others," 301–556. On Sartre's Cartesianism, see also Judith Butler, "Sex and Gender in Simone de Beauvoir's *Second Sex*," *Yale French Studies*, n. 72 (1986), the section on "Sartrean Bodies and Cartesian Ghosts," 37–40; and Merleau-Ponty's critique of Sartre's Hegelian maintenance of oppositional subject/object distinctions (as opposed to his own understanding of the radical reciprocity of self/other relations) in "The Intertwining—The Chiasm," in *Visible and Invisible* (1964), tr. Alphonso Lingis, ed. Claude Lefort (Evanston, Ill.: Northwestern University Press, 1968), 130–55. Judith Butler surfaces this critique by noting that, with this late work, Merleau-Ponty argues for an "ontology of the tactile" to replace Sartre's "social ontology of the look"; see Butler, "Sexual Ideology and Phenomenological Description: A Feminist Critique of Merleau-Ponty's *Phenomenology of Perception*," in *The Thinking Muse: Feminism and Modern French Philosophy*, ed. Jeffner Allen and Iris Marion Young (Bloomington: Indiana University Press, 1989), 97.

67. In this section, I am essentially reading Merleau-Ponty into poststructuralism (with the help of Butler, Irigaray, and Young), especially via his later work. I see the work of Merleau-Ponty (along with that of Lacan, Heidegger, and others) as setting the stage for Derrida's paradigmatically poststructuralist textual deconstruction of presence and the subject as a coherent being. In this regard, it is worth noting that Derrida's critique of phenomenology in *Speech and Phenomena* as still invested in a metaphysics of presence ("the recourse to phenomenological critique is metaphysics itself," 5) applies to an earlier permutation of phenomenology (Husserl) rather than that of Merleau-Ponty. Martin Jay discusses the radicality of Merleau-Ponty's work in this regard, arguing that, "indeed, the very bodily experience of being at once viewer and viewed, toucher and object of the touch, was an ontological prerequisite for that internalization of otherness underlying human inter-

subjectivity. The hoary philosophical problem of other minds was thus poorly posed, because the primary experience of sympathetic understanding was prereflexive and corporeal" (*Downcast Eyes*, 311).

68. In this sense, Merleau-Ponty's formulation is, I would argue, far more interesting and complex than many Lacanian feminist theories of self/other relations, which tend to understand these in terms of a strict opposition (I am thinking here, again, of the many texts in art critical writing that adopted Mulvey's formulation of the male gaze from "Visual Pleasure and Narrative Cinema"). However, I would also argue that this more instrumental understanding of self/other relations does not do justice to the complexity and indeed the phenomenological bases of Lacan's work.

69. Merleau-Ponty argues that there must be "an Eros or a Libido which breathes life into an original world, gives sexual value or meaning to external stimuli and outlines for each subject the use he shall make of his objective body" (*Phenomenology of Perception*, 156).

70. Merleau-Ponty, "The Chiasm—The Intertwining," 134, 135.

71. Ibid., 138.

72. Merleau-Ponty, *Phenomenology of Perception*, 354–55; Sobchack cites this passage and elaborates on it in *The Address of the Eye*, 141.

73. This is Elizabeth Grosz's definition of the flesh in *Volatile Bodies*, 101. I want also to link this concept to Marcel Duchamp's notion of the *hinge* in relation to the incongruence and asymmetry of self/other relations in the *infrathin* dimension; see my discussion of this in *Postmodernism and the En-Gendering of Marcel Duchamp* (Cambridge and New York: Cambridge University Press, 1994), 195–98.

74. Lacan, "The Function and Field of Speech and Language in Psychoanalysis," in *Écrits: A Selection* (1966), tr. Alan Sheridan (New York and London: Norton, 1977), 86. See also Lacan on the phenomenology of the transference in "Of the Subject Who Is Supposed to Know, of the First Dyad, and of the Good" and "From Interpretation to Transference," in *The Four Fundamental Concepts of Psycho-Analysis* (1973), tr. Alan Sheridan, ed. Jacques-Alain Miller (New York and London: Norton, 1981), 230–60.

75. Kojève, "Introduction to the Reading of Hegel," 101; Lacan, "Of the Subject Who Is Supposed to Know," 235.

76. See Lacan's "The Signification of the Phallus" (1958) in *Écrits*, 281. I am sidestepping Lacan's formulation of sexual difference because of its lingering (some have argued pervasive, if ironicized) misogyny.

77. See Butler, "Sexual Ideology and Phenomenological Description," 93–95. Butler points out that Merleau-Ponty uses as an example of the failure of self/other relations the case of Schneider (discussed also by Freud); Schneider's "abnormality," she notes, is illustrated by Merleau-Ponty through the fact that he is not aroused by pictures of nude women. Merleau-Ponty is thus assuming sexual subjectivity to be universal, while, in fact, positing a "relationship of voyeurism and objectification, a nonreciprocal dialectic between men and women" (95). See also Elizabeth Grosz's critique of Merleau-Ponty in *Volatile Bodies*, chapter 4, "Lived Bodies: Phenomenology and the Flesh," 86–111.

78. Luce Irigaray, "The Invisible of the Flesh: A Reading of Merleau-Ponty, *The Visible and the Invisible*, 'The Intertwining—The Chiasm,'" in *An Ethics of Sexual Difference*, tr. Carolyn Burke and Gillian C. Gill (Ithaca, N.Y.: Cornell University Press, 1993), 159.

79. Simone de Beauvoir, *The Second Sex* (1949), tr. and ed. H. M. Parshley (New York: Knopf, 1952). Beauvoir and Sartre were close friends and working colleagues with Merleau-Ponty from the late 1920s onward. Merleau-Ponty edited *Les temps modernes* with the couple, but they broke with him in the early 1950s when Sartre moved increasingly to the left and became involved in politics. Although Merleau-Ponty had been a political mentor to Sartre, in his move toward political activism Sartre became increasingly contemptuous of Merleau-Ponty's decision to keep his politics within his intellectual work; Sartre virtually forced Merleau-Ponty to resign from *Les temps modernes* in 1953. See Ronald Hayward, *Sartre: A Life* (New York: Simon and Schuster, 1987), 309. See also Beauvoir's acerbic "Merleau-Ponty et le Pseudo-Sartrisme," *Privilèges* (Paris: Gallimard, 1955), 201–72, where she accuses Merleau-Ponty of liquidating the Marxist dialectic and of egregiously misreading Sartre by positing a philosophy of the subject ("La philosophie de Sartre n'a jamais été une philosophie du sujet," 205). See also Toril Moi, *Simone de Beauvoir: The Making of an Intellectual Woman* (Oxford and Cambridge, Mass.: Blackwell, 1994), and Dorothy Kaufmann McCall, "Simone de Beauvoir, *The Second Sex*, and Jean-Paul Sartre," *Signs* 5, n. 2 (Winter 1979): 209–23.

80. Beauvoir, *The Second Sex*, xxviii. It is worth noting Beauvoir's anxiety about contingency and immanence, which reflects her own context as Sartre's partner and intellectual supporter.

81. Judith Butler, "Sex and Gender in Simone de Beauvoir's *Second Sex*," *Yale French Studies*, n. 72 (1986): 35–50; see also Margaret A. Simons, "Beauvoir and Sartre: The Philosophical Relationship" in the same issue, 165–79. Butler compares the Cartesianism within Sartre's philosophy to Beauvoir's conception of gender as process, and Simons explores the difference between Sartre's and Beauvoir's theories of otherness. While Sartre refused to account for the unconscious, insisting on a voluntarist account of radical freedom (the cornerstone of existentialism as it is popularly understood), Beauvoir articulated a more subtle theory of subjectivity that accounted for social oppression and the discriminatory apparatus of gender difference.

82. Lacan and Beauvoir knew one another, and Beauvoir apparently telephoned Lacan while she was writing *The Second Sex* to consult him (appropriately enough!) on the issue of alienation; see Moi, *Simone de Beauvoir*, 157.

83. Butler, "Sex and Gender in Simone de Beauvoir's *Second Sex*," 43. Butler argues that one of Beauvoir's most dramatic contributions to a radical engendering of the conception of the decentered subject is her insistence on gender as a process rather than an inherent quality tied to biology. Thus, in Butler's terms, Beauvoir's famous proclamation that "[o]ne is not born, but rather becomes, a woman" implies that becoming a gender "is an impulsive yet mindful process of interpreting a cultural reality laden with sanctions, taboos, and prescriptions" (Beauvoir, *The Second Sex*, 249; cited by Butler, 40). Beauvoir is actually far more ambivalent about this than Butler would have it (there are many lingering biologisms in her book, especially in the section titled "Destiny: The Data of Biology," 1–33); but Butler is correct to focus on this aspect of Beauvoir's work in that its perceived antiessentialism has, indeed, deeply informed subsequent feminist theory. Furthermore, Butler's stressed reading of Beauvoir gives us the conception of gender as *becoming* or as a *performance* of cultural codes, a conception that links up to Butler's later poststructuralist feminist theorization of subjectivity as (gendered) performance in *Gender Trouble: Feminism and the Subversion of Identity* (New York and London: Routledge, 1990) and *Bodies That Matter: On the Discursive Limits of*

"Sex" (New York and London: Routledge, 1993). Butler's reading of Beauvoir thus returns us definitively to body art and its relationship to the performative and particularized subjects of postmodernism.

84. Luce Irigaray, *Speculum of the Other Woman* (1974), tr. Gillian C. Gill (Ithaca, N.Y.: Cornell University Press, 1985). Legend has it that Irigaray, who was a student in Lacan's "École freudienne," was kicked out for writing *Speculum* (originally her dissertation), which does not address Lacan's work directly but deeply challenges its premises via a lengthy critique of Freudian theory.

85. Dean, *The Self and Its Pleasures,* 51. While Dean argues, problematically in my view, that the decentered subject *came to be* in the postmodern era (rather than that it *came to be recognized or acknowledged*), she provides a very useful intellectual history of this conception of split and incoherent subjectivity that I am arguing to be central to postmodernism and evident in body art. She also asks, usefully, why such a profound shift in (the conception of) subjectivity occurred largely in French philosophy.

86. The anxiety about conformity was expressed in books such as Sloan Wilson's *The Man in the Gray Flannel Suit* (1955) and William H. Whyte Jr.'s *The Organization Man* (1956).

87. Barbara Ehrenreich, "Early Rebels: The Gray Flannel Dissidents," in *The Hearts of Men: American Dreams and the Flight from Commitment* (New York: Anchor, 1983), 32, 33; David Riesman wrote his book in collaboration with Reuel Denney and Nathan Glazer (*The Lonely Crowd: A Study of the Changing American Character* [New Haven, Conn.: Yale University Press, 1950]). I discuss the issue of conformity and the crisis of masculinity at greater length in chapter 2.

88. Merleau-Ponty, "The Chiasm—The Intertwining," 139.

89. Lacan, "The Mirror Stage as Formative of the Function of the I as Revealed in the Psychoanalytic Experience," *Écrits,* 2.

90. Riesman carefully stages his sociological study as nonbiased in this regard, stating in his preface that the reader is not to privilege the term "inner-directed" even though it *"sounds* like a more autonomous and therefore better type than 'other-directed'" (*The Lonely Crowd,* vi). However, the tenor of the study as a whole and, especially, its consonance with the burgeoning number of contemporaneous texts bemoaning this shift, suggests that indeed the "other-directed" was viewed as extremely negative. Again, I explore this negativity further in chapter 2.

91. It is this goal—which often, in art discourse, related to the assumption that the feminist artist could and indeed should transparently or holistically present her presumably full "female experience" through a (deeply idealized) female body—that is the target of many of the charges of "essentialism" by later feminist voices such as Kelly's.

92. Vergine, *Il corpo come linguaggio,* 33, 35. I have taken the liberty of correcting the numerous typographical errors throughout this passage. See also Rosalind Krauss's discussion of narcissism and Lacan's mirror stage in relation to Acconci's work in "Notes on the Index, Part 1," 196–97.

93. Licht, *Bodyworks,* n.p.

94. As Jed Perl has stated, "Body art came in many guises: it could be a celebration of machismo or of feminist consciousness, it could be in the form of unique performances held in public spaces or photographs and videos of performances done in private" ("The Art

Scene: Vile Bodies," 20). I am grateful to Françoise Forster-Hahn, who stressed to me that male body art projects (especially those involving violence toward or objectification of women's bodies) may be viewed as a reaction formation *against* feminism rather than its parallel.

95. Women of color had more of a stake in keeping their bodies veiled and in attempting to adopt preexisting models of artistic genius under the assumption that these might give them momentary privilege as acting subjects in a culture that had never allowed them any access to creativity. See Lorraine O'Grady's excellent essay, "Olympia's Maid: Reclaiming Black Female Subjectivity," in *New Feminist Criticism: Art, Identity, Action,* ed. Joanna Frueh, Cassandra Langer, and Arlene Raven (New York: HarperCollins, 1994), 152–70.

96. In my essay "Dis/Playing the Phallus" I explore this ambivalence among male body artists at length.

97. This discussion of the vicissitudes of narcissism in contemporary culture is indebted to Bryan Turner's book *The Body and Society.* On narcissism as a "disturbance," see Michael Cohen's exhibition catalog *Narcissistic Disturbance* (Los Angeles: Otis College of Art and Design, 1995). Cohen reads narcissism in terms of a turning inward (accepting the conventional definition) but extends this to argue that it thus dissolves the oedipally induced lack assigned to subjects through external cultural phenomena. My understanding of narcissism views it as projecting the subject both outward and inward.

98. Gilles Deleuze and Félix Guattari, *Anti-Oedipus: Capitalism and Schizophrenia* (1972), tr. Robert Hurley, Mark Seem, and Helen R. Lane (Minneapolis: University of Minnesota Press, 1981); see Eugene Holland's excellent comparison of progressive (Deleuze and Guattari) and reactionary (Lasch) conceptions of this decoding or decentering phenomenon in "Schizoanalysis: The Postmodern Contextualization of Psychoanalysis," *Marxism and the Interpretation of Culture* (Chicago: University of Chicago Press, 1988), 405–16.

99. Christopher Lasch, *The Culture of Narcissism: American Life in an Age of Diminishing Expectations* (New York: Norton, 1979), 158. Later, citing the Living Theater of the late 1960s as an example, Lasch specifically attacks art practices that attempt to close the gap between audience and actor/artist, arguing that this "does not make the spectator into a communicant; it merely provides him . . . with a chance to admire himself in the new role of pseudo-performer" (162). Furthermore, Lasch cites Andy Warhol as an egregious example of the projection of the self as a performance, arguing that "to the performing self, the only reality is the identity he can construct out of materials furnished by advertising and mass culture, themes of popular film and fiction, and fragments born from a vast range of cultural traditions" (166, 170). The latter (mass culture, popular film, cultures other than the norm, etc.) are posed as analogous and assumed to be debased.

100. Audre Lorde, "Age, Race, Class, and Sex: Women Redefining Difference" (1984), reprinted in *Out There: Marginalization and Contemporary Cultures,* ed. Russell Ferguson et al. (New York: New Museum of Contemporary Art; and Cambridge, Mass., and London: MIT Press, 1990), 282. Predictably, as always with nostalgic theories of cultural change, the degraded narcissism of the contemporary subject and the replacement of "real" paternal power with the bureaucratic rationalism of the state (typified for Lasch by Roosevelt's New Deal) are blamed on bad mothering. For Lasch, it is the shallowness and unpredictability of the contemporary mother (herself labeled as narcissistic) that begets narcissistic children; he admits that the fathers are absent from this scenario, but, rather than having the father join in the responsibility

for what Lasch perceives to be a deplorable decay of culture, he blames the mother entirely; see especially 293–99. In the 1990s, it has become all too clear where such rhetoric leads us, with the currency of right-wing rhetoric about "family values" (which almost always focuses on the welfare mother or the unwed mother rather than on the absent father).

101. For Lacan, the self is necessarily constituted narcissistically, in relation to its own image; see "The Mirror Stage."

102. Krauss, "Notes on the Index, Part 1," 197. Krauss defines identity as "self-definition." I would amend her formulation to indicate that identity is not only "self-definition" but is intersubjectively constituted in relation to this "someone else."

103. Judith Butler writes, "The specular image of the body itself is in some sense the image of the Other" (*Bodies That Matter*, 76). This revision of Freudian narcissism also aligns with the work of Melanie Klein and, to a certain extent, with that of Heinz Kohut, whose work I cite in chapter 4. As Michael Cohen has argued, "For Klein, projected aggressive impulses [of narcissistic type] are neither contained within the subject nor clearly outside in the other. At a certain level of intensity, this lack of cohesiveness is experienced as falling apart." See Cohen, "Narcissistic Disturbance," *Narcissistic Disturbance*, 12.

The misrecognition of the subject (where, in Lacan's words, the "body in pieces finds its unity in the image of the Other, which is in its own anticipated image—a dual situation in which a polar, but non-symmetrical relation, is sketched out") situates the embodied self (or ego) as, in Butler's terms, "a permanently unstable site where that spatialized distinction [between interior and exterior of the subject] is perpetually negotiated; it is this ambiguity that marks the ego as *imago*, that is, as an identificatory relation" (Lacan, cited by Butler, and Butler in *Bodies That Matter*, 75, 76).

104. Butler, *Bodies That Matter*, 2–4.

105. Ibid., 10.

106. See Griselda Pollock, "Screening the Seventies." Turner examines this collapse in *The Body and Society*, 18. Against the dominant 1980s Anglo-U.S. trajectory of Brechtian feminism, Luce Irigaray and other French feminists have proposed proximity as a radical reconfiguring of oppositional patriarchal structures of self/other. See Irigaray, *Ethics of Sexual Difference*, and Butler's discussion of this in *Bodies That Matter*, 46.

107. As with any popularization of Freud, this notion of narcissism is focused on one small aspect of Freud's actual discussion, particularly his early formulation in "On Narcissism" (1914); see J. Laplanche and J.-B. Pontalis's discussion of Freud's analysis of narcissism in their book *The Language of Psychoanalysis*, tr. Donald Nicholson Smith (New York: Norton, 1973), 255–57.

108. See my essay "Interpreting Feminist Bodies: The Unframeability of Desire," in *The Rhetoric of the Frame: Essays Towards a Critical Theory of the Frame in Art*, ed. Paul Duro (Cambridge and New York: Cambridge University Press, 1996).

2. THE "POLLOCKIAN PERFORMATIVE" AND THE REVISION OF THE MODERNIST SUBJECT

1. Robert Goodnough, "Pollock Paints a Picture," *Art News* 50, n. 3 (May 1951): 38–41, 60–61; quotes from 38–39. The article also includes a reproduction of a finished painting and an image of Pollock's studio on Long Island by Rudolph Burckhardt.

2. In her essay "Reading Photographs as Text," Rosalind Krauss incorrectly states that none of the other essays in the series shows the artist "*in flagrante*" (in the act of creating the work). On the other hand, her suggestion that the essays were generally "organized around the more conventional view that 'painting' a picture was in fact a minor aspect of 'creating' a picture" is compelling (Krauss, "Reading Photographs," in *Pollock Painting*, photographs by Hans Namuth, ed. Barbara Rose [New York: Agrinde, 1978], n.p.).

Examples of essays in the series that show the artist at work include Nathaniel Pousette-Dart, "[Paul] Mommer Paints a Picture," *Art News* 50, n. 1 (March 1951), 36–38, 66; Dorothy Seckler, "[Honoré] Sharrer Paints a Picture," *Art News* 50, n. 2 (April 1951), 40–43, 66–67; Elaine de Kooning, "David Smith Makes a Sculpture," *Art News* 50, n. 5 (September 1951), 38–40, 50–51. Each essay title includes the name of the artist in her or his own handwriting; there are a surprising number of women represented, considering the time. It is perhaps precisely such nostalgic, glorifying types of representation of the artist that artists in the late 1950s and following were reacting strongly against in their explosively theatrical, ironic, and otherwise parodic self-representations.

3. The word *disseminated*, with its masculinist root, is particularly appropriate in this case. The photographs were first reproduced in *Portfolio* in 1951 then, later that same year, in the Goodnough article in *Art News*; see Barbara Rose, "Jackson Pollock: The Artist as Cultural Hero," *Pollock Painting*, n.p.

4. The film was also shown that same year at an art film festival in Woodstock, New York. Namuth has written of his desire to make a film of Pollock: "To make a film was the next logical step [after the photographs]. Pollock's method of painting suggested a moving picture—the dance around the canvas, the continuous movement, the drama." Paul Falkenberg helped edit the film. See Namuth, "Photographing Jackson Pollock," in *Pollock Painting*, n.p. On Namuth's film, see also Caroline Jones's "Filming the Artist/Suturing the Spectator," in *Machine in the Studio: Constructing the Postwar American Artist* (Chicago and London: University of Chicago Press, 1996), 60–113.

5. Harold Rosenberg, "The American Action Painters," *Art News* 51, n. 8 (December 1952): 22–23, 48–50; although Rosenberg does not name Pollock, it is clear that his descriptions make reference to Pollock's mode of production. Greenberg points out that, by the mid 1950s, several British art historians had published articles referencing Rosenberg's piece; see his "How Art Writing Earns Its Bad Name," *Encounter* (December 1962), reprinted in *Clement Greenberg: The Collected Essays and Criticism: Modernism with a Vengeance, 1957–1969*, vol. 4, ed. John O'Brian (Chicago: University of Chicago Press, 1993), 139. I explore later other artists who responded to Pollock's work abroad. Barbara Rose argues that Rosenberg's essay had a massive impact on "an entire generation of American painters and sculptors, persuading many to forsake the two-dimensional surface of the canvas to enter the 'arena' of real time, real space, and literal materials," in "Namuth's Photographs and the Pollock Myth," n.d.

6. Barbara Rose, "Namuth's Photographs and the Pollock Myth," n.p. Rose also notes how powerful Rosenberg's (Namuth-inspired) reading of Pollock as "action hero" was to younger artists such as Claes Oldenburg.

7. Mikel Dufrenne, *The Phenomenology of Aesthetic Experience* (1953), tr. Edward S. Casey et al. (Evanston, Ill.: Northwestern University Press, 1973), 30.

8. It is suggestive in this regard, in terms of the explosion of body art between the

late 1960s and the mid 1970s, that a retrospective of Pollock's work at the Museum of Modern Art in New York in 1967 included huge blowups of Namuth's photographs of the artist (see Barbara Rose, "Namuth's Photographs and the Pollock Myth," n.p.). This renewed production of the Pollockian performative on this scale and in such a central bastion of modernism might be seen as signaling an investment in the performative body of the artist (one also addressed, but far more indirectly, in the key texts about minimalism, a number of which came out around the same time; for example, Michael Fried's "Art and Objecthood" appeared in *Artforum* in June of that year, reprinted in Gregory Battcock, ed., *Minimal Art: A Critical Anthology* [New York: Dutton, 1968], 116–47).

9. Allan Kaprow, "The Legacy of Jackson Pollock," *Art News* 57, n. 6 (October 1958): 24. With clearly avant-gardist rhetoric, Kaprow speaks for a younger generation of artists inspired by the awesome personality that informed readings of Pollock's works: "He was . . . the embodiment of our ambition for absolute liberation and a secretly cherished wish to overturn old tables of crockery and flat champagne. We saw in his example the possibility of an astonishing freshness, a sort of ecstatic blindness" (24).

10. Ibid., 24, 26.

11. Ibid., 26.

12. This is Vivian Sobchack's Merleau-Pontyan formulation from her fascinating study of the phenomenology of film, *The Address of the Eye: A Phenomenology of Film Experience* (Princeton, N.J.: Princeton University Press, 1992), 103. "My body as a visible thing," Merleau-Ponty wrote, "is contained within the full spectacle. But my seeing body subtends this visible body and all the visibles with it. There is reciprocal insertion and intertwining of one in the other" ("The Intertwining—The Chiasm," *The Visible and the Invisible* [1964], tr. Alphonso Lingis [Evanston, Ill.: Northwestern University Press, 1968], 138).

13. I draw the notion of "author function" and these descriptive phrases from Michel Foucault's "What is an Author?" in *Language, Counter-Memory, Practice: Selected Essays and Interviews*, ed. Donald Bouchard (Ithaca, N.Y.: Cornell University Press, 1977), 124, 130. My thoughts on Pollock as an author function were greatly enriched by contact with Damon Willick's work on Pollock, ultimately brought together in "Jackson Pollock as a Critical Construction: The Author-Function Pollock," M.A. thesis, University of California, Riverside, 1996.

14. Martin Heidegger, "Building, Dwelling, Thinking," *Poetry Language Thought*, tr. Albert Hofstader (New York: Harper & Row, 1971), 157.

15. Simone de Beauvoir, *The Second Sex* (1949), tr. H. M. Parshley (New York: Knopf, 1952), 33.

16. Maurice Blanchot, *The Writing of Disaster* (Lincoln: University of Nebraska Press, 1986), 45; cited by Elizabeth Grosz in "Notes Towards a Corporeal Feminism," *Australian Feminist Studies* 5 (Summer 1987): 1.

17. From "Jackson Pollock: An Interview with Lee Krasner," *Arts*, April 1967, 38; cited by Andrew Perchuk in "Pollock and Postwar Masculinity," *The Masculine Masquerade: Masculinity and Representation*, ed. Andrew Perchuk and Helaine Posner (Cambridge, Mass.: MIT List Visual Arts Center; and Cambridge, Mass., and London: MIT Press, 1995), 38.

18. My book *Postmodernism and the En-Gendering of Marcel Duchamp* (New York and Cam-

bridge: Cambridge University Press, 1994) deals extensively with the problematic of posing one artist as origin for postmodernism (in this case, obviously, Duchamp).

19. This notion of two modernisms, one generally identified with dada and surrealism (especially Marcel Duchamp) and reemerging with U.S. postmodernism, the other with Picasso and then Pollock, subtends most histories of twentieth-century art. See, for example, Hal Foster's description of minimalism as identified with the radical "Duchampian" strain of modernism, "The Crux of Minimalism," in *Individuals: A Selected History of Contemporary Art, 1945–1986* (Los Angeles: Museum of Contemporary Art; and New York: Abbeville, 1986), 162–83. Notably, while the standard historical narrative positions John Cage and his followers in diametric opposition to Pollock and the abstract expressionists (the former usually aligned with postmodernism, the latter with romantic modernism), there were many interconnections among these two, hardly discrete, groups. Willem de Kooning and Franz Kline, Pollock's abstract expressionist colleagues, taught at Black Mountain College with Cage in the summers of 1948 and 1952, respectively, and Greenberg, Pollock's most influential supporter, taught there in the summer of 1950. Furthermore, as Black Mountain historian Mary Emma Harris has pointed out, Black Mountain students and faculty frequently traveled to New York City, where they often hung out with the abstract expressionists and the Beat poets at the Cedar Tavern (Mary Emma Harris, *The Arts at Black Mountain College* [Cambridge, Mass., and London: MIT Press, 1988], 183). Also, as Calvin Tomkins points out, the abstract expressionists had a great deal of admiration for Cage, attending his concerts and inviting him to lecture; however, Tomkins stresses, "Cage's denial of the artist's central control," a denial I would attribute to his opening out of the art process through performativity, "was a heresy that seemed to most of [the abstract expressionists] simply negative or quixotic" (Tomkins, *Off the Wall: Robert Rauschenberg and the Art World of Our Time* [Harmondsworth, Middlesex: Penguin, 1980], 69–70).

20. RoseLee Goldberg, *Performance Art: From Futurism to the Present*, rev. ed. (New York: Abrams, 1988).

21. See Robin Brentano in *Outside the Frame: Performance and the Object, A Survey History of Performance Art in the USA since 1950* (Cleveland: Cleveland Center for Contemporary Art, 1994), and Andreas Huyssen, "Back to the Future: Fluxus in Context," *In the Spirit of Fluxus* (Minneapolis: Walker Art Center, 1993), 140–51.

Such a teleological model of influence and cultural progression, itself modernist, is typified by Greenberg's attempt, in "'American-Type' Painting," to situate Pollock and his colleagues not as a radical break from European modernism (as Rosenberg had done in "American Action Painters"), but as its continuation; he makes this argument through a series of formalist claims in this essay, which was written as a response to Rosenberg ("'American-Type' Painting" [1955, rev. 1958], *Art and Culture: Critical Essays* [Boston: Beacon, 1961], 208–29). In "Art Chronicle: Jackson Pollock," Greenberg explicitly positions Pollock in a modernist lineage as the rightful heir to the geniuses of French modernism: "Pollock has gone through the influences of Miró, Picasso, Mexican painting, and what not, and has come out on the other side at the age of thirty-one" (*The Nation* [1943], reprinted in David Shapiro and Cecile Shapiro, *Abstract Expressionism: A Critical Record* [New York and Cambridge: Cambridge University Press, 1990], 363). Caroline Jones's work on Greenberg has been invaluable to me in addressing his positioning of Pollock and abstract expressionism; see, for

NOTES TO CHAPTER 2

example, "La politique de Greenberg et le discours postmoderniste," *Les cahiers du Musée national d'art moderne* 45/46 (Autumn/Winter 1993): 105–37.

22. Sally Banes, *Greenwich Village 1963: Avant-Garde Performance and the Effervescent Body* (Durham, N.C.: Duke University Press, 1993); see also Saundra Goldman's informative review of Banes's book in *The Drama Review* 39, n. 4 (Winter 1995): 197–99. Thomas Crow has recently published an excellent, if brief, history of the intertwined histories of the Happenings, Fluxus, and Judson groups in "Vision and Performance," chapter 4 of *The Rise of the Sixties: American and European Art in the Era of Dissent* (New York: Abrams, 1996), 105–33. Like Banes, Crow notes the interrelationship between the resurgence of performance and body-oriented work and political activism. I discuss this interrelationship further in chapter 5. See also the important historical texts in *Happenings and Other Acts*, ed. Mariellen Sandford (New York and London: Routledge, 1995); Kaprow's *Essays on the Blurring of Art and Life*, ed. Jeff Kelley (Berkeley and Los Angeles: University of California Press, 1993); and Barbara Haskell, *Blam! The Explosion of Pop, Minimalism, and Performance 1958–1964* (New York: Whitney Museum of American Art; and New York and London: Norton, 1984).

23. Banes, *Greenwich Village 1963*, 29. The notion of influence, Michel Foucault has argued, "provides a support . . . for the facts of transmission and communication; which refers to an apparently causal process (but with neither rigorous delimitation or theoretical definition)." The reductive notion of influence—"of too magical a kind [of support] to be very amenable to analysis"—is only bolstered by the division of cultural products into an oeuvre labeled by an author's name as a "secret origin." Foucault, *The Archaeology of Knowledge and the Discourse on Language*, tr. A. M. Sheridan Smith (New York: Pantheon, 1972), 21, 24–25.

24. In particular, Caroline Jones has explored with appropriate subtlety the links as well as divergences between Cage and the abstract expressionists in her essay "Finishing School: John Cage and the Abstract Expressionist Ego," *Critical Inquiry* 19 (Summer 1993): 628–65. Jones emphasizes Cage's work (especially in association with Robert Rauschenberg and Jasper Johns in the 1950s) as primary to the dissolution of the "Abstract Expressionist ego"; Cage opens the work to spectatorial engagement such that "[a]gency slips from the maker to the passerby" (647). This formulation is compatible with my articulation of body art and the performative artistic subject as a radical unveiling of the body of the modernist artist and of the circuits of interpretive desire (circuits that are closed in modernist interpretation). Interestingly, too, Jones argues that the counterpoint to the abstract expressionist ego offered by Cage, Rauschenberg, and Johns takes its power from their negotiation of the artistic subject *as* gay artists; for Cage, Rauschenberg, and Johns, "[s]ecrets become the engine of their art" (652), marking their relationship, as gay men, to a homophobic culture. This links in interesting ways to my discussion of the particularization of the subject in recent body art projects in chapter 5.

25. Michel Foucault, "Nietzsche, Genealogy, History" (1971), tr. Donald F. Bouchard and Sherry Simon, in *Language, Counter-Memory, Practice*, 140, 148.

26. This project, then, takes up Foucault's challenge to the myth of origins, which leads one "inevitably, through the naïvety of chronologies, towards an ever-receding point that is never itself present in any history." This point "is merely its own void," exposing the fact that "all manifest discourse," that is, every cultural product and expression, "is secretly based on an 'already-said.'" I deal with performativity (as "discourse" in the Foucauldian

sense), then, not as a specific strategy or practice with a definitive origin but "in that punctuality in which it appears [as and when it occurs], and in that temporal dispersion that enables it to be repeated, known, forgotten, transformed, utterly erased, and hidden, far from all view, in the dust of books" and, I would add, the misted indexical traces of photographs, videotapes, and films that constitute body art in the art historical sense. Foucault, *Archaeology of Knowledge*, 25.

27. I discuss at some length nineteenth- and early-twentieth-century tropes of artistic portraiture in my essay "'The Clothes Make the Man': The Male Artist as a Performative Function," *Oxford Art Journal* 18, n. 2 (1995): 18–32; some of the following is drawn from this article. While artists had obviously been depicted in the clothing and poses associated with easel painting or sculpture, these poses were almost always static. Nadar's well-known portraits of artists and other bohemians and Man Ray's portraits of artists are exemplary of the nineteenth-century and early-twentieth-century modernist approach to artistic portraiture in photography.

28. On the artist as God or divine heir, see Griselda Pollock and Rozsika Parker, "God's Little Artist," *Old Mistresses: Women, Art and Ideology* (New York: Pantheon, 1981), especially 82, and Donald Preziosi, *Rethinking Art History: Meditations on a Coy Science* (New Haven, Conn.: Yale University Press, 1989).

29. Lacan writes that "the phallus can only play its role as veiled, that is, as in itself the sign of the latency with which everything signifiable is struck as soon as it is raised (*aufgehoben*) to the function of signifier," in "The Meaning of the Phallus" (first given as a lecture in 1958), *Feminine Sexuality: Jacques Lacan and the* école freudienne, tr. Jacqueline Rose, ed. Juliet Mitchell and Jacqueline Rose (New York: Norton, 1985), 82.

30. Rodin's *Balzac* statues, which present the author *as* a phallic rod, could be viewed in these terms as a brilliant response to the usual tendency to veil overt signs of the artist's masculinity through discussions of the work in terms of a rhetoric of genius and divine inspiration. See also Donald Preziosi on the conflation of the artist and his work with the artist *as* a work of art in *Rethinking Art History*, where he notes that art discourse "works to recenter a potentially and dangerously decentered subjecthood. The-man-and-his-work must be thought of as the-man-as-a-work" (26).

31. Rose, "Jackson Pollock: The Artist as Cultural Hero," n. p.

32. Ibid.

33. Clement Greenberg and Ivan Karp, cited by Ellen Landau in *Jackson Pollock* (New York: Abrams, 1989), 11, 16.

34. For example, what Barthes terms the "poetic object" of clothing can be read as a "keyboard of signs" signaling changing conceptions of self and other, masculine and feminine, artist and bourgeois. Barthes, *The Fashion System* (1967), tr. Matthew Ward and Richard Howard (Berkeley and Los Angeles: University of California Press, 1990), 257.

35. Raymond Williams, *The Politics of Modernism: Against the New Conformists* (London: Verso, 1989), 53.

36. Ibid., 55–57. Williams is clear about the excoriation of femininity: the "bourgeois family," which in turn is a "covering phrase" signaling a debased connection to women and children, is anathema to the modernist artist, who generally comes from this very structure and must thus reject it at all costs to mark himself apart from these origins (thus Nietzsche

with his "great resentment and hatred of women") (57). Williams also stresses the continual shifts of these modes of artistic subjectivity across periods and geographical contexts.

37. See John Tagg on the social and political effects of the rise of the portrait industry in the nineteenth century and the first large-scale availability of portraiture to the "masses," in "A Democracy of the Image: Photographic Portraiture and Commodity Production," *The Burden of Representation: Essays on Photographies and Histories* (Amherst: University of Massachusetts Press, 1988), 34–59.

38. Laurie Milner discusses Cézanne's self-conscious sartorial identification with peasants (even though he was a land-owning bourgeois) in "Cézanne's Flute," chapter 4 of "Modernism's Absent Father: Constructions of Cézanne and His Art in Paris, 1886–1901," Ph.D. dissertation, Northwestern University, 1993.

39. Pierre Bourdieu explores this dynamic of class differentiation through taste in his monumental *Distinction: A Social Critique of the Judgement of Taste* (1979), tr. Richard Nice (Cambridge, Mass.: Harvard University Press, 1984).

40. I would insist on differentiating the modernist alienation of commodity culture outlined by Walter Benjamin in his brilliant and poignant essays from the "Arcades Project" from postmodern alienation; to this extent, I am agreeing with the general premises put forth by theorists of the postmodern such as Fredric Jameson and Jean Baudrillard, who situate postmodernism within tropes of simulation, alienation, and the loss of Enlightenment conceptions of authenticity or originality. While Jameson and Baudrillard ignore issues of race and gender, I would stress these as constitutive of the shifts in class relations (and vice versa) in the postmodern era. To this extent, my views are much closer to those of Donna Haraway, who articulates the shift to postmodernism in terms of economic and technological transformations, but only as these are intimately linked to transformations in subjectivity (the increasing cultural visibility and potency of an unfixable "cyborg" subject); see "A Cyborg Manifesto: Science, Technology, and Socialist-Feminism in the Late Twentieth Century," in *Simians, Cyborgs, and Women: The Reinvention of Nature* (New York: Routledge, 1991), 149–81.

41. I am not arguing that the difference between postmodernist and modernist performativity is simply one of the artist's original intentionality (which I believe we can never know and was never fully fixed or articulable in the first place). Rather, I am insisting that the complex way in which the artist *gets performed* (by the artist, by the photographer who takes her or his portrait, by the art critic or historian—both contemporaneously and later, etc.) as a subject shifts from one period to another. Further, my point is that this difference in emphasis in the speaking of the (artistic) subject, indeed, is partly how we discern and define the different cultural moments.

42. Judith Butler, *Bodies That Matter: On the Discursive Limits of "Sex"* (New York and London: Routledge, 1993), 2. Butler's formulation of the performativity of gender/sex constitution underlies my discussion of how identities are articulated and/or contested in body art practices.

43. Winthrop Sargeant, "Dada's Daddy," *Life*, April 28, 1952, 100. See my extended discussion of Duchamp's self-construction and construction through discourse and his relationship to U.S. postmodernism in *Postmodernism and the En-Gendering of Marcel Duchamp*; I discuss the *Life* spread on 64–65. See also Barbara Rose's discussion of Duchamp and Pollock as two poles of artistic subjectivity in "Namuth's Photographs and the Pollock Myth."

44. While Duchamp himself was coy about the gender of this figure, it was and continues to be discussed as a female nude—as a comment on the long tradition of rendering the female nude in Western painting.

45. Lacan also points out that virile display (for example, that of the worker artist) has the effect of feminizing the male subject: "The fact that femininity takes refuge in this mask [the function that dominates identifications of self/other], because of the *Verdrängung* inherent to the phallic mark of desire, has the strange consequence that, in the human being, virile display itself appears as feminine" ("The Meaning of the Phallus," 85).

46. In *Postmodernism and the En-Gendering of Marcel Duchamp*.

47. The homosexual identification of these artists, and the cultural and artistic ramifications of their compromised relationship to conventional modes of artistic subjectivity as quintessentially (heterosexually) masculine, has been, until very recently, largely masked or repressed in art historical research. See Caroline Jones, "Finishing School: John Cage and the Abstract Expressionist Ego"; and Jonathan Katz, "The Art of Code: Jasper Johns and Robert Rauschenberg," in *Significant Others: Creativity and Intimate Partnership*, ed. Whitney Chadwick and Isabelle de Courtivron (London: Thames and Hudson, 1993), 189–207. The point is not to "out" these artists in terms of their personal sexual habits but, rather, to note their homosexualization of the performative tropes of masculine artistic subjectivity.

48. During Warhol's lifetime, his queer sexuality was rarely openly identified as such, and most art historians would still prefer to keep it subtextual. Exceptions are art historians Caroline Jones, Jonathan Katz, and Joe Thomas. Thomas's paper "Pop Art and the Forgotten Codes of Camp" argues, rather too instrumentally perhaps, that the excoriation of Warhol's use of kitsch in modernist criticism throughout the 1960s was a direct reflection of the art world's continuing homophobia; Thomas does not acknowledge the misogynistic dimensions of this anxiety about kitsch, seeing it as singularly "about" homophobia. Unpublished paper delivered at "Memory and Oblivion," 29th International Congress of the History of Art, Amsterdam, 1996.

49. Andy Warhol with Pat Hackett, *Popism: The Warhol Sixties* (New York: Harcourt Brace Jovanovich, 1980), 12–13.

50. See Caroline Jones, "Andy Warhol's 'Factory': The Production Site, Its Context and Its Impact on the Work of Art," *Science in Context* 4, n. 1 (1991): 101–31; and, on Warhol's films, see David James, "Andy Warhol: The Producer as Author," *Allegories of Cinema: American Film in the Sixties* (Princeton, N.J.: Princeton University Press, 1989), 58–84.

51. Emile de Antonio, *Painters Painting*, filmed 1970, completed 1972; transcript published in de Antonio and Mitch Tuchman, *Painters Painting* (New York: Abbeville, 1982), 119.

52. Jules Barbey D'Aurevilly, *Dandyism* (1844), tr. Douglas Ainslie (New York: PAJ Publications, 1988), 64. The *flâneur* is also masculine in his empowerment vis-à-vis the urban arena, as Griselda Pollock argues in "Modernity and the Spaces of Femininity," in *Vision and Difference: Femininity, Feminism, and Histories of Art* (London and New York: Routledge, 1988); see especially 70–75. (Of course I am departing from Pollock's view that the *flâneur* is *only* masculine; I see the *flâneur* as existing in a discursive continuum with the feminized dandy, particularly in Baudelaire's writings.)

53. I discuss Rrose Sélavy at great length in "The Ambivalence of Rrose Sélavy and the (Male) Artist as 'Only the Mother of the Work,'" in *Postmodernism and the En-Gendering of*

Marcel Duchamp, 146–90. Historically speaking, it is notable that the period immediately after World War I, when Duchamp played as Rrose Sélavy, was, like the 1960s, marked by a crisis in gender roles. Dramatically performative figures abounded in the earlier period in France, England, and the United States, including the flamboyantly cross-gendered Baroness von Freytag Loringhoven, doyenne of New York dada and one of the most original artist performers of the modernist and postmodernist eras. I discuss the baroness and the performativity of New York dadaists at greater length in my essay "Eros, That's Life, or the Baroness's Penis," in *Making Mischief: Dada Invades New York*, ed. Beth Venn and Francis Naumann (New York: Whitney Museum of American Art, 1996).

54. Because I was unable to find information on the *Altered Image* photographs at the time, in an earlier discussion of these images I misdated them; see "'The Clothes Make the Man'" 25. The images were shown as a group at the Ronald Feldman Gallery in New York in 1989, and the April 1996 issue of *Interview* includes one on the cover and one facing an article (titled "Andy") by Ingrid Sischy. I am grateful to Marc Nochella of the Ronald Feldman Gallery for helping me track down and date these photographs, which are wonderfully close in spirit to many of Hannah Wilke's posed portrait photographs (also shown by the gallery), which I discuss at length in chapter 4.

55. The image reproduced in *Interview* (112) is one of the few showing Warhol without a wig; the bizarre juxtaposition of his heavily made up face and his trademark shock of white hair is perhaps even more jarring than the images with women's wigs.

56. Sischy, "Andy," 113.

57. Thus, the April 1996 cover of *Interview* borrows the stale language of traditional, modernist conceptions of the artist as genius, proclaiming: "Andy Mania! We remember the real thing, the vision, the genius, the wonderful wigged-outness." As with Duchamp, whose "nonsense and nihilism" are marshaled to support celebration of him as "pioneer," Warhol's "wigged-outness," his continual challenges to any attempt to fix him as definitive artistic origin, are commandeered as examples of his "genius." This is how art criticism and art history continue to function as modernist discourses, always returning that which is determined to be radically "postmodern" (Warhol's swish antagonism to the modernist figure of the artist/genius) to modernist structures of validation (the visionary genius).

58. I discuss this trajectory at greater length in "'The Clothes Make the Man.'"

59. The complex links between a "feminine" and a "homosexual" self-display (and subject-position, for that matter) are explored in Eve Kosofsky Sedgwick's *Epistemology of the Closet* (Los Angeles and Berkeley: University of California Press, 1990). Quentin Crisp, in his introduction to Barbey D'Aurevilly's book, observes astutely that while, in the mid nineteenth century, Barbey D'Aurevilly interpreted the effeminacies of the dandy in terms of female subjectivity and an aristocratic sensibility, "[n]owadays . . . [the dandy] would undoubtedly have been thought to be homosexual" (Barbey D'Aurevilly, *Dandyism*, 10).

60. As on the April 1996 cover of *Interview.*

61. Rosenberg, "The American Action Painters," 22.

62. Ibid., 23.

63. Sartre's insights on alienation have been forgotten in the rush to embrace the more abstruse and subtle articulations of Lacanian theory. Sartre writes: "The Other is the indispensable mediator between myself and me. I am ashamed of myself *as I appear* to the

Other. . . . It is as an object that I appear to the Other" (*Being and Nothingness* [1943], tr. Hazel Barnes [New York: Washington Square Press, 1956], 302). On Sartre, see also the analyses in Mark C. Taylor's introduction to *Deconstruction in Context: Literature and Philosophy* (Chicago and London: University of Chicago Press, 1986), 22–23, and Brian Kearney's introduction to *Dialogues with Contemporary Continental Thinkers* (Dover, N.H., and Manchester: Manchester University Press, 1984), 1–14.

64. Pollock, from *Possibilities I* (Winter 1947–48), reprinted in Shapiro and Shapiro, ed., *Abstract Expressionism*, 356; emphasis added.

65. Rosenberg elsewhere specifically situates Pollock as an "ancestor of Happenings," but argues this on the basis of Pollock's interest in the unconscious not through the performativity of his process (though Rosenberg does write an extended passage describing the way in which Pollock's body enacts his "consciousness" through "pauses, drifts, detours, and tides"). Rosenberg continues: "From these apprehensions of presences and energies in nature Pollock passed into union with them through releasing paint in fluids that directly record his physical movements. In the drip paintings, his striving toward an overwhelming symbol is lessened and breaks down into the rise and fall of rhythms rebounding from the canvas on the floor. He has discovered the harmony of the 'easy give and take' and has condensed it into a style belonging exclusively to him" ("The Mythic Act" [1969], in Shapiro and Shapiro, ed., *Abstract Expressionism*, 377, 379).

66. Ibid.

67. Greenberg taught a course on art criticism based on Kant's *Critique of Aesthetic Judgment* at the experimental Black Mountain College in the summer of 1950. See Harris, *The Arts at Black Mountain College*, 214.

68. Greenberg, "'American-Type' Painting," 208. Greenberg is using "self-purification" in reference to modernist painting's purging of all "conventions not essential to the viability of [its] medium." I am using it, more loosely, to refer back to the issue of subjectivity, since I am arguing that the erasure of subjectivity (the disembodiment of interpreter and artist) is implicit in Greenberg's project. As Rosalind Krauss has pointed out, Greenberg also took issue specifically with Rosenberg's definition of action painting in his essay "How Art Writing Earns Its Bad Name"; see Krauss's "Reading Photographs as Text," n.p.

69. Greenberg, "Review of Exhibitions of the American Abstract Artists, Jacques Lipchitz, and Jackson Pollock" (1946), reprinted in *Clement Greenberg: The Collected Essays and Criticism*, vol. 2, *Arrogant Purpose, 1945–49*, ed. John O'Brian (Chicago: University of Chicago Press, 1986), 75; emphasis added. Elsewhere, he writes of Pollock's competing with John Marin "for recognition as the greatest American painter of the twentieth century" ("Review of Exhibitions of Worden Day, Carl Holty, and Jackson Pollock" [*The Nation*, 1948], reprinted in *Arrogant Purpose*, 203).

70. Greenberg, "The Present Prospects of American Painting and Sculpture" (*Horizon* 1947), reprinted in *Arrogant Purpose*, 166.

71. In "The Meaning of the Phallus" Lacan explicitly states that the phallus cannot be "possessed" but is rather a sign of desire that must pass through the Other: it is not "as such an object. . . . It is even less the organ, penis or clitoris, which it symbolizes. . . . If the phallus is a signifier then it is in the place of the Other that the subject gains access to it. But in that the signifier is only there veiled and as the ratio of the Other's desire, so it is this

desire of the Other as such which the subject has to recognise, meaning, the Other as itself a subject divided by the signifying *Spaltung* [splitting]" (79, 83). At the same time, as numerous feminists have pointed out, Lacan frequently slips back into an essentializing logic that conflates the phallus with the anatomical penis (which, of course, biological males do possess). Thus, he writes: "One might say that this signifier is chosen as what stands out as most easily seized upon in the real of sexual copulation, and also as the most symbolic in the literal . . . sense of the term. . . . One might also say that by virtue of its turgidity, it is the image of the vital flow as it is transmitted in generation" (82). See Jane Gallop's critique of this slippage in "Penis/Phallus: Same Difference," in *Thinking through the Body* (New York: Columbia University Press, 1988), 124–33.

72. Immanuel Kant, *Critique of Judgment* (1790), tr. Werner S. Pluhar (Indianapolis: Hackett, 1986), 45, 46. It should be clear that I am not by any means attempting to give a definitive reading of Kant's theory of aesthetics; rather, I am simply pulling out a few elements of his very complex theory in order to highlight the logic behind Greenberg's formalist critical model. I am very grateful to Karen Lang for her comments on my analysis of the Kantian aesthetic.

73. Ibid., 51.

74. Ibid., 54, 55. As I understand it, Kant's argument is tautological: a judgment that isn't universal would imply particular investments, therefore it can't be a judgment of aesthetic taste; a judgment that involves sensate experience or involves particular investments (needs, desires) by its very nature can't be aesthetic, since the aesthetic judgment must be universal.

75. In his excellent and provocative book *Downcast Eyes: The Denigration of Vision in Twentieth-Century French Thought* (Berkeley, Los Angeles, London: University of California Press, 1993), Martin Jay describes poststructuralist philosophy precisely in terms of the resistance to this Enlightenment focus on disembodied vision.

76. Kant, *Critique of Judgment*, 69.

77. By masculinist I mean to imply not just privileging of male creativity but also, implicitly, privileging of whiteness, heterosexuality, and any specific elevated class designations that accrue to normative conceptions of "masculinity" at any point in Western history.

78. It is precisely this effect that Michael Fried, in the 1960s Greenberg's most dedicated follower, refers to in his attacks on the "theatrical" (performative?) effects of minimalism and later postmodernism. See his essay "Art and Objecthood" (1967); in his comments at a 1987 conference, reprinted in *Discussions in Contemporary Culture*, n. 1, ed. Hal Foster (Seattle: Bay Press, 1987), Fried explicitly links 1970s and 1980s postmodernism to his earlier excoriation of artwork that, through theatricality, draws in rather than distances the body: "Boy, was I right about art moving towards theater! There's a sense in which everything new in art since then has happened in the space between the arts, the space I characterized as theater" (84). I discuss these implications of Fried's theory of minimalism in my essay "Art History/Art Criticism: Performing Meaning," in *Performing the Body/Performing the Text*, ed. Amelia Jones and Andrew Stephenson (forthcoming).

79. Andrew Perchuk uses this term in his useful "Pollock and Postwar Masculinity," 31–42. On one level, then, the immediate rise of the cold war and the beginning of the Korean War could be viewed as responses to the threat of conformity to masculinity (as attempts

to reinforce the sagging myth of the iron-clad, virile soldier male). See Klaus Theweleit's brilliant discussion of how fascism functioned in this way after World War I to hypermasculinize the soldier male (with corollary processes of exclusion, including anti-Semitism, working to ensure the armored contours of this impenetrable masculinity) in *Male Fantasies,* vol. 1, *Women, Floods, Bodies, History,* tr. Stephen Conway, and *Male Fantasies,* vol. 2, *Male Bodies: Psychoanalyzing the White Terror,* tr. Erica Carter and Chris Turner (Minneapolis: University of Minnesota Press, 1987 and 1989).

80. He writes: "The cultured American has now become more knowing than cultivated, glib in a kind of fashionable *koinê* but without eccentricity or the distortions of personal bias, a compendium of what he or (more usually) she reads in certain knowing magazines—anxious to be right, correct *au courant,* rather than wise and happy" (Greenberg, "The Present Prospects," 162, 161).

81. The "outer-directed man" for Riesman "bespeaks a western urban world in which, with growing economic abundance, work has lost its former importance and one's peers educate one in the proper attitudes toward leisure and consumption—indeed, in which politics and work become, in a sense, consumables"; see David Riesman, in collaboration with Reuel Denney and Nathan Glaser, *The Lonely Crowd: A Study of the Changing American Character* (New Haven, Conn.: Yale University Press, 1950), vii. Riesman thus identifies the parameters of what we now call "late capitalism" as constitutive of the dislocated (masculine) subject who thus becomes contingent on his others. From Riesman's particular point of view, this dislocated subject is defined negatively as outer-directed or conformist. He also notes that, while it is generalizable, the outer-directed self "does find itself most at home in America" (20).

82. J. Robert Moskin, "The American Male: Why Do Women Dominate Him?" *Look* 22, n. 3 (February 4, 1958): 76–80, and George B. Leonard Jr., "The American Male: Why Is He Afraid to Be Different?" *Look* 22, n. 4 (February 18, 1958), 95–104. A third installment— "The American Male: Why Does He Work So Hard?"—appeared in the next issue.

83. Moskin, "The American Male: Why Do Women Dominate Him?," 77. To support his "scientific" argument, Moskin cites authorities such as Margaret Mead and, indeed, David Riesman. The most threatening putative role change seems to be women's supposedly newfound appreciation for sex: "Today's American male, if the experts are right, has even lost much of his sexual initiative and control; some authorities believe that his capacity is being lowered. More women are taking control of sex relations"—and their demand for sexual satisfaction is emasculating the American male, who cannot fully provide it because he is "fatigued" with the overwork he must perform to supply his wife with "material possessions" (78).

84. Ibid., 80.

85. Leonard, "The American Male: Why Is He Afraid to Be Different?" 95; this article is cited and discussed by Barbara Ehrenreich in "Early Rebels: The Gray Flannel Dissidents," in *Hearts of Men: American Dreams and the Flight from Commitment* (New York: Anchor/ Doubleday, 1983), 30. Ehrenreich's title, of course, refers to Sloan Wilson's best-selling 1956 novel *The Man in the Gray Flannel Suit,* a detailed exploration of the postwar life of a war hero sapped of his courage and individuality by the corporate group mentality. Barbara Rose has also made a link to the "gray flannel" phenomenon and the anxieties it generated in noting

that Allan Kaprow's essay "The Legacy of Jackson Pollock" "spoke to an entire generation of younger American artists . . . who yearned for revolution and spontaneity in a drab, repressed, gray flannel era" ("Namuth's Photographs and the Pollock Myth," n.p.).

86. Rosenberg, "The Mythic Act," 377; Barr, in *The New American Painting* catalog (New York: Museum of Modern Art, 1959), 5; "Jackson Pollock: An Interview with Lee Krasner," 38. Barr and Pollock are cited by Perchuk in "Pollock and Postwar Masculinity," 40, 38.

87. Luce Irigaray, *Speculum of the Other Woman* (1974), tr. Gillian C. Gill (Ithaca, N.Y.: Cornell University Press, 1985), 137.

88. Namuth's memoir of Pollock is one of the key sources for the melodramatic mythology surrounding Pollock's having fallen off the wagon the day the film was completed and destroying a dinner party by lifting the table full of food and dishes. According to this myth, Namuth's filming of Pollock virtually signaled the end of his drip and pour paintings and the beginning of his long decline (further metaphorized by his return to figural painting in 1951). See Namuth, "Photographing Jackson Pollock," n.p.; see also Rose, "Namuth's Photographs and the Pollock Myth."

89. Perchuk, "Pollock and Postwar Masculinity," 42. I hope to avoid here any suggestion that I see Perchuk's description as yet another explanation for Pollock's histrionic suicide. Rather, I adopt it for its explanatory force in relation to the construction of Pollock in 1950s cultural discourse. No one can know what led Pollock to drink himself to death (probably least of all, were he available, Pollock himself).

90. According to Namuth's description of this event, it seems clear that Pollock would have had the disconcerting experience of seeing Namuth film him from below the glass. Namuth writes, "I finally figured out how to lie on my back with the camera on my chest and photograph him from below" ("Photographing Pollock," n.p.). Rose adds to this: "Placing himself under a sheet of plate glass on which Pollock was painting, Namuth held the camera in a position to record the loops of liquid paint as they fell. The resulting illusion is that the spectator, seeing through the camera eye, feels that the painting is coming out at or literally on him" ("Namuth's Photographs and the Pollock Myth," n.p.).

91. Michael Leja's book *Reframing Abstract Expressionism: Subjectivity and Painting in the 1940s* (New Haven, Conn.: Yale University Press, 1993) explores at length the particular ideological components of the "selfhood" that the artists and critics believed was being "reflected" in the paintings.

92. With "sublate," Irigaray links her discussion to a dynamic Freud called "sublimation"—the process by which sexual instincts are diverted toward nonsexual aims (such as artistic creation) that are socially productive.

93. From the transcript of a taped interview conducted by William Wright in 1950, broadcast in 1951 on station WERI, Westerly, Rhode Island. And Barnett Newman claimed that the self, "terrible and constant, is for me the subject matter of painting and sculpture" (catalog statement for the 1965 São Paulo Bienal). Both cited by Leja in *Reframing Abstract Expressionism*, 37, 38.

94. Leja often seems to buy into the notion that the unconscious can be "represented"; see especially his chapter "Jackson Pollock and the Unconscious," *Reframing Abstract Expressionism*, 121–202. He also emphasizes the influence of Freudian and, especially in Pollock's case, Jungian theory on the artists. The widespread permeation of Freudian ideas into

American postwar culture had encouraged an understanding of the self as alienated from itself (via the unknown unconscious aspect of the self). I would add that this conception of the self is also informed by popular conceptions of existentialism (perhaps primarily through Rosenberg himself), which are, of course, in turn heavily indebted to Freudian ideas.

95. Christopher Knight has argued that "Americans casually regard the arts to be a feminine activity, not a masculine one," in "Effeminism," *Art issues,* n. 38 (Summer 1995): 23. While I find this proposition useful to a limited degree (I agree that there is an anxiety about the feminizing capacity of the arts in this country), I would argue that Knight vastly oversimplifies the situation. Furthermore, I strongly disagree with Knight's egregious and misinformed appropriation of feminism (masculinized for male use as "effeminism") to counter "Victorian sentimentalism and its exclusionary moral standards" and to "revolt against falseness" (25). Knight uses this appropriated feminism to reinforce ideas that end up being coincident with some of the most disturbing aspects of Greenbergian modernism (*viz.* Greenberg's well-known argument against "ersatz" culture and sentimentalism ["vicarious experience and faked sensations"]) in "Avant-Garde and Kitsch" (1939), reprinted in *Art and Culture,* 10.

96. Cited by Rose in "Namuth's Photographs and the Pollock Myth"; Segal's comment is fascinating in its ambivalence as he moves back and forth between the silent, brooding machismo of the Pollock in the picture and the work of art's nonverbal quality that this figure seems to speak. Ellen Landau compares Pollock to Dean and Brando but without any sense of irony in her book *Jackson Pollock;* she argues that Brando—especially in his roles as motorcycle rebel in *The Wild One* (1953) and as Stanley Kowalski in *A Streetcar Named Desire* (1959)—is, like Pollock, a "primitive and passionate . . . atavistic brute whose instantaneously eruptible feelings were more intensely conveyed physically than verbally" (15), linking back to Segal's formulation of Pollock "speaking" the message that art is inexplicable. This Pollock/Brando (who is animal-like, intuitive, primitive) is on one level extremely equivocal in gender (the primitive being aligned, in terms of his *or* her otherness, with femininity); however, Landau, like Greenberg and Rosenberg before her, orchestrates her manuscript around the reinscription of this primitive subjectivity into a kind of heightened, and divinely inspired, masculinity.

97. Gayle Rubin, "Gay Male Leather 1960–1990," paper delivered at UCLA, May 25, 1993. Fionna Barber has written an astute analysis of abstract expressionist clothing as a signifier of a particular, troubled masculine subjectivity in the cold war period: "T-Shirts, Masculinity, and Abstract Expressionism," paper delivered in the "Visualising Masculinities" session at the Association of Art Historians, London, April 1993. Barber argues that the working-class T-shirt entered masculine outerwear fashion after World War II, when it was "incorporated as a signifier of a healthy, normal heterosexuality"; Brando's character from *A Streetcar Named Desire* "could be read as personifying in a particularly virile and macho form the newly remasculinised workforce in heavy industry after World War Two."

98. Richard Shiff, "Performing an Appearance: On the Surface of Abstract Expressionism," *Abstract Expressionism: The Critical Developments* (New York: Abrams; and Buffalo, N.Y.: Albright Knox Art Gallery, 1987), 97–98.

99. Like Shiff, Allan Kaprow differentiates the effects of Pollock's paintings from the iconicity of earlier painting: while "large paintings done in the Renaissance . . . glorified an

everyday world quite familiar to the observer . . . Pollock offers no such familiarity and our everyday world of convention and habit is replaced by that one created by the artist" ("The Legacy of Jackson Pollock," 56).

100. Shiff, "Performing an Appearance," 100.

101. Banes discusses this issue of democratization and the emphasis on the authenticity of the body in *Greenwich Village 1963*; she also points out the rather reactionary dimension of this desire for authenticity that motivated the turn to the body in the 1960s.

102. Allan Kaprow, *Assemblage, Environments, Happenings* (New York: Abrams, 1966), 10; another illustration of Pollock painting, this time a blur of activity, appears on page 142, right across from a photograph of Kaprow himself surrounded by automobile tires. These are, again, Namuth's photographs from 1950. The conflation of the artist with his work was, for Kaprow, a central defining force of the environmental aspect of the Happening, which, he argues, dramatically shifted the conception of an art object away from its being a limited, bounded "picture" to the artwork as a performative process taking place in a lived environment (assemblage works thus bring "sharply into focus the fact that *the room has always been a frame or format too*" [154]). Kaprow's argument is a crucial early moment in the acknowledgment of an expanded conception of artmaking (as well as reception: the audience is to be enveloped in this environment). For Kaprow, it should be stressed, the idea of art as performance or act was a way of playing out the dissolution of boundaries between "art" and "life," with the "customary gallery situation [rendered] obsolete" (155). In this way, the use of the body of the artist in the work as well as the engagement of the spectator as part of the work (in the Happening) can be seen as a way of connecting—via these very bodies— art as process and as narrative with everyday experience.

This bridging of the gap between the embodied artistic subject and embodied and desiring (interested) viewers, with its corollary rejection of picture making and the related formalist critical models from the 1950s, is precisely what Greenberg seems to have feared. Kaprow's potential radicalism is his pushing of the Pollockian performative to its very limits: "If Jackson Pollock spoke of being in his work while he painted . . . it was true in so far as he stood among the pools of paint he had just poured. . . . With a little work a spectator before the finished painting *could feel into* the same state of immersion. But in the case of Environments there is no question that one is inside and, for better or worse, a real part of the whole" (165). Breaking apart the modernist triad, where the artist (inspired by the divine) is linked inexorably to the art critic or historian (who can read directly the "correct" meanings the artist intended through the forms of the work of art, and thus aims to convey these "correctly" to the audience through "neutral," "disinterested" language), Kaprow invites the bodies of the "other" into the process of meaning production: "Besides the initial artist, further turns of the roulette wheel decide exactly who shall execute the work, and when" (177). Temporal, repeated more than once (thus not "unique"), unpredictable, explicitly embodied, merging the audience with the artwork, utilizing only materials *not* "from the arts," the Happening or the "Event" transgresses almost every tenet of Kantian logic.

103. Constantinos Proimakis is writing a dissertation that addresses Klein and Joseph Beuys in relation to continental philosophies addressing the problematic of space (including the writings of Martin Heidegger and Jacques Derrida). I am indebted to Proimakis for sharing his dissertation abstract with me. The dissertation, entitled "Common Places: Tales

of Interrelation between Postwar Art and Philosophy," is being written for the New School of Social Research in New York.

104. According to Thomas McEvilley, Klein's tuxedo was blue ("Yves Klein: Conquistador of the Void," *Yves Klein 1928–1962: A Retrospective*, exhibition catalog [Houston: Institute for the Arts, Rice University, 1982], 60). The audience of approximately one hundred was also requested to wear evening clothing. Klein's reference to the tradition of the female nude also links the performance to the Woman series of Willem de Kooning, and his "Monotone Symphony" certainly seems a reference to John Cage, whose piece *4′33″* (1952) consists of four minutes and thirty-three seconds of silence. On these connections and the hostile reception Klein's work received with its first U.S. showing at Leo Castelli Gallery in 1961, see Crow's interesting account in *The Rise of the Sixties*, 122–23. I discuss Klein's work within a different context in "Dis/Playing the Phallus: Male Artists Perform Their Masculinities," *Art History* 17, n. 4 (December 1994): 552–54, 560–64.

105. Like Duchamp, Klein posed for numerous portrait photographs, which are commonly circulated in relation to his work (including images of him as a Knight of St. Sebastian, a judo master, and a performer of various artworks); see *Yves Klein 1928–1962: A Retrospective* and Sidra Stich, *Yves Klein* (Stuttgart: Cantz Verlag, 1994).

106. This biographical material is drawn primarily from *Yves Klein 1928–1962: A Retrospective* and Stich, "Beginnings," *Yves Klein*, 13–22. It is interesting to conjecture that having parents who were painters seems to have propelled Klein into a double rebellion—against both Pollock and what he stood for and against his parents (perhaps especially his rather successful mother).

107. See Charles Baudelaire, "The Life and Work of Eugène Delacroix" (1863), in *The Painter of Modern Life and Other Essays*, tr. Jonathan Mayne (New York: Da Capo, 1964), especially 28–29.

108. See McEvilley, "Yves Klein: Conquistador of the Void," 46. Sidra Stich argues that, for Klein, Rosicrucianism and judo fulfilled a similar spiritual role (*Yves Klein*, 40).

109. Klein rather melodramatically reiterates a conventional notion of artistic genius in much of his writing. For example, in "The War: A Little Personal Mythology of the Monochrome" (1960), he writes: "A painter is a man who, consciously or not, cuts apart and destroys his own soul, with or without sorrow, or even with joy, to transform the scraps of his soul, through the alchemy of painting, into physical, ephemeral matter or the picture. The painter, like Christ, says the mass when he paints, and gives his own body and soul as nourishment to others." Translated by Thomas McEvilley and reprinted in *Yves Klein 1928–1962: A Retrospective*, 219.

110. In another, private version of this performance held in his studio, Klein himself rubbed paint on a model's body; see *Yves Klein 1928–1962: A Retrospective*, 174–75. I have taken the description of the *Anthropometries of the Blue Period* primarily from Nan Rosenthal's thoroughly documented "Assisted Levitation: The Art of Yves Klein," in ibid., 123–25.

111. And perhaps particularly a French male artist, both privileged as member of a culture long defined as the center of modernist painting and damned by its recent defeat in the face of American modernism.

112. Yves Klein, "Truth Becomes Reality" (1961), tr. Howard Beckman, in *Yves Klein 1928–1962: A Retrospective*, 230.

113. Ibid. Klein repudiated precisely the kind of painting associated with Pollock and the New York School in other statements as well: "I detest artists who empty themselves in their paintings. . . . In place of beauty, goodness, truth, they render, ejaculate, spit out all their horrible, impoverished and infectious complexity in their painting" ("Mon livre," cited by Stich in *Yves Klein*, 68).

114. Klein, "Due to the Fact That" (1961), cited by Rosenthal in "Assisted Levitation," 124.

115. Butler, *Bodies That Matter*, 10.

116. Rachel Lachowicz executed a feminist critique of Klein's *Anthropometries* performances entitled *Red Not Blue* at Shoshana Wayne Gallery, Santa Monica, California, 1992. She rubbed red lipstick over men's naked bodies, then dragged them across large sheets of paper on the floor to reverse the terms of Klein's performances. Lachowicz also tied a lipstick rod to the penis of one of the male models, then held it in front of him to draw a single red line down the length of a roll of paper on the wall (both stood on a scissor lift that descended to make the line).

117. See Rosenthal, "Assisted Levitation," 124 and 135, note 135.

118. This is the common English translation; see Alexandra Munroe's excellent history, "*To Challenge the Mid-Summer Sun:* The Gutai Group," in *Japanese Art after 1945: Scream against the Sky* (Yokohama: Yokohama Museum of Art; and New York: Abrams and the Guggenheim Museum; and San Francisco: San Francisco Museum of Art, 1994), 84. Interestingly, she explains that the word is comprised of two characters: "*gu*, signifying tool or means, and *tai*, signifying body or substance." The word would thus also literally translate as "means for enacting the body." Michel Tapié supplies another suggestive translation that implicates the body directly: "The word signifies something like an action of incarnation or incorporation" (*Groupe Gutai*, gallery pamphlet [Paris: Galerie Stadler, 1965], n. p.; my translation). Yoshihara himself wrote about the name "Gutai" as follows: "We must give matter a purpose for life. In other words, there is a way of thinking that says the only way this can be put into words is to say that the inner workings of the human heart are concretely indicated by matter" (Osaki Shinichiro, "Gutai: Action on Painting," *Giappone all'avantguardia: Il Gruppo Gutai negli anni Cinquanta* [Rome: Galleria nazionale d'arte moderna, 1990], 21, 23).

119. There are discrepancies in dating the founding of Gutai; Yoshihara claims a date of 1951 in *Gutai: Japanische Avantgarde: 1954–1965* (Darmstadt: Ausstellungshallen Mathildenhöhe, 1991), 433. This publication was released in conjunction with the exhibition *Giappone all'avantguardia*.

120. Yoshihara, "Gutai Art Manifesto" (1956), tr. Reiko Tomii, in *Japanese Art after 1945*, 370.

121. This is illustrated in *Japanese Art after 1945*, 93.

122. Yoshihara, "Gutai Art Manifesto," 370; Yoshihara includes Mathieu in this description. According to Munroe, Pollock provided a way of breaking the hold of social realism on the Japanese art scene ("*To Challenge the Mid-Summer Sun*," 87). The inspiration seems to have been reciprocal: Pollock apparently knew of the Gutai group through their *Gutai* magazine (published in Japanese and English), copies of which were found in his studio after his death. See James Roberts, "Painting as Performance," *Art in America* 80, n. 5 (May 1992): 113. I am grateful to Roberts for his research assistance.

123. Munroe, "*To Challenge the Mid-Summer Sun*," 84.

124. Shinichiro, "Gutai. Action on Painting," 19. Shinichiro is critical of the fact that Gutai has been evaluated by Westerners either as an outgrowth of the French *informe* group (including Mathieu) or as a pioneer of Kaprow's Happenings; see page 19. It is Tapié, along with Kaprow (who included the Gutai group in his important early history *Assemblages, Environments, and Happenings*), who defined Gutai in relation to Western body art, serving both to promote it internationally and to erase its specific cultural history within Japanese traditions; see Munroe, "*To Challenge the Mid-Summer Sun*," 94, 97.

125. Shinichiro, "Gutai. Action on Painting," 33. At the same time, he claims priority for Gutai works: "in the 1958 International Art of a New Era, the works of the Gutai group were displayed alongside those of Pollock . . . and Mathieu. . . . But . . . the Gutai group was more purely successful in solving the problems addressed in all these attempts" (37).

126. Both performances are documented in *Japanese Art after 1945*, 120.

127. Jiro Yoshihara, "On the First 'Gutai-ten'," *Gutai* 4, special edition of the First Gutai Exhibition (Shozo Shimamoto, Nishinomiya City, 1956), 2. Furthermore, the relationship of Japan—or Japanese masculinity, for that matter—to U.S. culture and masculinity after World War II would certainly have been extremely highly charged; it is interesting, in fact, that the case of Gutai indicates a relatively amenable, noncompetitive relationship to both French and U.S. culture, even adopting Western conceptions of heroic, individualistic artistic creation (the links to Japanese calligraphy tradition notwithstanding).

128. The heroizing biographies include B. H. Friedman's *Jackson Pollock: Energy Made Visible* (New York: McGraw-Hill, 1972) and Jeffrey Potter's *To a Violent Grave: An Oral Biography of Jackson Pollock* (New York: Putnam, 1985). Damon Willick discusses these books in his "Jackson Pollock as a Critical Construction."

129. See Yamasaki's collage *Mirror* (1956) and Tanaka wearing her *Electric Dress* (1956) in *Japanese Art after 1945*, 94, 121. Kaprow's *Assemblage, Environments, Happenings*, includes work by both artists (221–22).

130. Very little was published on Gutai in the United States until very recently, with the Roberts article and Munroe's essay in the catalog for *Japanese Art after 1945*.

131. As the French example, Mathieu's performances of painting are a reference point here as well (although it is worth noting that Saint Phalle, born of a French father and an American mother, grew up in the United States and returned to Europe only around 1950, as a young adult). Other notable works linked to Saint Phalle's *Tir* pieces are Chris Burden's notorious *Shoot* (1971) and Berlin artist Barbara Heinisch's violent slit paintings from the mid to late 1970s, in which the "model" (who is covered by the canvas, then slices it with a knife and emerges from its rent surface) becomes an active force in the production of the painting. Heinisch wrote in 1977: "Painter and model are each as active as the other—the model is no longer a mere object" ("Notes from My Diary," *Barbara Heinisch: Malerei als Lebendiger Prozess* [Berlin: Künstlerhaus Bethanien, and Sliedrecht, Holland: Van den Dool, 1980], n.p.). On Heinisch, see *Bildnisse: Auf den Leib gemalt 1977–1979* (published by the artist); *Aktion im Fundatie Junsthuis Amsterdam* (September 8, 1979; published by the artist); and *Barbara Heinisch* (Düsseldorf: Galerie Elke und Werner Zimmer, 1981). I am grateful to Moira Roth for pointing out these sources to me. On the Chris Burden piece, see *Chris Burden: A Twenty-Year Survey* (Newport Harbor, Calif.: Newport Harbor Art Museum, 1988), 53.

132. The first *Tir* was produced in an empty lot behind her Paris studio; subsequent *Tir*s were performed in galleries in Paris, Nice, and New York, and at Virginia Dwan's house in Malibu, California. See Phyllis Braff, "Nanas, Guns and Gardens," *Art in America* 80, n. 12 (December 1992): 104–5.

133. *Niki de Saint Phalle* (Paris: Centre Georges Pompidou Musée national d'art moderne, 1980), 15; the photographs I am discussing are illustrated on 14–15. Interestingly, a number of these pieces were executed by U.S. artists such as Robert Rauschenberg and Jasper Johns; see *1960: Les nouveaux réalistes* (Paris: Musée d'art moderne de la ville de Paris, 1986), 84–85, and Susan Hapgood, *Neo-Dada: Redefining Art 1958–62* (New York: American Federation of Arts, 1994), 77–79.

134. David Bourdon, "Fling, Dribble, and Dip," *Life*, February 27, 1970, 62–63.

135. While this may seem to have essentializing implications, it does not necessarily. I am simply claiming that, within the U.S. cultural scene (especially at this highly charged time), Benglis's obvious reiteration of Pollock's poses and gestures would have been viewed as parodic and dislocating (precisely because she retains her social identification as a woman). An overtly gay artist would have a similar effect, as I will suggest in relation to the work of Keith Boadwee.

136. I discuss this image at length in "Postfeminism, Feminist Pleasures, and Embodied Theories of Art," in *New Feminist Criticism: Art, Identity, Action*, ed. Joanna Frueh, Cassandra Langer, and Arlene Raven (New York: HarperCollins, 1994), 33–36.

137. Susan Krane, *Lynda Benglis: Dual Natures* (Atlanta, Ga.: High Museum of Art, 1991), 29. Krane interprets Benglis—via her own statements—as having a much more worshipful, positive attitude toward Pollock and the abstract expressionist tradition than I am suggesting her work implies. The *effects* of her performative photographs of herself pouring, as well as those she used on numerous gallery announcements, are in my view acerbically witty and parodic, and these photographs, along with the poured latex pieces, ironicize the drip painting tradition in specific feminist ways.

138. In her book *The Optical Unconscious*, (Cambridge, Mass., and London: MIT Press, 1993), Rosalind Krauss links the pivoting of the canvas from the horizontal to the vertical register to the issue of what I am identifying here as Pollock's ambivalent, performative masculinity. Linking back to Irigaray's formulation, Krauss argues that Greenberg's recuperative accounts of Pollock "sublimate" him, "raising him up from that dissolute squat, in his James Dean dungarees and black tee-shirt, slouched over his paintings in the disarray of his studio. . . . Clem's [Greenberg's] mission was to lift him above those pictures [the photographs of Pollock painting], just as it was to lift the paintings Pollock made from off the ground where he'd made them, and onto the wall. Because it was only on the wall that they joined themselves to tradition, to culture, to convention . . . that they became 'painting'" (244).

Hannah Wilke's wall-hung pieces, skinlike, labial flaps of latex rubber hanging limply down the wall or in flesh-colored, puckered "flowers" that seem to protrude like vaginal orifices, are an interesting counterpart to Benglis's abject floor "paintings," as are Wilke's ceramic sculptures, folded "cunts" or wounds laid on the floor. See *Hannah Wilke: A Retrospective*, ed. Thomas H. Kochheiser (Columbia: University of Missouri Press, 1989), 114, 116–17.

139. I am grateful to Caroline Jones for this insight vis-à-vis Benglis's piece.

140. In this regard, see also the maintenance artwork of Mierle Ukeles, the housework performances from *Womanhouse*, and Janine Antoni's scrub piece, described later; these are illustrated and discussed in the *Womanhouse* catalog (Valencia: California Institute of the Arts, 1972), in Amelia Jones, ed., *Sexual Politics: Judy Chicago's* Dinner Party *in Feminist Art History* (Los Angeles: UCLA/Armand Hammer Museum of Art; Los Angeles and Berkeley: University of California Press, 1996), and in Norma Broude and Mary D. Garrard, *The Power of Feminist Art: The American Movement of the 1970s, History and Impact* (New York: Abrams, 1994). Benglis worked in close contact with a number of minimalist artists, including Robert Morris and Carl Andre, in the late 1960s and early 1970s. Her piece *For Carl Andre* (1970), a black blob of rubber that resembles a huge pile of excrement, is a witty comment on minimalist pretensions (and another offering to masculine tradition that reads as both homage and critique).

141. As Kristine Stiles has described this performance, Kubota "dipped the brush in red paint [and moved over the paper] to produce an eloquent gestural image that exaggerated female sexual attributes and bodily functions and redefined Action Painting according to the codes of female anatomy." See Stiles, "Between Water and Stone, Fluxus Performance: A Metaphysics of Acts," in *In the Spirit of Fluxus*, organized by Elizabeth Armstrong and Joan Rothfuss (Minneapolis: Walker Art Center, 1993), 82.

142. Janine Antoni's *Loving Care* (1992) took this intersection of Pollockian gesture and female labor to an even more dramatic extreme; the piece is illustrated (and misdated) in Broude and Garrard, ed., *The Power of Feminist Art*, 286. Performing at the Anthony D'Offay Gallery in London, Antoni soaked her hair in dye, then proceeded to mop the floor with it. Subverting the usual outcome of the laborious act of mopping by making the floor dirty rather than clean, Antoni's "painting" becomes this reverse action (which will undoubtedly soon thereafter be mopped up from the pristine gallery floor). The photograph documenting the piece shows her body literally *on the floor*—unlike Pollock's images, in which his body always maintains a modicum of control over the mess of paint, or Klein's images, where he most commonly attempts to keep his body free of paint altogether and forces the female body to make contact with the floor. Antoni enacts the debasement of the immanent, laboring female body both in the domestic and the artistic sphere. Her piece also brings to mind Nam June Paik's *Zen for Head* (1962), in which he dipped his head into a bowl of ink and tomato juice and then dragged it along a long strip of paper; see Elizabeth Armstrong, "Fluxus and the Museum," *In the Spirit of Fluxus*, 14–15.

The 1990s work of Cheryl Donegan, brief performances on video, explicitly references the Pollockian performative as well: in *Head* (1993), Donegan pours milk from a plastic container into her mouth, swallowing it, dribbling it back into the container, then spitting it out to create an "action painting" image against a backdrop; in *MakeDream* (1993), she stands in front of an empty canvas, wearing a paint-filled plastic bottle on a string around her waist, then gripping the bottle between her thighs and squeezing it to produce an "action painting." See the descriptions of these pieces in the Electronic Arts Intermix pamphlet "New Artists, New Tapes, Special Series" (New York, 1995).

143. The relationship of 1990s feminist practice (that is, particularly works being done by young feminists in their thirties and forties) to 1970s feminist practice is complex. By and large, much of the history of 1970s feminist art has completely dropped out of the

art historical picture (especially as taught in art schools), such that many of these younger feminists are reinventing the wheel, as it were, although obviously from a different perspective (often one inflected by the consciousness of race and sexuality as constitutive of the effects of gender). On the forgetting of 1970s feminist art history, see my essay "The 'Sexual Politics' of *The Dinner Party: A Critical Context*," in *Sexual Politics*, 82–118; Lucy Lippard, "Moving Targets/Concentric Circles: Notes from the Radical Whirlwind," *The Pink Glass Swan: Selected Feminist Essays on Art* (New York: New Press, 1995), 3–28; and Mira Schor, "Backlash and Appropriation," in *The Power of Feminist Art*, 248–63.

144. See Caroline Jones, "Finishing School: John Cage and the Abstract Expressionist Ego," and Jonathan Katz, "The Art of Code."

145. Boadwee's works and videos were on view at Ace Gallery, Los Angeles, in 1995.

146. Michael Warner, "Homo-narcissism; or, Heterosexuality," in *Engendering Men: The Question of Male Feminist Criticism*, ed. Joseph Boone and Michael Cadden (New York and London: Routledge, 1990), 202.

147. Both Butler and Sedgwick mobilize the notion of panic in relation to the warding off of homosexuality (in Butler's case, she is speaking specifically of lesbianism); see Butler, *Bodies That Matter*, 51, and Sedgwick, *Epistemology of the Closet*, 19.

148. Butler, *Bodies That Matter*, 48–49; emphasis added.

149. Ibid., 52.

3. THE BODY IN ACTION: VITO ACCONCI AND THE "COHERENT" MALE ARTISTIC SUBJECT

1. Russell Ferguson, "Introduction: Invisible Center," in *Out There: Marginalization and Contemporary Culture*, ed. Russell Ferguson et al. (Cambridge, Mass., and London: MIT Press; and New York: New Museum of Contemporary Art, 1990), 9, 10. Ferguson is writing specifically of the United States, but his argument obviously applies, with different inflection, to Europe as well.

2. Steven Melville argues that Acconci's work is "the most literal living through of the formalist project of 'radical self-criticism' that seems currently imaginable"; see "How Should Acconci Count for Us?" *October* 18 (Fall 1981): 80. Although I agree that Acconci's work negotiates formalism, my terms differ from Melville's. He insists upon Acconci's "promotion of the self . . . to the status of medium" (87) and draws rather authoritatively on the terms of psychoanalysis, phenomenology, and aesthetic theory to deploy Acconci's work in a critique of the theories of Clement Greenberg. Melville makes what I view as a common error: he defines Acconci's work as "demand[ing] a special complicity of the beholder" but then poses himself as authoritative (reading through Lacan, Derrida, and Hegel to deliver final pronouncements on the works' significance) rather than engaged in the processes of determining meaning. Melville also ignores the gendered aspects of Acconci's enactments of sexually charged self-other relations.

3. Whiteness is implicit in the formulation "male artist" (that is, just as masculinity is implicit in "artist" in Western culture, the dominant conception of the artist also assumes whiteness). The sexual and class identifications of "artist" are more complex. I emphasize the class dimensions in my discussion of Pollock in chapter 2; regarding the sexual orien-

tation of the artist, it is worth noting that in spite of many coexisting discriminations, the art world is one of the few places in our culture where homosexuality can be felicitously joined to a position of creative privilege for male artists (although, as recent scholars such as Jonathan Katz have noted, male artists' homosexuality has also traditionally been veiled by tropes of genius that ameliorate its threat to heterosexual masculinity). See Jonathan Katz, "The Art of Code: Jasper Johns and Robert Rauschenberg," *Significant Others: Creativity and Intimate Partnership*, ed. Whitney Chadwick and Isabelle de Courtivron (London: Thames and Hudson, 1993), 189–207. Needless to say, gay women and gay artists of color have not fared well in this system until very recently (and even this recent privilege is tenuous, at best).

4. Judith Butler, *Bodies That Matter: On the Discursive Limits of "Sex"* (New York and London: Routledge, 1993), 13, 17.

5. Class figures ambiguously in Acconci's work, as does ethnic identity; he generally performs as a working-class Italian American New York persona, but, as Acconci himself has frequently surfaced in his writings and spoken statements, this is interwoven with the tropes of artistic genius and the language of the intellectual, raising his class status to the intelligentsia and inevitably leveling his ethnicity by raising it to a state of privileged, educated "whiteness."

6. Judith Mastai has stressed to me the importance of the drug culture, with its nurturing of excessive behavior, in encouraging such extravagantly improper social acts in body art works. I am grateful to her for sharing her experiences of this period. The works of Acconci discussed here are also discussed and reproduced in Mario Diacono, *Vito Acconci: Dal testo-azione al corpo come testo* (New York: Out of London Press, 1975); in Judith Russi Kirshner, *Vito Acconci, A Retrospective: 1969 to 1980* (Chicago: Museum of Contemporary Art, 1980); and in Kate Linker, *Vito Acconci* (New York: Rizzoli, 1994). The most important source on these early works is Acconci's own framing of them in *Avalanche*, n. 6, special issue on Vito Acconci (Fall 1972).

7. Sigmund Freud, "The Dynamics of Transference" (1912), tr. Joan Riviere, *Therapy and Technique*, ed. Philip Rieff (New York: Collier, 1963), 114, 112; see my discussion of interpretation as transference/counter-transference in *Postmodernism and the En-Gendering of Marcel Duchamp* (New York and Cambridge: Cambridge University Press, 1994), 113–17.

8. Vito Acconci, "Steps into Performance (and Out)," *Performance by Artists*, ed. A. A. Bronson and Peggy Gale (Toronto: Art Metropole, 1979), 34; and Acconci in Florence Gilbard, "An Interview with Vito Acconci: Video Works 1970–1978," *Afterimage* (November 1984): 9. Acconci recognizes that his self-explorations resulted in a reinforcement of the very "personality cult" or "hero" mentality of conventional notions of "artist as priest, art as religion, artwork as altar": "my work started from the notion of art as a distribution system, but obviously what that system makes is heroes" (Gilbard, "An Interview with Vito Acconci," 11). Acconci also acknowledges here his debt to the experimental dance movement of the 1960s (particularly the New York–based Judson Dance Theater), with its exploration of the body as a site of protest and symbolic meaning.

9. Maurice Merleau-Ponty, "The Philosopher and His Shadow," *Signs*, tr. Richard C. McCleary (Evanston, Ill.: Northwestern University Press, 1964), 175; cited by Vivian Sobchack in *The Address of the Eye: A Phenomenology of the Film Experience* (Princeton, N.J.: Princeton University Press, 1992), see 103, 120.

10. Christine Poggi's work on Acconci, which she graciously shared with me as I was revising this chapter, explores Acconci's exploitation of masculinity and its privilege in the self/other relation. Her essay "Vito Acconci's Bad Dream of Domesticity," in *Not at Home: The Suppression of Domesticity in Modern Art and Architecture*, ed. Christopher Reed (London: Thames and Hudson, 1996), 237–52, examines this self/other relation in terms of domesticity. Her unpublished essay "Reasons to Move: Vito Acconci's Early Work" is an excellent study of Acconci's shift from poetry to body art in the late 1960s, and the link of this shift to a widespread interest in phenomenology.

11. Judith Butler, "Performative Acts and Gender Constitution: An Essay in Phenomenology and Feminist Theory," *Theatre Journal* 40, n. 4 (December 1988): 521.

12. Cindy Nemser, "Subject-Object Body Art," *Arts Magazine* 46, n. 1 (September–October 1971): 42.

13. Jacques Derrida, "That Dangerous Supplement," in *Of Grammatology* (1967), tr. Gayatri Chakravorty Spivak (Baltimore and London: Johns Hopkins University Press, 1976), 157.

14. Peggy Phelan, *Unmarked: The Politics of Performance* (New York and London: Routledge, 1993), 151–52.

15. Acconci in Cindy Nemser, "An Interview with Vito Acconci," *Arts Magazine* 45, n. 5 (March 1971): 21. Acconci's *Openings* also fulfills what Lea Vergine identifies, in her important early examination of body art, as a fixation with "the uses and abuses of all of the body's orifices." Lea Vergine, *Il corpo come linguaggio (La 'body-art' e storie simili)*, tr. Henry Martin (Milan: Giampaolo Prearo Editore, 1974), 19.

16. Friedrich Nietzsche, *Nietzsche Contra Wagner*, in *The Portable Nietzsche*, tr. and ed. Walter Kaufmann (Harmondsworth: Penguin, 1976), 665–66.

17. Butler, *Bodies That Matter*, 51.

18. Klaus Theweleit, *Male Fantasies* Vol. 1, *Women, Floods, Bodies, History*, tr. Stephen Conway (Minneapolis: University of Minnesota Press, 1987), 244.

19. Robin White, "Interview" with Vito Acconci, *View* (Oakland), 1979, 21.

20. Vergine, *Il corpo come linguaggio*, 25.

21. Acconci's *Openings* relates in interesting ways to Kenneth Anger's focus on the navel as a site of homoerotic desire in both his *Fireworks* (1947) and *Scorpio Rising* (1963). Anger is an underground filmmaker whose films play with tropes of hypermasculinity in Hollywood movies; thus, *Scorpio Rising* uses clips of the excessively macho figure of Marlon Brando in *The Wild One* discussed in chapter 2 in relation to Jackson Pollock. Both Acconci and Anger negotiate these tropes, but Anger plays out their homoerotic aspects while Acconci performs himself primarily through the structures of heterosexual engagement.

22. Mary Douglas, *Purity and Danger: An Analysis of Concepts of Pollution and Taboo* (New York and Washington: Praeger, 1966), 121. Douglas explores this rupturing of boundaries in terms of cultural differences, linking anxieties about transgressing bodily boundaries to those regarding the threat to community boundaries, linking the "protection of bodily orifices" to "social preoccupations about exits and entrances" (126). In this sense, Acconci's ambivalent "opening" and simultaneous "closure" of his body would have broader implications vis-à-vis both the New York intelligentsia during this period and the state at large

(1970 being the height of protests against the violation of the body politic by the U.S. involvement in Vietnam).

23. Butler, "Performative Acts and Gender Constitution," 527. See also Butler's *Gender Trouble: Feminism and the Subversion of Identity* (New York and London: Routledge, 1990), where she reworks and expands this material.

24. Sobchack, *Address of the Eye,* 203.

25. Butler, "Performative Acts and Gender Constitution," 522.

26. I discuss this feminization of theater and kitsch as antipodal to a masculinized modernism at length in my *Postmodernism and the En-Gendering of Marcel Duchamp,* especially 16–21; see also Andreas Huyssen, "Mass Culture as Woman: Modernism's Other," *After the Great Divide: Modernism, Mass Culture, Postmodernism* (Bloomington: Indiana University Press, 1986), 44–62.

27. Fried's essay, originally published in *Artforum,* is reprinted in *Minimal Art: An Anthology,* ed. Gregory Battcock (New York: Dutton, 1968), 116–47.

28. Douglas Crimp, "Pictures" (originally published in *October,* 1979), reprinted in *Art after Modernism: Rethinking Representation,* ed. Brian Wallis (New York: New Museum of Contemporary Art; and Boston: Godine, 1984), 176–77; Maurice Berger, *Labyrinths: Robert Morris, Minimalism, and the 1960s* (New York: Harper and Row, 1989), 10. While Crimp's essay is remarkable in its early attempt—within *October* magazine—to propose a definition of postmodern art that goes beyond the usual emphasis on strategies of production and formal issues (see my discussion of the "Octoberists" in chapter 1), he deflates the importance of his own observation by going on immediately to claim that "you had to be there" to experience this work because the artworks "required the presence of the spectator to become activated [and were] . . . fundamentally concerned with that registration of presence as a means towards establishing meaning" (177). I fundamentally disagree with Crimp's argument, which exemplifies the apparent nostalgia for presence that I challenge in chapter 1. It is precisely through the activation of the theatrical, intersubjective relation by which meaning takes place that the works of the 1970s (including body art) show the impossibility of attaining such "presence." Our "establish[ment of] meaning" can only take place as an ongoing process in the face of the fact that even the material proximity of the body of the artist can never ensure a coherent, fixed meaning.

Other writers on performance and body art who have addressed Fried's model include Henry Sayre, in *The Object of Performance: The American Avant-Garde since 1970* (Chicago: University of Chicago Press, 1989), 6–7, and Kathy O'Dell, in "Toward a Theory of Performance Art: An Investigation of Its Sites," Ph.D. dissertation, City University of New York, 1992, 323–29. As noted, I discuss Fried's argument specifically in relation to minimalism in "Art History/Art Criticism: Performing Meaning," in *Performing the Body/Performing the Text,* ed. Amelia Jones and Andrew Stephenson (forthcoming).

29. The link between body art and minimalism is made explicit in the work of Scott Grieger, who from 1968 to 1973 staged a number of performative photographs in which he enacted himself as works of minimalist and other modernist sculptures. In *Human Scale* (1973), for example, Grieger poses, naked from the waist up, with Donald Judd-like metal shelves protruding from his chest. These works were exhibited in 1994 at the Margo Leavin Gallery in Los Angeles.

30. Fried, "Art and Objecthood," 125. While Fried argues that the inclusion of the beholder takes place through a distancing effect that creates an "unexacting" relationship of the viewer to the object (128), his own anxiety regarding this inclusion seems to admit to a rather "exacting" and in fact dangerous relationship—one that exposes the very stakes of modernist criticism.

31. Ibid., 141–42. The emphases are all Fried's and give the essay a rather hysterical tone.

32. Ibid., 145, 46.

33. This reading obviously differs from Anna Chave's designation of minimalism as simply misogynist in its impulses and critical positioning in her essay "Minimalism and the Rhetoric of Power," *Arts Magazine* 64, n. 5 (January 1990): 44–63. While Chave's observations are suggestive, I would insist that she pushes her case too far. Fried's response makes clear that minimalism was not such an easy case and, in fact, points to the fact that minimalism began to challenge the authoritarianism of modernist formalist critical models in deep structural ways. Chave's mistake is to assume that authority can be "implicit in the identity of the materials and shapes the artists used" (44); as I argue throughout this book, no meaning or value is implicit in form or material—it is, rather, through the engagements the object and its discourses encourage that meaning takes place, and this meaning is never fixed but always contingent on the interpretive dynamic (including, of course, institutional positionings).

34. Fried cites Morris and makes this comment in "Art and Objecthood," 127.

35. Maurice Berger discusses this dynamic, vis-à-vis Annette Michelson's phenomeno-logical reading of Morris (and critique of Fried); see Berger, *Labyrinths,* 11–13. Of course, through linguistic rather than visual or sculptural models, works by the official conceptual artists also deeply interrogated the premises of formalism as well. In a general sense, I consider body art works to be conceptual as well as (like minimalist works) spatial and phenomenological in that they further this interrogation through conceptual (if also em-bodied) means.

36. Amelia Jones, "Dis/Playing the Phallus: Male Artists Perform Their Masculini-ties," *Art History* 17, n. 4 (December 1994): 546–84.

37. Ben Patterson, an African American Fluxus artist, is one of the only exceptions I know of from the 1960s and 1970s, and he did not, to my knowledge, ever "unveil" his body in his performances. He did, however, compose *Whipped Cream Piece (Lick Piece),* which called for covering a body with whipped cream and having a number of people, male and female, lick it off; the first time this piece was performed, in 1964 at the Fluxhall/Fluxshop in New York City, a woman artist, Lette Eisenhauer, volunteered to be the cream-covered body. It does not seem incidental that a woman would have taken this role, which (given Patterson's authorial position) would have served to confirm rather than dislocate his masculinity/artistic authority. Too, in 1962, while Nam June Paik organized *Young Penis Symphony,* in which a row of men poked their penises through a sheet of white paper towards the audience, as far as I know he never unveiled his own body. See Kristine Stiles's description of these pieces in "Between Water and Stone, Fluxus Performance: A Metaphysics of Acts," in *In the Spirit of Fluxus,* organized by Elizabeth Armstrong and Joan Rothfuss (Minneapolis: Walker Art Center, 1993), 84–85. More recently, men of color—especially gay men of color—have

interrogated the normative subject through the use of their own bodies; filmmaker Marlon Riggs and photographer Lyle Ashton Harris are exemplary in this regard.

The stakes of performing the penis for white male artists seem clear, in that, when it is indeed "unveiled," the tendency is to present the penis as penetrating and transformative. This is particularly obvious in the work of the Viennese actionists. In Otto Muehl's 1963–69 film entitled *Mama and Papa*, a large male organ penetrated the page of an art book; Hermann Nitsch produced elaborate ritual performances involving animal blood and penises held auspiciously on bloodly tablets; and, in a now mythologized act, in 1969 Rudolf Schwarzkogler supposedly amputated his penis and died as a result (Stiles has definitively debunked this myth in her "Performance and Its Objects," *Arts Magazine* 65, n. 3 [November 1990]: 35, 37). On the work of the Actionists, see the exhibition catalog *Wiener Aktionismus/ Viennese Aktionism, Wien/Vienna 1960–1971, Der zertrümmerte Spiegel/The Shattered Mirror* (Klagenfurt: Ritter Verlag, 1989); on Muehl's film, see Amos Vogel, *Film as a Subversive Art* (New York: Random House, 1974), 252. Finally, the misogyny that is structurally linked to the heroization of the penis/phallus is enacted in Nitsch's horrifying *Mariae Empfängnis*, action with Hanel Koeck, Munich, 1969. In a photograph documenting this piece, a woman's body is shown ripped open at the crotch, internal organs visible; a large shaft penetrates her vaginal canal, now a muscle stripped of its bodily surroundings. See Renate Berger, "Pars pro toto: Zum Verhältnis von künstlerischer Freiheit und sexueller Integrität," in *Der Gasten des Lüste. Zur Deutung des Erotischen un Sexuellen bei Künstlern und ihren Interpreten*, ed. Renate Berger, Daniela Hammer-Tugendhat (Cologne: DuMont Buchverlag, 1985), 170. I am grateful to Bea Karthaus-Hunt for directing me to this source.

38. Leo Bersani discusses the potentially negative effects of such an appropriation in "Is the Rectum a Grave?" *October* 43 (Winter 1987): 205–9. In this image, as Mira Schor has written, Morris "turns himself into a penis, a G.I. helmet forming the head, and his bare and oiled pecs and biceps the shaft. But, decorously, he is shot from the waist up and for good measure you can spot his BVDs waistband at the bottom edge of the photograph." Schor stresses that Morris's body operates as phallus only through the occlusion of his anatomical penis. See Mira Schor, "Representations of the Penis," $M/E/A/N/I/N/G$ 4 (November 1988): 9.

39. Susan Krane discusses both images and the relationship of Benglis and Morris in the exhibition catalog *Lynda Benglis: Dual Natures* (Atlanta: High Museum, 1991), 40–41. According to Krane, Morris accompanied Benglis to buy the dildo she used in her piece and the two artists posed with it in a group of staged Polaroids (42). Although the Benglis piece is in the public domain, I have acceded to the artist's wishes that I not reproduce it here; Benglis has objected to my reading of her piece, which she sees as too personal. While I deeply respect the artist, I find her objection astonishing in view of the revelatory nature of images that are essentially playing with codes from pornography—not to mention in view of the fact that the particulars of the artists' relationship have already been published in the Krane book. See my extended discussion of this image and other feminist body art projects in "Feminist Pleasures and Embodied Theories of Art," *New Feminist Criticisms: Art/Identity/ Action*, ed. Cassandra Langer, Joanna Frueh, and Arlene Raven (New York: HarperCollins, 1994), especially 29–37.

40. W. J. T. Mitchell, "Wall Labels: Word, Image, and Object in the Work of Robert Morris," *Robert Morris: The Mind/Body Problem* (New York: Guggenheim Museum, 1994), 73.

41. Editorial written by Lawrence Alloway, Max Kozloff, Rosalind Krauss, Joseph Masheck, and Annette Michelson, *Artforum* 13, n. 4 (December 1974): 9. The image has recently come to have a kind of legendary status in feminist art historical texts written in the United States. For example, I have recuperated the image as feminist in a recent exhibition and catalog, published as *Sexual Politics: Judy Chicago's* Dinner Party *in Feminist Art History*, ed. Amelia Jones (Los Angeles: UCLA/Armand Hammer Museum of Art; Los Angeles and Berkeley: University of California Press, 1996); see 35.

42. See the exhibition catalog *Masculine Masquerade: Masculinity and Representation*, ed. Andrew Perchuk and Helaine Posner (Cambridge, Mass.: MIT List Visual Art Center; and Cambridge, Mass., and London: MIT Press, 1995). As I have suggested in my discussion of Duchamp's "masquerade" as Rrose Sélavy, there are theoretical questions to be raised regarding the application of the term "masquerade" to male subjects, since as initially interpreted in psychoanalytic models it applied to women alone (see chapter 5, "The Ambivalence of Rrose Sélavy," in *Postmodernism and the En-Gendering of Marcel Duchamp*, 146–90). Joan Riviere's 1929 essay "Womanliness as a Masquerade" is the key source text here; it is reprinted in *Formations of Fantasy*, ed. Victor Burgin, James Donald, and Cora Kaplan (London: Methuen, 1986), 35–44.

43. In 1914 Freud explicitly identified narcissism with homosexual object choice: "We have found, especially in persons whose libidinal development has suffered some disturbance, as in perverts and homosexuals, that in the choice of their love-object they have taken as their model not the mother but their own selves. They are plainly seeking themselves as a love-object and their type of object-choice may be termed *narcissistic*." See Freud, "On Narcissism: An Introduction" (1914), tr. Cecil M. Baines, *Collected Papers*, vol. 4 (London: Hogarth Press and the Institute of Psycho-Analysis, 1953), 45. In his later work, he discussed narcissism as a stage in between autoeroticism and object-love (a stage in which the "abnormal" homosexual and undeveloped woman remain stuck while the "healthy" heterosexual male moves on to opposite-sex object-choice; see J. Laplanche and J.-B. Pontalis, *The Language of Psychoanalysis*, tr. Donald Nicholson-Smith (New York and London: Norton, 1973), 255. For a critique and expansion of the Freudian model, see Michael Warner, "Homo-Narcissism; or, Heterosexuality," in *Engendering Men: The Question of Male Feminist Criticism*, ed. Joseph Boone and Michael Cadden (New York and London: Routledge, 1990), 190–206; Klaus Theweleit, *Object Choice (All you need is love . . .)* (London: Verso, 1994); and Whitney Davis's incisive review of Theweleit's book, "Book of Love," in *Artforum* 33, n. 9 (May 1995): 29–30.

44. Kathy O'Dell argues that masochism, which is central to body art practices in this period (primarily among male artists, but also the work of Gina Pane), is used as a vehicle to symbolize moments in infantile development surrounding the Oedipus complex. Masochism enables the performer to lead the viewer along a trajectory of psychical development, reenacting the painful, traumatic split between self and other that initiates the "subject" as such. O'Dell also relates the masochistic fixation, in its relationship to the subject's entry into language and the paternal law, to the artist's negotiation of the *social* contract, itself thrown into question by the Vietnam War. See O'Dell, "Toward a Theory of Performance Art."

45. Thus, Michael Warner argues that the Western conception of heterosexuality depends upon the disavowal of its bases in narcissism (its immanence, in Beauvoir's terms) and its projection of this narcissism onto the supposedly thereby deviant homosexual: the model of the homosexual as narcissistically contained through his self-obsession *"allows the constitution of heterosexuality as such"* ("Homo-Narcissism," 202).

46. Simone de Beauvoir, *The Second Sex* (1949), tr. H. M. Parshley (New York: Knopf, 1952), xvi, 60, 233.

47. Vito Acconci, "Early Work: Moving My Body into Place," *Avalanche*, n. 6, special issue on Vito Acconci, 7. Acconci's fascination with the *imprint* or semiotic trace links up with his interest as a poet in the concrete effects of language.

48. Jacques Lacan, "The Mirror Stage as Formative of the Function of the I as Revealed in Psychoanalytic Experience" (1949), in *Écrits: A Selection*, tr. Alan Sheridan (New York and London: Norton, 1977), 1–7. It is in this essay that Lacan is the closest to existentialist phenomenological models of self and other (especially Beauvoir's) but also explicitly differentiates himself from Sartre's metaphysical view of the self as internally coherent: "that philosophy [of "being and nothingness"] grasps negativity only within the limits of a self-sufficiency of consciousness, which, as one of its premises, links to the *méconnaissances* that constitute the ego, the illusion of autonomy to which it entrusts itself. This flight of fancy . . . culminates in the pretention [*sic*] of providing an existential psychoanalysis . . . [E]xistentialism must be judged by the explanations it gives of the subjective impasses that have indeed resulted from it" (6).

49. Rosalind Krauss, "Note on the Index: Part 1" (1977), in *The Originality of the Avant-Garde and Other Modernist Myths* (Cambridge, Mass., and London: MIT Press, 1985), 197; notably, Krauss maintains in this essay what is, in view of the role of sexual difference in the processes of identification, a rather disturbing allegiance to male gender pronouns.

50. See Vivian Sobchack's helpful differentiation of Merleau-Ponty and Lacan on this issue of the self/other relation in *Address of the Eye*, 97–128.

51. Acconci, "Trappings," in *Avalanche*, n. 6, special issue on Vito Acconci, 56.

52. Acconci stated plaintively of the piece: "A viewer passes by the closet space—the closet is low, he has to look down—a place where I can regress, make a fool of myself—. . . he shouldn't want to have anything to do with me—I'm something to throw off, withdraw from" (ibid., 56). In a 1977 article "In Pursuit of Acconci" (*Artforum* 15, n. 8 [April 1977]: 38–41), Edward Levine argues that Acconci radically dissolves the distance between self and other in his body art works, breaking down the limits of the self. Levine's argument contrasts with Kathy O'Dell's assertion that body art in the late 1960s and early 1970s is about the attempt to maintain boundaries between subject and object (see "Toward a Theory of Performance," 282). Both Levine and O'Dell I think miss the subtlety of self/other intersubjectivity as described through phenomenological models, which reinforce Acconci's own suggestion that he both distances the spectator and attempts to incorporate her/him. Thus, in a quote already partly cited earlier, Acconci admits his desire to get rid of the middle term by putting the artist directly in public space—but is bothered by the failure to attain the situation "I-meet-you" (that is, the failure to abolish distance, to ensure his presence): "first of all, those two people meeting—the I and you, the viewer—were never really on equal ground . . . It was always . . . a piece, it was always announced, I was always the artist,

it was very much—'I'—'I-as-art-star' meet you, the viewer. . . . So it wasn't these two people meeting, but very much a viewer almost taking this journey towards me. . . . I was setting myself up, really, in a very traditional stage kind of position" (White, "Interview" with Vito Acconci, 21).

53. Jean-Paul Sartre, *Being and Nothingness: A Phenomenological Essay on Ontology*, tr. Hazel E. Barnes (New York: Washington Square Press, 1956), 355.

54. Lacan, "The Eye and the Gaze," *The Four Fundamental Concepts of Psycho-Analysis* (1973), tr. Alan Sheridan (New York and London: Norton, 1981), 72.

55. On the imago, see Laplanche and Pontalis, *The Language of Psycho-Analysis*, 211.

56. Lacan, "The Mirror Stage," 2, 4. See Paul Taylor on the relationship of Acconci's work to Lacan's model of individual development in his essay "Self and Theatricality: Samuel Beckett and Vito Acconci," *Art + Text* 5 (Fall 1982): 7–9.

57. Lacan, "The Mirror Stage," 4, 5.

58. Cited in Ellen Schwartz, "Vito Acconci: I Want to Put the Viewer on Shaky Ground," *Art News* 80, n. 6 (Summer 1981): 96.

59. I noted in chapter one Roland Barthes's discussion of this "having been there" dimension of photography in "Rhetoric of the Image," *Image-Music-Text*, tr. Stephen Heath (New York: Hill and Wang, 1977), 44–45. "Mirrorical return" is a Duchampian notion having to do with the "virtual" space of the fourth dimension as perceived by the human eye; impossible to "see" (as we are blocked by our own bodies), the fourth dimensional continuum is analogous to the perceived infinite space of the mirror (which is nonetheless actually a two-dimensional plane). In a sense, as read through Lacan and the phenomenologists, the mirrorical return could be seen as a metaphor for the phenomenologically inflected domain of self/other perception: we see the other but only through ourselves (our relationship to the world is always through our own bodies and consciousnesses). See Marcel Duchamp, "The Green Box" (1934), in *The Writings of Marcel Duchamp*, ed. Michel Sanouillet and Elmer Peterson (New York: Da Capo, 1973), especially 65, 91, 94.

60. Craig Dworkin, "In Other Words: Vito Acconci and the Body of the Text," paper delivered at the Sixth Annual University of California, Berkeley, Graduate Student Symposium (March 1995), 8.

61. On *différance*, see Derrida, "Différance" (1968), tr. Alan Bass, *Critical Theory since 1965*, ed. Hazard Adams and Leroy Searle (Tallahassee: Florida State University Press, 1986), 120–36.

62. Acconci, "Introduction: Notes on Performing a Space," in *Avalanche*, n. 6, special issue on Vito Acconci, 2.

63. Intentionality has a different connotation within phenomenology than it has within conventional art history (the metaphysical variety I critique in this book). The intentional arc has to do with the projection of the self into the world. In Merleau-Ponty's terms, intentionality precisely does not confirm the Cartesian self-sufficiency of the subject; rather, it is the always elusive means by which we establish ourselves, *in our contingency*, in the world. The body is a self precisely because it is "a dynamic synthesis of intentionalities which, by responding to the world's solicitations, brings perceptual structures into being in a ceaseless dialectic whereby both body and objects are constituted as such." Monika M. Langer, *Merleau-Ponty's* Phenomenology of Perception: *A Guide and Commentary* (Tallahassee:

Florida State University Press, 1989), 149. See also Gary Brent Madison, *The Phenomenology of Merleau-Ponty* (Athens: Ohio University Press, 1981), especially 169–70.

64. Iris Marion Young, "Throwing Like a Girl: A Phenomenology of Feminine Bodily Comportment, Motility, and Spatiality," *The Thinking Muse: Feminism and Modern French Philosophy*, ed. Jeffner Allen and Iris Marion Young (Bloomington: Indiana University Press, 1989), 58, 60, 66. This essay is, in my view, one of the most important feminist contributions to (and critiques of) phenomenology.

65. The myth of the castration complex can be seen to instantiate this striving, in that it pretends to identify while in fact enacting a dynamic in which all subjectivity returns to the incontestable existence of the flap of flesh external to men's bodies—a flap of flesh that always (whatever protestations may be made to the contrary) is assumed to carry its own inherent value within it, with its meaning never contingent on external values. See Jane Gallop, "Phallus/Penis: Same Difference," in *Thinking through the Body* (New York: Columbia University Press, 1988), 124–33.

66. Beauvoir in particular stressed that, while both men and women (as Lacan and others have argued) are alienated, women are doubly alienated; boys can at least take some comfort from projecting their alienation onto their penis to invest it with transcendence. See Toril Moi, *Simone de Beauvoir: The Making of an Intellectual Woman* (Oxford and Cambridge, Mass.: Blackwell, 1994), 158. On the double alienation of women in patriarchy, see also Gayatri Spivak's "Displacement and the Discourse of Woman," *Displacement: Derrida and After*, ed. Mark Krupnick (Bloomington: Indiana University Press, 1983), 169–95.

67. In "Notes on the Index: Part 1," Krauss explores the failure of movement fully to cohere the subject (still gender neutral in her account) in spite of its indexical appeal to the rhetoric of presence. As proof of this failure she argues that the work of Acconci disrupts the economy of the sign; on Acconci, see 196–97.

68. Liza Béar, "Vito Acconci . . . Fragile as a Sparrow, but Tough," *Avalanche*, n. 9 (May 1974): 21.

69. Merleau-Ponty, *Phenomenology of Perception* (1945), tr. Colin Smith (New York: Humanities Press, 1962), 102.

70. For example, Krauss's discussion of the way in which postmodern artists shift the stress in artmaking from the "internal logic" of formalism (where the sign is understood to be connected to a referent along a physical axis) to the conception of paintings as empty signs glosses over the way in which such an exploration has different stakes for men and women artists because of their different relationship to the formalist tradition (men artists—at least white, Western men artists—have an identificatory stake in the perpetuation of certain aspects of this tradition, even while they may ironicize others). See Krauss, "Notes on the Index: Part 1," and "Notes on the Index: Part 2," in *Originality of the Avant-Garde*, 196–219.

71. See Judith Butler, "Sexual Ideology and Phenomenological Description: A Feminist Critique of Merleau-Ponty's *Phenomenology of Perception*," in *The Thinking Muse*, 85–100.

72. Paraphrased by Iris Marion Young in "Throwing Like a Girl," in *The Thinking Muse*, 60. See also Merleau-Ponty on the primary function by which we bring space into existence for ourselves through the body, in *Phenomenology of Perception*, 154.

73. Young, "Throwing Like a Girl," 58.

74. Ibid., 63.

75. Ibid., 66, 67.

76. Acconci, "Early Work: Moving My Body into Place," *Avalanche*, n. 6, special issue on Vito Acconci, 7.

77. Bersani, "Is the Rectum a Grave?" 216, 217; Bersani is citing Michel Foucault's ideas from his *History of Sexuality*, vol. 1, *An Introduction*, tr. Robert Hurley (New York: Vintage, 1980), 93–94.

78. Acconci, "Trademarks," from *Avalanche*, n. 6, special issue on Vito Acconci, 11. *Trademarks* relates closely to Acconci's earlier *Performance for the Coffee Hour (Making Time)* of 1969, in which Acconci, before an audience at the Rhode Island School of Design, repeatedly pressed a bottle cap into his arm to leave an impression and mark himself as "the 'noted' person"; see Linker, *Vito Acconci*, 22–23. Kathy O'Dell, who notes that (unlike the Rhode Island performance) *Trademarks* existed publicly only through its photographic representations and textual descriptions, argues that *Trademarks* is an examination of oral stage ambivalence toward the maternal figure ("Toward a Theory of Performance Art," 158–68); while I find this suggestive if it is viewed very generally, I prefer to steer away from such explanations since they seem to rely on psychobiography and to impute intentionality (if unconscious) to individual artists.

79. Acconci, "Trademarks," 11. In addition to marking his own body, Acconci inked the bite marks on his arm to print his "trace" on paper ("I can shift the focus—apply printers' ink to the bites so that they can be made available—I can point out other targets by stamping bite-prints on paper, on a wall, on another body"; through this process of marking, "[I can] show myself outside . . . send my inside outside" [ibid.]). See also Cindy Nemser, "Interview with Vito Acconci," 20.

80. *Following Piece* was executed over a one-month period as part of the New York Architectural League's "Street Works IV" program; see Linker, *Vito Acconci*, 20.

81. Another obvious comparison would be the later following pieces of Sophie Calle, where she adopts the role of predator, first following strangers in the street, then shadowing one man intensively around Venice; see *Suite Vénitienne* (Seattle: Bay Press, 1988) and Calle's description of the related piece "Le confessionel," in *Sophie Calle, à suivre* (Paris: Musée d'art moderne de la Ville de Paris, 1991), n.p. Calle's interest in "la filature" (a feminine noun that, interestingly, means both "spinning" and a detective's "shadowing") extended as well to her project *La Filature*, where she had her mother hire a private detective to follow Calle ("Elle demanda qu'on me prenne en filature"); in the text accompanying the piece, Calle describes herself becoming increasingly obsessed with her staged voyeur, hoping that he desires her (in the English version she writes: "enjoying this scattered, diffuse and ephemeral day I have offered him—our day. . . . I wonder if he likes me"); see *Sophie Calle, à suivre*. Like Ono, then, Calle both reverses (in *Suite Vénitienne*) and enacts (in *La Filature*) the gendering of the structures of following and being followed: the classic dynamic has the woman being followed by a man and wanting to be "desired" in this way.

82. Cited in Gilbard, "An Interview with Vito Acconci," 9.

83. Yoko Ono, "Film Script No. 5, Rape (or Chase)," in Barbara Haskell and John G. Hanhardt, *Yoko Ono: Arias and Objects* (Salt Lake City: Peregrine Smith, 1991), 94.

84. Lacan, "The Line and Light," in *Four Fundamental Concepts*, 104.

85. See Laura Mulvey's well-known argument regarding sadistic scopophilia and the objectification of women, "Visual Pleasure and Narrative Cinema" (1975), in *Visual and Other Pleasures* (Bloomington: Indiana University Press, 1989), 14–26.

86. Ono, "On Rape" (1969), in Haskell and Hanhardt, *Yoko Ono*, 94. While Ono directs her comments to a male reader, she hardly essentializes the notion of masculinity, making clear that any subject can be "masculinized" by an abusive relationship to the other: "So we go on eating and feeding frustration every day, lick lollipops and stay being peeping-toms dreaming of becoming Jack-The-Ripper" (ibid.). Ono's particular experience of otherness as a woman has been exacerbated by her subordination in the public eye, her identification solely as John Lennon's partner (in spite of her earlier international career as an artist), as well as by her ethnic and cultural otherness to the Anglo-American norm.

87. Acconci, "Openings," *Avalanche*, n. 6, special issue on Vito Acconci, 22.

88. In other words, because the veiled empowerment of Pollock's privileged phallocentrism is the focal point against which body art practices are articulated, they tend to adopt (if often oppositionally) his terms. The following section on masochism has been modified from my essay "Dis/Playing the Phallus."

89. On Burden's 1971 *Shoot Piece*, see *Chris Burden: A Twenty-Year Survey*, exhibition catalog (Newport Harbor, Calif.: Newport Harbor Museum of Art, 1988), 53. On Wegman's and Le Va's early masochistic pieces, see Nemser, "Subject-Object Body Art," 38, 41, and Max Kozloff, "Pygmalion Reversed," *Artforum* 14, n. 3 (November 1975): 33. Skip Arnold's *Closet Corner* piece (1987) was exhibited at Exit Art, New York, in the 1995 exhibition *Endurance* (worth noting too was Arnold's 1993 performative piece *On Display* at Burnett Miller Gallery in Santa Monica: sitting in a fetal position, naked, Arnold was contained in an acrylic box on a pedestal for hours on end). I discuss Bob Flanagan's work in chapter 5. Stell'Arc's work is discussed by C. Carr in *On the Edge: Performance at the End of the Twentieth Century* (Hanover and London: University Press of New England/Wesleyan University Press, 1993), 10–14. Dennis Oppenheim's work is discussed in *Dennis Oppenheim: Retrospective—Works 1967–1977* (Montreal: Musée d'art contemporain; and Toronto: Art Gallery of Ontario, 1978). Terry Fox's projects are explored in Brenda Richardson, *Terry Fox* (Berkeley: University Art Museum, University of California, Berkeley, 1973). Paul McCarthy's video piece *Rocky* (1976) was presented at the Shoshana Wayne Gallery in Santa Monica in Michael Cohen's exhibition *The Paranoid Machine* in 1996, and his work is discussed by Thomas McEvilley in "Art in the Dark," *Artforum* 21, n. 10 (Summer 1983): 66.

90. O'Dell, "Toward a Theory of Performance Art," 292, 293.

91. As I discuss in chapter 5, Bob Flanagan, with the help of dominatrix Sheree Rose, is highly unusual in that he presents his clinical masochism *as* public performance. O'Dell discusses the use of metaphor within masochistic performance at great length in "Toward a Theory of Performance Art." Here, she theorizes masochism in performance as "deconstructive" of the social order because of its metaphoric representation of oedipal and pre-oedipal moments from the modern subject's developmental past—moments that, because they take place in the domestic site where the law of the father takes hold, necessarily link up to the social contract. By confronting the traumas of individual development, O'Dell argues, the masochistic performer inevitably critiques the failure of the social contract. While her insights are suggestive, O'Dell tends to assume an *inherent* meaning for performance art

projects, arguing, for example, that masochistic performances by Gina Pane and others are necessarily radical—that, "motivated by the structural breakdown in contractual agreements between state and citizens" in the early 1970s, they necessarily "deconstruct" the social contract (279), that masochistic acts are "inherently alienating," and that they necessarily force viewers to become "automatic participants" in the work, and thus to acknowledge their complicity in the psychological states performed (349).

My reservations vis-à-vis this kind of interpretive determinism lead me to insert myself into my interpretations so as to make clear my investment in reading body art works in relation to masculine subjectivity. Thus, as a feminist, I obviously have an interest in artworks that I see as critiquing masculinity. My point here is that, particularly in practicing a feminist art history, since feminism has worked to question the notion of cultural value, and/or in attempting to situate performance as critical of modernist value systems and notions of historical or aesthetic truth, it behooves me to complicate my own processes of determining value for this work. O'Dell, who claims an antimodernist value for masochistic performance, would be more convincing in this argument if she were to question her interpretive system, which still—as it claims antimodernism for the works—maintains a modernist investment in inherency and artistic intentionality. (I want to stress here at the same time how rich her work is and how much I have learned from her ideas; also, to acknowledge how difficult it is to avoid claiming definitive meanings.)

O'Dell also makes recourse to the notion that the performance work (particularly the masochistic performance piece) is necessarily more radical than nonperformative work because it "literalizes and metaphorizes the figurative split" in the subject experienced during the Lacanian mirror stage, "profoundly accelerat[ing] . . . the questioning process" (243–44). This tendency to claim priority for performance work because of the implied literal "presence" of the artist's body within it is questionable in that it reinforces the very modernist metaphysics of presence—and particularly the notion of the coherent individual—that performance art is said to critique. I discuss this dilemma in chapter 1.

92. See Freud, "Sadism and Masochism" (1905), *Three Essays on the Theory of Sexuality*, tr. James Strachey (New York: Basic Books, 1962), 23–26. Such a popular conception extends and reduces Freud's ambivalence toward masochism to a one-sided model; while Freud specifically insisted that a "sadist is always at the same time a masochist," he also consistently used this conjoining of impulses paradoxically to confirm a dualistic model of sexuality, connecting the "simultaneous presence of these opposites with the opposing masculinity and femininity which are combined in bisexuality—a contrast which often has to be replaced in psycho-analysis by that between activity and passivity" (25, 26). Furthermore, Freud revised this theory of the simultaneity of sadomasochism in "The Economic Problem of Masochism" (1924), tr. Joan Riviere, *The Standard Edition of the Complete Psychological Works of Sigmund Freud*, vol. 19 (London: Hogarth Press and the Institute of Psycho-Analysis, 1961), 157–70, where he argues that masochism has a primary state that is not contingent on sadism.

93. Sigmund Freud, "A Child Is Being Beaten" (1919), tr. Alix and James Strachey, *Sexuality and the Psychology of Love* (New York: Macmillan, 1963), 126. See also Jean-Paul Sartre's discussion of the inevitable failure of the masochist's desire to exist as pure object (as, in Freud's terms, purely feminine), in *Being and Nothingness*, where he describes the masochist's

dilemma as follows: "I attempt . . . to engage myself wholly in my being-as-object. I refuse to be anything more than an object. I rest upon the Other. . . . As the Other apprehends me as an object by means of *actual desire*, I wish to be desired, I make myself in shame an object of desire" (491). This is the failure that I have interpreted Acconci as enacting in his performative references to the penis and spectatorial desire.

94. Theodor Reik, *Masochism in Modern Man*, tr. Margaret H. Beigel and Gertrud M. Kurth (New York: Farrar, Straus, 1941), 163.

95. Gilles Deleuze, "Coldness and Cruelty," in *Masochism* (New York: Zone, 1989), 22.

96. Burden's descriptions of his performance events rarely reveal whether the perpetrator of the violent act upon his body was male or female, but in those cases in which a photograph or the text gives this information, the figure is most often male.

97. It is important to note that this is an issue of reception as well as production. On the one hand, Burden did enact a number of performance pieces in which he presented himself to the audience in such a way that issues of gender and subjectivity are subtly highlighted. I discuss several of these in my essay "'The Clothes Make the Man': The Male Artist as a Performative Function," in *Oxford Art Journal* 18, n. 2 (1995): 18–32. On the other hand, Burden carefully staged each performance and had it photographed and sometimes also filmed; he selected usually one or two photographs of each event for display in exhibitions and catalogs, where the photographs are accompanied by a "relic" from the event and by Burden's laconically macho description of the performance action. Like Klein, Burden tends to reinforce his authority through his decidedly masculine, spare yet forceful self-presentational style (especially evident in films that document his life and work and include interviews with Burden, such as Peter Kirby's *Chris Burden: A Video Portrait*, made in 1988).

In this way, Burden produced himself for posterity through meticulously orchestrated textual and visual representations. As with Klein, art critics and historians tend to exaggerate further the heroic effects of Burden's actions; thus Donald Kuspit celebrates Burden's self-destruction as follows: "Burden's early self-torturing performances were . . . more extreme than the typical avant-garde risk-taking. . . . Burden's destructiveness is more complicated than the usual daredevil 'flirtation' with death. . . . The ingenious way Burden keeps changing [his] method [of self-testing] . . . forces us to ask to what desperate purpose he is proving himself. Who is the self that keeps wrestling with the angel of death? . . . [Burden] has his hand on the very pulse of art" (Kuspit, "Chris Burden: The Feel of Power," in *Chris Burden : A Twenty-Year Survey*, 37, 38, 42).

98. Kozloff, "Pygmalion Reversed," 34.

99. In this regard, Skip Arnold's histrionic but humorous *Scare Crow* (1986) provides an interesting comparison; Arnold's "crucified" body, hung from a cross in between two large piles of burning sticks, is marked as an empty body, a fake person (a "scare crow").

100. Much of one's interpretation of Burden's work—whether or not one determines it to be critical or recuperative of normative masculinity or both—has to do with whether or not one perceives Burden as being ironic. It is crucial to recognize the way in which body art, especially, throws one back on one's perceptions vis-à-vis authorial attitudes (since the work is apparently so explicitly revealing of "attitude"). And yet body art just as clearly makes us aware of the impossibility of knowing Burden's "original intentions" in this regard.

101. Acconci in Florence Gilbard, "An Interview with Vito Acconci," 11.

102. Cited by Kate Linker in *Vito Acconci*, 47. Tying in to my discussion in chapter 1, Linker points out that Acconci in this and other pieces addresses ideas developed by Erving Goffman in his books *The Presentation of the Self in Everyday Life* (1959) and *Interaction Ritual* (1969/70); see 46–47. The video footage from *Claim* is now distributed as a single-track video piece.

103. Gilbard, "An Interview with Vito Acconci," 11.

104. Although, of course, her refusal was presumably scripted by Acconci, the author of the piece, reiterating his control even as she appears to reject it.

105. Acconci, "Remote Control," in *Avalanche*, n. 6, special issue on Vito Acconci, 59.

106. Acconci cited by Blue Greenberg in "Vito Acconci: The State of the Art, 1985," *Arts Magazine* 59 (Summer 1985): 122.

107. The vehemence with which, say, openly homosexual men, "feminine" men, and men of color are continually blocked from the social privileges that accrue to normative masculinity makes clear the extent of the stakes involved in securing masculinity in its normative guise (and what other guise would it have?).

108. Maurice Merleau-Ponty, *The Visible and the Invisible* (1964), tr. Alphonso Lingis, ed. Claude Lefort (Evanston, Ill.: Northwestern University Press, 1968), 131, 134, 138.

109. Ibid., 139.

110. Luce Irigaray, "The Blind Spot of an Old Dream of Symmetry," in *Speculum of the Other Woman*, tr. Gillian Gill (Ithaca, N.Y.: Cornell University Press, 1984), 33.

111. In Kirshner, *Vito Acconci*, 17.

112. Merleau-Ponty, *The Visible and the Invisible*, 139.

113. Mary Ann Doane uses this term in *The Desire to Desire: The Woman's Film of the 1940s* (Bloomington and Indianapolis: Indiana University Press, 1987), 13.

114. Schor, "Representations of the Penis," 7.

115. Either way, one must agree with Schor that in the performance itself Acconci hid his penis from view (although one can strain to view it in the photograph used to document the event). See the image reproduced here and in Robert Pincus-Witten's article "Vito Acconci and the Conceptual Performance," *Artforum* 10, n. 8 (April 1972): 47. This is an interesting case vis-à-vis the issue of photographic documentation versus the "actual" experience of the original performance event, since the photograph gives information (the unveiled body of the artist) that was specifically withheld in the performance.

116. Acconci, cited by Linker, *Vito Acconci*, 48.

117. Linda Montano and Tehching Hsieh also produced several important intersubjective performances (which cross over gender as well as ethnic difference), including *Art/Life One Year Performance* (1983–84), in which they spent a year tied together with an eight-foot rope; see C. Carr, *On the Edge*, 3–9. See also Klaus Rinke's *Masculine-Feminine* (1970), in which Rinke chained himself to a woman in a small room (this is documented in *Klaus Rinke* [Oxford: Museum of Modern Art Oxford, 1976], n.p., and in "Klaus Rinke," *Avalanche*, Winter 1971, 57) and the cross-gendered Fluxus wedding of George Maciunas and Billie Hutching, *Black & White*, 1978 (discussed and reproduced in Stiles, "Between Water and Stone," 84–85).

118. See *Österreichischer Kunstverein Internat. Performance Festival* (Innsbruck: Galerie Krinzinger;

Graz: Galerie Humanic, 1978), n.p. See also Thomas McEvilley, "Marina Abramović/Ulay," *Artforum* 22, n. 1 (September 1983), 52–55.

119. See Bronson and Gale, ed., *Performance by Artists*, 60ff.

120. O'Dell, "Toward a Theory of Performance Art," 204; see especially O'Dell's interesting reading of Ulay/Abramović's *Balance Proof* (1977), a piece in which they stood separated by a double-sided mirror, as an allegory of sexual difference (197–205).

121. Freud specifies the erotic nature of transference in "The Dynamics of Transference," 112.

122. Laplanche and Pontalis, *The Language of Psycho-Analysis*, 460.

123. Eve Kosofsky Sedgwick, *Epistemology of the Closet* (Berkeley and Los Angeles: University of California Press, 1990), 81; emphasis added.

124. Donald Preziosi, *Rethinking Art History: Meditations on a Coy Science* (New Haven, Conn.: Yale University Press, 1989), 22. Preziosi does not explore the gender specificity of this dynamic, but Griselda Pollock has in various essays. See "Artists Mythologies and Media Genius, Madness and Art History," *Screen* 21, n. 3 (1980): 57–96, and, with Rozsika Parker, "God's Little Artist," in *Old Mistresses: Women, Art, and Ideology* (New York: Pantheon, 1981), 82–113.

125. Cited in Kirshner, *Vito Acconci: A Retrospective*, 15.

126. Schor, "Representations of the Penis," 8. In another piece, *Reception Room* (1973), in which he lay naked on a table rolling back and forth underneath a white sheet and exposing himself periodically, Acconci literalized and ironicized this desire to hide his penis, intoning in an audiotape played simultaneously, "What I'm really ashamed of is the size of my prick, but I won't show them that." O'Dell describes this piece at length in "Toward a Theory of Performance Art," 205–11.

127. Drawing on phenomenology, Butler performs on a theoretical and specifically queer feminist register this radical intersubjectivity that Acconci's work explores through masculinity: "As a projected phenomenon, the body is not merely the source from which projection issues, but is also always a phenomenon in the world, and estrangement from the very 'I' who claims it. Indeed, the assumption of 'sex,' the assumption of a certain contoured materiality, is itself a giving form to that body, a morphogenesis that takes place through a set of identificatory projections. That the body which one 'is' is to some degree a body which gains its sexed contours in part under specular and exteriorizing conditions suggests that identificatory processes are critical to the forming of sexed materiality" (*Bodies That Matter*, 17).

128. In Butler's terms, "the Phallus is installed as an 'origin' to suppress the ambivalence" produced in the slippage between its claim as originary and its reliance on the staging of continual anatomical examples (ibid., 61).

129. Merleau-Ponty, *Phenomenology of Perception*, 354–55.

130. Butler, *Bodies That Matter*, 138.

131. Ibid., 135.

132. Ibid., 17.

133. Ibid., 141.

134. Ibid., 136.

135. Acconci, "West, He Said (Notes on Framing)," *Vision* (Oakland), n. 1 (September 1975): 59.

136. Ibid.

137. Ibid., 61.

138. See Jean-François Lyotard, *The Postmodern Condition: A Report on Knowledge* (1979), tr. Geoff Bennington and Brian Massumi (Minneapolis: University of Minnesota Press, 1984).

139. Acconci himself describes a performative film in which he smashed a cockroach into his chest as follows: "I'm absorbing him. However, at the same time, he's absorbing me because he comes into my body" (Cindy Nemser, "An Interview with Vito Acconci," 22). David Salle argues that Acconci wants "to become one identity with the audience . . . so he can make a jump to objectifying a relationship between him and himself" (as in *Trappings*); see "Vito Acconci's Recent Work," *Arts Magazine* 51, n. 4 (December 1976): 90.

On narcissism as an attempt to incorporate the other and as a radical dispersal of the (masculine) self, see Marie-Françoise Plissart and Jacques Derrida, "Right of Inspection," *Art + Text* 32 (autumn 1989): 20–97, and, specifically in relation to postmodernism, Eugene Holland, "Schizoanalysis: The Postmodern Contextualization of Psychoanalysis," *Marxism and the Interpretation of Culture* (Chicago: University of Chicago Press, 1988), 405–15.

140. Acconci's pathetic masculinity has come back into vogue with the celebration of the work of artists such as Mike Kelley; see Elizabeth Sussman, *Mike Kelley: Catholic Tastes* (New York: Whitney Museum of American Art, 1993). From Los Angeles, where Paul McCarthy has been actively performing pathetic masculinity since the early 1970s, Kelley is linked to both Acconci and McCarthy. Kelley recently completed a video project restaging a number of Acconci's performances with young, preppy men and women, dramatically changing the effects of Acconci's pieces; these are compiled in a video entitled *Fresh Acconci* (1995).

141. See Gilles Deleuze and Félix Guattari, *Anti-Oedipus: Capitalism and Schizophrenia* (1972), tr. Robert Hurley, Mark Seem, and Helen R. Lane (Minneapolis: University of Minnesota Press, 1983); Klaus Theweleit discusses this model in relation to the soldier male in *Male Fantasies*, vol. 1, *Women, Floods, Bodies, History*.

142. Kaja Silverman, "Masochistic Ecstasy and the Ruination of Masculinity in Fassbinder's Cinema," *Male Subjectivity at the Margins* (New York and London: Routledge, 1992), 264–65.

143. This is Lacan's term for the analyst, authorized through transference by the analysand as the "subject supposed to know"; see "Of the Subject Who Is Supposed to Know, of the First Dyad, and of the Good," in *Four Fundamental Concepts*, 230–43.

144. On the doubled alienation of women in patriarchy, see Gayatri Spivak's "Displacement and the Discourse of Woman."

4. THE RHETORIC OF THE POSE: HANNAH WILKE AND THE RADICAL NARCISSISM OF FEMINIST BODY ART

1. From a 1985 film by ernst of an interview with Wilke (Hannah Wilke Estate).

2. Schneemann interview with Christy Sheffield Sanford, *Red Bass* (New Orleans, 1989), 18.

3. Barbara Smith, "On the Body as Material," an interview with Carolee Schneemann, *Artweek* 21, n. 32 (October 4, 1990): 25.

4. This chapter reworks and extends material from several earlier essays; see "Post-feminism, Feminist Pleasures, and Embodied Theories of Art," in *New Feminist Criticism: Art, Identity, Action,* ed. Joanna Frueh, Cassandra Langer, and Arlene Raven (New York: Harper-Collins, 1994); "Interpreting Feminist Bodies: The Unframeability of Desire," *The Rhetoric of the Frame: Essays on the Boundaries of the Artwork,* ed. Paul Duro (Cambridge and New York: Cambridge University Press, 1996); "*Intra-Venus* and Hannah Wilke's Feminist Narcissism," in *Intra-Venus/Hannah Wilke* (New York: Ronald Feldman Gallery, 1995); and "Pleasures of the Flesh: Feminism and Body Art" (unpublished). I am deeply grateful to Hannah Wilke, whom I met just before she died and who was fascinating and feisty even in the throes of illness; and to Donald Goddard, her long-term partner whom she married just before she died, and Marsie Scharlatt, her sister, for their help and encouragement. I am indebted also to Saundra Goldman, LouAnne Greenwald, and Thatcher Carter, whose thoughts on Wilke were provocative.

5. Owens's term is actually "rhetoric of pose." Craig Owens, "The Medusa Effect; or, The Spectacular Ruse" (1984), reprinted in *Beyond Recognition: Representation, Power, and Culture,* ed. Scott Bryson et al. (Los Angeles and Berkeley: University of California Press, 1992), 192. See also in this collection his essay "Posing" (1985), 201–17.

6. Other important feminist artists whose work insistently negotiated the pose include Ulrike Rosenbach (who performs herself as Botticellian Venus, object of male desire and projected sexual fantasies, in *Reflections on the Birth of Venus,* 1976), and Valie Export (see Roswitha Mueller, *Valie Export: Fragments of the Imagination* [Bloomington and Indianapolis: Indiana University Press, 1994]).

7. They are also models that, as many feminists have complained, tend to slide from the *descriptive* into the *prescriptive* realm such that the analysis of the privileging of anatomical masculinity in patriarchy (body-with-penis as "whole"; body-without-penis as "lacking" in the castration complex) becomes its justification. See Jane Gallop, "Phallus/Penis: Same Difference," in *Thinking through the Body* (New York: Columbia University Press, 1988), 124–33.

8. Laura Mulvey, "Visual Pleasure and Narrative Cinema" (1975), reprinted in *Visual and Other Pleasures* (Bloomington and Indianapolis: Indiana University Press, 1989), 14–26.

9. Luce Irigaray argues that "[f]emale sexuality has always been conceptualized on the basis of masculine parameters," which oppose it to male sexuality with the supposed fullness of its phallic activity such that women are defined as "a non-sex," their lot that of "lack" and "penis envy." See "This Sex Which Is Not One," in *This Sex Which Is Not One* (1977), tr. Catherine Porter with Carolyn Burke (Ithaca, N.Y.: Cornell University Press, 1985), 23.

10. Judith Butler, *Bodies That Matter: On the Discursive Limits of "Sex"* (New York and London: Routledge, 1993), 13, 10.

11. While I don't address at length the potential for a lesbian or bisexual gaze vis-à-vis Wilke's work, this should be understood as a consequence of the challenge to a fixed, coherent, male gaze (as will be clear in my analysis later on of feminist critical responses to her work).

12. Wilke, interview with the author, November 22, 1992.

13. Trinh T. Minh-ha, from her movie *Surname Viet Given Name Nam* (1989), script published in Trinh, *Framer Framed* (New York and London: Routledge, 1992), this quotation page 78.

14. Wilke, "Stand Up," words for a song written and performed for *Revolutions Per Minute: The Art Record* (Ronald Feldman Fine Art and Charing Cross Co., 1982), cited in Thomas H. Kochheiser, *Hannah Wilke: A Retrospective* (Columbia: University of Missouri Press, 1989), 146. In this version of the text, the final *you're* is incorrectly spelled *your.*

15. Early photographs of Wilke show that, even at the age of two or three, her self-presence and consciousness of photography as an inscription of identity are evident: she consistently stands in striking poses, smiling engagingly, while her sister Marsie shows the far more common shyness of a young child before an adult with a camera. I am grateful to Marsie Scharlatt for sharing early photo albums of their life as children together in the 1940s and early 1950s.

16. Like many women artists of her generation, Hannah Wilke took and kept the last name of her first husband, her patronymic being Butter. While she was growing up, Wilke was known by her first name, Arlene, rather than by her middle name, Hannah. Hannah Wilke, then, represents a total transformation—through the performativity of the name as well as the image—of the subject Arlene Butter.

17. Owens, "The Medusa Effect," 198.

18. Donald Preziosi, *Rethinking Art History: Meditations on a Coy Science* (New Haven, Conn.: Yale University Press, 1989), 31.

19. Kochheiser, ed., *Hannah Wilke,* 116.

20. See Gerrit Henry, "Views from the Studio," *Art News* 75, n. 5 (May 1976): 44–45.

21. At the time, the art world was also structurally heterosexual in its assumptions; this has changed to a certain extent, with openly gay men gaining a certain amount of power and rewriting histories of art. Unfortunately, this shift has benefited primarily gay men and has not always worked to the advantage of women artists such as Wilke (not to mention lesbian artists).

22. Maurice Merleau-Ponty, *Phenomenology of Perception* (1945), tr. Colin Smith (New York: Humanities Press, 1962), 102.

23. The original exhibition at P.S. 1 included forty-eight photographs and one hundred cards with the quotes typed on them by Wilke. These original quotes included some texts by women (Lucy Lippard, Eleanor Antin, and others), but these were excised in the live performance versions. Some male politicians (Hitler, etc.) and writers (Joyce, Goethe, etc.) were also included in both versions. I am very grateful to Donald Goddard for this detailed information.

24. These come from Wilke's toy ray gun collection, which she began while she was involved with Claes Oldenburg (whose ray gun collection is far better known); on Wilke's struggle with Oldenburg over authorship of *his* image, see Tim Cone, "Life over Art: Oldenburg's Privacy, Wilke's Publicity," *Arts Magazine* 64, n. 1 (September 1989): 25–26. In 1986 Wilke stated of this image: "The porn magazines degrade people. The woman becomes a dodo bird. She's being manipulated. *I say Hannah Wilke is making this art.* It's mine. . . . I'm *me,* doing my own portrait. I'm in control of my body. If I sit there in a photograph with my crotch open, Lucy Lippard will say it's pornography. But there's a message. I'm looking devastated and there are toy guns on the floor and my feet are guns" (in Judy Siegel, "Between the Censor and the Muse," *Women Artists News* 86/87 [Winter 1986]: 4). Wilke is referring to Lucy Lippard's critique of her work, which I discuss later; see Lippard, "The

Pains and Pleasures of Rebirth: European and American Women's Body Art" (1976), reprinted in *From the Center: Feminist Essays on Women's Art* (New York: Dutton, 1976), 126.

25. The quotations from the piece can be found in Kochheiser, *Hannah Wilke*, 153–55.

26. I am very grateful to Marc Nochella and the Ronald Feldman Gallery for loaning me tapes of this and other performances discussed in this chapter.

27. Owens cites Roland Barthes: "Looking at a photograph, I invariably include in my scrutiny the thought of that instant, however brief, in which a real thing happened to be motionless in front of the eye. I project the present photograph's immobility upon the past shot, and it is this arrest which constitutes the pose" (Owens, "Posing," 210). He is citing Barthes, *Camera Lucida: Reflections on Photography*, tr. Richard Howard (New York: Hill & Wang, 1981), but does not give a page number.

28. Owens, "Posing," 215.

29. Eleanor Antin, "An Autobiography of the Artist as Autobiographer," in *LAICA Journal* (Los Angeles Institute of Contemporary Art), n. 2 (October 1974): 18.

30. Schneemann emerged as an artist in New York City in the late 1950s and early 1960s, working with the Living Theater in collaboration with dancers (Yvonne Rainer, Steve Paxton, Lucinda Childs, and others from the Judson Dance Theater), with experimental filmmakers (Stan Brakhage) and other visual artists (Robert Morris). Unlike Wilke, Schneemann appears to be driven less by the rhetoric of the static pose per se than by the rhetoric of randomness, body movement, and bohemianism developed by these experimental dance and film practitioners. The best source on Schneemann is her *More Than Meat Joy: Complete Performance Works and Selected Writings*, ed. Bruce McPherson (New Paltz, N.Y.: Documentext, 1979).

31. As Dan Cameron has pointed out, in performing themselves nude, feminist artists such as Schneemann were surely responding to the by then clichéd appearance in male performance pieces of a live female nude (in "the mid-60s, an evening of avant-garde performance could hardly be considered complete without a live nude woman appearing at some point in a piece, invariably one authored by a man"); see Cameron, "In the Flesh," *Carolee Schneemann: Up to and Including Her Limits* (New York: New Museum of Contemporary Art, 1996), 11. By *mobilizing* this body, Schneemann and other feminists curtailed the dynamic of objectification proposed in such practices (Cameron notes that "Schneemann and other women artists of her generation were marginalized as a direct result of their successful usurpation of male privilege within the rules of representation" [12]).

32. Interview with Sanford, *Red Bass*, 23. In *More Than Meat Joy* Schneemann also stresses her desire "to confound this culture's sexual rigidities—the life of the body is more *variously* expressive than a sex-negative society can admit" (194). In a recent interview she states that the performative body "has a value that static depiction won't carry, representation won't carry" and that the performance of the body is precisely a means for her to cut through the "mostly male . . . mythology of the 'abstracted self'"; see "Carolee Schneemann," an interview with Andrea Juno in *Angry Women* (San Francisco: Re/Search Press, 1991), 72, 69. Elsewhere, linking her performative use of her body to the gestural dynamics of action painting, Schneemann states: "Early on I felt that the mind was subject to the dynamics of its body. The body activating pulse of eye and stroke, the mark signifying event transferred from 'actual' space to constructed space. And that it was essential to dance, to exercise

before going to paint in order to *see better:* to bring the mind's-eye alert and clear as the muscular relay of eye hand would be." See Schneemann, "Fresh Blood" (1980), cited by Ted Castle, "Carolee Schneemann: The Woman Who Uses Her Body as Her Art," *Artforum* 19, n. 3 (November 1980): 70.

33. Merleau-Ponty, *Phenomenology of Perception*, 140. Merleau-Ponty is discussing the existence of the body in time and space; the body, then, is not an essential, unchanging entity with meaning lodged within it but the manifestation of a subjectivity in process: "In so far as I have a body through which I act in the world, space and time are not, for me, a collection of adjacent points nor are they a limitless number of relations synthesized by my consciousness, and into which it draws my body. I am not in space and time, nor do I conceive space and time; I belong to them, my body combines with them and includes them. The scope of this inclusion is the measure of that of my existence; but in any case it can never be all-embracing. The space and time which I inhabit are always in their different ways indeterminate horizons which contain other points of view" (140).

34. Schneemann, *More Than Meat Joy,* 52, 56. A perfect example of such a staging is Robert Morris's *Site,* in which Schneemann, who was initially brought on as an equal collaborator, was made to pose nude as Manet's *Olympia* while Morris struggled across the stage with large pieces of wood. I discuss this piece in "Dis/Playing the Phallus: Male Artists Perform Their Masculinities," *Art History* 17, n. 4 (December 1994): 557, 560.

35. See the description of this piece in *More Than Meat Joy,* 180–81. Kristine Stiles uses *Naked Action Lecture* rather negatively as an example of works that have tempted historians and critics to overemphasize Schneemann's feminism, posing it in negative relief in relation to *Schlaget Auf* (which, in Stiles's words, "does not lend itself to a more focused feminist concern"); see her essay "Schlaget Auf: The Problem with Carolee Schneemann's Painting," *Carolee Schneemann: Up to and Including Her Limits,* 18, 19. Obviously, I differ from Stiles's position, which proposes that critics and historians have opportunistically overemphasized Schneemann's *feminism* in order to garner more attention for her (it seems obvious to me that Schneemann's feminism, rather than positioning her favorably, has served to relegate her work to the sidelines of contemporary art history) and rather precipitously dismisses those who have focused on *Interior Scroll* as a major feminist piece. Too, while I recognize the polemical and strategic value of Stiles's insistent attempts to assert and celebrate Schneemann as singular origin of a particular kind of embodied practice, I depart from her celebratory approach to Schneemann's work, which tempts her to oversimplify the issue of influence. (In the context of this chapter it is worth noting, however, that Schneemann's explorations in this arena did begin long before the rise of the women's movement and Wilke's production of body art works.)

36. Schneemann, *More Than Meat Joy,* 180. Through these questions, Schneemann's *Naked Action Lecture* contrasts strongly with Morris's *21.3* (1963), where Morris reiterates the codes of male academic authority by posing as a Panofskyan lecturer. I discuss this piece in "'The Clothes Make the Man': The Male Artist as a Performative Function," *Oxford Art Journal* 81, n. 2 (1995): 27.

37. Schneemann, *More Than Meat Joy,* 52.

38. Lorraine O'Grady, "Olympia's Maid" (1992), in *New Feminist Criticism,* 155.

39. Adrian Piper, "Food for the Spirit, July 1971," in *High Performance* 13 (Spring 1981),

reprinted in Adrian Piper, *Out of Order, Out of Sight: Volume I, Selected Writings in Meta-Art, 1968–1992* (London and Cambridge, Mass., 1996), 55; and Jane Farver, *Adrian Piper: Reflections 1967–1987* (New York: Alternative Museum, 1987), 13.

40. O'Grady, "Olympia's Maid," 155. See also Joanna Frueh's discussion of the piece in "The Body through Women's Eyes," in *The Power of Feminist Art: The American Movement of the 1970s, History and Impact,* ed. Norma Broude and Mary D. Garrard (New York: Abrams, 1994), 194.

41. Piper describes her obsession with Kant, which led to her Ph.D. studies in philosophy, in her essay "Flying," in Farver, *Adrian Piper: Reflections 1967–1987,* 22.

42. Ibid., 23.

43. Piper's work also plays on the absurdity of the way blackness is defined in U.S. culture—according to the culturally sanctioned "one drop rule" (based on anxieties about the potential corruption of "pure" whiteness), people are considered black if they have so much as "one drop" of black blood (even if they appear to be and identify as white). Piper has related racism and sexism: "To the extent that the primary foundation of racism is visual, it is commensurate with sexism. Some people are discriminated against because they have breasts, while others are discriminated against because they have woolly hair. If you happen to have breasts *and* woolly hair, you are in double trouble." She continues: "We need to understand how these deeply buried archetypes function in our character and personalities, how they engender a sense of security when people look and act as they are 'supposed to' and fear and anger when they don't. These perceptual issues are fundamental." See Maurice Berger, "The Critique of Pure Racism: An Interview with Adrian Piper," *Afterimage* 18, n. 3 (October 1990): 9. I should acknowledge here the way in which my readings of Piper's works (readings that are clearly informed by and invested in poststructuralist, feminist theory) are willful transgressions of Piper's own stated antipathy to poststructuralism as "a plot" to "co-opt women and people of color and deny them access to the potent tools of rationality and objectivity" (6). While I deeply respect Piper's work and admire her commitment to Kantian philosophy, I take issue with her desire to retain a belief system that rests on "rationality and objectivity" and with what I think is her misconception of poststructuralist theories; these, after all, are multitudinous and conflicted and include feminist and antiracist philosophies that, as Berger points out, reject notions of "rationality and objectivity" for their ultimate collusion in patriarchal privileging of masculine structures of thought. I take the liberty to make such a willful reading through recourse to another insight of Piper's in this same interview (and one that is perfectly compatible with poststructuralism!)—that artists do not "have privileged access to the significance of what they're doing" (6). At the same time, I would also humbly admit the investedness and contingency of my reading of her work, which places it firmly within the parameters of my own argument.

44. The notion of the logic of the self-same describes the situation in Western patriarchy in which female subjects are defined in relation to men, such that "woman's only relation to origin is one dictated by man's." See Irigaray, "The Law of the Self-same," in *Speculum of the Other Woman* (1974), tr. Gillian C. Gill (Ithaca, N.Y.: Cornell University Press, 1985), 33.

45. Peggy Phelan, *Unmarked: The Politics of Performance* (New York and London: Routledge, 1993), 13.

46. In *Line-Up*, Acconci also projected slide images from previous performances onto himself, marking the artist/subject's identity as defined through his (self-projected) self-as-the-work-of-art. See Kate Linker's description of this piece in *Vito Acconci* (New York: Rizzoli, 1994), 58; the performance was not taped or filmed.

47. Wilke had played the audiotapes from the piece (recorded from 1973 through 1975) in a 1975 exhibition, *Lives*, at the Fine Arts Building in New York; the performance took place at the London (Ontario) Art Museum and Library and was taped on video.

48. Jacques Derrida, *The Truth in Painting*, tr. Geoff Bennington and Ian McLeod (Chicago and London: University of Chicago Press, 1987), 22, 23.

49. Stiles, "Schlaget Auf," 18. Schneemann has written and spoken extensively about her resistance to the separation of mind and body (of visual power [the "male gaze"] and the female body as object, of theory versus physicality) in many of the theories of postmodern art; see Schneemann, *More Than Meat Joy*, and the various citations of Schneemann in David Levi Strauss, "Love Rides Aristotle through the Audience: Body, Image, and Idea in the Work of Carolee Schneemann," *Carolee Schneemann: Up to and Including Her Limits*, 26–34. Linked to this, as suggested at the beginning of the chapter, is the capacity of the erotic or sensual to collapse these boundaries. As Leslie C. Jones has argued, via Herbert Marcuse's observation that "the cognitive function of sensuousness has been constantly minimized. . . . Sensuousness [is] . . . the 'lowest' faculty," sensuousness thus becomes "an ideal means of representation to challenge the modernist art practice based on vision." See Jones, "Transgressive Femininity: Art and Gender in the Sixties and Seventies," *Abject Art: Repulsion and Desire in American Art*, ed. Craig Houser, Leslie C. Jones, and Simon Taylor (New York: Whitney Museum of American Art, 1993), 43.

50. Lynda Nead, *The Female Nude: Art, Obscenity and Sexuality* (New York and London: Routledge, 1992), 6.

51. Donald Goddard has interpreted this work as being *not* perverse or obscene but about "mourning and innocence," a reading that might align it with abjection (from personal correspondence with the author, February 3, 1997). In making my particular argument, I am well aware of my own role in reframing the work in a new, but still exclusionary, way, but I stick to this reading, which places Wilke's project in relation to the broader scene of aesthetics. As Derrida admits to doing in the "Passe-Partout" section of *The Truth in Painting*, I am writing a new frame "around" this body art work, formerly excluded from the frame as "not art," in order to include it as "valuable" and "transgressive." Through this reframing, I am in this sense "*giv[ing]* . . . *rise* to the work" (Derrida, *The Truth in Painting*, 9). By implicating myself in this way, however, although I continue to assign value (and I can conceive of no other way to "do" art history and criticism at this point), I hope to make use of this erotic body art work to expose the interpretive relation as necessarily *interested* in its operations and so to open up the framing apparatus as I perpetuate it. This is a gesture that aims to contest the ostensibly neutral yet historically masculinist objectivity of art historical and critical judgment. These interpretations are offered, then, as feminist interventions in the framing apparatus of art historical interpretation, suggesting provisionally that there might be a way to "frame" that is not (or not simply) masculinist in effect. After all, as Derrida reminds us, "[t]he internal edges of a passe-partout are often beveled" (13), encouraging leakage between inside and out and, more to the point, among the various constituencies of meaning production.

52. On faciality, see Gilles Deleuze and Félix Guattari, "Year Zero: Faciality," in *A Thousand Plateaus: Capitalism & Schizophrenia* (1980), tr. Brian Massumi (Minneapolis: University of Minnesota Press, 1987), 167–91. Wilke's face as orifice seems to illustrate perfectly their descriptive exploration of faciality: "Faces are not basically individual; they define zones of frequency or probability, delimit a field that neutralizes in advance any expressions or connections unamenable to the appropriate significations. . . . The face itself is redundancy. . . . The face constructs the wall that the signifier needs in order to bounce off of; it constitutes the wall of the signifier, the frame or screen. The face digs the hole that subjectification needs in order to break through; it constitutes the black hole of subjectivity as consciousness or passion, the camera, the third eye" (168). Wilke performs her face *as* the hole "that subjectification [especially female?] needs in order to break through."

53. Here, my reading relies on my investment in and knowledge of Wilke as a feminist artist. In contrast, René Magritte's famous painting *The Rape* (1934), in which a woman's face is comprised of her naked torso (the breasts as "eyes," the navel as "nose," the pubis as "mouth"), reads to me within the context of surrealism as rather obviously misogynist (although it might also be said inadvertently to expose what was at stake for male surrealists in their obsessive objectification—and silencing—of women). Within the context of her work, and the period of feminist activism, Wilke's self-imaging is hardly "silenced" in the same way. There is another, private significance to *Gestures*—one that could only be known by access to Wilke's family. As Scharlatt and Goddard have both explained to me, *Gestures* was conceived as a mourning ritual for Scharlatt's ex-husband Hal (Wilke's former brother-in-law), who had just died very suddenly.

54. Merleau-Ponty, "The Intertwining—The Chiasm," in *Visible and the Invisible*, tr. Alphonso Lingis, ed. Claude Lefort (Evanston, Ill.: Northwestern University Press, 1968), 131.

55. On the "flesh," see Merleau-Ponty, "The Intertwining," and Didier Anzieu, *The Skin Ego: A Psychoanalytic Approach to the Self*, 1985, tr. Chris Turner (New Haven, Conn., and London: Yale University Press, 1989).

56. Merleau-Ponty, "The Intertwining," 131, 138, 140–41.

57. Marvin Jones et al. interview with Hannah Wilke, "Hannah Wilke's Art, Politics, Religion, and Feminism," *The New Common Good*, May 1985, 9. In speaking Wilke for a poststructuralist feminism, I have strategically excised from this quote its more essentializing aspects (Wilke claims priority for women because "women are biologically superior. I can have a baby, you can't" [9]). This reinforces my point that Wilke, no more than any cultural producer, is not "inherently" dislocating of the conventional links between femininity and biological procreation, but her work can enable such readings.

58. Merleau-Ponty, "The Intertwining," 139.

59. Wilke described her gum "sculptures" as a "totally andogenous [*sic*]—totally a male female form" in "Artist Hannah Wilke Talks with ernst," *Oasis de Neon* 1, n. 1 (1970). n.p. She also frequently played out their specifically vulvar connotations.

60. Barbara Schwartz, "Art: Hannah Wilke," *New York Woman* 1 (1973): 55; Lil Picard, "Hannah Wilke: Sexy Objects," *Interview*, January 1973: 18; Noel Frackman, "Hannah Wilke," *Arts Magazine* 52, n. 9 (May 1978): 28.

61. Elizabeth Hess, "Self- and Selfless Portraits," *Village Voice* 34, n. 39 (September 26, 1989): 93. Judith Barry and Sandy Flitterman, "Textual Strategies: The Politics of Art-

Making," *Screen* 21, n. 2 (Summer 1980): 39. On 1980s critiques of Wilke, see also Anette Kubitza's interesting "Hannah Wilke: Bilder vollständiger und unvollständiger Schönheit," *Frauen Kunst Wissenschaft* 17 (May 1994): 72–84. I am grateful to Anette Kubitza for sharing this essay with me.

62. Hess, "Self- and Selfless Portraits," 93. Hess continues, "Over the years Wilke has constructed a narrative around herself, while Simpson, a generation younger, is more interested in the racial, or racist construction of female identity." This claim is not convincing, as I discuss in my examination of Wilke's exploration of Jewishness as an aspect of her identity. Hess also privileges Simpson for using text, apparently not recognizing that Wilke often employed text and image as well.

63. Catherine Liu, "Hannah Wilke," *Artforum* 28, n. 4 (December 1989): 138.

64. Liu is astute in her identification of a link between the liberationist rhetoric of the 1960s and early 1970s and Wilke's project. Such liberationist ideals were key to the development of a conception of bodily "freedom" and the ambitious attempt to perform a kind of masculine relationship to transcendence by Wilke as well as other feminists such as Schneemann and Judy Chicago. Schneemann has been eloquent on this point: "There were many reasons for my use of the naked body in my Kinetic Theater works: to break into the taboos against the vitality of the naked body in movement, to eroticise my guilt-ridden culture and further to confound this culture's sexual rigidities" (*More Than Meat Joy*, 194).

65. See my discussion of how antiessentialist feminist theory in this way dovetails with conservative modernist prohibitions against visual pleasure in "The 'Sexual Politics' of *The Dinner Party*: A Critical Context," in *Sexual Politics: Judy Chicago's* Dinner Party *in Feminist Art History*, ed. Amelia Jones (Los Angeles: UCLA/Armand Hammer Museum of Art; Los Angeles and Berkeley: University of California Press, 1996).

66. Wilke in Cynthia Rose, "O Supernude," interview with Hannah Wilke, *New Musical Express*, March 19, 1983, 13.

67. See Mira Schor's negative evaluation of Sherman's work in "Backlash and Appropriation," *The Power of Feminist Art*, 255. I discuss Sherman's work in relation to body art in my essay "Tracing the Subject with Cindy Sherman," in *Cindy Sherman* (Chicago: Museum of Contemporary Art; Los Angeles: Museum of Contemporary Art, forthcoming [1997]).

68. Kim Paice suggestively places Wilke's *S.O.S.* series as "poised precariously at the juncture of essentialism and femininity's now-popularly discussed anticenter, masquerade," in "Resisting, Essentially: The Case of Hannah Wilke," *Art + Text* 48 (May 1994): 24.

69. Simone de Beauvoir, *The Second Sex*, tr. H. M. Parshley (New York: Knopf, 1952), 592.

70. Thus, as I discussed in chapter 1, antiessentialist feminist Mary Kelly has argued that "when the image of the woman is used in a work of art, that is, when her body or person is given as a signifier, it becomes extremely problematic"; "No Essential Femininity: A Conversation between Mary Kelly and Paul Smith," *Parachute* 37, n. 26 (Spring 1982): 32. Catherine Lupton has written an excellent critique of the hegemonic status of Kelly's argument in her "Circuit-Breaking Desires: Critiquing the Work of Mary Kelly," in *Art Has No History!: The Making and Unmaking of Modern Art*, ed. John Roberts (New York and London: Verso, 1994), 230–56.

71. Lucy Lippard, "The Pains and Pleasures of Rebirth," 125. It is this evaluation of feminist body art as narcissistic that has, in part, functioned to justify its exclusion from

histories of contemporary art. I am, of course, using its "narcissism" to privilege it, reposi-tioning it within this history self-servingly (narcissistically?)—to legitimate this work and, by extension, myself as its proponent.

72. Ibid., 125, 126.

73. An interesting aspect of Lippard's analysis, as well as of antiessentialist feminist critiques of Wilke's work, is thus the tendency to accept and naturalize the idea of "beauty" rather than pointing out that it is, in fact, itself a social construction. This is not to say that Wilke is *not* beautiful as this might conventionally be understood but, rather, to emphasize that she is gorgeous specifically according to certain socially determined ideals (and she does look stereotypically "Jewish" as well, confusing the normative dimensions of these ideals). In my view, this constructedness and contingency of her "beauty" was precisely what Wilke highlighted in flaunting herself continuously. See also Ann Sargent-Wooster's dismissal of Wilke's "beauty and self-absorbed narcissism" as making her work hard to take seriously, in "Hannah Wilke: Whose Image Is It?" *High Performance*, Fall 1990, 31.

74. The term "fascist feminism" appears on Wilke's 1977 poster displaying Wilke, bar-ing her chest, with the text "Marxism and Art: Beware of Fascist Feminism." Wilke's chest and face are covered with bubble gum marks and a man's tie hangs between her breasts. I discuss this poster briefly in "Postfeminism, Feminist Pleasures, and Embodied Theories of Art," 32. Wilke stated to me that her "Beware of Fascist Feminism" poster was a response to readings such as Lippard's (hardly antiessentialist) account as well as to subsequent antiessentialist evaluations of her work; she was infuriated by the "fascism" (the dogmatic prescriptiveness) of such determinations of her work as simply narcissistic. See also her comments in "Artist Hannah Wilke Talks with ernst," n.p. The implication of such deter-minations is that no conventionally attractive woman can use her body in her work as this will necessarily be condemned as frivolous, narcissistic, and acquiescing to heterosexual male desires. On the other hand, there were certainly "fascist" (that is, dogmatic and pre-scriptive) elements to so-called essentialist feminist discourse in the early 1970s as well; the complex case of Judy Chicago is exemplary of this—see Jones, ed., *Sexual Politics*.

75. These "performalist" images form a fake book jacket; they were taken with Richard Hamilton, Wilke's friend and a British Independent Group artist, in Cadaques, Spain, where Duchamp had lived on and off during his later years. See Frueh, "Hannah Wilke: Art," in Kochheiser, ed., *Hannah Wilke*, 34.

76. See my "Re-placing Duchamp's Eroticism: 'Seeing' *Étant donnés* from a Feminist Perspective," in *Postmodernism and the En-Gendering of Marcel Duchamp* (New York and Cam-bridge: Cambridge University Press, 1994), 191–204.

77. See the book of Duchamp's collected writings, *Marchand du sel: Écrits de Marcel Duchamp*, ed. Michel Sanouillet (Paris: Terrain vague, 1959).

78. Wilke, "I Object: Memoirs of a Sugar Giver," in Dieter Daniels, ed., *Übrigens Ster ben Immer die Anderen: Marcel Duchamp und die Avantgarde seit 1950* (Cologne: Museum Ludwig, 1988), 270.

79. Irigaray, *Speculum of the Other Woman*, 113.

80. Rose, "O Supernude," 13.

81. Ovid, *Metamorphoses*, tr. Mary M. Innes (Harmondsworth: Penguin, 1955), 85, 87.

82. Ibid., 86.

83. According to Freudian analysis, Narcissus plays out a self-love that is endemic to homosexual masculinity—in that the homosexual male pathologically loves men ("himself") rather than women (the other). I want to avoid confirming such a troublesome formulation, which assumes that difference can only be experienced through anatomical gender (i.e., that by loving other men, a homosexual man is loving "himself," as if all men are identical in their subjectivity).

84. As Joanna Frueh has written in reference to Wilke's work, "Narcissus fell in love with himself, but women tend to fall in love with images created for them." See "Hannah Wilke: Narcissism," in Kochheiser, ed., *Hannah Wilke*, 63.

85. See Sigmund Freud, "On Narcissism: An Introduction" (1914), *Collected Papers*, vol. 4, tr. Joan Riviere (London: Hogarth Press and the Institute of Psycho-Analysis, 1953), 59. There is also, however (as Acconci's *Openings* suggested), another psychoanalytic theory that locates narcissism within a structure that is closer to the original model of Narcissus: within the pre-oedipal stage wherein the infant is merged with the maternal woman in a collapse of self into (m)other. As elaborated by French feminist theorists such as Luce Irigaray and Hélène Cixous, the female subject herself experiences just such a closeness with her own body. See, especially, Irigaray's essays in *This Sex Which Is Not One*.

86. I suggest this metaphorically, not presuming to assert that Wilke was actually impervious to the criticisms leveled at her work (this would be belied by her production of the fascist feminism poster).

87. Edward Jones, "Critique of Empathetic Science: On Kohut and Narcissism," *Psychology and Social Theory*, n. 2, "Critical Directions in Psychoanalysis and Social Psychology" issue (Fall/Winter 1981): 30. I am grateful to Marsie Scharlatt for suggesting that I look at Kohut's work.

88. See Irigaray, "The Law of the Self-Same," 32–34.

89. This is not to say that women can never take on agency or project themselves into the myth of transcendence/coherence. Rather, it is to say that in our femininity, as articulated within patriarchy, we necessarily experience this impossibility as paramount while men who attain socialized masculinity are given access to many tools that enable them to deny it (to assert their "transcendence"). Even when women adopt "transcendence" (when we, for example, assume the position of author), we are generally made continually aware of its illusory (if still potentially empowering) nature.

90. Jones, "Critique of Empathetic Science," 30. Obviously this "true object" aligns with what I have defined as the mythical Cartesian *subject* (an impossibility that is nonetheless perceived and that, thus, confers power on masculine subjects). For Kohut, too, narcissism is present in every subject, but in "healthy" situations takes on a mature form that supersedes the childhood forms that cannot accommodate any kind of object choice. Of interest here, Kohut also explores (without acknowledging gender differences) the way in which all subjects labor to cohere themselves through the "coalescence of self-nuclei" in order to move beyond the stage of infantile fragmentation, where each body part and mental function is experienced as discrete and unrelated. All subjects still experience their bodily and mental functions as "narcissistic zones of the body-mind self" that can be incorporated into an overall structure of self (33). I would stress, per Lacan, that this "self" is never fully attained.

91. Butler, *Bodies That Matter*, 10, 13.

92. Lea Vergine, *Il corpo come linguaggio (La "body-art" e storie simili)*, tr. Henry Martin (Milan: Giampaolo Prearo Editore, 1974), 35. Again, I have corrected the numerous typographical errors from this source.

93. Mary Ann Doane has argued that "narcissism confounds the differentiation between subject and object and is one of the few psychical mechanisms Freud associates specifically with female desire"; see *The Desire to Desire: The Woman's Film of the 1940s* (Bloomington and Indianapolis: Indiana University Press, 1987), 32. I have made a similar claim for Lynda Benglis's brilliant video pieces from this period; see my "Interpreting Feminist Bodies." This is simply to reinforce that Wilke is in many ways paradigmatic of feminist body artists during this period.

94. Barthes discusses the politics of refusing pleasure in *The Pleasure of the Text* (1973), tr. Richard Miller (New York: Hill and Wang, 1975), where he argues that the left refuses pleasure because of its association with hedonism (as well as, I would add, its perceived link with the manipulative seduction of the "culture industry"), while on the right, "everything that is abstract, boring, political, is shoved over to the left and pleasure is kept for oneself" (22). I am diverging from Barthes's one-sided view, which places pleasure on the side of the right: he can do so because he addresses pleasure from a French point of view; in the United States, conversely, erotic pleasures are determined as "illicit" enjoyments of the flesh and excoriated by the right (the "moral majority"). Nonetheless, his point is useful: the continual yet always already failed attempts to contain pleasure on the part of both right and left (depending on the political context) tell us something about its power to transgress borders and complicate attempts at (interpretive) containment.

95. Laura Mulvey, "Visual Pleasure and Narrative Cinema" (see my discussion of this Mulveyan paradigm and its effects in "Postfeminism, Feminist Pleasures, and Embodied Theories of Art"); and bell hooks, "The Oppositional Gaze," in *Black Looks: Race and Representation* (Boston: South End Press, 1992), 124.

96. Wilke in "Artist Hannah Wilke Talks with ernst," n.p. The *S.O.S.—Starification Object Series* also included a number of performances in which Wilke handed gum out to audience members, asking them to chew it, and then stripped and "sculpted" these gum wads into cock/cunts and applied them to her naked body (merging the saliva of the "other" with the flesh of the "self"). Because of the "always already" quality of women's woundedness, Wilke's exploration of the scarring of the subject (as in the work of Gina Pane) contrasts strikingly with the work of male artists who damage their bodies masochistically.

97. The first part of this quotation is from Hannah Wilke, from "Intercourse With . . ." (1977), reprinted in Daniels, *Übrigens Sterben*, 266; the second part, beginning "I decorated," is from "Artist Hannah Wilke Talks with ernst," n.p. Wilke's externalization of the "scars" of femininity and Jewishness (and her use of the term "scarification/starification" in relation to these pieces) thus also references the practice in some African cultures of scarification. Kubitza discusses Wilke's sense of beauty as both a positive thing and an injury (signified by the scars/wounds) in "Hannah Wilke: Bilder vollständiger," 74. See also Kristine Stiles's examination of the shaving of female collaborators' heads during and after World War II in relation to representations of the traumatized body, in "Shaved Heads and Marked Bodies: Representations from Cultures of Trauma," *Lusitania*, n. 6: *Vulvamorphia* (1994), 23–40.

98. Cited in Avis Berman, "A Decade of Progress, but Could a Female Chardin Make a Living Today," *Art News* 79, n. 8 (October 1980): 77.

99. Wilke in Jones et al., "Hannah Wilke's Art," 1.

100. Wilke in "Artist Hannah Wilke Talks with ernst," n.p.

101. Herbert Marcuse develops his discourse of erotic and artistic liberation from the instrumentalism of the capitalist regime in *Eros and Civilization* (London: Routledge & Kegan Paul, 1956), highly influential in the New York art world in the 1960s and 1970s; on Marcuse's influence, see Maurice Berger's excellent *Labyrinths: Robert Morris, Minimalism, and the 1960s* (New York: Harper & Row, 1989), especially 74–75, 161. The work of French theorists Gilles Deleuze and Félix Guattari also explores the way in which desire is repressed and expressed in capitalism; see *Anti-Oedipus: Capitalism and Schizophrenia* (1972), tr. Robert Hurley, Mark Seem, and Helen R. Lane (Minneapolis: University of Minnesota Press, 1983).

102. Hannah Wilke, text from catalog of *American Women Artists 1980* (São Paulo, Brazil: Museo de arte contemporanea da universidade de São Paulo, 1980), cited in Jones et al., "Hannah Wilke's Art," 10.

103. Wilke in Cassandra Langer, "The Art of Healing," *Ms.*, January/February 1989, 132. After she became ill, Wilke described her changed self-conception: "*Right now, I'm more concerned with my head than with my vagina because I have an illness. With the big face drawings, I'm trying to save myself. . . . Life is more important than art*"; see Janet Wichenhaver, "Hannah Wilke: SoHo Artist Does 'About Face,'" *West Side Spirit* 5, n. 34 (October 1, 1989): 5.

104. Bonnie Finnberg, "Hannah Wilke Interview," *Cover*, September 1989, 16.

105. In Goddard's words, "I suppose it was posing, but it wasn't really. It was . . . less like posing than *So Help Me Hannah*, although that was also a case of endless opportunities once the door had been opened" (letter to the author, February 3, 1997).

106. See, for example, Andrew Perchuk's glowing review in *Artforum* 32, n. 8 (April 1994): 93–94, and Paice, "Resisting, Essentially." It is worth noting that *Artforum* refused to publish a features piece on Wilke's last project that I proposed a few months before the show opened (that is, before the new position had been taken on Wilke's work); while this rejection could have been due simply to an honest perception of my lack of skill as a writer, as I had long been a reviewer for the magazine I tend to doubt this explanation. Rather, it seemed clear to me that the magazine was interested neither in accommodating the work of a feminist artist deemed "essentialist" (until *Intra-Venus* complicated this picture) nor in having this work discussed by an overtly feminist writer. Also, Elizabeth Hess had the courage radically to revise her earlier reading of Wilke's artistic project in a review of *Intra-Venus*, "Fem Fatale," *Village Voice*, January 25, 1994, 82. These "courageous" works recontextualize Wilke's earlier works for Hess, breathing "new life" into her entire oeuvre.

107. Kubitza argues that aging, illness, and death are just as crucial components of Wilke's work as is beauty; in "Hannah Wilke: Bilder vollständiger," 72. Vivian Sobchack has also pointed to the role of *ageism* in determining the "value" of a woman-as-image; see "Revenge of *The Leech Woman*: On the Dread of Aging in a Low-Budget Horror Film," in *Uncontrollable Bodies: Testimonies of Identity and Culture*, ed. Rodney Sappington and Tyler Stallings (Seattle: Bay Press, 1994), 79–91.

108. See Cassandra Langer, "The Art of Healing," 132–33, and LouAnne Greenwald, "Subject; Object: Boundaries Unbound—A Look at the Work of Three Feminists in Their

Exploration of Subjectivity through Representation," unpublished paper. On Jo Spence, see Nead, *The Female Nude*, 79–82, and Jo Spence, *Putting Myself in the Picture: A Political Personal and Photographic Autobiography* (Seattle: Real Comet Press, 1988). Thatcher Carter explores Wilke's and Spence's work in "An Un/Official Breast: A Theoretical Examination of Mastectomy," unpublished paper for my graduate seminar at University of California, Riverside, 1996. The exploration of body transformations and their effects on the "self" (as perceived internally and by the culture at large) has been a focus for many feminist artists, such as Eleanor Antin (with her piece *Carving: A Traditional Sculpture*, 1973), Martha Wilson (*I Make Up the Image of My Perfection/I Make Up the Image of My Deformity*, 1974), and Lynn Hershman (with her performance of the alter ego Roberta Breitmore in the early 1970s).

109. The small metal objects are actually from Wilke's collection of ray guns.

110. Beauvoir, *The Second Sex*, 592.

111. Jacques Derrida, *Memoires for Paul de Man*, tr. Cecile Lindsay et al. (New York: Columbia University Press, 1989), 32, 33.

112. Ibid., 32.

113. I discuss this dynamic vis-à-vis the death of my own father in "Love and Mourning: Who Am I That You Are No Longer?" *Framework* 7, n. 2 (1995): 14–19.

114. Susan Sontag, *Illness as Metaphor* (New York: Farrar, Straus and Giroux, 1977), 48.

115. This image in particular highlights the issue of collaboration: if Goddard, Wilke's partner and later husband, was wielding the camera, is this image necessarily just another example of the nefarious effects of the "male gaze"? Or is the picture telling us, as I will suggest, that the "gaze" does not simply reside in the person who appears to look (take pictures) but also (always already) in the body/self that is looked at (that poses).

116. As Nead notes, the naked is the "negative 'other'" of the nude, representing the body "in advance of its aesthetic transformation"; and the obscene is "what is off, or to one side of the stage, beyond presentation" (*The Female Nude*, 14, 25). In an essay on the suppressed sexual investments of discourses on the aesthetic from Plato through Kant to Michael Fried, Kelly Dennis argues persuasively that these discourses—which devalue that which is considered feminine and appear to exclude femininity from their purview—in fact make femininity their "originary condition": "the continued omission of *femininity [is]* . . . *the precondition* of ontological questioning." Dennis adds to this point the following: "What is therefore at stake in the mimetic theory underlying the Western tradition of art history is the preservation of 'Truth' by disavowing the necessity of the viewer's participation in the illusionism of imagery and the potential not only for losing the self in the identification with resemblance but the pleasure derived therefrom." See Kelly Dennis, "Playing with Herself: Feminine Sexuality and Aesthetic Indifference," in *Eros and Masturbation: The Historical, Theoretical, and Literary Discourses of Autoeroticism*, ed. Paula Bennet and Vernon A. Rosario II (Durham, N.C.: Duke University Press, forthcoming).

117. Pierre Bourdieu, *Distinction: A Social Critique of the Judgement of Taste* (1979), tr. Richard Nice (Cambridge, Mass.: Harvard University Press, 1984), 489.

118. I have expanded this argument vis-à-vis Annie Sprinkle's similar unveiling of the female sex in "Interpreting Feminist Bodies," 236–38. There I point out that, as Jean-François Lyotard has remarked in relation to the pornographic spread-eagled naked female body in

Marcel Duchamp's *Etant donnés*, "con celui qui voit" (he who views is a cunt). Jean-François Lyotard, *Les Transformateurs Duchamp* (Paris: Galilée, 1977), 138.

119. Jacques Lacan, "The Split between the Eye and the Gaze" (1964) and "Anamorphosis" (1964), in *The Four Fundamental Concepts of Psycho-Analysis*, ed. Jacques-Alain Miller, tr. Alan Sheridan (New York: Norton, 1981), 77, 84–85.

120. Bryan S. Turner, *The Body and Society* (New York and Oxford: Basil Blackwell, 1989), 7.

121. These are the terms of Rosalind Krauss, borrowed from surrealist Georges Bataille; Krauss uses them to describe the denaturalizing of the conceptual boundaries of corporeality in surrealist photography. See Krauss, "Corpus Delicti," in Krauss and Jane Livingston, *L'Amour Fou: Photography and Surrealism* (New York: Abbeville, 1984), 64, 65. Not incidentally, Krauss herself reapplies this model in relation to the performative self-portrait photographs of Cindy Sherman, which are closely related to Wilke's project. See Krauss, *Cindy Sherman 1975–1993* (New York: Rizzoli, 1993), especially 89–97.

122. Through this modification of Krauss's theory I take issue with her complete, willful blindness to the way in which *bassesse* functions in surrealist photography almost exclusively in relation to the *female* body-as-*informe*; Krauss is, astoundingly, also oblivious to sexual difference in her application of this theory to the work of Cindy Sherman (see my discussion of this in "Tracing the Subject with Cindy Sherman"). Thus, I am arguing here that through the particular context of this image—as part of Wilke's lifelong project of self-construction, as a ravaged version of the "beautiful" if dejected Wilke in *What does this represent*—she subverts the very tradition by which the debased body of the woman is objectified.

123. See Irigaray, "When Our Lips Speak Together," in *This Sex Which Is Not One*, 205–18.

124. Jones et al., "Hannah Wilke's Art," 11. I have corrected the spelling of *gorgeous*, which is misspelled throughout as *georgeous*.

125. Jean-Paul Sartre, *Being and Nothingness* (1943), tr. Hazel Barnes (New York: Washington Square Press, 1956).

126. See Kimberlé Crenshaw on the "intersectionality" of race and gender in "Whose Story Is It, Anyway? Feminist and Antiracist Appropriations of Anita Hill," in *Race-ing Justice, En-gendering Power: Essays on Anita Hill, Clarence Thomas, and the Construction of Social Reality*, ed. Toni Morrison (New York: Pantheon, 1992), 402–440. In this last section I am highlighting Wilke's complication of the monolithic nature of whiteness; at the same time, Peggy Phelan's observation that "[w]hite women . . . have been encouraged to mistake performance for ontology" is well taken in that white feminist body artists do tend to assume *their* femininity to be universalizable. See Peggy Phelan, *Unmarked: The Politics of Performance*, 105.

127. By placing "transcends" in quotation marks I want to ironicize it; further, I want to make clear that, while I do see white feminism as being inevitably bound up in ethnicity (as opposed to what an assumption of whiteness as normative would imply), I also completely agree with the general point of this critique: that (white) feminism tended to downplay other differences in the exclusive focus on gender. Jewishness has a complex relationship to whiteness—in U.S. culture in certain contexts (such as, to a large extent, the intelligentsia and the art world), the two largely function as coextensive. Lisa Bloom's work

on feminism and ethnicity, especially Jewishness, is an important corrective to (white) feminism's myopia. See her "Contests for Meaning in Body Politics and Feminist Art Discourses of the 1970s and 1980s: The Work of Eleanor Antin," in *Performing the Body/Performing the Text,* ed. Amelia Jones and Andrew Stephenson (forthcoming). See also Nancy Ring's discussion of Jewishness in relation to Judy Chicago, "Identifying with Judy Chicago," in Amelia Jones, ed., *Sexual Politics,* 126–40.

128. Sontag, *Illness as Metaphor,* 48, 82–83.

129. Wilke makes note of the way in which her Jewishness inflects her appearance as an ideal beauty in the 1985 filmed interview with ernst. On the conflation of race (specifically Jewishness), gender, and sexual identity in fascist ideology, see Klaus Theweleit, *Male Fantasies,* vols. 1 and 2, tr. Erica Carter, Stephen Conway, and Chris Turner (Minneapolis: University of Minnesota Press, 1987 and 1989).

130. Reuben Rine, *Narcissism, the Self, and Society* (New York: Columbia University Press, 1986), 40; cited by Frueh in "Hannah Wilke: Narcissism," 65.

5. DISPERSED SUBJECTS AND THE DEMISE OF THE "INDIVIDUAL": 1990S BODIES IN/AS ART

1. Harry Gamboa, from the script for the play "Ismania," in Gamboa, *Urban Exile: Collected Writings of Harry Gamboa Jr.,* ed. Chon Noriega (Minneapolis: University of Minnesota Press, forthcoming). As Marshall McLuhan puts it in his epochal *Understanding Media* (1964; Cambridge, Mass., and London: MIT Press, 1996), "individualism is not possible in an electronically patterned and imploded society" (51).

2. Quoted by Amy Harmon in "Daily Life's Digital Divide," *Los Angeles Times,* July 3, 1996, A10.

3. This is a paraphrase from Bruce Yonemoto's presentation for "Video Chronologies," a panel organized by Erika Suderburg, sponsored by the Lannan Foundation, and held at Los Angeles Contemporary Exhibitions, October 19, 1996. I participated on this panel, along with Yonemoto, David James, and Carol Anne Klonarides.

4. See the essays on the impact of the rights movements in *The 60s without Apology,* ed. Sohnya Sayres et al. (Minneapolis: University of Minnesota Press, 1984).

5. Audre Lorde, "Age, Race, Class, and Sex: Women Redefining Difference" (1984), reprinted in *Out There: Marginalization and Contemporary Culture,* ed. Russell Ferguson et al. (New York: New Museum of Contemporary Art; Cambridge, Mass. and London: MIT Press, 1990), 282.

6. Gamboa, "Ismania," manuscript page 27; Gamboa has his character Ismaniac continue with a postmodern existentialism: "Existence is relative to measurement: Moments, days, years, eons, and it is all over in an instant / I exist, therefore I am anxious about the nonexistence that awaits me. I exist and it all seems so random."

7. See Benjamin Buchloh's polemic regarding what he sees as the reactionary political implications of the return to large-scale representational oil painting in the 1980s, "Figures of Authority, Ciphers of Regression: Notes on the Return of Representation in European Painting" (1981), reprinted in *Art after Modernism: Rethinking Representation,* ed. Brian Wallis (New York: New Museum of Contemporary Art; Boston: Godine, 1984), 107–36. Of

course, as others have pointed out, painting is not inherently reactionary (no more than are body art, Brechtian practices, etc.). The main point here is that, within the context of the 1980s in Europe and the United States, the body dropped out of radical artistic practice, finding a place only in representational (and highly commodified) paintings that rendered it in idealized, fetishized, or otherwise nostalgic ways.

8. This is by no means to suggest that 1980s feminist art practice and discourse have in any simple way promoted the same politics—simply that there is a disconcerting conflu-ence of ideas intersecting in a generalized anxiety about the body in this period. I discuss this unfortunate ideological confluence in my essay "The 'Sexual Politics' of *The Dinner Party:* A Critical Context," in *Sexual Politics: Judy Chicago's* Dinner Party *in Feminist Art History,* ed. Amelia Jones (Los Angeles: UCLA/Armand Hammer Museum of Art; Berkeley and Los Angeles: University of California Press, 1996), 82–118.

9. At this point, I replace the term "body art" with "body-oriented practices"; the 1990s work often involves complex strategies relating to the body (fragmenting it, symboliz-ing it, rendering it through highly distorting technologies of representation) that justify discussing the work as oriented toward, but not necessarily including, the artist's own body.

10. It is tempting to define these artists as a younger generation, as I will tend to do here; however, it is worth stressing that there are too many overlaps in age group for this characterization to be entirely accurate. Many of the most interesting figures now working with body-oriented practices are in their mid forties to early fifties, the same age as some of those who were initially visible in the early 1970s are now; often, an artist who has been work-ing with the body since the 1970s (such as Maureen Connor) will only have come to be fully appreciated in the 1990s, now that the body is again viewed as a vital site of exploration.

11. By using the term *posthuman* I mean to stress the rejection of humanism (with all the romantic mythology that this entails) enacted by this work. Numerous scholars have used this term. See, for example, Jeremy Gilbert-Rolfe's "The Visible Post-Human," in *Beyond Piety: Critical Essays on the Visual Arts, 1986–1993* (New York and Cambridge: Cambridge University Press, 1995), and Kathleen Woodward, citing Andrew Ross, in "From Virtual Cyborgs to Biological Time Bombs: Technocriticism and the Material Body," *Culture on the Brink: Ideologies of Technology,* ed. Gretchen Bender and Timothy Druckrey (Seattle: Bay Press, 1994), 49.

12. While inevitably I use labels to designate various "identities" throughout this chap-ter, these labels are meant as provisional indicators of self-consciously adopted positionali-ties and not finally determinable in the effects they seem to propose.

13. For a full description of this piece, see Lynne Cooke, "Postscript: Re-Embodiments in Alter-Space," *Gary Hill* (Seattle: Henry Art Gallery, University of Washington, 1994), 82–83.

14. Ibid., 85.

15. For a brief history of video art, see John G. Hanhardt and Maria Christina Vil-laseñor, "Video/Media Culture of the Late Twentieth Century," *Art Journal* 54, n. 4 (Winter 1995): 20–25. It should be noted that earlier body art did sometimes use multiple video monitors, but the single-channel video and performance art formats (as well as the perfor-mative photograph) were far more common until the 1980s and 1990s.

16. Derrida, "Videor" (1990), *Resolutions: Contemporary Video Practices,* ed. Michael Renov

and Erika Suderburg (Minneapolis: University of Minnesota Press, 1996), 74. Other major figures who have begun to employ video in an aggressively spatial, phenomenological way that engages the body include Tony Oursler, Dorit Cypis, Joe Santarromana, and Bruce and Norman Yonemoto. The work of these artists, as well as that of Faith Wilding (whose on-going artistic and theoretical explorations of bodies and technology have been inspirational to me), has deeply informed this chapter.

17. Cooke, "Postscript," 82.

18. This body is not always Anglo, and not always Hill; especially in his more recent pieces—such as *Tall Ships* (1992)—he includes a range of other people, men and women, old and young, white, black, Asian, etc.

19. David Joselit criticizes Hill for being nostalgic and for supporting the tendency of media to escape into fantasy in his unpublished essay, "Gary Hill: Between Cinema and a Hard Place." I would expand Joselit's notion of nostalgia to take issue with Hill's work on the basis that it avoids particularizing the body, as much of the most effective recent work does (hence, nostalgically looking to a notion of universality). While multiplying types of bodies in his works, he still presents them as vague figures that seem to want to stand in for humanity in general. At the same time, Hill's pieces such as *Inasmuch As* can be seen to defer any final delivery of a body that secures the subject in a Cartesian relation (thus, while the niche that holds the monitors might at first seem to promise to cohere the video images into a singular representation of an "individual," ultimately it merely exacerbates the impossibility of such cohesion in the perception of the viewer, who negotiates the multiplicity of body fragments as conveyed through the screen of video/of fantasy).

20. For more on this piece, see Andrea Liss, "The Art of James Luna: Postmodernism with Pathos," *James Luna Actions & Reactions: An Eleven Year Survey of Installation/Performance Work 1981–1992* (Santa Cruz: University of California, Mary Porter Sesnon Art Gallery, 1992), 8–9; and Leah Ollman, "Confronting All the Demons," *Los Angeles Times* (June 16, 1996), Calendar section, 58–59. Luna's body was labeled with tags identifying the marks on his body in terms of clichés associated with Native Americans (scars, for example, were identified as the result of excessive drinking and brawling).

21. Another major project exploring this interactive dimension of the constitution of Western identities in oppositional relation to "primitive" otherness is Coco Fusco and Guillermo Gómez-Peña's *Two Undiscovered Amerindians Visit . . .* (with the final word of the title to be filled in with the name of each venue of the performance), performed internationally in the early 1990s. Fusco and Gómez-Peña performed in a large cage, with outlandish kitsch-"primitive" outfits and behavior, to unsuspecting crowds who most often interpreted the piece as a "real" ethnographic display. Central to the effect was the aspect of *engagement*, whereby spectators become participants in the construction of "otherness." Fusco discusses the implications of this piece in her important essay "The Other History of Intercultural Performance," in *English Is Broken Here: Notes on Cultural Fusion in the Americas* (New York: New Press, 1995), 37–64.

22. Crutches may refer to the frequent occurrence of diabetes on Indian reservations (diabetes often necessitates amputation); this possibility is mentioned in the Santa Monica Museum press release for *Dream Hat Ritual* (1996).

23. Luna stated that he made the born-in-a-TV claim in response to an Indian elder,

who noted that he was born in a tepee. From Luna's lecture/performance in conjunction with *Dream Hat Ritual* at the Santa Monica Museum, July 12, 1996.

24. Ibid. Trinh T. Minh-ha is clear on the dangers of the discourse of authenticity, which, in the context of tourism and postcolonialism, "turns out to be a product that one can buy, arrange to one's liking, and/or preserve. . . . Today, planned authenticity is rife; as a product of hegemony and a remarkable counterpart of universal standardization, it constitutes an efficacious means of silencing the cry of racial oppression." See *Woman, Native, Other: Women, Postcoloniality, and Feminism* (Bloomington and Indianapolis: Indiana University Press, 1989), 88, 89.

25. Mark Poster, *The Mode of Information: Poststructuralism and Social Context* (Chicago: University of Chicago Press, 1990), 15–16.

26. Poster, *The Second Media Age* (Cambridge: Polity Press, 1995).

27. Vivian Sobchack, "The Scene of the Screen: Envisioning Cinematic and Electronic 'Presence,'" *Materialities of Communication*, ed. Hans Gumbrecht and K. Ludwig Pfeiffer (Stanford, Calif.: Stanford University Press, 1994), 85, 83. Sobchack includes as well transportation technologies such as the automobile. I differ from Sobchack in some of the specifics of her comparison of photography, film, and computer technologies (in particular, as will be clear in this chapter, her argument that electronic representation "denies the human body its fleshly presence and the world its dimension" [105]; I see the "disembodiment" as a *desire* rather than as an achieved state) but am indebted to her for the basic phenomenological model I've attempted to apply to recent body art. She is one of the few cultural theorists with a deep knowledge and appreciation of phenomenology, and her work has been inspirational to this study. See her essays "Beating the Meat/Surviving the Text, or How to Get Out of This Century Alive," in *Body & Society* 1, n. 3–4, special issue titled "Cyberspace, Cyberbodies, Cyberpunk, Cultures of Technological Embodiment" (1995): 205–14; and her acerbic critique of technoeuphoria, "New Age Mutant Ninja Hackers: Reading *Mondo 2000*," in *Flame Wars: The Discourse of Cyberculture*, ed. Mark Dery (Durham, N.C., and London: Duke University Press, 1994), 11–28.

28. Donna Haraway, "A Cyborg Manifesto: Science, Technology, and Socialist-Feminism in the Late Twentieth Century," in *Simians, Cyborgs, and Women: The Reinvention of Nature* (New York and London: Routledge, 1991), 161, 163, 151, 160, 163.

29. Félix Guattari, "Regimes, Pathways, Subjects," *Incorporations*, special edition of *Zone* 6, ed. Jonathan Crary and Sanford Kwinter (New York: Zone, 1992), 16.

30. These ideas often have a definitively sci-fi tinge. Thus, Randy Walser and Eric Gulichsen have stated, "In cyberspace there is no need to move about in a body like the one you possess in physical reality. As you conduct more of your life and affairs in cyberspace, your conditioned notion of a unique and immutable body will give way to a far more liberated notion of 'body' as something quite disposable and, generally, limiting." Walser and Gulichsen originally were quoted in "The Wildest Dreams of Virtual Reality," *M Magazine* (March 1992); cited by Simon Penny in "Virtual Reality as the Completion of the Enlightenment Project," *Culture on the Brink*, 243.

31. Freud, *Civilization and Its Discontents* (1930), tr. and ed. James Strachey (New York: Norton, 1961), 38–39.

32. Kathleen Woodward discusses the confluence of these desired extensions in her essay "From Virtual Cyborgs to Biological Time Bombs," 47–64.

33. Simon Penny, "Virtual Reality as the Completion of the Enlightenment Project," 241; he also states convincingly that "VR blithely reifies a mind/body split that is essentially patriarchal and a paradigm of viewing that is phallic, colonializing, and panoptic. . . . VR reinforces Cartesian duality by replacing the body with a body image, a creation of mind" (238, 243).

34. Maurice Merleau-Ponty, "The Intertwining—The Chiasm," in *The Visible and the Invisible*, tr. Alphonso Lingis, ed. Claude Lefort (Evanston, Ill.: Northwestern University Press, 1968), 138.

35. On the hymen as a fleshy "sign of fusion," see Jacques Derrida, *Dissemination*, tr. Barbara Johnson (Chicago: University of Chicago Press, 1981), 209.

36. "I'm looking for an emotional response," Connor has stated of her work, "something that would push you out of your head and into your body"; cited by George Melrod in "Lip Shtick," *Vogue*, June 1993, 90. While this appears to stress a rather Cartesian notion of the head as separate from the body, I would argue that Connor's artwork emphasizes the importance of corporealizing thought.

37. Because this often-used label for the subject who experiences the work of art is patently inaccurate given the phenomenological multidimensionality of Connor's work, I have avoided using this term up until now; but it serves well in this specific instance.

38. Judith Butler, *Bodies That Matter: On the Discursive Limits of "Sex"* (New York & London: Routledge, 1993), 6.

39. Performed at Carnegie Recital Hall and the Kitchen in 1979; see Janet Kardon, "Laurie Anderson: A Synesthetic Journey," *Laurie Anderson: Works from 1969 to 1983* (Philadelphia: Institute of Contemporary Art, University of Pennsylvania, 1983), 21. *Americans on the Move* was later incorporated into the extravaganza *United States, Parts I–IV,* first performed at the Brooklyn Academy of Music in 1983.

40. Anderson's early work involved performance, photography, and the conceptual interrogation of language as constitutive of gendered subjectivity. For descriptions of her early work, see Kardon, *Laurie Anderson: Works from 1969 to 1983*, and Laurie Anderson, *Stories from the Nerve Bible: A Retrospective 1972–1992* (New York: HarperCollins, 1994). In this discussion, I am also indebted to Sam McBride's "Constructing Laurie Anderson: Postmodernism, Feminism, and Cultural Critique," Ph.D. dissertation, University of California, Riverside, 1997.

41. In his study "Constructing Laurie Anderson" McBride points out that Anderson studied Merleau-Ponty's writings in college; her familiarity with Merleau-Ponty (who, as I noted earlier, was popular among minimalist and conceptualist artists in the 1960s and early 1970s) surfaces in several of her art reviews. See, for example, her review of the work of Klaus Rinke in *Art News* 71, n. 3 (May 1972): 54. Sean Cubitt discusses the effect of Anderson's negotiation of technology on the "phenomenological production of a performance persona" in "Laurie Anderson: Myth, Management and Platitude," *Art Has No History!: The Making and Unmaking of Modern Art*, ed. John Roberts (London and New York: Verso, 1994), see 279–82.

42. Craig Owens, "The Discourse of Others: Feminists and Postmodernism" (1983),

in *Beyond Recognition: Representation, Power, and Culture,* ed. Scott Bryson et al. (Berkeley and Los Angeles: University of California Press, 1992), 169; Anderson, *Stories from the Nerve Bible,* 7.

43. Anderson uses the term "talking styles" in "Interview with Laurie Anderson," *Performance Art* 2 (n.d.): 16, cited in Kardon, "Laurie Anderson: A Synesthetic Journey," 21.

44. Owens, "The Discourse of Others," 169, 170; the earlier reading that Owens decries occurs in his otherwise brilliant essay "The Allegorical Impulse: Toward a Theory of Postmodernism, Part 2" (1980), reprinted in *Beyond Recognition,* 70–72.

45. Cited in Owens, "The Discourse of Others," 169.

46. Anderson, *Stories from the Nerve Bible,* 150. After experimenting extensively with the voice of authority in 1980s performances, Anderson eventually stopped using it so often; in her words, "I began to use my own [unmodulated] voice for pieces that contained pointed social criticism. I've always thought that women make excellent social critics. We can look at situations . . . and size them up fairly well; since we don't have much authority ourselves, we don't have that much to lose" (261).

47. The exploration of gender, language, and representation is even more explicit in Anderson's 1973 *Object/Objection/Objectivity* series, consisting of a series of photographs she took in response to being verbally harassed on the street. She then mounted each photograph, placing a bar over the (mostly) male subjects' eyes, and displayed them on top of handwritten texts describing their response to her attempt to reverse the object/subject relation they had established by calling out to her through her photographic action. These are reproduced in Craig Owens's earlier version of part of the "Discourse of Others" essay, "Sex and Language: In Between," in *Laurie Anderson: Works from 1969 to 1983,* 49–53.

48. N. Katherine Hayles, "Virtual Bodies and Flickering Signifiers," *October* 66 (Fall 1993): 76, 77.

49. Ibid., 72.

50. K. Larson, "For the First Time Women Are Leading, Not Following," *Art News* 79, n. 8 (October 1980): 72; cited by Sam McBride in "Constructing Laurie Anderson."

51. Hayles, "Virtual Bodies and Flickering Signifiers," 81, 89; Anderson, *Stories from the Nerve Bible,* 150. Hayles is careful to specify the embodiment of the subject within such a mutable structure of meaning: "If, on the one hand, embodiment implies that informatics [Haraway's term for the new system of communication] is imprinted into the body as well as mind, on the other, it also acts as a reservoir of materiality that resists the pressure toward dematerialization. . . . Information, like humanity, cannot exist apart from the embodiment that brings it into being as a material entity in the world; and embodiment is always instantiated, local, and specific" (91).

52. Anderson, *Stories from the Nerve Bible,* 154–55. In some projects Anderson explicitly forces the audience to act, as in the earlier Happenings (see "The Audience as Performers," 154); I am also including the more general sense of intersubjectivity (audience as performers of meaning) that I have addressed throughout the book.

53. See a description of this piece, itself called *Stories from the Nerve Bible,* in ibid., 279.

54. Laurie Anderson with Hsin-Chien Huang, *Puppet Motel* (New York: Voyager, 1995). See the review and description of *Puppet Motel* by Shannon Maughan, *Publishers Weekly,* April 24, 1995, 33.

55. Anderson's previous live performances often included segments in which she played

the sound of her own voice on a violin (rigged with tape heads that had her prerecorded voice on them).

56. Margaret Morse argues that incorporation replaces identification in the age of cybernetics and other electronic media because of their immersive effects (identification, she points out, requires a distance that is not afforded by the interactive CD-ROM experience). Interestingly, she cites Bob Flanagan's performance in the Nine Inch Nails music video of the song "Happiness in Slavery" (where his entrails appear to be ground into meat) as exemplary of the fantasy of incorporation, in this case the fantasized, atavistic male desire to be devoured and penetrated by the machine. She specifically notes that in this "reversible logic . . . subject and object are not clearly differentiated, rather than being eaten one can try to *become the other* by 'getting into someone else's skin.'" See Morse, "What do Cyborgs Eat? Oral Logic in an Information Society," *Culture on the Brink*, 164–65.

57. Anderson in "The Renaissance of a One-Woman Art Form," an interview with Clayton S. Collins, in *Profiles: The Magazine of Continental Airlines*, July 1995, 41.

58. Sobchack, "The Scene of the Screen," 85. All of this is not to assert her unique authorship at the expense of the people who assisted her on the technological aspects of the CD-ROM, especially Hsin-Chien Huang; but, as the project is presented as "Anderson's," it is appropriate to read it within the author function "Anderson."

59. I would insist on extending "ethnic" to whites; that is, it is not only "people of color" who have been forced to reckon with their "ethnicity" but, increasingly, as whites lose their hegemony over culture, we, too, have been forced to acknowledge the particularity of our ethnicity (rather than to naturalize it). One of the effects of this in the United States is the increasing acknowledgment that "white" is and historically has been multi-ethnic (Jewish, Irish, Italian, etc.).

60. Haraway, "A Cyborg Manifesto," 155, 163. Haraway is clear about her debt to post- (or, as she calls it, anti-) colonial theorists such as Chela Sandoval (the two have worked together at the University of California Santa Cruz). Sandoval's work on the "oppositional consciousness" proposes a way of thinking beyond hegemonic feminist models (which ignore racial and ethnic differences) to "provide . . . access to a different way of conceptualizing not only U.S. feminist consciousness but oppositional activity in general." See Sandoval, "U.S. Third World Feminism: The Theory and Method of Oppositional Consciousness in the Postmodern World," *Genders* 10 (Spring 1991): 1. Haraway's model ultimately entails an appropriation of the "woman of color" as a disruptive force linked to the machinic cyborg; this appropriation in some ways parallels my own tendency to think disruption in terms of nonnormative identities to which I apparently have only identificatory (not "essential"— whatever that might be) access. (In fact, I would argue that one's access to others can always entail various complex identifications, regardless of the seemingly obvious differences in visible "skin color" etc.). As Haraway's self-conscious and ironic model suggests, this gesture of appropriation is always somewhat problematic to the extent that it continues a long, colonializing tradition of exoticizing women of color (privileging them for their ostensible closeness to some "truer"—or in this case "more radical"—identity or mode of existence). Audre Lorde has articulated the dangers of white feminists' appropriation of the politics of color: "Now we hear that it is the task of black and third world women to educate white women, in the face of tremendous resistance, as to our existence, our differences, our rela-

tive roles in our joint survival. This is a diversion of energies and a tragic repetition of racist patriarchal thought." See Lorde, "The Master's Tools Will Never Dismantle the Master's House," in *This Bridge Called My Back: Writings by Radical Women of Color,* ed. Cherríe Moraga and Gloria Anzaldúa (New York: Kitchen Table/Women of Color Press, 1981/1983), 100.

61. The notion of gender as the primary determinant of identity comes out of feminist writings from the late 1960s and early 1970s. See Shulamith Firestone's *The Dialectic of Sex: The Case for Feminist Revolution* (New York: Quill/William Morrow, 1970), where she draws on the anatomical differences between the sexes to argue that gender—not class— is the fundamental difference: "For feminist revolution we shall need an analysis of the dynamics of sex war as comprehensive as the Marx-Engels analysis of class antagonism was for the economic revolution. More comprehensive. For we are dealing with a larger problem, with an oppression that goes back beyond recorded history to the animal kingdom itself" (12). Yet the complexity of Firestone's "essentialism" is evident in her sophisticated early acknowledgment of the imbrication of racism and sexism (*"racism is a sexual phenomenon. . . . racism is sexism extended"* [105]) and in her prescient theorization of *cybernetics* as crucial to the "freeing" of women from the class/gender/race system ("Cybernetics, in questioning not only man's relation to work but the value of work itself, will eventually strip the division of labour at the root of the family of any remaining practical value" [206]). Firestone's important text, which begins to articulate many of the ideas theorists such as Haraway would develop in the 1980s and 1990s, makes clear that issues of race and sexuality have since the 1960s been discussed within feminism and related discourses; however, while these issues were addressed, it is only recently that artists and scholars have increasingly come to theorize fully their mutual implication in one another.

62. Trinh T. Minh-ha, *Woman, Native, Other,* 100.

63. Identity, she suggests, cannot be viewed other than as patriarchal in effect: as "a by-product of a 'manhandling' of life"; she continues, "it is impossible to me to take up a position outside this identity [of fe/male] from which I presumably reach in and feel for it" (ibid., 95). As Hazel V. Carby has noted, "In arguing that most contemporary feminist theory does not begin to adequately account for the experience of black women we also have to acknowledge that it is not a simple question of their absence, consequently the task is not one of rendering their visibility. . . . We can point to no single source for our oppression. When white feminists emphasize patriarchy alone, we want to redefine the term and make it a more complex concept." See Carby, "White Women Listen! Black Feminism and the Boundaries of Sisterhood," *The Empire Strikes Back: Race and Racism in 70s Britain* (London and Melbourne: Hutchinson; Birmingham: Centre for Contemporary Cultural Studies, 1982), 213. Carby's recognition, like Trinh's, that patriarchy still must be interrogated but must be understood as *constituted through* racial, class, and other oppressions is crucial to the rethinking of theories of sexual difference as primary to the structures of subjectivity.

64. Kobena Mercer, "Busy in the Ruins of Wretched Phantasia," in *Mirage: Enigmas of Race, Difference, and Desire,* ed. Ragnar Farr (London: Institute of Contemporary Art and British Film Institute, 1995), 31, 32. I am grateful to Harris for sharing this source with me. Mercer is of course referring to Fanon's *Black Skin/White Masks* (New York: Grove, 1967). Fanon's project parallels Beauvoir's (which specifies the gendered axes along which the master/slave dialectic aligns itself, and deals with the class implications of this split, but does not address race).

65. This is Vivian Sobchack's term, shared with me in conversation, to differentiate this kind of recognition of existence of oneself as object from the negative connotations of "objectification."

66. By veiled I do not mean to suggest that this objectification is not violent and persistent, but merely that in the 1990s racism is generally publicly disavowed in the United States under the rhetoric of "color blindness."

67. As bell hooks has written, "The discourse of black resistance has almost always equated freedom with manhood, the economic and material domination of black men with castration, emasculation. . . . [F]reedom from racial domination was expressed [in 1960s and 1970s black power literature] in terms of redeeming black masculinity. And gaining the right to assert one's manhood was always about sexuality" ("Reflections on Race and Sex," in *Yearning: Race, Gender, and Cultural Politics* [Boston: South End Press, 1990], 58–59).

68. See especially Mapplethorpe's *Black Males*, introduction by Edmund White (Amsterdam: Gallerie Jurka, 1982), and *The Black Book*, foreword by Ntozake Shange (New York: St. Martin's, 1986). Mapplethorpe's black male nudes have been intelligently discussed by Kobena Mercer in "Skin Head Sex Thing: Racial Difference and the Homoerotic Imaginary," in *How Do I Look?: Queer Film and Video*, ed. Bad Object-Choices (Seattle: Bay Press, 1991), 169–210. Glenn Ligon produced an installation that is an explicit negotiation of Mapplethorpe called *Notes on the Margin of the Black Book*, 1991; see Mercer's "Busy in the Ruins of Wretched Phantasia," 38.

69. Mercer, "Skin Head Sex Thing," 208.

70. Following the anthropological model of the exchange of women, even the most potent white myth about black masculinity, that of the danger to the virginal white woman, was at least originally about white male anxieties, not, strictly speaking, about white female "safety." On the exchange of women, see Gayle Rubin, "The Traffic in Women: Notes on the 'Political Economy' of Sex," in *Toward an Anthropology of Women*, ed. Rayna R. Reiter (New York: Monthly Review Press, 1975), 157–210; and on the issue of cross-racial rape anxieties, see hooks, "Reflections on Race and Sex," 57–64.

71. Thomas Allen Harris's recent film *Vintage: Families of Value* (1996) is a compelling study of queer siblings, including himself and Lyle Ashton Harris.

72. Harris in *Inside Out: Psychological Self-Portraiture* (Ridgefield, Conn.: Aldrich Museum of Contemporary Art, 1995), 46. Interestingly, the curator (who is also a collector and practicing oncologist) opens this catalog by stating that the exhibition was inspired by his viewing of Hannah Wilke's last project, *Intra-Venus*, at Ronald Feldman Gallery in New York in 1994. See Marc J. Straus, "Inside Out: Curator's Self-Portrait," 3.

73. In the state of California, the passage of Proposition 187 (penalizing undocumented immigrants currently living in the state) and Proposition 209 (proposing to disband affirmative action programs statewide) in the mid 1990s has been accompanied by a great deal of discussion that has surfaced the racism and xenophobia underlying these propositions. On their supporting side, for example, ethnic identity is frequently conflated with national identity—with the implication that to be Chicano/a is to belong in Mexico (regardless of the facts that California used to be an extension of Mexico and that Chicanos and Chicanas can claim a far more extensive ancestral lineage in this area than can whites). Mario Ontiveros explores this intercultural history in "Circumscribing Identities:

Chicana Muralists and the Representation of Chicana Subjectivity," M.A. thesis, University of California, Riverside, 1994.

74. It should be noted that this reading is against the grain of Aguilar's own stated premises, which are universalizing: "My artistic goal is to create photographic images that compassionately render the human experience, revealed through the lives of individuals in the lesbian/gay and/or persons of color communities. My work is a collaboration between the sitters and myself, intended to be viewed by a cross-cultural audience. Hopefully the universal elements in the work can be recognized by other individuals or communities and can initiate the viewer to new experiences about gays, lesbians and people of color." See the artist's statement in *Nueva Luz: A Photographic Journal* 4, n. 2 (1993): 22. I am grateful to the artist for providing me with this and other materials on her work. Through my reading I am suggesting that, in spite of her own attachment to the notion of identity as a representable set of components, her performance of herself in her self-portraits unhinges the proposed link between the codes of identity that body seems to purvey and my (or any viewer's) experience of her body/self. Through the very photographic technologies that are meant to secure this link, Aguilar *gives* her body/self over to the observing *other* (such as myself) and opens it to interpretive exchanges of desire and identification.

75. On the video camera as an instrument of testimonial, see Michael Renov, "Video Confessions," *Resolutions*, 78–101. Renov argues convincingly that the "confession" of the subject on her or his videotape is a powerful tool for "self-understanding, as well as for two-way communication, for the forging of human bonds" (97). In this sense, while Aguilar deploys video apparently as a means of transformation or personal redemption, I am engaging her video-subject for a different—more social—kind of redemptive practice. On the particularly Latin *testimonio*, see also Chon A. Noriega, "Talking Heads, Body Politic: The Plural Self of Chicano Experimental Video," in *Resolutions*, 207–28. Here, drawing on the work of Doris Sommer, Noriega argues that the *testimonio* proposes an "ethics of identity" that places the videotaped subject in a relation of "lateral identification" with the viewer. We do not identify *directly* with the narrator (in Sommer's words, "We are too different") but, rather, identify with the narrator's *project*; further, the "talking head" of the narrator in the *testimonio* belongs definitively to "a body politic." Thus, our engagement with Aguilar is definitively both personal and political; we identify with her pain and the social implications of her expressed identities, if not with these particular identities themselves.

76. The video is put together from a number of different monologues: in most of them, we are confronted with an extremely close-up view of Aguilar's face. In others, we see her upper torso and head and, at points, the image cuts to her naked, "decapitated" torso (but we still hear her monologue voice-over), a close-up view of her nipple and breast, flattened against her large stomach, and a side view of her stomach and breasts as she strokes her belly while discussing her use of photography and video to learn to be comfortable with herself (in her body).

77. She repeatedly speaks her comfort with her body as being against the grain of others' perceptions of it (perceptions themselves interpreted, of course, through her own point of view).

78. Peggy Phelan, *Unmarked: The Politics of Performance* (New York and London: Rout-

ledge, 1993), 7. Phelan continues, "The same physical features of a person's body may be read as 'black' in England, 'white' in Haiti, 'colored' in South Africa, and 'mulatto' in Brazil" (8).

79. Ibid., 13.

80. Allucquére Rosanne Stone, "Speaking of the Medium: Marshall McLuhan Interviews Allucquére Rosanne Stone," in *Orlan: This is my body . . . This is my software . . .* , ed. Duncan McCorquodale (London: Black Dog, 1996), 46.

81. Technophiles use the term *meat* (or *meat cage,* or *wetware*) derogatively to indicate the supposedly obsolete, organic body. See Vivian Sobchack's critique of Baudrillard's disdain for the body in her essay "Beating the Meat/Surviving the Text," 208. It is worth noting in this context the important recent work of Stelarc, which involves the use of mechanical prosthetics to extend his body. The performance *Telepolis* involved Stelarc's cyborg-body in advanced interactive computer technologies; participants' interventions, from various international sites, choreographed his body's movements (using modem-linked computers and a "multiple muscle stimulation system") with the performative body then broadcast "live" on the Web (November 10–11, 1995). This information was published in a press release over the Internet (dated November 9, 1995). Another artist using interactive technology to link the participant with the artist (in a radically new chiasmic intertwining) is Joe Santarromana. Working with Ken Goldberg and a team of technical assistants from the University of Southern California in Los Angeles (USC), Santarromana produced *The Telegarden* (1994), which linked a Web site to a robotic arm placed in a garden at USC. Roving participants on the Web were given the option of registering through e-mail to engage the robotic arm to plant seeds and tend them; upon registration, the participant/user became part of a community of "gardeners," and was responsible for her/his portion of the garden. A chat space linked to this Web site afforded a chance for dialogue. Goldberg and Santarromana have since installed the work elsewhere; it can be accessed at http://www.usc.edu/dept/garden. Santarromana presented this work at the panel "Views on Video Installation," organized by Erika Suderburg, sponsored by the Lannan Foundation, and held at Los Angeles Contemporary Exhibitions, November 9, 1996.

82. Orlan is citing Eugénie Lemoine-Luccioni, *La Robe: Essai psychanalytique sur le vêtement* (Paris: Seuil, 1983), 95; see Sarah Wilson, "L'histoire d'O, Sacred and Profane," *Orlan: This is my body . . . This is my software . . .* , 13. I am grateful to Michelle Hirschhorn for sharing this catalog, which contains a CD-ROM of Orlan's work (and also includes this quotation), with me; the catalog accompanied an exhibition at Zone Photographic Gallery, Newcastle upon Tyne.

83. Stone, "Speaking of the Medium," 49. Stone, a transsexual, is particularly interested in the way in which transsexual surgeries disturb this attempt to ground identity in physical form. To this end, the photographer Loren Cameron has produced a project photo-documenting his surgical transformation from female to male; the art historian Monica Kjellman introduced Cameron's work to me.

84. Orlan takes her ideals, which she instructs the surgeon to follow, from computer-synthesized morphs of a number of art historical images of women (from Botticelli's *Venus* to Leonardo's *Mona Lisa*); see Carey Lovelace's "Orlan: Offensive Acts," *Performing Arts Journal,* n. 49 (1995): 13, and Orlan's description of the importance of each of these models in her "Conference," *Orlan: This is my body . . . This is my software . . .* , 88–89. On Orlan's critique of

ideals of female beauty, see Sarah Wilson, "Féminités-Mascarades," *Féminimasculin: Le sexe de l'art* (Paris: Centre national d'art et de culture Georges Pompidou, 1995), 302. Other more recent works have involved Orlan's making herself grotesque (for example, with the placement of silicon implants over her eyebrows).

85. This is Parveen Adams's description in "Operation Orlan," *The Emptiness of the Image: Psychoanalysis and Sexual Difference* (London and New York: Routledge, 1996), 143; Adams was kind enough to supply this text to me before its publication. See also David Moos's discussion of how Orlan "constructs memory through a plurality of media that will ensure that 'something'—whether a face (hers), a feeling (yours), a desire (of artist and spectator)—be both transmitted and received," in his essay "Memories of Being: Orlan's Theater of the Self," *Art + Text* 54 (1996): 68. Moos rather disturbingly, given the explicit feminist critique of the Western artistic tradition of objectifying female bodies proposed in Orlan's project, connects Orlan's undoing and remaking of her body image to Willem de Kooning's process of painting women's bodies in the *Woman* series of the 1950s.

86. See Alan Sekula's important essay on turn-of-the-century theories of physiognomy and photography, "The Body and the Archive," in *The Contest of Meaning: Critical Histories of Photography*, ed. Richard Bolton (Cambridge, Mass., and London: MIT Press, 1989), 343–89.

87. Adams, "Operation Orlan," 143, 156. I differ from the conclusions Adams draws from the detachability of Orlan's face. She argues that this shows the face to be "pure exteriority," revealing that *"there is nothing behind the mask"* (145). While I agree with Adams that this detachability "undoes the triumph of representation" (145), exposing the impossibility of "knowing" a subject through her bodily appearance, I see this detachability as *exacerbating* the gross materiality of the body and face, the indissoluble connection between bodily appearance and "selfhood" as experienced by the subject and her others. Even the detachable face is still associated with the subject "Orlan": while the face can literally, surgically be detached, its effects linger in and through the body.

88. In fact, the final unveiling of Orlan's face that was scheduled at the end of her seventh operation had to be canceled because her face hadn't been properly remade; another operation had to be scheduled. This unveiling was to have taken place at the end of a six-week exhibition of the videotape of the operation and bloody artifacts at Sandra Gering Gallery in New York. See Lovelace, "Orlan: Offensive Acts," 15.

89. Stone, "Speaking of the Medium," 49.

90. This piece was initially presented at the Centre national d'art et de culture Georges Pompidou in Paris.

91. Ewa Lajer-Burcharth, "Real Bodies: Video in the 1990s," *Art History* 20, n. 2 (June 1997), 201.

92. Christine Ross discusses the notion of Hatoum's otherness as abjection in "Redefinitions of Abjection in Contemporary Performances of the Female Body," unpublished paper delivered at the College Art Association, 1996; I am grateful to Ross for sharing her paper with me. Orlan's project has consistently negotiated Catholicism. *Omnipresence* is part of her larger series of surgeries grouped under the title *The Reincarnation of Saint Orlan*, which includes photographic self-portraits of Orlan posing in baroque robes as "Saint Orlan," a figure reminiscent of Bernini's St. Theresa. Furthermore, Orlan has her surgeries performed

in elaborate, choreographed settings that recall Catholicism's emphasis on ritual. See the image of Orlan as "a Baroque White Virgin Armed with a Bouquet of Flowers" in Barbara Rose, "Is It Art? Orlan and the Transgressive Act," *Art in America* 81 (February 1993): 82. As Carey Lovelace has observed, "Catholicism, too, is rife with the notion of taboo, of boundaries not to be crossed—but that are crossed, and then healed again, through ritual" ("Orlan: Offensive Acts," 25).

93. Ross, "Redefinitions of Abjection," 2–3. In this excellent paper on Hatoum's work, for which she presented the video component at the College Art Association's 1996 meeting, Ross uses a model very similar to that I have employed here and in other essays, arguing that the uncontrollable body elicits improper pleasures that disrupt the idea of the body as container as well as the frame of aesthetics (see especially my essay "Interpreting Feminist Bodies: The Unframeability of Desire," in *The Rhetoric of the Frame: Essays on the Boundaries of the Artwork*, ed. Paul Duro [Cambridge and New York: Cambridge University Press, 1996], 223–41). Michelle Hirschhorn also develops this idea in her essay "Orlan: Artist in the Post-Human Age of Mechanical Reincarnation," M.A. dissertation, University of Leeds, 1994, 8–10; portions of this have been published as "Orlan Artist in the Post-Human Age of Mechanical Reincarnation: Body as Ready (to be Re-) Made," in *Generations and Geographies in the Visual Arts: Feminist Readings*, ed. Griselda Pollock (New York and London: Routledge, 1996), 110–34.

94. Hatoum spoke of her interest in engaging spectators through installation works such that they "complete the work" at a public lecture at the J. Paul Getty Center for the History of Art and the Humanities, September 10, 1996. On the hymen as in between space, Jacques Derrida writes, "'Hymen' . . . is first of all a sign of fusion, the consummation of a marriage, the identification of two beings, the confusion between two. *Between* the two, there is no longer difference but identity. Within this fusion, there is no longer any distance between desire (the awaiting of a full presence designed to fulfill it . . .) and the fulfillment of presence . . . between desire and satisfaction . . . between difference and nondifference." See Derrida, *Dissemination*, tr. Barbara Johnson (Chicago: University of Chicago Press, 1981), 209.

95. Ross, "Redefinitions of Abjection," 3.

96. Cited by Lovelace in "Orlan: Offensive Acts," 18.

97. For popular readings of the effects of plastic surgery on the interconnected self and body, see Charles Siebert, "The Cuts That Go Deeper," *New York Times Magazine*, July 7, 1996, 20–25, 34, 40, 43–44; and Pat Blashill, "The New Flesh," *Details* 14, n. 3 (August 1995): 46–54, 162. Blashill's essay includes a section on Orlan. As with Adams, Siebert tends to accept that plastic surgery *confirms* the separation of the body from the self ("We have achieved . . . a complete objectification of the body" [22]); I insist, rather, that Orlan's work shows such a *desired* separation (the desire for transcendence of our bodies and the mortality they entail) to be a profound failure. After all, we can rework our face and even our bones to an astounding degree, but by doing so—through our own fixation on our bodies—we simply reinforce the inexorability of these bodies and their effect on our (sense of) self.

98. Sobchack, "Beating the Meat," 207.

99. Didier Anzieu, *The Skin Ego*, tr. Chris Turner (New Haven, Conn., and London: Yale University Press, 1989), 200.

100. Rose's role in Flanagan's performances and other body art works goes far beyond that of a pain-giver; her photographs and videotapes are central to their installation works,

and her role as a visual artist clearly informed Flanagan's move from poetry to the visual arts; furthermore, her feminism deeply influenced Flanagan and changed the way he thought about gender and sexuality. See the interview with Sheree Rose in *Modern Primitives: An Investigation of Contemporary Adornment and Ritual*, ed. Andrea Juno and V. Vale (San Francisco: Re/Search Press, 1989), 109–13. On Rose and Flanagan's collaboration and life choices, see Dennis Cooper, "Flanagan's Wake" and "Rack Talk: Deborah Drier Interviews Bob Flanagan and Sheree Rose," both in *Artforum* 34, n. 8 (April 1996). I am indebted to Flanagan and Rose for generously sharing many aspects of their work with me.

101. Flanagan describes the effects of going to catechism as a youth—"I got to experience Catholic guilt and confession, the Stations of the Cross, and the saintliness of suffering. I think I related my suffering and illness to the suffering of Jesus on the cross— the idea that suffering in some way was kind of holy"—in *Bob Flanagan: Super-Masochist*, ed. Andrea Juno and V. Vale (San Francisco: Re/Search Press, 1993), 13. He then goes on to describe his appreciation of his parents' gift of the record of *Jesus Christ Superstar*; he expressed his gratitude by lashing himself along with Pilate's 39 lashes of Christ.

102. It is important to note that Anzieu is referring to a loss of containment due to improper mothering. I am referring to a loss of containment due to actual illness (and would take issue with his deferral of all blame onto the mother); *The Skin Ego*, 201. See also Elaine Scarry, *The Body in Pain: The Making and Unmaking of the World* (New York and Oxford: Oxford University Press, 1985).

103. Ron Athey's *Deliverance* (performed at Highways in Santa Monica, California, in 1994) is an extravagant, humorous, and difficult multipart S/M performance addressing the AIDS-era issue of the wounded and dying body/self; Athey is exemplary in using S/M practices to explore the intertwined emotional and physical agonies of those who develop AIDS as well as of those who love and take care of them. Like Flanagan, but more overtly, Athey incorporates religion (in his case, the fundamentalist Pentecostal church he was raised in) into the works. See Athey, "Raised in the Lord: Revelations at the Knee of Miss Velma," *LA Weekly*, June 30, 1995, 20–25, and "Gifts of the Spirit," in *Unnatural Disasters: Recent Writings from the Golden State*, ed. Nicole Panter (San Diego, Calif.,: Incommunicado, 1996), 70–80.

104. "The illness is therefore not known," Sartre writes, "it is *suffered*, and similarly the body is revealed by the illness and is likewise suffered by consciousness." Sartre, *Being and Nothingness: A Phenomenological Essay on Ontology* (1943), tr. Hazel Barnes (New York: Washington Square Press, 1956), 443.

105. In his "Pain Journal," Flanagan recorded his response to the medicine he was plied with during his frequent stays in the hospital: "Drugged. Groggy. Headache. Sweats. The Prednisone. The Percocet. The Oxazepam." See the excerpts from "Pain Journal," *Unnatural Disasters*, 139; portions are also reprinted in *Artforum* 34, n. 8 (April 1996): 76–81.

106. The film *Sick: The Life and Death of Bob Flanagan, Supermasochist* (1996), directed by Kirby Dick with footage by Sheree Rose, is an overwhelming document of Rose and Flanagan's sixteen years together; the last portion of the film includes footage of Flanagan dying in the hospital. The brute agony of Flanagan's death—the searing physical pain and his horrified resistance to its finality, as he desperately clings to Rose—is almost unbearable to watch. See also Dennis Cooper's eloquent description of Flanagan's condition and life choices in "Flanagan's Wake" and "Rack Talk."

107. It is the disparity between his usual self-presentational nonchalance and his visible agony as he is dying that makes the final portion of the film *Sick* so wrenching.

108. Nacht defines masochism as an attempt to save the primary attributes of masculinity and subjectivity (that is, the penis) through a partial sacrifice of other, less crucial parts of the male body in his book *Le Masochisme*, 3d ed. (Paris: Petite Bibliothèque Payot, 1965), see especially 7. This discussion of Flanagan's masochism is revised from my essay "Dis/Playing the Phallus: Male Artists Perform Their Masculinities," *Art History* 17, n. 4 (December 1994): 546–84.

109. Bob Flanagan, "Why?" in *Dear World*, ed. Camille Roy and Nayland Blake (San Francisco: self-published [?], 1991), 55–56.

110. *Bob Flanagan: Supermasochist*, 32. Flanagan's controlling side is evident in some of the "private" footage (taken at home with Rose and Flanagan) in the film *Sick*, in which he is quite aggressive in his exhortations as he directs her domination of his body/self.

111. I discuss this 1991 performance in my essay "If Men Could Get Pregnant . . . : Bob Flanagan and Sheree Rose's *Issues of Choice*," *New Observations* 100 (March/April 1994): 21–26.

112. For Reik, masochism requires a witness and Christian masochism is the most extravagantly *exhibitionist* of all masochistic perversions, all of which have an exhibitionist element: "the suffering, discomfort, humiliation, and disgrace are being shown and so to speak put on display. . . . In the practices of masochists, denudation and parading with all their psychic concomitant phenomena play such a major part that one feels induced to assume a constant connection between masochism and exhibitionism." Reik, *Masochism in Modern Man*, tr. Margaret H. Beigel and Gertrud M. Kurth (New York: Farrar, Straus, 1941), 72.

113. Kaja Silverman, "Masochism and Male Subjectivity," *Male Subjectivity at the Margins* (New York and London: Routledge, 1992), 198; see also her comments on Reik, 196–97. Paul Smith argues that "in much occidental cultural production the Christ figure could be said to have operated chronically as a privileged figure of the pleasurable tension between the objectification and what I will call the masochizing of the male body" in "Action Movie Hysteria; or, Eastwood Bound," *Differences* 1, n. 3 (1989): 98–99. I would argue as well, however, that the exhibitionism of Christian masochism, as epitomized in the case of Jesus Christ, assigns the sufferer an incomparable role of centrality and power in relation to those who view him; it is this centrality that Flanagan extends through his directorial power over both Rose and the audience.

114. Flanagan, in *Bob Flanagan: Super-Masochist*, 63; adding to this, Flanagan states that "[b]eing penetrated is great. . . . I think I like being penetrated more than Sheree does, so it's a good switch."

115. Smith, "Action Movie Hysteria," 98.

116. Ibid., 102–3.

117. Ibid., 95.

118. Ibid., 103. See also Smith's convincing discussion of the role of male hysteria in destabilizing masculine subjectivity in "Vas," *Camera Obscura* 17 (1988): 106, 107.

119. Flanagan, in *Bob Flanagan: Super-Masochist*, 63. Of course, one could argue that Flanagan *didn't* actually castrate himself (or have himself castrated), and that he did not fully relinquish the privileges of white male authority, a fact proven by his current visibility as an

artist. However, the ambivalences in Flanagan's practice and writings render such simplistic assessments unconvincing.

120. Ibid., 75.

121. Rose in "Rack Talk," 79. She continues: "When Bob goes up in the air [hanging above the audience in the performance *Visiting Hours*, 1992] . . . [h]e's a real person, but at the same time he's also this object hanging there, and playing with that concept makes people really uncomfortable."

122. Sobchack, "The Passion of the Material: Prolegomena to a Phenomenology of Interobjectivity," forthcoming in her *Carnal Thoughts: Bodies, Texts, Scenes, and Screens* (Berkeley and Los Angeles: University of California Press), manuscript pages 12–13; I thank Sobchack for sharing this manuscript with me. As Mark Poster points out, Walter Benjamin's epochal essay "The Work of Art in the Age of Mechanical Reproduction" (1936) argues that there is a reversible engagement between author and audience *through* the new technologies of photography and film. Poster argues, through Benjamin, that the mediation of technology shifts the point of identification from the performer (in "live" theater) to the technology, promoting a "critical stance" by "undermining one of the chief means [the hierarchization of author and audience] by which art championed . . . authoritarian politics" (Poster, *The Second Media Age*, 13). As I have theorized live performance as *not* having ontological priority over the "mediated" presentations of film and other technological means of reproduction, I agree only that these new technologies have increasingly heightened our awareness of the contingency and mediated quality of all subjects (whether in live or taped/photographed performances). Thus, it seems to me that Benjamin's brilliance lay in part in his ability to see at a very early date how this mediation was changing the way we view *all* representations (including those staged by the previous "auratic" arts) and, I would add, correlatively the way we experience subjectivity itself. Benjamin's essay is reprinted in *Illuminations*, tr. Harry Zohn, ed. Hannah Arendt (New York: Schocken, 1968), 217–51.

123. All of the information and quotes on the trilogy come from Flanagan's project description for a Guggenheim fellowship (1995) and from Rose's revised version of this proposal (1996).

124. Rose hopes to complete them both eventually. *Video Coffin*, the only realized piece, was presented in the exhibition *Narcissistic Disturbance*; see *Narcissistic Disturbance*, ed. Michael Cohen (Los Angeles: Otis Gallery, Otis College of Art and Design, 1995), 28–29, 31.

125. Rose is planning to revise *The Viewing* so that she can complete it, replacing the actual body of Flanagan with a video approximation of his body decaying. Rose has also introduced a further element, staging the piece in a "mausoleum" including her huge balloon "sculpture" of Flanagan in bondage and with an erection—the *Boballoon* (this was exhibited in the exhibition *On Camp/Off Base*, organized by Kenjiro Okazaki, at the Tokyo International Exhibition Center in Japan in August 1996). This addition to the casket trilogy is a brilliant comment on Rose's (and to a certain extent the audience's) new relationship to Flanagan, who continues to "exist" for us through his artistic "presence" (interestingly, in this case, passed *through* Rose, as from the beginning of his artistic career). The 20 foot *Boballoon* is a fitting memorial to an artist, collaborator, and (for Rose) partner of many years who explored his own suffering but never took himself too seriously; with this piece, Rose

very sensitively continues the legacy of their work together by humorously (but cuttingly) rendering Flanagan as a huge vessel of (hot?) air, floating above us all.

126. Jacques Derrida, *Memoires for Paul de Man*, tr. Cecile Lindsay et al. (New York: Columbia University Press, 1989), 32–33.

127. My relationship to Flanagan was, indeed, personal (as is my relationship to Connor, Aguilar, and Harris). It is for this reason that the grief I feel at viewing him dying in the film is acute and indescribable, in part *because* I have thus incorporated his suffering (to a certain extent)—as well as Rose's traumatic sense of loss—into my own experience. Their mutual loss becomes inextricably linked to my recent loss of my father, who died in a hospital virtually indistinguishable from that housing Flanagan in his last days. Death comes to be experienced multiply in a relay effect of horrific loss. (I articulate my loss of my father and anticipate that of my brother-in-law, who died very suddenly in 1997, in "Love and Mourning: Who Am I since You Are No Longer?" *Framework* 7, n. 2 (1995): 14–19.)

128. Sobchack, "The Passion of the Material," 12. She is citing Levin's "Visions of Narcissism," in *Merleau-Ponty Vivant*, ed. M. C. Dillon (Albany: State University of New York Press, 1991), 67.

129. Sobchack, "The Passion of the Material," 16.

130. Ibid., 17. Sobchack cites Levin again on the promotion of "a self-developing socialization, eliciting from the deep order of our embodiment its inherent capacity to turn experiences of social relationship into an assumption of the *position* identified with the other" (19); from Levin, "Visions of Narcissism," 70–71.

INDEX

Abramović, Marina: work of, 140, 141, 141 (fig.), 142 (fig.)

Abstract expressionism, 55, 68, 72, 80, 83, 265n19; masculinity and, 73

Acconci, Vito, 39, 48, 151, 231, 290n56, 296n104; body/self and, 104–5, 111, 119, 148; corporeal immanence and, 178; femininity and, 107–11, 130, 136, 144; gaze and, 170; homoeroticism and, 109–10; identity and, 140; indexicalization by, 123, 124; interpretive exchange and, 152; intersubjectivity and, 109, 140, 143–46, 152; masculinity and, 107, 132, 134–35, 138, 140, 146, 148, 149, 284n10, 298n140; masochism of, 125–26, 129, 135; on movement, 124, 283n8; narcissism of, 116, 121, 136–37, 179; otherness and, 166; performance by, 13, 104, 112, 137, 296n115; phallus and, 107, 118–19; Pollockian performative and, 133; self/other and, 106–7, 289n52; theatrical relation and, 113; transference and, 145; work of, 13, 16, 102, 103, 105–6, 105 (fig.), 106 (fig.), 108 (fig.), 110, 113, 117–18, 117 (fig.), 119 (fig.), 121, 126 (fig.), 132, 133–34, 133 (fig.), 134 (fig.), 135 (fig.), 136, 138, 138 (fig.), 140, 141–44, 144 (fig.), 146, 147 (fig.), 148–50, 151, 153, 165 (fig.), 235, 249n8, 284n10, 304n46

Action painting, 72–73, 89, 91–92, 281nn141,142; alternative to, 94; feminist critiques of, 100; masculinized, 100–101; photo of, 90; subversion of, 98–99

"Action Painting" (Rosenberg), 73

Adams, Parveen, 227, 230; on Orlan, 324nn85,87, 325n97

Aesthetic judgment, 75–76, 112, 168, 180; ideological dimension of, 76–77

Aguilar, Laura, 322n75, 329n127; body/self and, 214–15, 217–26, 322n74; Cartesian subject and, 225; death and, 236; photographic/video technology and, 215, 220–21; self-portraits by, 221–22, 225; work of, 17, 221–22, 221 (fig.), 222 (fig.), 223, 224–25

AIDS, 230, 326n103

Alienation, 51, 149, 159, 170, 191, 192; exploring, 153; modern/postmodern, 268n40; sickness and, 193

AMELIA JONES is associate professor of art history at the University of California, Riverside. Among her numerous publications is *Postmodernism and the En-Gendering of Marcel Duchamp* (1994). Jones organized the exhibition *Sexual Politics: Judy Chicago's* Dinner Party *in Feminist Art History* at UCLA's Hammer Museum in 1996; the accompanying catalog of the same name also was published in 1996.